Monet *The Seine and The Sea 1878–1883*

Michael Clarke and Richard Thomson

MONET

The Seine and The Sea 1878–1883

National Galleries of Scotland
Edinburgh · 2003

Published by the Trustees of the
National Galleries of Scotland on the occasion
of the exhibition *Monet: The Seine and The Sea 1878–1883*
held at the Royal Scottish Academy, Edinburgh,
from 6 August to 26 October 2003

© Trustees of the National Galleries of Scotland 2003
ISBN 1 903278 44 9

Designed by Dalrymple
Typeset in Enschedé Collis by Brian Young
Printed by Snoeck-Ducaju & Zoon, Belgium

Front cover: Claude Monet *Poppy Field near Vétheuil*, 1879
(detail) Foundation E. G. Bührle, Zurich (cat.no.16)

Back cover: Claude Monet *The Manneporte, Etretat*, 1883
The Metropolitan Museum of Art, New York (cat.no.74)

Frontispiece: Claude Monet *The Sea at Pourville*, 1882
(detail) Philadelphia Museum of Art (cat.no.54)

FOREWORD

Edinburgh last hosted a major Monet exhibition in 1957. Appropriately this was also held in the Royal Scottish Academy. *Monet: The Seine and The Sea 1878–1883*, our current show, heralds the completion of the first phase of the Playfair Project. This has involved the restoration and upgrading of the magnificent Academy building which is now owned and run by the National Galleries of Scotland and will be our major exhibition venue. A year from now, in the summer of 2004, we shall open the second phase of the project, which consists of the provision of extensive visitor facilities in an underground link between the Academy and the National Gallery of Scotland. This major scheme has received splendid support from the Scottish Executive, the Heritage Lottery Fund and a number of very generous donors.

Whereas the earlier Monet exhibition embraced the whole of the artist's career, our current show focuses on five important years in the great Impressionist's life, from 1878 to 1883, a period which has been relatively unconsidered in previous exhibitions devoted to the artist. We are fortunate that the National Galleries of Scotland possess no less than five paintings by Monet. One of these, *The Church at Vétheuil* of 1878, has provided the starting point for our show which brings together nearly eighty works by the master as well as, for comparative purposes, a specially selected group of paintings by some of his most illustrious predecessors, such as Corot, Courbet and Daubigny.

We are deeply conscious that such an exhibition, which heralds a milestone in the history of the National Galleries of Scotland, could not have been realised without the generosity of lenders both private and public from around the world. We extend our grateful thanks to them all. Obviously, an ambitious show involves very considerable cost and our sponsors, the Royal Bank of Scotland, have been extraordinarily generous with their support. The exhibition itself has been devised and curated by Professor Richard Thomson, Watson Gordon Professor of Fine Art at the University of Edinburgh, and Michael Clarke, Director of the National Gallery of Scotland (and of the Playfair Project). We owe them a great debt of gratitude for their vision, enthusiasm and painstaking attention to detail in this fascinating field. I know they would wish me to extend their thanks, in particular, to their colleagues in the National Galleries who have worked so hard to ensure the exhibition's success. Lastly, I would like to offer my own very personal note of thanks to my Board of Trustees, so ably led by their Chairman, Brian Ivory, who have been so splendidly supportive of all our major initiatives in recent years.

SIR TIMOTHY CLIFFORD
Director-General, National Galleries of Scotland

< Detail from cat.no.33

SPONSOR'S PREFACE

The Royal Bank of Scotland has an international perspective and reputation and we seek to achieve the highest standards and aspirations. The exhibition *Monet: The Seine and The Sea* is, therefore, a fitting match for our interest in the visual arts. It echoes our past support for the exhibitions *Velázquez in Seville* held at the National Gallery of Scotland, Edinburgh, in 1996, *Georges Braque* at the Royal Academy, London, in 1997 and *Scotland's Art* at the City Art Centre, Edinburgh, in 1999. We are particularly pleased that the Monet show is the opening exhibition in the beautifully restored Royal Scottish Academy building.

Sponsorship is a privilege, but it is also a responsibility. The greatest care must be taken to ensure a result that makes a difference, in quality as much as in scale. In the past, individual patronage brought to Britain some of the finest works of art in the world. That patronage also encouraged an outward-looking sense of discrimination and inspired the highest creative ambitions. We believe it is the responsibility of the Royal Bank of Scotland as a major institution to sustain these challenging standards through our support.

This wonderful exhibition provides us with that opportunity. It will give pleasure to all that visit and see the magnificent paintings, which have been brought together in Scotland. It is a tribute to the National Galleries of Scotland, who have achieved so much and set themselves such ambitious goals, that they are accepted in a peer group with many of the major galleries in the world. The Royal Bank of Scotland's sponsorship is a measure of our confidence in their achievements, not only this exhibition but also the Playfair Project, which we have also been pleased to support. We are very proud to be involved with this exhibition and wish it every success.

SIR GEORGE MATHEWSON
Chairman, The Royal Bank of Scotland Group

The Royal Bank of Scotland

AUTHORS' ACKNOWLEDGEMENTS

We would like to express our thanks to generations of Monet scholars – many of whom are acknowledged in the bibliography – whose work has informed our understanding and interpretation of Monet at this fascinating period in his life. In particular John House has kindly provided much useful information and advice. We are also indebted to Marco Goldin, Robert Gordon, MaryAnne Stevens and Paul Hayes Tucker for help in tracing pictures. Bradley Fratello, Thierry Gardi and Nicola Ireland have kindly provided valuable information.

The following have all generously assisted in various ways: Michelle Ahern, H. Anda-Bührle, Colin B. Bailey, Karen Bäsig, Loredana Battalora, Felix Baumann, Christoph Becker, Stephanie Belt, Jacques de la Béraudière, Maryse Bertrand, Janine Bofill, Ulrich Bischoff, Ada Bortoluzzi, Rod Bouc, Yves Brayer, Arnauld Brejon de Lavergnée, Isaure de Bruc, Hans Henrik Brummer, John E. Buchanan Jr, E. John Bullard, Mary Herbert Busick, Françoise Cachin, D. A. S. Cannegieter, Joao Castel-Branco Pereira, Philippe Cazeau, Blandine Chavanne, Gilles Chazal, Anne-Marie Chevrier, Guy Cogeval, Françoise Cohen, Isabelle Collet, Minora Collins, Philip Conisbee, Willem Cordia, Laura Coyle, Tim Craven, James Cuno, Marianne Delafond, Ingmari Desaix, Jo Digger, Douglas Druick, Philippe Durey, Elizabeth Easton, Folke W.M. Edwards, Ann Eichelberg, Diane Farynyk, Richard L. Feigen, Larry Feinberg, Laura Fleischmann, David Fleming, Tanya Fisher, Anne-Birgitte Fonsmark, Sarah Frances, Bjorn Fredland, Flemming Friborg, Gerbert Frodl, Ivan Gaskell, Lukas Gloor, Purificacion Ripio Gonzalez, Olle Granath, Diane De Grazia, Darrell Green, Ted A. Greenberg, Torsten Gunnarson, Sarah Hall, Karin Hammerling, Tim Hardacre, Anne d'Harnoncourt, Arnaud d'Hauterives, Carrie Hedrick, Grant Holcomb III, Christian von Holst, Robert Hoozee, Maryl Hosking, David Jaffé, Hans Janssen, Lillie Johansson, Lee Johnson, Jay Kamm, Ieva Kanepe, Dorothy Kellett, Marlene Kiss, Christian Klemm, W. van Krimpen, Jack Lane, Arnold L. Lehman, Serge Lemoine, David C. Levy, Kimberley Liddle, Erika Lindt, David Liot, Irvin Lippman, Tomas Llorens, J. L. Locher, P. Loorij, Henri Loyrette, Neil MacGregor, Decourcy E. McIntosh, Marceline McKee, Carole C. McNamara, Wolfgang Mahr, Karin Marti, Caroline Mathieu, Evan M. Maurer, Giselda Mehnert, Jennifer Melville, O. Mensink, Miklos Mojzer, Philippe de Montebello, Gordon Morrison, Angie Morrow, Lori Mott, Steven A. Nash, Tobias Natter, Lorna Neill, Ann Noon, Patrick Noon, Neil O'Brien, Lynn F. Orr, Maud Paleologue, Harry S. Parker III, Kim Pashko, Castel-Branco Pereira, Claude Petry, Vincent Pomarède, Earl A. Powell III, Marie-Hélèn Priou, Eubenio Raez, Katharine Lee Reid, Maria Reilly, Lesley Retallack, Rebecca Rex, Nora Riccio, Andrea Rich, Christopher Riopelle, Joseph Rishel, Anja Robbell, Duncan Robinson, Dan Rockwell, Malcolm Rogers, Angela Rosengart, Lucas Rubin, Samuel Sachs II, Béatrice Salmon, Laurent Salomé, Elizabeth Salvon, Charles Saumarez-Smith, Frau I. A. Schielinski, Manuel Schmit, Daniel Schulman, Douglas G. Schultz, Pieter Klaus Schuster, Kate M. Sellers, Jacquelyn Serwer, George T.M. Shackelford, Suzanne Shenton, Gretchen Shie, Monica Simpson, Rebekah Sobel, Paul Spencer-Longhurst, Ann Steed James Steward, William Stout, Mary Suzor, Matthew Teitelbaum, Gary Tinterow, Julian Treuherz, Triton Foundation, Gabriela Truly, Patrick Vallais, Gerard Vaughan, Richard Verdi, Cornelia Wedekind, Katie Welty, Angelika Wesenberg, Karen Westphal-Eriksen, Lawrence J. Wheeler, Elspeth Wiemann, Jonathan Wilson, James Wood, Godfrey Worsdale, Nancy Wulbrecht, Martin Zimet.

The project has benefited greatly from a grant from the Arts and Humanities Research Board. Through this, Anne L. Cowe, while undertaking a Ph.D. under the supervision of Professor Thomson, has also acted as an invaluable research assistant and author of the useful chronology. We are extremely grateful for her diligent and good-humoured efficiency. We would also like to thank the libraries where research has taken place, including the Bibliothèque nationale de France, the Documentation of the Musée d'Orsay, the National Library of Scotland and the Witt Library. Frances Pratt assisted with documentation at an early stage.

Richard Thomson would like to express his gratitude to Frances Fowle, Richard Kendall, and Belinda Thomson for their comments on his essay. Under the auspices of the Visual Arts Research Institute, Edinburgh, Dr Fowle co-organised the conference *Soil & Stone: Impressionism Urbanism Environment*, held in October 2001, which prefigured some of the themes tackled in this catalogue, and co-edited the papers which are published concurrently. We are grateful to all the contributors to *Soil & Stone* and to the conference *Monet and French Landscape, 1870–1900* which accompanies this exhibition in October 2003.

All exhibitions are collaborative efforts. An enormous amount of work has been undertaken by many departments in the National Galleries of Scotland. We are grateful to all our splendid colleagues, but particular mention should be made of the Registrar (Exhibitions), Agnes Valencak-Kruger, and Sheila Scott, Mr Clarke's long-suffering and highly efficient Personal Assistant. Particular thanks should be extended to the architects of the restoration of the Royal Scottish Academy building, John Miller and Su Rogers, who have also acted as designers of the exhibition. Scott Robertson has been the highly effective Project Adviser to the Playfair Project, the first phase of which consists of the Academy restoration.

Our site visits to France were greatly aided by David Joel who generously shared with us his extensive knowledge of both Vétheuil and the Normandy coast and was a splendid cicerone. Jean-Marie Toulgouat, great-grandson of Alice Hoschedé Monet, and his wife, Claire Joyes Toulgouat, were most welcoming and provided valuable information. The Mayoress of Vétheuil, Dominique Herpin Poulenat, offered every assistance and support, as did the Tourism departments of Seine-Maritime and of Paris and Ile de France.

Richard Thomson would like to record his particular thanks to Michael Clarke for yet another seamless collaboration, proving that friendship, scholarship and even different understandings of the purpose of an *autoroute* can co-exist. Michael Clarke offers his unsolicited endorsement of the many automobile and tyre manufacturers whose products ensured his survival during many traversals of northern France with his esteemed collaborator at the wheel.

MICHAEL CLARKE AND RICHARD THOMSON

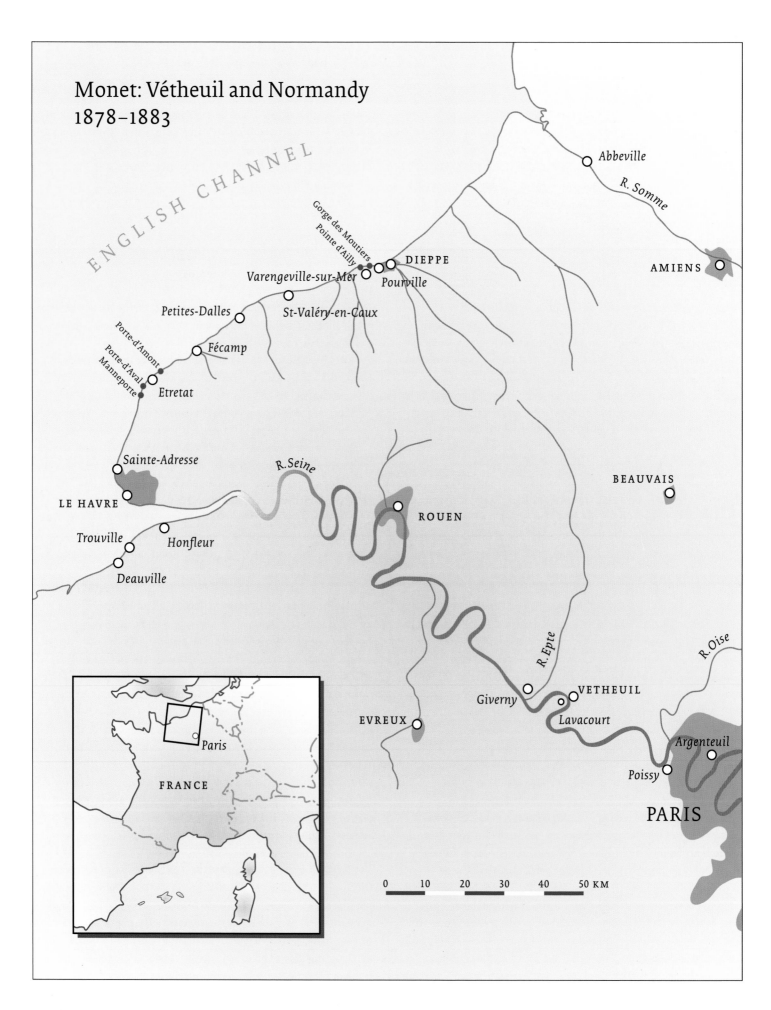

Monet: Vétheuil and Normandy
1878–1883

ENGLISH CHANNEL

Abbeville

R. Somme

AMIENS

Gorge des Moutiers
Pointe d'Ailly
DIEPPE
Varengeville-sur-Mer
Pourville
Petites-Dalles
St-Valéry-en-Caux
Porte-d'Amont
Fécamp
Porte-d'Aval
Manneporte
Etretat

Sainte-Adresse

R. Seine

BEAUVAIS

LE HAVRE

ROUEN

Trouville
Honfleur

Deauville

R. Epte

R. Oise

EVREUX

Giverny
VETHEUIL
Lavacourt

Argenteuil

Poissy

PARIS

Paris

FRANCE

0 10 20 30 40 50 KM

INTRODUCTION

Richard Thomson

The exhibition *Monet: The Seine and The Sea 1878–1883* immediately raises two questions. Why stage another Monet show, and why concentrate precisely on this short period of his career? The answer to both of these lies in the artist's work.

Monet's creative span as a painter covered more than six decades, from the early 1860s until his death in 1926. This longevity itself is remarkable in the history of art, and bears comparison with that of other titanic figures such as Titian and Picasso. Monet's range of subjects may not have been as wide as the Venetian's, and his preference for oil on canvas as an expressive medium denied him the inventive range of materials that Picasso used. But among the almost two thousand paintings that survive from Monet's prodigious output, we find a most striking variety. There are the ambitious early figure paintings – grand compositions intended to impress the public at the Paris Salon – modest still lifes, perceptive portraits, rooms grandly decorated with panels of water-lily ponds, and above all landscapes, of all kinds: highly resolved and rhyming series, cityscapes, storm-tossed marines, tranquil pastures, rapid sketches, pretty tondos, extreme weather conditions, boating scenes, and nature marked by modernisation or pulsing with light and life. It is this extraordinary, almost unequalled, range as a painter of landscape that won Monet the international reputation that developed in the last forty years of his career, and the global fame that his work enjoys over three-quarters of a century after his death. For in Monet's lifetime the benefits of progress were frequently tempered with a sense of loss, as they are in our own day. That uncomfortable tension in the modern condition enhances the appeal of art based on nature's verities, as Monet's work so evidently is.

Undoubtedly Monet's painting has great resonance for the contemporary audience. In recent years the outstanding success of such exhibitions as *Monet in the '90s* (1989–90) and *Monet in the Twentieth Century* (1998–9) has demonstrated this. But his work was not so widely fêted immediately after his death in 1926. Memorial exhibitions were staged in both Boston and Philadelphia (1927), reflecting the popularity of his work among American collectors. Retrospectives were also staged in Paris by the artist's long-term dealer Durand-Ruel (1928) and at the Musée de l'Orangerie, where his water-lily decorations are installed (1931). For two decades thereafter Monet's work was typically seen in bulk at dealers' shows rather than museum exhibitions. 1952 saw a major retrospective tour from Zurich to Paris and The Hague. The second great post-war exhibition was held at the Royal Scottish Academy, during the Edinburgh Festival of 1957. Selected by Douglas Cooper and John Richardson, this show combined remarkable works with a cogent scholarly catalogue. Edinburgh thus has a proud and pioneering place in the reassessment of Monet's art in the modern era. *Monet: The Seine and The Sea* is intended to continue in that tradition.

But why choose to centre an exhibition on a period of less than five years of the artist's long career, and why this particular period? In late summer 1878 Monet moved to the village of Vétheuil, on the river Seine some seventy kilometres north-west of Paris. He remained there for over three years, until December 1881, when he shifted to Poissy, also on the Seine but closer to the capital. Monet never liked Poissy as a place to paint, and in April 1883 he rented a property at Giverny, not far

from Vétheuil. Giverny is where Monet settled, eventually buying his house, planting the water-garden that would be the inspiration for his last quarter-century as a painter, and dying there. However, much as he enjoyed painting the villages and river-scapes around Vétheuil in the three years he lived there, it was at this time that Monet rediscovered the Normandy coast. Between arriving in Vétheuil and settling at Giverny Monet made six painting trips to the Channel, some for extended campaigns of many weeks. He produced some 350 canvases during this period. These divide into the landscapes he painted of the agricultural and fluvial countryside around Vétheuil and the marines made on the cliffs and beaches of the Channel coast. To these should be added the rarer but lively portraits and the still-life paintings that he occasionally executed. Both the exhibition and the catalogue seek to demonstrate that the work which Monet produced over this half decade was adventurous in its range, remarkable in its quality, and crucial in the way that it defined his evolving objectives as an artist.

This important phase in Monet's work deserves to be reviewed and reconsidered in detail. Although every survey of the artist's career gives the period its due, only twice (as work began on this project) have aspects of his output at this time been given closer scrutiny: in Robert Herbert's excellent book *Monet and the Normandy Coast* (1994) and in a small exhibition of canvases made at Vétheuil seen in Ann Arbor, Dallas and Minneapolis in 1998. By contrast, *Monet: The Seine and The Sea* is a sustained survey of every aspect of Monet's work during this half decade, both on the river and the coast. David Joel's book *Monet at Vétheuil, 1878–1883*, with its fine site photographs, and which covers similar ground, appeared as work on this exhibition drew to a close. One advantage for this exhibition was that a significant number of canvases painted at this period are in British collections, notably the National Gallery of Scotland's own *Church at Vétheuil*, one of the first Monet made on his arrival in 1878.

That year Monet was thirty-eight. He was a mature painter with almost two decades of work behind him, a married man with two small sons. During the 1860s his career had been characterised by the diversity, ambitions and false starts of a gifted but inexperienced artist. He had been fortunate enough to receive advice and support from a variety of older, progressive artists. His fellow Norman Eugène Boudin and his friend the Dutchman Johan-Barthold Jongkind, both painters of marines, had tutored Monet on working *en plein air*. Edouard Manet had encouraged him to imbue his pictures with a modernity that combined subject and a personal painterly touch. Gustave Courbet set an example of a robust creative temperament in the face of nature. In the 1860s Monet had exhibited both large landscapes and fashionably dressed figures at the prestigious Paris Salon; sometimes he won a degree of acclaim, at others he was rejected. He had worked in the forest of Fontainebleau, cradle of adventurous French landscape painting in the first half of the century, on his native Normandy coast, and in the midst of the new Paris rebuilt by Baron Haussmann, although by the end of the decade he had found that the western suburbs of the city suited him best. Places such as Bougival and Croissy offered a useful combination of still unspoilt nature, modern motifs of middle-class leisure, and proximity to the metropolis. The Franco-Prussian War of 1870–1 had driven Monet from France, but the hiatus of temporary exile had introduced him to the stimulus of painting in

places to which he was not habituated, whether London or Holland. On his return to France in late 1871 Monet settled once more in the Parisian suburbs, renting a house in Argenteuil until 1878. There he again concentrated on the varied motifs afforded by the edge of the city. He painted leisure pursuits on the river banks, the train traffic and industry of the modern suburb, and his carefully tended garden, all under the changing seasons and their particular '*effets*'. Monet also ventured beyond Argenteuil, and there are occasional canvases of Rouen and the Normandy coast, Holland again, and clusters treating modern Paris, notably those of the Gare St-Lazare made in 1877. Monet's financial situation was rarely stable and sometimes precarious. A period of considerable prosperity in the early 1870s had been short-lived. His critical reputation was also unstable. As a regular exhibitor since 1874 with the newly dubbed Impressionist group he had won some good press, though many reviewers found his work too abbreviated, even slapdash. Reliable critical support, like regular buyers of his work, was difficult to come by. In addition, Monet had personal worries, for by 1878 his wife Camille's health was fading fast.

Monet: The Seine and The Sea thus concentrates on an artist who had already produced remarkable pictures in a continuing process of confronting the vagaries of nature and responding to them in highly personal ways in oil on canvas. The exhibition explores in detail a half decade in that process of visual challenge and pictorial discovery that was Monet's career. It is explored both in the display of his magisterial canvases on the walls of the Royal Scottish Academy and in the two catalogue essays. Some crucial elements within the warp and weft of Monet's development must necessarily be confined to the catalogue. Hence the impact of the death of Camille and Monet's continuing financial difficulties, which begin our period, belong in the essays, as do the increasing critical recognition, concomitant financial rewards, and the stabilisation of personal life that bring it to a close. But the exhibition is intended to open up wider issues. These are implicit in the very character of Monet's paintings. Both on the wall and in the catalogue, the exhibition looks closely at Monet's considerable achievements as a painter of *plein-air* landscape. But this goes beyond scrutiny of a major figure within the Impressionist movement. The exhibition asks – and asks the visitor to ask – the questions Monet put to himself in these years. What was the essence of landscape painting? How might this be achieved? How might one follow one's own *sensations*, achieve one's own instinctive goals in the representation of nature? How did one organise paint in ways that were at once descriptive and expressive? These were probing questions about the nature of painting and the future of art. When one looks into the detail, reading Monet's correspondence for example, one finds him fussing about the changeable weather or pestering friends for loans of money. Yet when one stands back and looks intently at the works, one is confronted not only with paintings of supreme vitality and sensitivity, but also an artist coming to terms with major issues in modernism.

This exhibition, however, is more than a celebration and an analysis of five years' work by a great artist. Lodged within it is another question about the character of Monet's work at this time. During the second half of the 1870s a number of the major painters who had raised landscape painting to such a high status in recent French art

had died: Corot and Millet in 1875, Courbet in 1877, Daubigny in 1878. To coincide with the Universal Exhibition staged in Paris in 1878 the art dealer Paul Durand-Ruel laid on a survey of mid-century French art rich in work by these painters. Thus in the year Monet moved from Paris to Vétheuil he would have been made acutely aware of the achievements and disappearance of the previous generation, men whose work he much admired. Perhaps his artistic realignment at this time – shifting from painter of suburban Argenteuil and the Gare St-Lazare to painter of the village and meadows around Vétheuil – was in some way a reassessment of recent landscape painting and his relation to it. We know that while at Etretat in early 1883 he thought back to Courbet's work there over a decade before.

But what was the nature of Monet's responses to the work of the previous generation? Did he seek to emulate it, or to surpass it? Did he pay it homage in his work, placing himself in a line of descent, or did he make his elders' examples obsolete with the confidence of his more modern means of representing landscape? These questions are subtly addressed in Michael Clarke's essay, but they are also to be faced on the walls of the exhibition. *Monet: The Seine and The Sea* is a monographic exhibition; it pivots on the work of a single artist. But we have chosen to break from the conventions of such exhibitions by including some works by Monet's older contemporaries. Thus, among paintings by Monet are hung works by others, perhaps of a similar motif, or the same site. Four paintings from Monet's 1883 campaign at Etretat are accompanied by one painted there by Courbet in 1869. By these means we hope to complicate the character of the monographic exhibition, and to enrich the public's experience, encouraging every visitor to gauge their own view of the relationship between Monet's work and that of the older generation.

There is an additional dimension to the exhibition, which takes us beyond our dedicated period of 1878–83. During his long career Monet sometimes returned to places where he had painted previously, perhaps many years before. He first painted in London in 1870, for instance, but returned there several times around 1900. Usually such returns were in search of new sites and sensations. But in 1896 and again in 1897 he went back to the cliffs above Pourville, wistfully noting in his letters how particular places had changed since he had been there in 1882. And in 1901 he spent several weeks in the summer painting views of Vétheuil. The paintings from these campaigns seem less a search for new experience than nostalgic and sweetly melancholic. Some examples are included in the exhibition because their retrospective nature seems to be Monet's latter-day seal of approval on his work around Vétheuil and on the Normandy coast between 1878 and 1883. For in those years, in the prime of life, Monet pitched his easel on riverbank or cliff and painted canvases that are lyrical and muscular, vibrant in touch and singing in colour, pictures that show a mastery of nature's moods perhaps never surpassed before or since. Those great paintings form the very core of *Monet: The Seine and The Sea*.

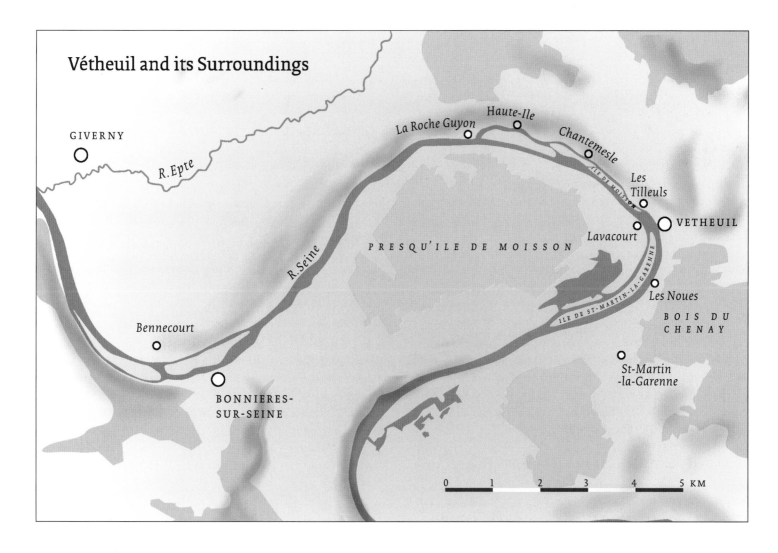

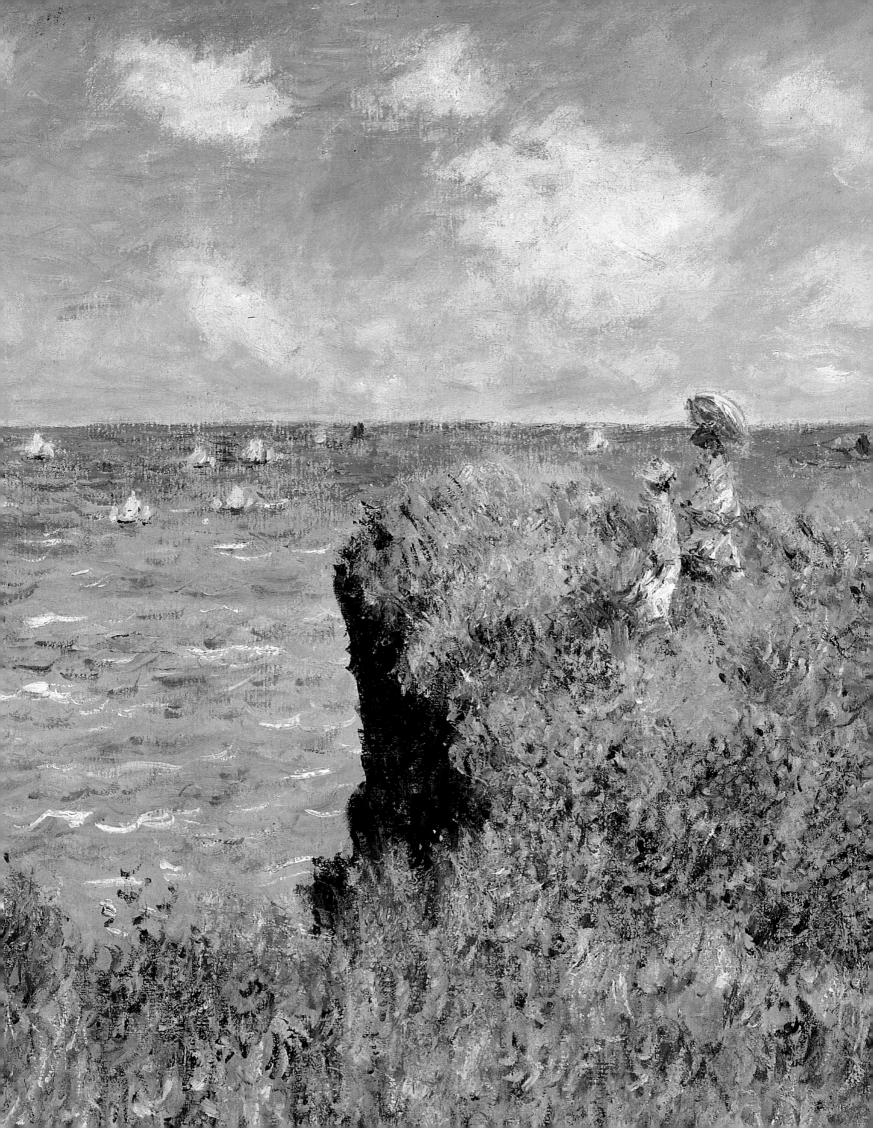

LOOKING TO PAINT: MONET 1878–1883

Richard Thomson

WILDENSTEIN NUMBERS
Throughout this catalogue the prefix w.
refers to Daniel Wildenstein, *Claude
Monet. Biographie et catalogue raisonné*,
5 vols., Lausanne and Paris 1974–91

< Detail from cat.no.65

THE QUEST FOR ORIGINALITY

The changes that took place in Monet's work and career between 1878 and 1883 pose complex questions about the factors that affect an artist. At this time Monet's range was varied to the point of audacity. As a painter of landscapes, he tackled very contrasting motifs: sweeping river vistas and dense orchards, storm-beaten cliffs and views straight out across the Channel's breakers. Weather and seasonal effects (*effets*) were equally varied: frozen earth and water, sun-drenched fields under high cirrus, or veils of fog creating a spectral scene. As well as some 350 canvases covering this wide gamut of the landscape painter's experience, during the four and a half years he lived at Vétheuil and Poissy he had also worked in two other genres, completing fourteen portraits and some thirty still-life paintings. Investigating this intense and exploratory phase in Monet's work, we need to pay closest attention to the primary evidence, the paintings themselves, as we attempt to trace patterns and evaluate the achievement of this remarkable output. But outside factors also played a part in Monet's work. For, however much Monet's paintings implicitly – and his words explicitly – strove to promote the idea of a dedicated landscape painter pitting his skills and sensations *en plein air* directly against the constantly shifting faces of nature, both his work and career were shaped by factors outside his control. These were equally inconstant forces, as haphazard as personal tragedy and economic change, the success of others and shifting opinions about what should concern an artist in the France of 1880.

During Monet's first months at Vétheuil the tide of French politics turned. The Third Republic, set up in 1870 during the desperate days of the Franco-Prussian War, had the following year overseen the fratricide of the Paris Commune and the humiliating cession of Alsace-Lorraine to Germany. Its early governments had hardly been republican, but inclined to slogans of 'moral order' and a return to monarchy, as the nation strove to recover in the wake of defeat. Cultural policy was involved in this recuperative process. The first post-war Exposition Universelle, held in 1878, was intended to show how Paris, and French art and industry, had recovered from the catastrophe. At the same time, in the field of painting the state's purchases at the annual Salons encouraged landscapes that represented a timeless French countryside of calm villages and fertile fields – reassuring images at a time of enemy invasion, civil war and rural depopulation. However, this appeal to conservatism and core values had its artistic limitations. The critic Victor Champier, reviewing the art on view in 1878, worried that landscape painting had become too concerned with exactitude, to the detriment of personal expression.[1] This view was echoed, both elsewhere and in the prestigious columns of the *Gazette des Beaux-Arts*, where the volume and importance of landscape painting in contemporary French art was acknowledged and the regretful admission made that most landscapists were men of talent and not higher gifts.[2] Another tendency critics noted was that landscape painters tended to specialise in particular effects and locales. Thus, wrote Arthur Baignères in the *Gazette* in 1879, one can tell from a distance that a canvas is by X or Z: Emmanuel Damoye prefers the flat landscapes of the Paris basin, Edmond Yon the Marne, and so on.[3]

Such discourse called into question the originality of contemporary landscape painting. Were artists personal enough in their

interpretations of nature, or did their strivings for readily recognisable identity restrict them to formulae? These were issues with which Monet would have had to cope. This is not to say that he was a great reader of critical debate, though he was shrewd enough to acknowledge the power of the press and kept newspaper clippings about his own work. But Monet's working practice allowed him plenty of time for reflection about what he was trying to achieve. Working on a canvas required intense concentration. But, while scouting for motifs, paddling home in his studio-boat, sheltering under a cliff from a passing shower, or reviewing the day's work during the evening, he would no doubt have pondered on matters of touch, colour, composition, on his originality as an artist and his place in the wider context. Monet was forty in 1880, an artist in early middle age with a remarkable and varied body of work and a range of experience behind him. Where his now more-or-less dedicated practice as a *plein-air* landscape painter might take him, and how his work would be received, no doubt gave him cause for thought.

The art world itself was subject to fluctuations of fortune and tone. The economic situation counted here, and as the relatively stable and prosperous 1870s gave way to the more volatile economy of the 1880s, Monet's career – like that of countless others – was necessarily affected. Politics once again comes into play. The election of Jules Grévy, the first genuinely republican President of the Republic, in February 1879, within months of Monet's arrival at Vétheuil, marked a sea-change in French politics. The gradual liberalisation that followed directly affected artists. In July that year the new Minister for the Fine Arts, Jules Ferry, announced his support for a more adventurous attitude to landscape painting, and showed himself sympathetic to *plein-air* work.[4] Viewed one way or another, republicanism increasingly became involved in the judging of art. Reviewing the 4th Impressionist exhibition for the fastidiously bourgeois *Le Siècle* in the spring of 1879, Henri Havard voiced his suspicions about the new painting as a 'republican and a Frenchman', thus attuned to a clarity and logic apparently flouted by the loose handling of Monet and Pissarro.[5] Philippe Burty, on the other hand, lauded Monet's one-man show in March 1883 in the Gambettist *La République française* on the grounds that republicanism needed new art based on the expression of individual personality.[6]

At first sight Monet's work in the four and a half years he lived at Vétheuil and Poissy seems to divide into two clusters, the one the result of a period of retrenchment, manifested in the river and village landscapes he painted in 1879 and 1880, and the other a more dynamic phase of experimentation with the coastal motifs he tackled in 1881, 1882 and early 1883. But the pattern was more complex and not so simply divisible, as we shall see. Throughout this time Monet was engaged in sustaining and developing his established originality as an artist. This involved contradictions and compromises. His implicit competition with the painters of the previous generation, as Michael Clarke's essay demonstrates, was a mixture of homage, appropriation, fine judgement of market certainties, and downright aggressive assertion of novelty and invention. In the interview for *La Vie moderne* that Monet gave to the journalist Emile Taboureux in spring 1880, as well as in the articles friendly critics such as Burty and Théodore Duret wrote with his connivance, the artist encouraged a view of himself as a painter who worked entirely out of doors. This was a deceit, a myth even. Monet increasingly touched up or completed paintings away from the motif, and some large works were probably entirely studio replicas. But the promotion of himself as the *plein-air* painter *par excellence* was a means of asserting his independence, his own *sensation* in front of nature, thus differentiating himself both from the mid-century masters and from the landscape painters of the Salon whose work seemed dully descriptive. The myth insisted on an image of Monet as an artist who looks directly and in his own way, and paints personally.

To a certain extent, of course, Monet had to temper how and even what he painted to suit market demand. But his exhibition tactics also were motivated by the urge to convey his continuing originality. For instance, at the 1879 Impressionist exhibition he showed two paintings from the 1860s and again at his 1883 one-man show he displayed a canvas from 1864.[7] Such a ploy of hanging old pictures with new work demonstrated development, progress – the prosaic of then against the daring of now. In addition, the way in which Monet's exhibitions ran the gamut of varied sites, motifs, pictorial typologies and meteorological effects indicated his range, his ability to adapt his eye to all aspects of nature, and the fact that he had no need to rely, as so many Salon landscape painters did, on the conventional and the specialised. The momentum behind Monet's work from 1878 to 1883 was to hone his originality as a painter and to fix it in the public mind.

VILLÉGIATURE À VÉTHEUIL

Monet's move to Vétheuil in the late summer of 1878 is explicable in terms of advantage and expediency. On the one hand, he moved to a village community, which offered quiet for his ailing wife Camille, in poor health since the birth of their second son Michel the previous March. For the painter himself, the motifs provided by Vétheuil and the neighbouring communities strung along the Seine would revivify his art. Since late 1871 his work had centred on the river around the suburban town of Argenteuil, a bustling community to the north-west of Paris, only some ten kilometres from the city centre. Argenteuil had provided Monet with an environment that had combined the natural – sweeping Seine, big skies, meadows on the Gennevilliers flood-plain – with the social and industrial: boating, promenaders, factory chimneys, and the traffic of the road and rail bridges. By 1877–8 Monet seems to have had an increasing sense that he had exhausted Argenteuil. He became more drawn by the capital, painting around the inner suburb of Courbevoie and sites in the city centre such as the Gare St-Lazare and the Parc Monceau.[8] Another symptom of his search for new stimuli was the group of large decorative paintings, and some other canvases, that he had executed in 1876 of motifs at Montgéron, a little château to the south of Paris owned by Ernest Hoschedé and his wife Alice.[9] These views of grounds, gardens and comfortable living suggest a prosperity that was, however, hollow.

Three years older than Monet, Hoschedé came from a family with a thriving business in lace and shawls. In 1863 he had married Alice Raingo, also from a family with wealth based on the luxury market, in her case bronze founding. It was Alice who owned Montgéron, which she had inherited in 1870.[10] Hoschedé was not a natural businessman, and preferred to invest his time and money in his art collection,

commissioning his portrait from the prestigious Paul Baudry and buying work by established artists such as Courbet and Daubigny. We do not know exactly when Hoschedé and Monet met, or precisely how their business and personal fortunes became entwined. Certainly, after the poverty of the 1860s, Monet had been comfortably off early in the 1870s. In 1873 he sold canvases to the value of some 25,000 francs, a very substantial income which allowed him to employ two domestic servants and a gardener for the property he rented at Argenteuil, and to have a studio-boat fitted out. But swiftly his fortunes took a downturn. From December 1873 the dealer Paul Durand-Ruel, for the last few years a reliable support, was no longer able to purchase his work. Within a year Monet had to give up the Paris studio/show-room he had maintained, in order to trim expenditure. By 1875 he was asking friends for small loans. Hoschedé's commissioning of decorations for Montgéron in later 1876 must have seemed a godsend, but it was a project built on sand. Hoschedé's own finances were in jeopardy, requiring him on 14 April that year to auction part of his collection. The fact that the auction included some works by Monet that Hoschedé did not own hints that the two men may have had a business arrangement that both hoped would be to mutual advantage at a time of shared crisis.[11] Whatever the schemes, they failed. In August 1877 Hoschedé declared bankruptcy. Montgéron was lost. The two men arrived at the combined decision to move both families to rented accommodation in rural Vétheuil. Monet would produce landscape paintings for quick sale. Hoschedé would base himself in Paris, working on a fashion magazine, L'Art de la mode, which would use his expertise in the luxury trades. Camille Monet and Alice Hoschedé would be able to look after their families – a total of eight children – in the reassuringly cheap circumstances of the village.

As the crow flies, Vétheuil is about fifty-five kilometres to the west-north-west of Paris. The village lies in a valley formed by three streams. The broad front of the village faces westwards, across the Seine to the wide cultivated expanse of the flood-plain caused by one of the great loops that the river makes on its course between Paris and Rouen. This peninsula-like terrain is known as the presqu'île de Moisson, after the largest of the villages on it. A smaller one, Lavacourt, stands on the riverbank immediately opposite Vétheuil, 250 metres across the Seine. Behind Vétheuil, to the east, ridges rise towards the rich rolling agricultural land of the Vexin, though as the Seine flows north-west from the village it is flanked by a steeply rising slope topped with chalk cliffs. These run along the sweep of the river, past the hamlets of Chantmesle and Haut-Isle to La Roche-Guyon, with its great château of the Rochefoucauld family, and beyond towards Bennecourt. Vétheuil's riverside setting in a valley debouching on to the Seine, with a sparsely covered ridge beyond, is well captured in a view from the south painted by Lejeune in 1889 (cat.no.90), the kind of reliably precise landscape painting that critics such as Champier and Baignères had begun to grumble at a decade before.

Vétheuil's livelihood centred on agriculture. Chalk made the ridges themselves difficult to cultivate; peas grew well on the slopes, but the vines had been reduced by disease in mid-century. The valleys behind had good soil, and fruit was grown successfully: chiefly cherries, but also apples, pears and plums, with some peaches and apricots. Industry was minimal. The terrain supported plaster works; Paul Coqueret –

who we will meet later – ran a small factory manufacturing compasses in the nearby hamlet of Les Millonnets; and in Monet's day there was a flourmill. There were the usual village shops, and since 1868 a market every Wednesday.[12] Vétheuil's major feature is the church of Notre-Dame, to the north of the village's heart and atop a rise which gives it a commanding position. It is a large building, begun in the twelfth century and endowed with an elaborate Renaissance façade in the sixteenth. Listed as a monument historique in 1845, it had then been restored, the work being completed in 1860.[13]

Although on the Seine, Vétheuil seems to have drawn little advantage from it. The curve of the river around the presqu'île de Moisson is lined with long islands substantial enough to sustain large trees and even be cultivated. The northern tip of the elongated Ile de St-Martin-la-Garenne lies between Vétheuil and Lavacourt, and it was along its bank that the substantial barge-traffic of one of the nation's chief waterways passed but did not stop. Between sunrise and the end of the day one could be ferried from one side to the other, between Vétheuil and Lavacourt, for five centîmes.[14] Vétheuil was not on the railway. To visit Paris, Monet had to engage the local carter to travel the twelve kilometres or so to the nearest major town, Mantes, from where he could catch a train to the Gare St-Lazare. 'If you catch the 8am train from Paris,' he informed the collector Dr Georges de Bellio, 'you get to Vétheuil for lunch.'[15] Given all these circumstances, Vétheuil's recent fortunes were typical of many villages during the course of the nineteenth century. Not far downriver Bonnières had seen its population double in recent decades, aided by industrial development and the arrival of the railway, whereas Bennecourt's on the immediately opposite bank had dwindled.[16] Vétheuil's population likewise declined gradually over the nineteenth century, although during Monet's time there it swelled temporarily, from 567 in 1876 to 647 in 1881.[17] Almost literally, in geographical and social terms, Vétheuil was a backwater.

Nevertheless, Vétheuil offered Monet something that in his twenty-year career as a landscape painter he had not yet experienced, an extended opportunity to paint rural France, all but uncluttered by the intrusions of modernity. If this may not have been his primary objective in settling there – financial considerations being so pressing – in the three and a quarter years Monet inhabited Vétheuil he made some two hundred paintings, not including those he made on visits to the coast. This is an output redolent of contentment and stability. Indeed, that was the character of the great bulk of these canvases. The paintings of Vétheuil and its outskirts represent the church rising proudly and protectively over the village, either nestling in the valley or banked up above the river. They treat the great crescent of the Seine, curving around the islands. They place painter and spectator within the embrace of nature – vast swathes of corn stretching out before us as we stand in the fields, or flat tracts of water as we sit in the studio boat. Not all the Vétheuil canvases are so idyllic, for Monet painted the river in flood and in the grip of ice. But most of the work echoes the sense of peace and delight he conveyed when he wrote in September 1878 to the pastry-cook, collector and amateur artist Eugène Murer that he had moved 'to the banks of the Seine at Vétheuil, to a ravishing spot from which I should be able to extract some things that aren't bad.'[18] Given that for much of this period Monet was first tending his

stricken wife and then mourning her death – crippling circumstances exacerbated by financial crisis – it is easy enough to suggest that he found solace in work, assuaging the difficulties of his personal life in the representation of the grand rhythms of nature. There was, in fact, commercial sense in this, given that the establishment favoured landscapes that resonated with the timeless natural vigour of *la France profonde*. The market – the high prices of Corot and Daubigny, Durand-Ruel's 1878 show – echoed this direction. It was at Vétheuil that Monet, with some false starts, began to work out both what would serve him best as an artist and to establish a consistent and ever-improving presence on the art market.

Painting pictures at Vétheuil was a question of choice, of editing. Much of the work he did there was within two kilometres or less from his house on the north-western edge of the village.[19] Indeed, in the summer of 1879, as Camille lay dying, what work he did outside was within hailing distance of their home. The selection of stimulating, marketable motifs involved both the denial and the manipulation of the modern. Although the Seine appears in scores of these paintings, its busy river traffic of barges and steam-tugs features in only a handful of motifs of the Lavacourt channel.[20] However Monet used another modern element at will. This was Les Tourelles, a thin towering house of recent construction, its twin pinnacles in neo-Renaissance style almost as dominant an accent of the village skyline as the church tower. At times Monet gave this rather ugly building, designed to maximise its owner's panoramic view of the loop of the Seine, emphatic status in his paintings. A group of pictures of the road from La Roche-Guyon entering the village, made in 1879, have it dominating the houses below in such a way that it might be confused for a church (cat.nos.5 and 6). Among those houses on the left of the road was the one Monet rented. Aptly enough, the owner of Les Tourelles was his landlady, Mme Elliott. On other occasions Monet took vantage points which elided Les Tourelles with the church, so that the village appears surmounted by a far more grandiose, cathedral-like structure than was actually the case.[21] Yet again, there are views in which one might expect to see the emphatic modern tower, only to find that the painter has excluded it.[22] Monet may have played down the modern in his Vétheuil work, but he did not dwell on the picturesque either. He used the church of Notre-Dame as a dominant form in his landscapes, and clearly enjoyed the nobility of its fourteenth-century tower and the clean-cut cuboids with which he could counterpoint the fluidity of cloud cover and reflection. But in his paintings it typically has an organic, and not closely focused, presence within the village. His only two views of the façade, painted shortly after his arrival, do not parade its every feature, in the manner of lithographs in the Romantic convention of the *Voyages pittoresques*, records of the

Fig.1. Vétheuil Church, 1886

medieval monuments of France, but settle the building into the social environment of the village (fig.1; cat.no.1). Together with two paintings of old farmyards, these are the sum of Monet's close focus on Vétheuil as a source of picturesque, time-honoured motifs.[23]

On the evidence of his paintings, Monet also made remarkably little of the people and activities of Vétheuil. When roads appear, they are never cluttered with horses or carts, merely showing occasional pedestrians. Just as there are few barges in his river canvases, there are no paintings of the Wednesday market, of shops, trade or produce. One is tempted to see these paintings, particularly in contrast to his Argenteuil work, as asocial, a denial of community. Yet Monet did not entirely ignore the life of Vétheuil. In his paintings the population is discreetly present, and legible. Monet was very adept at simultaneously giving the impression that the human presence counted for far less in his landscapes than meteorological *effet* and pictorial unity and yet still giving his small-scale and telegraphically brushed figures a plausible identity. On occasion the figures are specific enough even to be read in class terms. In one of the paintings of Notre-Dame, a man's top-hat picks him out as bourgeois, while the figure in blue dress and white apron passing down the street looks more like a countrywoman (cat.no.1). In another painting of the church, made from the studio-boat moored in mid-stream, Monet inserted about fifteen figures, standing in the ferry or walking on the bank, and among them it seems that we can pick out *bourgeoises* to the centre and at the right perhaps washerwomen and men watering cows (cat.no.12). Some paintings are quite full of undemonstrative incident. In a canvas made at Lavacourt, one of the few to show a passing tug, we find a couple and another man walking along the towpath, two figures by a cart on the riverbank, and a group of ducks waddling down to the water (cat.no.8). Present though they are, these figures are never the focus of Monet's landscape; they do not come forward to engage us, but belong within the fabric of the village view.

The nineteenth-century neologism *villégiature* may help us here. The word was used to describe the extended stays in the country – perhaps in a family home, perhaps rented accommodation – that comfortably-off city dwellers made during the summer. The Monet and Hoschedé families formed part of the Vétheuil community, though how deeply we do not exactly know. The children would have been at school, and Jean-Pierre Hoschedé remembered how they played in the road in front of the house.[24] Monet knew local people, such as Coqueret, who commissioned portraits from him, and Léon Peltier, an amateur painter whose portrait Monet painted in 1879, apparently in exchange for a pair of boots.[25] Two unpublished little paintings by Peltier add important evidence (figs.2, 3). One represents an elegantly dressed *bourgeoise* seated in Monet's studio-boat. If we did not know that this was a working craft fitted out for an artist to paint from, one might take it as a scene of well-heeled leisure. The other (apparently mis-dated, since Monet had left Vétheuil by 1882) shows the studio-boat again, this time moored to a pontoon or jetty, while adolescents swim and smaller children watch, supervised by two women in chic costume. These are images of *villégiature*, not of work. In Monet's paintings the middle-class figures we can detect may represent the local *bourgeoisie* or those *en villégiature*: we cannot tell, and indeed it may neither have mattered nor occurred to Monet. But

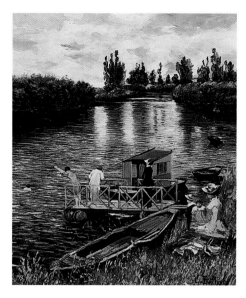

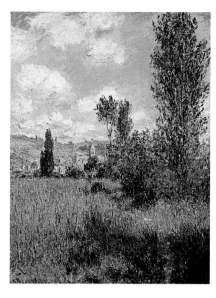

Fig.2 · Léon Peltier *Monet's Studio Boat at Vétheuil*, 1878
John Bennett Fine Paintings, London

Fig.3 · Léon Peltier *Bathers by Monet's Studio Boat*, 1882
John Bennett Fine Paintings, London

Fig.4 · Claude Monet *Path on the Ile St-Martin*, 1880
The Metropolitan Museum of Art, New York (w.592)

there is something about his whole engagement with Vétheuil, both as site and as society, that suggests that he treated the experience as if he were in a semi-permanent state of *villégiature*. Place and population are viewed from a distance. Unlike Pissarro, with his paintings of the markets, parks and *jardins-potagers* of Pontoise, or Sisley, with his canvases of the barges and boatyards of St-Mammès, Monet elected to detach his creativity somewhat from community.

THE CONSCIOUSNESS OF LOOKING

This detachment allowed Monet to cultivate his own *sensations*. This was a key term for the landscape painters in the Impressionist circle, and meant the originality of both an artist's way of seeing and his way of putting it down in oil paint on canvas. Reducing his looking to the elements of landscape – water and cloud, hill and vegetation – Monet was able to concentrate his practice more exclusively on the difficulties they posed for his skills as a painter: how to paint reflections on flowing water, the village obscured by thick fog, or the vast space of sky with cirrus high over a corn-covered plain. This renunciation allowed a more direct response to nature, an absorption in the twinned practice of looking and painting.

We are accustomed to accept paintings of the kind Monet produced at Vétheuil as the acme of *plein-air* naturalism. The artist himself was determined that we should do so. The reputation that he tried successfully to cultivate around himself and his work was that of the painter dedicated to the frankest possible transcription of nature into paint through the practice of executing his canvases *en plein air*. This was the procedure he vaunted in his correspondence. For example, he wrote to Duret from Vétheuil in October 1880 that he had been forced to abandon two paintings of apple trees because when he returned to continue his paintings the fruit had been picked.[26] Equally, his letters to Alice Hoschedé from the Normandy coast constantly link work and weather: 'Alas, there's my lovely sunshine gone, rain all morning, I'm fed up, because with one or two sessions I'd finish several studies'.[27] Equally, during his interview with Taboureux before

his one-man show in 1880, when asked where his studio was, Monet confidently and persuasively – and somewhat duplicitously – gestured to the Vétheuil riverscape all around him, proclaiming 'There's my studio. Mine!'[28]

Monet's Vétheuil paintings are often highly effective in enticing the spectator to collude in the fiction of their naturalism. In *Path on the Ile St-Martin* (fig.4), made in high summer 1880, there are no figures, although a path follows the line of vegetation to the right, behind which lies the river. The path not only tells us how the artist got there, and where he stood. It also invites us to imagine how we might be on that path, on that warm day. The painting evokes the kind of gaze a walker makes when he turns to see how far he has come, or looks ahead to see how far he has to go. This naturalism is enhanced by the rich medley of greens, so true to summer fullness, and the harmonious blue and white of the sky, and by the way the brushwork flickeringly defines the forms, thus giving a sense of a fresh breeze passing. All these effects of likelihood and immediacy were contrived by Monet's painterly means. The vermilion dabs – poppies – animate the complementary greens. The deeper tones establish the structure that draws the eye into space, providing vertical markers of decreasing size. The whole creates a convincing pictorial reconstruction not just of a landscape seen, but a landscape experienced.

There were times when Monet took his audacity in looking and recording too far. In 1879 he painted a view of Vétheuil masked by fog (fig.5). The mist rising from the river so veils the village that it is barely perceptible. The painting is an extraordinary exercise in denial, the artist renouncing the legibility and definition of object and structure that typically defines a landscape picture. Monet gave the painting a simple symmetrical armature. But the church is definable by little more than its triangular eaves, the certainty of the central motif melting in the play of pearly tones. Even nature dissolves. There are no trees, no bushes, just a blanched blue-green passage running along what we deduce to be the riverbank. Monet offered the painting for sale to the opera singer Jean-Baptiste Faure, who had a collection of his

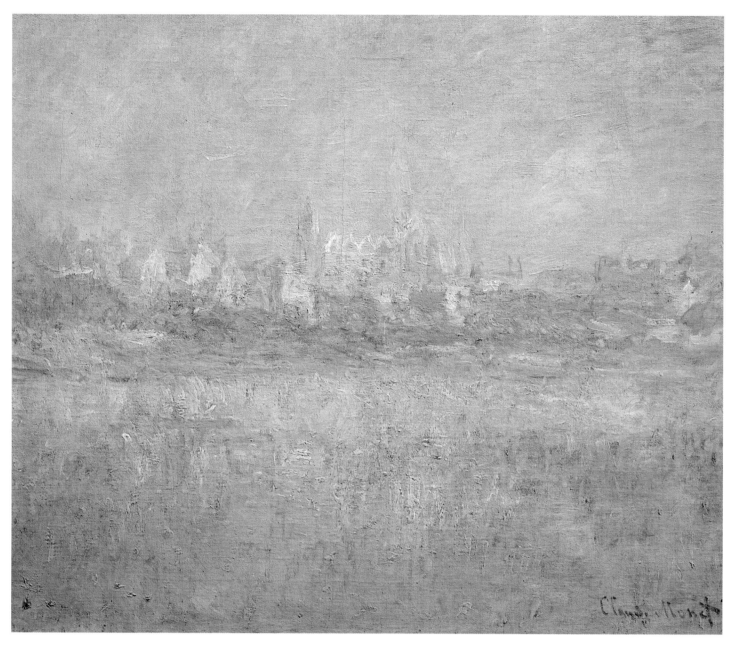

Fig.5 · Claude Monet *Vétheuil in the Fog*, 1879
Musée Marmottan, Paris (w.518)

work. But the baritone, perturbed by the painting's monochromatic dissolution of form, would not even take it for 50 francs. In the event, Monet kept it all his life, not risking it in public exhibition until 1889. *Vétheuil in the Fog* carried audacity of looking and inventiveness of execution – Monet's originality – further than other eyes could then see.

Monet's painting at Vétheuil, I believe, offers internal evidence of his awareness of the business of seeing. Take the 1880 canvas, *Vétheuil in Summer* (cat.no.33). A view from the Lavacourt bank, the painting both creates the illusion of depth – the distance across the open water – and is also harmonised on the picture plane, the mid-pitched horizon line balanced by the tree-covered island below it to the left and the far ridge above it to the right. The emphatic verticals in the left half are counterpointed by the pale mass of the large house and the greater sense of space on the right. Such painterly contrivances are typical

enough. What is particularly curious about this painting is also embedded in the way the painting was made. The centre of the canvas is where there are most colour accents – contrasts of dark blue and off-white, pink and green – and also the area where the play of the medium is densest. The substance of paint is not where it might be expected, describing the mass of a building for instance, but in the reflections on the surface of the water. The forms of the village and the facture of the reflections concentrate attention in the centre of the canvas. This is enhanced by the way in which Monet articulated his brushwork, so that it is at its most active in an elongated oval within the long rectangular canvas. He left the corners relatively unworked compared to the centre (the top left not quite so much), with the brushmarks suggesting curves at the peripheries that minimise the right-angled corners. In such a way Monet implied the eye's ovoid field of vision.

A generation earlier others had been aware of how the eye actually sees, and had adapted their methods of representation to bring them into line. In Britain Ford Madox Brown had experimented with oval-shaped canvases for his precisely detailed landscapes such as *An English Autumn Afternoon, Hampstead* (1852–5, Birmingham Museum and Art Gallery), though it is unlikely Monet would have known of such initiatives. He would, however, surely have been aware of the way in which pioneer landscape photographers such as Camille Silvy mounted their photographs, taken on right-angled plates, in oval mats, the better to approximate to the 'truth' of viewing (fig.6).[29] He would certainly have known the paintings of Théodore Rousseau, who tended to arrange his compositions with an implicit internal oval to draw the gaze into the fiction of his pictures (fig.7).[30] While Monet belongs within this broad current of awareness about the physiology of looking and its contrivance in art, his solutions were highly personal. He did not control the format, like Brown or photographers, nor did he order the compositional forms as Rousseau did. With Monet, it was partly a case of the subtle manipulation of composition, but as much to do with the relative density or scarcity of paint. We find this in a number of Vétheuil canvases of different types, for instance the Orsay *Break up of the Ice* (fig.8). Here, although a perspectival vista down the river is established, the floating ice in the lower corners arcs upwards just as the upper corners remain uncluttered with painterly incident and seem to tip downwards.

Heightened consciousness about how we look at the world around us was common among the loose confederation of artists who were then exhibiting at the Impressionist exhibitions. This was acknowledged in a backhanded way by hostile critics, who accused them of Daltonism (the inability to distinguish between red and green) and other perceptual dysfunctions. That consciousness was something that – on an entirely informal basis – drew together artists as different as Monet and Degas, Sisley and Caillebotte. Individually and collectively they were involved in questioning and extending naturalism, the exact representation of the everyday world which had by the late 1870s and early 1880s taken an extensive and somewhat prosaic grip on painting at the Salons. Although very different in style, subject and even

medium, the works on display at an Impressionist exhibition were attempts by their authors both to explore how we see and perceive what surrounds us and, at the same time, to distance themselves from what were increasingly becoming conventions of representation, among them the tedious exactitude we have already heard critics condemning in much landscape painting. One consistent way of doing this was to subvert stale pictorial nostrums about composition, particularly the established convention that the artist/spectator was given a privileged and uncluttered view of the painting's subject, and that this subject should be prioritised, the most important elements being the most evident and, in all likelihood, central. Despite being co-exhibitors at the Impressionist exhibitions, Monet and Degas were far from friends, and sniped behind each other's backs. Nevertheless around 1880 their shared concern with how one looks, and how that can be conveyed in a modern way by pictorial means, caused them to come up with very similar solutions, despite their different subjects and, frequently, different media.

In both Monet's *Apple Trees at Vétheuil* and Degas's *A Ballet seen from*

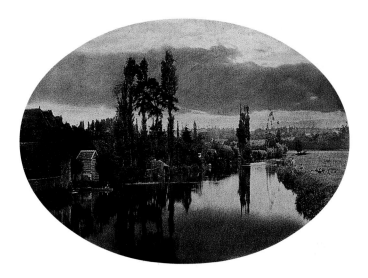

Fig.6 · Camille Silvy *River Scene, France: La Vallée de l'Huisne*, 1858
The J. Paul Getty Museum, Los Angeles

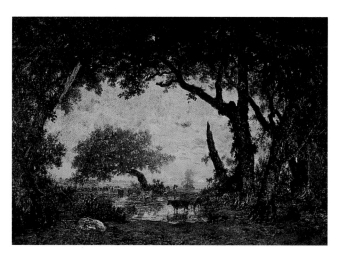

Fig.7 · Théodore Rousseau *The Edge of the Fontainebleau Forest*, 1848–9
Musée du Louvre, Paris

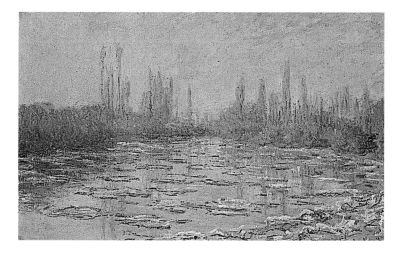

Fig.8 · Claude Monet *The Break up of the Ice*, 1880
Musée d'Orsay, Paris (w.567)

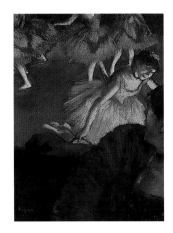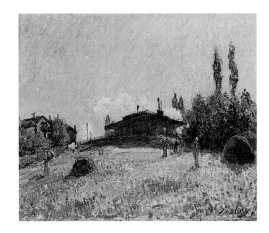

an Opera Box one is allowed only a partial view of what one expects to see – the panorama of the village and the dancers on stage (figs.9, 10). The 'main' motif is partially hidden by another, which spills in from the edge, so one can see neither the full extent of the orchard nor all of the female spectator. One has to look 'round' these intrusive forms, the presence of which reminds us of what is to be seen beyond our field of vision. Because what the picture shows us is, in conventional terms, insufficient, this implies that we can move our position to improve our view, in turn suggesting that this, or any, view is temporary, contingent. Indeed, in neither of these works is there a central feature in our fictive field of vision. We are reminded of the haphazardness of looking. The scenes both Monet and Degas proffer are apparently *natural* (though highly artificial). We cannot fully see what convention tells us is most important, and are led to believe pictorially that what we are prevented from seeing is of equal or greater significance than what the picture presents us with. Such images are not just about contriving naturalistic ways of seeing on a two-dimensional surface; they raise fundamental questions about seeing the world and looking at art.

Another way of revitalising the processes of looking was to challenge conventional picture-making's stock treatment of the eye-line and horizon. The majority of Monet's Vétheuil landscapes employ a horizon placed about mid-way up the canvas, much as Daubigny and countless predecessors had done, dividing the canvas more-or-less equally between sky and water. The *Apple Trees* just discussed is one of a small group of paintings made in 1878 with quite high horizons and a view downwards: these are exceptions.[31] Other landscape painter colleagues in the late 1870s were more adventurous, particularly Alfred Sisley. His *Railway Station at Sèvres* may have the horizon halfway up the

canvas, but the painting is contrived so that we look up at the horizon, rather than across to it (fig.11). The station itself forms a central feature, but another object of interest, the train, is out of sight. Only its steam denotes its presence, and we understand that it must occupy space that we are not shown, but that Sisley implies behind the building. The painting is thus about how we might look (in this case, upwards), about how looking can infer (here, an object and space we cannot see), and about a kind of looking (a rapid glance evoked by rapid touch). In other respects it covers the same terrain as Monet. It is a picture about an *effet*, strong midday summer sunlight.

Monet next experimented with viewpoints and horizon lines again in later 1880, after he had been at Vétheuil two years. This delay is surprising, given both his colleagues' initiatives and also the local landscape. The ridge that towers over the road from Vétheuil to La Roche-Guyon is surmounted by chalk crags and provides a superb vantage-point for sweeping panoramas both over the Seine valley and down on to the village. Two canvases in particular made use of the steep slope of Les Tilleuls, above Vétheuil to the north. The most dramatic of these used a vertical canvas to compress the plunging view (cat.no.36).[32] Looking down necessitated a high horizon line that denies distant space, and tipped up the perspective of the valley floor. The viewpoint forced Monet to paint mass – the ground beneath his feet and the far ridge – and also imply void. In a landscape painting with a conventional horizon the painter has to evoke space between the viewer's position and the objects in the fictional space – to look across space, if you like. In Monet's view down on Vétheuil he set himself the challenge – still rather novel for him – of suggesting not only space across the painted landscape but also over it, and of implying the 'unseen' void between the scrubby outcrop on which he stood and the point where the village comes into view. The painting's experimental quality is apparent from the rather cluttered and indeterminate brushwork in the centre.

Interestingly enough, Monet had made no attempt to pursue this kind of looking and painting when he went to Les Petites-Dalles in September 1880. His first visit to the sea-coast for some years was preliminary and short on experimental results. However, at Fécamp early the following year he rapidly and avidly realised the potential that the great cliffs gave him for just this kind of viewing. Eight canvases exploited that possibility, and launched him – as we shall see – into a new phase of his career, selling well and forming a core to his

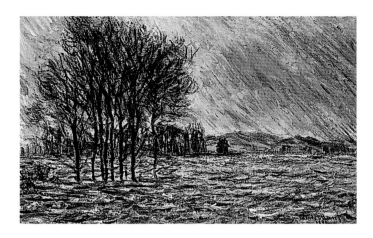

display at the 1882 Impressionist exhibition.[33] On his return to Vétheuil from Fécamp in the spring of 1881 he seems to have been so enthused by the new kind of looking that his experience on the Channel cliffs had provoked that he attempted to duplicate it. He painted a standard-size canvas and – exceptionally – two small oil sketches of motifs from the chalk crags above Vétheuil (cat.nos.42, 44).[34] Hitherto he had made no attempt to exploit either the site's potential to combine a mass of foreground rock with a distant planar expanse or to feature the strange forms of the chalky heights, despite their being regularly mentioned in guide-books.[35]

It is easy to think of Monet's work around Vétheuil and on the Normandy coast between 1878 and 1883 as distinctly different, indeed almost polar, artistic experiences: river and sea, crammed and open, habitation and pure nature, even conventional and exploratory. This is true to a point, but there are consistencies and connections. One of the most important of these is Monet's sporadic experimentation with high viewpoints on the chalk bluffs at Vétheuil. His efforts in 1880 set him on the path to his achievements at Fécamp. But once he returned from Fécamp his attempts to retrieve that kind of looking and painting at Vétheuil foundered. At which point he lost interest in Vétheuil. With a few extraordinary exceptions, including the limpid view of a cornfield and the paternal celebration of the *Artist's Garden at Vétheuil*

(cat.nos.45, 46), the canvases Monet painted at Vétheuil in the summer of 1881 are dull, repetitive or unresolved.[36] By the end of the year he had moved house. The Fécamp campaign had confirmed Monet in a new way of looking, one first tentatively essayed at Vétheuil. But, despite trying, he found he could not retrieve it on the Seine. The way he looked had changed.

If we turn briefly to Monet's working procedures at this stage of his career, the tensions between naturalism and artifice emerge quite clearly. On the one hand, he worked out of doors, in all weathers, on the river in the studio-boat – as the rhetoric surrounding his work insisted. There is evidence enough for all of this in his paintings. A canvas like *Inondation* (fig.12) encapsulates it. Painting from the studio-boat moored in mid-stream, rain falling and the floodwaters rendered choppy by a driving wind, Monet worked quickly. The grey ground was appropriate for the *effet*. The sky was brushed in rapidly, leaving a patch of bare canvas which he later filled in with the stark silhouettes of the water-logged trees. The trees themselves were painted in two layers, a denser, drier preliminary approximation later picked out with darker, more graphic strokes. The range of colours – greys, blues, white, a deep, dull aubergine – was spare. This was quick work, necessarily given the physical conditions but also appropriate to the gusty nature of the *effet*. Monet was happy to exhibit this kind of work, as it manifested an essential element of his reputation. *Inondation* itself was shown at the 1882 Impressionist exhibition. But for all this Monet also cultivated the artifices of his trade. He scouted for sites using a sketchbook, rapidly outlining in his *carnet* motifs that he might use, frequently pencilling in a frame around a section of the drawing further to define a possible picture.[37] Thus the apparent spontaneity of a painting may have been the result of an extended process of accretion: reconnoitring likely motifs, honing potential compositions in swiftly executed drawings, going back to that same motif in different conditions or approaching it from a different angle. Sometimes Monet improvised. A snow-scene painted at Lavacourt, probably in 1879, was painted over a layer of green, suggesting that Monet seized a canvas readied for an entirely different seasonal *effet* and used it for his winter picture.[38]

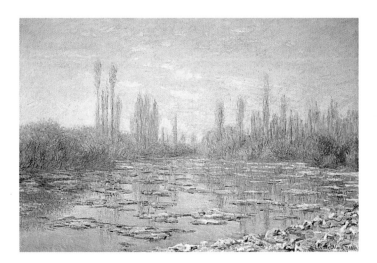

Fig.13 · Claude Monet *The Break up of the Ice*, 1880
Musée du Louvre, Paris (w.572)

Fig.14 · Claude Monet *Les Glaçons*, 1880
Shelburne Museum, Shelburne, Vermont (w.568)

The variety of Monet's modes of work is apparent in the powerful group of paintings he made in early 1880 of thawing ice on the Seine. Some of these 'Débâcles' were evidently painted *en plein air*, in freezing conditions. The canvas now in the Louvre, for instance, was executed swiftly, with few colours (fig.13). The Orsay painting (fig.8), too, may have been painted *en plein air*, but its more complex colouring and graphic touches to outline the ice-floes suggest that, while it might have been begun out of doors, it could have been completed in the attic studio Monet used in his little house at Vétheuil. This composition served as the basis for the substantially larger and more highly finished studio version that he painted for submission to the 1880 Salon (fig.14). Again, one might wonder why two of the *Débâcle* canvases are dated 1881, the year after the dramatic natural event they represent. Both were bought by Durand-Ruel in February 1881.[39] It is quite possible that Monet casually signed and dated them in the year they were sold rather than painted. Alternatively, they might have been only partially resolved during the great thaw, and then taken up for completion in 1881 when the dealer was buying work. A third, remoter, possibility is that Monet painted them entirely in 1881 as variants on an established composition, to meet market demand, though – were this supposition to be the case – it would have been quite contrary to what we know about his practice. Whatever the case in this instance, the *Débâcle* paintings as a group show a range of different kinds of work, in terms of execution, scale and finish.

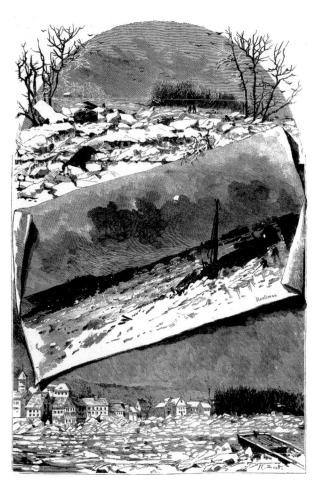

Fig.15 Anon. 'Break up of Ice on the Seine and Marne'
Le Monde illustré, XLVI, 17 January 1880, p.45

FINDING A MARKET

If at one level the *Débâcles* provide evidence of Monet's working methods, at another they indicate how Monet's practices as a painter elided with his awareness of the requirements of the art market. The quite exceptional conditions over the winter of 1879–80 literally gripped the nation. From mid November 1879 temperatures were below zero. Snow fell throughout December, and on 6 December the Seine began to freeze, forming ice up to half a metre thick.[40] The press was full of the dramatic sights, destructive hazards and ingenious responses that the great freeze brought. *Le Monde illustré* offered its readers images of the marché St-Martin in central Paris, its roof crushed by the weight of snow, and of *la buvette groënlandaise*, an enterprising wine-stall created in an igloo by the Hôtel de Ville, proclaiming that 'It's no longer Paris, it's St Petersburg.'[41] The thaw began in Paris on 3 January 1880, the Seine rising a metre and a half in three hours and massive floating blocks of ice wrecking two bridges. The great floes reached Vétheuil before dawn on 5 January, grinding downstream with terrifying clamour, splintering trees and carrying debris in their path (fig.15).[42] The shocking winter conditions so completely transformed the landscape and especially the waterways of France that painters were inevitably attracted to represent them. It has recently been pointed out that the Salon of 1880 included a notable number of canvases – by Ludovic Lepic, Luigi Loir, Edmond Yon, Paul Saïn and others – which approximate quite closely to Monet's compositions: great slabs of ice stretching far across frozen rivers, the bare trees a puny feature in the stark, leaden landscape.[43] The similar compositional solutions were coincidental, whereas the desire to please the market by capitalising on the recent natural phenomenon was obvious.

Monet's need to sell his work was pressing. In 1879 his sales amounted to 12,285 francs.[44] This was half what he had earned in 1873, and his commitments were greater. He now had two sons to care for, and a responsibility, too, for Mme Hoschedé and her children. Ernest Hoschedé had the primary duty there, of course, but gradually the situation seems to have shifted. While in May 1879 Monet proposed that he and his family move out of their shared house because they were a drain on Hoschedé's strained finances, by December 1880 the fashion magazine *L'Art de la mode* on which Hoschedé pinned his hopes of financial recovery had not come good,[45] and the onus was increasingly on Monet. He tried a number of expedients, among them regional, even local, possibilities. In late summer 1880 he sent several canvases to an exhibition at Le Havre, on the advice of his Lecadre relatives who lived there. To Monet's chagrin, the Havrais collectors disapproved of his work.[46] Monet also received some help from Paul Coqueret, the proprietor of the local compass factory. Not only did he purchase at least two landscapes, but the artist also painted portraits of Coqueret, his son and another family member.[47] Indeed it may also have been through Coqueret that Monet painted other portraits, such as that of little Jeanne Serveau, daughter of a Mantes shopkeeper, and André Lauvray, young son of a notary from nearby Les Andelys who had a house at Vétheuil.[48] Of the dozen portraits painted while he was living in the village, six were of Monet or Hoschedé family members, five apparently negotiated through Coqueret, and the last of Peltier. From 1883 to 1890 Coqueret served on the committee of Vétheuil's

Bureau de bienfaisance, distributing money to the local indigent, and he may have seen making purchases and engineering commissions for Monet as part of his civic duty as a local man of means.[49] Monet, it seems, was not entirely comfortable with this small town patronage, ungraciously referring to Coqueret as an 'idiot' in one letter of February 1883.[50]

Monet knew well that reputations were won and good livings made on the Paris art market. On moving to Vétheuil in August 1878 he took a small studio in central Paris, at 20 rue Vintimille, the wealthy fellow painter Gustave Caillebotte covering the rent. It was used to store work, and as a showroom for Parisian clients when Monet was in town.[51] Vétheuil provided the goods, in terms of pictures, and Paris the market. The produce consisted primarily of landscape painting – the Vétheuil portraits remaining resolutely local – but it also included still lifes. Monet painted seventeen still-life paintings while at Vétheuil, using the materials easily to hand – flowers from his garden, fruit and game birds, all local and painted in season. They were probably made when the weather disinclined him from working outdoors. The settings in which he arranged the objects were typically unpretentious – baskets and bare backdrops, nothing more elaborate than a vase on a polished table, a damask tablecloth the occasional reminder of better days. These straightforward paintings were effective money-spinners. In October 1880, for instance, he sold two of baskets of fruit to the Parisian dealer Delius for a total of 1,400 francs, a better rate than his landscapes were then fetching.[52] With that in mind, Monet consistently displayed his still lifes, at the 1882 Impressionist exhibition and at both his one-man shows in 1880 and 1883. Thus he added another string to his commercial bow, using the opportunities offered by the countryside to appeal to the metropolitan market.

It was the market, and the wider structures of Parisian culture with which it was interlinked, that moved Monet's career into a different gear. His own considerable efforts were not enough on their own. He was reliant, as we all are, on others' initiatives and arrangements, and also on luck, to provide him with new opportunities, which he then seized. Events unfolded thus. Monet decided to submit two paintings to the Salon, which opened in May 1880. Both were large and well finished canvases of contrasting subjects, designed to attract attention, a summer view across the river to Lavacourt and the grandest *Débâcle* (cat.no.30; see fig.14). In the event the jury refused the winter painting – perhaps to repress a rebellious Impressionist; perhaps because the Salon had a glut of such canvases that year – and accepted only *Lavacourt*, which was skied, despite Monet's private estimation of it as 'bourgeois'.[53] Despite its disadvantageous position, the painting was noticed quite favourably by both Monet's old acquaintance the successful novelist Emile Zola and the conservative former Minister for the Fine Arts, Philippe de Chennevières.[54] There were wheels within wheels here. Chennevières's few words of encouragement were not quite so unexpected, for gradually critics were beginning to acknowledge landscape painters who painted quite loosely, ordering their motifs into large masses. In his 1880 Salon review Roger-Ballu listed Yon, Emmanuel Damoye and Antoine Guillemet among them.[55] Guillemet had served on the jury, and wrote to Zola that he had tried to support good work in the face of entrenched prejudice.[56] Perhaps he had supported Monet's. In any event, Monet had re-engaged directly in

the prime proving-ground of the Paris art world, in comparison to the year before when his display at the 1879 Impressionist exhibition had been somewhat desultory, put together only by the efforts of Caillebotte.

Within weeks of the Salon opening another opportunity came Monet's way: *La Vie moderne* offered him a one-man show. Owned by the publisher Georges Charpentier, *La Vie moderne* was a weekly illustrated periodical launched on 10 April 1879. It addressed its upper- and middle-class readership with short stories, gossip columns and the froth of fashionable life, accompanied by drawings by a variety of artists, from lions of the art market such as Ernest Meissonier and Jean-Léon Gérôme to the still controversial Impressionists like Degas, Renoir and Mary Cassatt. *La Vie moderne* sub-let a shop from the champagne merchant Mercier at the entrance of the passage des Princes on the boulevard des Italiens, near its offices.[57] There it had held a number of the small exhibitions that were becoming more and more fashionable in Paris: a mixed show of decorated tambourines in December 1879, and in April 1880 a one-man show by Manet, chiefly of pastels. The gallery thus echoed the magazine in its promotion of the chic. It is not clear who initiated Monet's exhibition. It might have been Manet, whose drawing of Monet adorned the little catalogue, or their mutual friend Duret, who helped with the prompt planning and wrote the catalogue introduction, or even Hoschedé, who had connections in the deluxe businesses.[58] The bulk of the eighteen works listed in the catalogue consisted of Vétheuil works, including two still lifes, a *Soleil couchant* of the same scale as the Salon submission but which Monet had considered too audacious to submit to the jury (cat.no.26), and the rejected *Débâcle*.[59]

Monet made one significant sale from the show. Mme Georgette Charpentier wrote to him that she wanted to buy the *Débâcle* for her husband. Instead of meeting the ambitious asking price of 2,000 francs she proposed 1,500 francs – more in line with the painting's market value – in three instalments. Monet agreed, though asked for the 15% commission due to *La Vie moderne* to be waived.[60] The sale of a large work, rejected by the Salon, to a notable figure was a substantial boost to Monet's reputation. But, again, there were wider ramifications. The Charpentiers had only recently become wealthy enough to diversify into luxury magazines and speculate in risky modern art. Up until 1877 the publishing house had been a sound but hardly flourishing business. However, that year Zola, who had been contracted to Charpentier since 1873, had a runaway success with *L'Assommoir*, a no-holds-barred account of working-class Parisian life laced with slang. Expected to sell six thousand copies, it had reached its thirty-eighth printing by the end of the year, and had sold 100,000 copies by 1881.[61] Like his author, Charpentier became a wealthy man, and Monet benefitted. Furthermore, Charpentier had connections with republican politicians, who after the election of Grévy in 1879 were steering French politics into new waters. Léon Gambetta, one of the more radical republican leaders, was an *habitué* of the Charpentiers' regular salon. Republicanism stood for values of democratic freedom, scientific progress and individual expression, values that interlocked with the aesthetics of Zola's literary naturalism, based as it was on the scrutiny of all modern subjects with an apparently objective eye. The Charpentiers' patronage of Impressionist

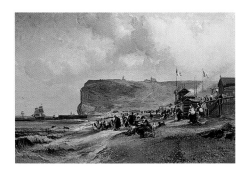

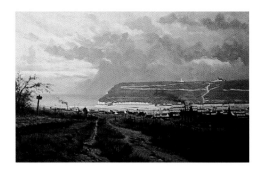

Fig.16 · Jules Noël *The Beach at Fécamp*, 1871
Musée des Arts et de l'Enfance, Fécamp

Fig.17 · H. Le Roy *View of Fécamp*, 1880
Palais Bénédictine, Fécamp

Fig.18 · Claude Monet *The Cliff at Grainval, near Fécamp*, 1881 Private Collection [w.653]

painters associated them with this new ideological and cultural formation, the way the country was moving. Indirectly and providentially, Monet was a beneficiary.

One person who responded as swiftly as possible to Monet's improved circumstances was Durand-Ruel. In February 1881 he visited Monet's Paris *pied-à-terre* and bought fifteen paintings for 4,500 francs. The funds enabled Monet to visit the Normandy coast for a campaign of painting at Fécamp which he would otherwise have been unable to afford. On the artist's return that summer, Durand purchased twenty-two canvases, sixteen of them of Fécamp motifs, for 300 francs apiece. This set the benchmark for a canvas, enabling Monet to tell other purchasers that the days of cheaper works, when he needed funds fast, were over.[62] It was the platform for prosperity. In 1881 Monet made 20,400 francs *in toto*, almost returning to the level of 1873 and nearly doubling the earnings of 1879.[63] Durand-Ruel was able to invest so deeply in Monet's work because he now had the backing of the Union Générale bank. This had been set up by Jules Féder specifically to support Roman Catholic businesses in defiance of Grévy's anti-clerical Republic, which was beginning to drive through laïcising reforms. Durand himself was a devout Catholic whose politics were royalist. Monet's change of fortune thus stemmed from such diverse and paradoxical sources as a raunchy novel and a fashionable magazine, a progressive republican political climate and the forces of Catholic business determined to oppose it.

THE TOURIST IN DENIAL

The Normandy coast had been a popular subject with painters since the 1820s, when, turning their backs on the classical landscape of Italy, French artists began the thorough exploration of their own territory. Normandy offered manifold advantages. It was the nearest coastline to the capital, accessible down the great waterway of the Seine and, later, by train, as the fingers of the railways began to stretch out from Paris in the 1840s and 1850s. The cost of living was cheap in the fishing communities that bordered the English Channel. And, above all, there was the landscape. Lower Normandy offers gentler terrain, the rich agricultural land of Calvados tipping down towards the sea along the coast from Isigny to Honfleur. Along the coast of the Pays de Caux, reaching north-eastwards in a great arc from Le Havre, the cliffs are more dramatic, great walls of chalk flanking the shore like some vast fortification, broken every few miles by a narrow valley where the little ports huddle. It was on this stretch that Monet opted to paint in the early 1880s. On the six visits he made between 1880 and 1883 to the

coastline between Etretat and Dieppe Monet chose to confront a landscape encompassing vast views and enormous forms – a landscape, in a word, sublime – which his extended campaigns allowed him to explore in all its moods. One contemporary writer lauded Normandy over Brittany on the grounds that 'its lines are more clear-cut, its masses heavier, its horizon closer. Even as a storm approaches, the Norman sea is denser, more sluggish.'[64] The novelist Guy de Maupassant, himself a Norman who had watched painters such as Courbet, Corot and Monet work along his beloved coast, argued that what drew artists was the quality of the light, as various as the wines of Bordeaux.[65]

It is difficult, and probably unhelpful, to dissociate artist and tourist on the Normandy coast. Perhaps it had been painters who were the pioneer visitors, but they, too, were usually temporary inhabitants, looking for attractive sites and different experiences. With the arrival of the railways and the development of coastal towns as resorts the bourgeois tourist was served by the painter, often bourgeois himself, who sold pictures of the coastal landscape, the native fishing communities and even the tourists themselves. In the 1860s the young Monet, following his mentor Eugène Boudin, had produced such staples. So common had these subjects become that the *Gazette des Beaux-Arts's* review of the Salon of 1879 devoted a whole section to them, the critic Baignères explaining, 'The railways have extended the outreach of the suburb, and instead of [the artist] going to work at Viroflay or Chaville, as once one did, one goes to make studies at Sainte-Adresse, Villerville and beyond. A new genre has been created that one could call the marine with figures.'[66] Jules Noël's 1871 canvas of the beach at Fécamp typifies this kind of painting (fig.16). It combines natural grandeur – the massive Falaise d'Amont, the expanse of sky, waves breaking on the shingle – with different kinds of human intervention: on the cliff the

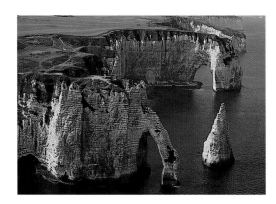

Fig. 19 · Etretat: the Porte-d'Aval, L'Aiguille, and the Manneporte

ancient Notre-Dame-du-Salut, and below the mole of the busy harbour the bathing-huts and tourists on the beach, a sprinkling of local people among them. Noël's vantage-point edited out the town behind the beach. In recent decades Fécamp had developed an impressive infrastructure to service the tourists on whom Noël focussed – hotels, a casino, facilities for hydrotherapy. But Fécamp's population of 13,000 was not dependent on tourism. It was France's largest fishing port, with over a hundred boats and an annual catch worth 4.5 million francs. The construction in 1865 by Alexandre Le Grand of a distillery for manufacturing Bénédictine, producing two million bottles a year, had given the town an additional industry. The logistics of tourism, fish and liqueur were all facilitated by the railway extending right into the port.[67] The modern character of Fécamp was stressed in Le Roy's 1880 painting of the town, looking from allotments over distillery and

October 1882, was a relatively small *station des bains*; it had a casino, but no post office![70] That year he had settled on Pourville having first tried nearby Dieppe, a much larger port and resort recommended by John Murray's *Handbook for Travellers in France* for its extensive facilities, English newspapers, formal gardens and 'gay throng' in season.[71] After a canvas each of harbour (cat.no.50) and château Monet rejected Dieppe for Pourville.[72] It was a response similar to that at Fécamp the previous year, when he had preferred to paint the adjacent cliffs rather than the port. On the other hand, in the first three weeks of February 1883 he had a productive stay at Etretat, painting some twenty canvases of a locale that was to become a favourite site over the next few years.[73] Although only a small village, with a population of just over 2,000, and not even a port, its fishing boats being pulled up on to the shingle beach, Etretat was hardly off the beaten track.[74] Its

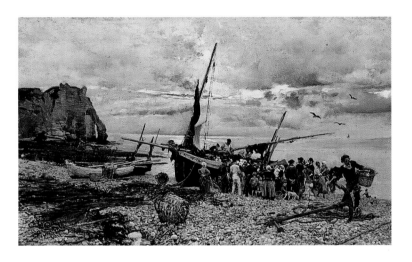

Fig.20 · Giovanni Boldini *The Return of the Fishing Boats, Etretat*, 1879
Sterling and Francine Clark Art Institute, Williamstown, Massachusetts

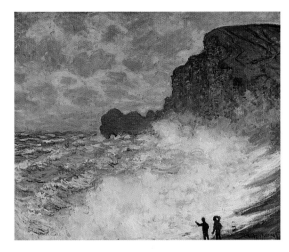

Fig.21 · Claude Monet *Stormy Weather at Etretat*, 1883
National Gallery of Victoria, Melbourne, Australia (w.826)

port out to the open sea (fig.17). When Monet came to work at Fécamp in March 1881 he painted two conventional motifs of vessels careened in the harbour at low tide and one of the mole in a storm.[68] That was the extent of his interest in Fécamp. Although he lodged in the town, the remaining eighteen or so canvases that he painted there over the next month were made from the cliffs and beaches to each side of the town. They focus on natural elements, different *effets* of weather, the changing light in the sky and on the sea, the massive chalk bluffs and the breakers buffeting the beach. In a few canvases made on the cliffs of Grainval, to the south-west of Fécamp, he viewed the port in enfilade. But although Notre-Dame-du-Salut, the mole and some harbour traffic can be made out, Monet all but masked Fécamp behind the great undulations of the Grainval cliff (fig.18).

The pronounced differences between the approaches of Monet, Noël and Le Roy return us to issues of modernity in Monet's work. In terms of his choices of locale his attitudes appear contradictory. On the one hand, he seems to have favoured small places from which he could escape the clutter of tourism. He worked briefly at the modest fishing village of Petites-Dalles in September 1880 and again in April the following year, producing only a handful of canvases.[69] Pourville, the location for two extended campaigns in February–April and June–

wondrous cliffs had attracted visitors since it had been popularised by the best-selling novelist Alphonse Karr in the 1840s. To the north-east the curve of the cliffs culminates in an arch carved by the water under the last great chalk hump. This, the Porte-d'Amont, is matched to the south-west by the even more dramatic Porte-d'Aval, a taller sea arch that seems to prop up the high, striated cliff like a buttress flanking a cathedral. Beyond it in the next bay is a rearing conical island, L'Aiguille, and on the far side a third and yet more massive sea-arch, the Manneporte, as if the sea had punched a hole through the vast cliff wall (fig.19). Such a natural phenomenon was bound to attract tourists and artists.

At Etretat in February 1883 Monet did not paint the village's inhabitants, native or temporary, as for example Giovanni Boldini had done in 1879 (fig.20). The Italian showed off his precise painterly skills, detailing every pebble on the beach and particularly picking out among the fisherfolk tourists in boater, bowler and a *chic* check jacket. But this is not to say that Monet did not populate his Etretat canvases. One painting in particular represents two figures standing on the shingle as waves and spray lash the beach (fig.21). However, one cannot tell if they are fishermen or tourists. Given that many of Monet's paintings of that campaign depict figures by the boats, often

in inclement weather, as well as beached boats alone and the local *caloges* (old craft thatched and used for storage), one suspects the former (for example, cat.no.73).[75] The winter season supports this. That said, these paintings cannot be taken as sympathetic images of staunch fisherfolk at time-honoured odds with the ocean, of the type so popular at the Salon. Monet kept his distance from these figures, further than Boldini. Indeed, many of the Etretat canvases were painted from his window at the Hôtel Blanquet.[76] Thus what he painted was the typical view of the tourist.[77]

Perhaps we should expect this. He had painted at Etretat briefly before, and in 1883 was aware that he was following a path already explored by Courbet and many others. It was, after all, convenient to have advice on, and precedents for, key vantage-points. Monet accepted and used them. His views of Etretat were in the main conventional, and in 1881 his vantage-point on the cliffs at Grainval was exactly the one illustrated in Adolphe Joanne's standard guide-book to the *département*.[78] One wonders whether Monet was not even occasionally ironic about the recommended tourist views. Early in the 1870s Eva Gonzalès had painted a view looking over the beach of Dieppe from the cliff above the château (fig.22). Her canvas summarises the tourist's view – beach, promenades, hotels, entry to the harbour, and an impressive distant view of the cliffs of Upper Normandy. In 1882 Monet painted that very vantage-point (cat.no.67). He put in women tourists clutching their parasols a cautious distance from the fragile fence casually strung along the unstable edge of the massive cliff, towering above the tiny bathers below. The new cliff-top villas, regular beneath their unweathered roofs, seem puny, shoved into the upper corner of the canvas by the gigantic block of chalk on which they intrusively and precariously stand. Gonzalès's painting claims the tourist's right to have this view, one might say, while Monet's mocks it. But such an image is rare. Generally, when Monet's motifs correspond to a known viewpoint they do so for practical reasons. Perhaps it was actually the best view. Perhaps it was also a marketable one. His Etretat trip in 1883 might have had a specifically commercial motive beyond simply painting a celebrated site. Among those who had villas there were not only painters such as Maupassant's relative Eugène Le Poittevin, Charles Landelle and Hugues Merle, the last a staple of the galerie Durand-Ruel from the early 1860s. There were also potential collectors. One of these was Faure, who already owned canvases by Monet. In July 1883, only shortly after Monet's return, he purchased *Stormy Weather at Etretat* (see fig.21) from Durand. How appropriate, Faure may have thought, to

own a painting of the very place where one owned a holiday villa. Another Etretat villa owner was Victor-Antoine Desfossés, proprietor of the mass-circulation *Le Petit Journal*.[79] He purchased his first Monet, a view of Vétheuil in fact (cat.no.12), on 7 April 1885, from Boussod & Valadon. Did Monet make his trips to Etretat to be seen there working, to rub shoulders with patrons he hoped would be attracted to his painting?

At Vétheuil Monet took the privileged view of the bourgeois *en villégiature* – on the outside, enjoying the locale, but not especially interested in the life of the place. On the Normandy coast, he did not want to see the trappings of tourism (as he had been prepared to do in his paintings of the 1860s), but could not always escape looking in the way tourists did. He tried to repudiate this way of seeing by seeking out dramatic vantage-points and other gambits, as we shall see, but still painted out of his hotel window. Although Monet tried to deny or minimise the modernity of the coastline, its harbours and resorts still lurk in the background of his paintings, and in one way or another modernity underpins his Normandy campaigns of the early 1880s. It terms of what Monet represented, modernity is barely visible, but it is implicit in the kind of looking and in the market he sought for his work. It is paramount in the way he painted, but before considering that we need to turn our attention briefly to another denial.

THE MODERN SUBLIME

In the years straddling the early 1880s, while Monet himself focussed so intently on the problem, many others were engaged in the representation of the great spectacle of the Normandy coast. Not only painters and draughtsman, but also poster designers, photographers, journalists, guide-book writers, novelists and even the visiting tourist were using images and words as they attempted to define the experience of expansive skies, gigantic cliffs and crashing waves. How might one represent and remember such natural grandeur was a question the cultured mind asked when thrilled by this extraordinary land- and seascape.

Two naturalist novelists, writers Monet knew personally, Emile Zola and Guy de Maupassant, were among those who were fascinated. Both subscribed to an aesthetic of exactitude, in which accurate description was primary. On the other hand, both realised the shortcomings of such stylistic austerity, and allowed themselves to slip into metaphor to enliven their prose and its effect on the reader's imagination. This is particularly true of their writing about the Normandy coast. In 1884 Zola published *La Joie de vivre*, set at the fictional fishing village Bonneville. One instance of his use of metaphor in the novel is when the September tides shatter a break-water constructed to protect the village. Zola describes the waves as like monsters with manes of foam, and as like battering rams in their destructive power.[80] Maupassant, a native Norman who had known the coast of the Pays de Caux since boyhood, frequently used it in his writing. In the story *Le Modèle* of 1883 he described the cliffs at Etretat in anthropomorphic terms, the Porte-d'Amont as a 'dwarf's foot' and the Porte-d'Aval as the 'leg of a colossus'. That same year his novel *Pierre et Jean* envisaged the harbour of Le Havre as the mouth of 'a devouring ogre' which vomited vessels out into the sea.[81] So hyperbolic did prose-writers' search for maritime metaphors become that in his comic

Fig.22 · Eva Gonzalès *The Beach at Dieppe*, c.1871–2
Château-Musée de Dieppe

novel *L'Ecornifleur* (The Sponger) of 1892 Jules Renard took delight in rendering them disgusting: 'The sea is like a beautiful woman, who, outwardly well-groomed, neglects her underwear ... This little harbour is as revolting as a diseased mouth.'[82]

What Zola and Maupassant were searching for was a means of conveying the terrific power of this environment. In particular they found it in metamorphic imagery. Such associations added a sense of scale and imaginative awe to their prose. Although Monet read this kind of literature – an evening after work on the coast was routinely supper, writing a letter to Alice Hoschedé, a few pages of Zola, and early bed – metaphor does not flavour the practicality of his correspondence. Only once does a letter slip into metaphor, when he describes 'my passion for the sea ... I feel that each day I understand her better, the hussy'.[83] Monet's momentary metamorphosis of the sea into a woman was an ancient image, and a commonplace in contemporary literature from Jules Michelet's *La Mer* (1861) to Renard's *L'Ecornifleur*. Indeed, it is significant that this association did not infiltrate his correspondence with Alice until 1886, when their intimate relationship was well established. Whether it had formed part of his mental landscape in the earlier 1880s, in particular in early 1883 when he was painting at Etretat and tormented by the thought of losing her, we do not know. Nor do we know whether Monet's visual imagination slipped into the associative or metamorphic when he was choosing a motif or painting it. On occasion his motifs might seem to echo the imagery so common in prose. One view from the cliffs at Pourville, for instance, could be read as a great maw (cat.no.66). Certainly others found it appropriate to make that commonplace. Among a sheet of caricatures of work from the 1882 Impressionist exhibition, the Parisian humourist Draner rendered one of Monet's canvases of the cliffs at Grainval as the angry profile of a Neptune-like head (fig.23).[84] Monet, however, only used metaphor in a letter – in prose, as writers did. Metaphor does not help us understand his paintings, though it does illuminate the ways in which others – from novelists to caricaturists – sought to get beyond mere description. In his search for originality, his determination to get beyond the naturalism of a Jules Noël, Monet, too, strove for more than mere description. His solution was to use the possibilities of picture-making and the means of painting.

When we consider Monet's marines of the early 1880s as a group, they strike one as being an extraordinary combination of the obvious and the adventurous. Obvious, in the sense that they took the three predominant features of this landscape – coast, sea, sky – and treated them in likely ways: looking along the cliff-edge, or the beach, this way and that, or looking straight out to sea. These are the ways we look in such a setting; we have all done it. Yet on to these expectations Monet imposed his own way of seeing, his own shaping and phrasing of his composition, the individual conception of colour relations, the personal weight and gesture of his brushwork. Looking at these canvases, we can find consistencies of approach, all quite logical enough in relation to what he represented. There is repetition: the rows of waves rolling in, the continuous undulation of the cliffs (cat.no.40). There is simplification: the panoramic marine as strips of sky and breaker, the reduction of the sheer bulk and the complex geology of a cliff to a mere silhouette. And there is also picture-

making's use of the pathetic fallacy, conjoining cliff and sunset, darkness and colour, in a formal evocation of the lasting and the passing (cat.nos.71, 72).

Although such observations take us some way towards understanding these remarkable paintings, one engages with them more closely, I believe, if one considers them as an extended pictorial meditation on the sublime. Up to 1883 the prime opportunity to assess Monet's marines was at the 1882 Impressionist exhibition, at which twelve of the thirty-five paintings listed in the catalogue were canvases of the Normandy coast.[85] These pictures attracted much attention from the critics, and were generally well received. A typical note of approval was to praise the visual 'truth' of the paintings, symptomatic of the aesthetic climate of naturalism and the *plein-air* reputation of Monet's work.[86] Neither the word 'sublime', nor in any great measure the language associated with it, featured in the critics' responses. This is hardly surprising, as during the Romantic period it had been more common in British than French aesthetic parlance, and since then had lapsed from the critical vocabulary as obsolete. The concept lingered, however, in the parlance of latter-day Romantics like Barbey d'Aurevilly, whose obituary of Millet praised his fellow Norman's paintings of the rugged sea-coast of the Cotentin peninsular: 'Nobody better than Millet has expressed the infinity of nature and the melancholy of man when he is thrown into that infinity, a sentiment unknown to the brutalists of today!' (cat.no.84)[87] Monet was not, I would argue, trying to resuscitate an old aesthetic, to which he probably gave no conscious thought. Rather, he instinctively seized on its core principles, discarded its accessories and fused them with his own practices to create an art of physical power and modern ambition, a new sublime that asserted his *sensations*, his originality. This was not necessarily a deliberate strategy, but an emotive artistic response to this stunning coastal landscape.

The Romantic sublime in early nineteenth-century French landscape painting might be typified by Eugène Isabey's *View on the Normandy Coast* (fig.24). Here the human figure is set against nature,

Fig.23 · Draner 'Une Visite aux impressionnistes' *Le Charivari*, 9 March 1882

the delicacy of the girl and the puniness of the little silhouette dead centre as feeble as the man-made embankment in relation to the towering cliff. Although the fishermen have to struggle with the sea to bring back their catch, it is the cliff that dominates in Isabey's conception, cutting them off from the land, forcing them to make their existence between rock and sea, between two elemental forces. The cliff eclipses the sky that one would expect to see in a landscape painting with a conventional horizon. On Monet's first excursion to the coast in the 1880s, the brief visit to Petites-Dalles in September 1880, he had produced one canvas that uses a similar vocabulary to Isabey's – dwarfed man-made structures, figures confronting the spectacle of scale and storm (fig.25). But by 1882 Monet had developed something different. The figurative and even anecdotal elements were generally reduced and often entirely banished from his canvases, in favour of a concentration – notably in the cliff-top paintings – on form. Compare Isabey's canvas to Monet's *Cliff near Pourville* of 1882 (cat.no.70), in which the cliffs have the same overpowering presence, pressing against the sky. Wind and water are present in Monet's picture, but their descriptive presence, one might say, is only as significant as the formal presence of mass and void. There are no figures, for this is the artist's meditation on those two fundamentals. Light counts, too, of course, and the *effet* of a brisk sou'westerly blowing clouds fast across a sunlit sky. But fundamentally the canvas is about the sublime.

The best evidence we have about how Monet thought about his aims and activities, how he imagined the coast at Fécamp, Pourville or Etretat, is of course the canvases themselves. But there are hints in his letters that the sublime – the sentiment of human feebleness in the face of the awesome grandeur of eternal nature – was on his mind. Letters regularly report fierce storms or ferocious tides. Exploring Etretat in February 1883 he enthused to Alice, 'The cliffs here are like nowhere else. Today I climbed down to a place where I'd never dared venture before and I saw some admirable things there.'[88] The following day he told her how he had taken his brother along cliff-top paths so vertiginous that he had had to take the terrified Léon's hand – the

bragging of a man hardened to awesome nature.[89] The year before he had particularly appreciated Ernest Chesneau's review of the 1882 Impressionist exhibition.[90] It is perhaps no coincidence that, of all the critics, it was Chesneau's text – on 'the surgings and the long sighs of the sea, and the seethings of the waves drawing back, and the glaucous colourings of the deep waters' – that was most suggestive of the sublime.[91]

Monet's cliff paintings are quintessentially elemental. Earth and water are to the fore: the rock, chalk and soil of the cliffs and headlands, the sea in all its moods. But so is fire – in the sunset paintings – and air, because Monet often gives – subtly, to be sure – a sense of the play of wind on grass, bushes and trees (cat.no.48). Although it is the least visually overt of the elements, air is actually one of the most important in his canvases. The air is void to the cliffs' solid, just as the cliff is mass to the sea's plane. From the pictorial play of the four elements Monet created a modern sublime.

These canvases ponder on mass and void. Their sparseness, the absence of the modern, the rarity even of the human, endows them with a sublime quality. But that in itself is expressed in a modern way, in its economy and the way it is articulated. That articulation operates on several levels, inter-relating and sometimes contradictory. The first is formal. The canvases can seem abrupt and confrontational, yet sometimes the lovely skies and illusion of warmth mollify the awesome motif (cat.nos.51, 60). That double-sided, contrary quality echoes the perception of Monet that the critic Montjoyeux, who seems to have known him, described in 1879. Montjoyeux defined his artistic temperament as 'capable of powerful enthusiasms and subject to unswervable dislikes. Floating prey between the exaltations of triumph and the prostrations of defeat', concluding that 'today's neurosis has brushed him'.[92] In other words, contradiction and uncertainty were part of the contemporary condition, and articulating them in one's work was an expression of modernity.

A second factor in this equation involved Monet's choice of motifs and his *plein-air* procedure. Working from cliff-tops and edges, or looking up at a cliff from the beach, meant that Monet was renouncing

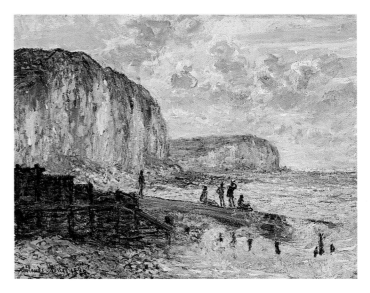

Fig.24 · Eugène Isabey *View on the Normandy Coast*, c.1830–40
Musée du Louvre, Paris

Fig.25 · Claude Monet *The Cliffs at Les Petites-Dalles*, 1880
Museum of Fine Arts, Boston, Denman Waldo Ross Collection (w.621)

much of what a landscape painter expects to deal with. These places are bare and austere. He tended to select cliff-tops that the wind had kept free of trees, beaches meagrely furnished with rocks. By thus stripping down his sites to essentials, without the clutter of 'landscape' detail, he could concentrate on *effets* of light and weather. With his eyes and brush he could feel out the essential forms of cliff and water, mass and plane, while sensing and transcribing atmosphere and *effet*. During these same years a similar process of renunciation and concentration was taking place in the work of a very different artist, no particular friend of Monet, although they esteemed each other's work – Degas. After a decade or more during which the practice had lain fallow, Degas was returning to life drawing. He began once more to pose the nude model in his studio, and to prepare poses for his figure compositions with drawings from life (fig.26).[93] Independently, and with very different working practices, the two artists were seeking out the very fundamentals of their craft – uncluttered form. The cliff landscape is like the naked body, stripped of trees, hedges or roads just as the nude has no clothes.

A third factor is touch and colour. Once the motif has been pared down as much as some of Monet's cliff paintings were, he was to a certain extent free from the obligations of exact description. There was room for improvisation and invention. Marks did not necessarily have to describe specific forms, colours could differ from the locally correct, even float free from form to play an improvised part on the painted surface. The *plein-air* practice, in combination with the temperamental and awesome changeability of cliff and shore, lent a hand here. If Monet was unable to complete a work on site – say because of fearsome winds or crashing tides – he increasingly came to finish off his canvases in the studio, in other words, to rely on memory or even to invent. In this way, the looking – apparently the primary activity – became only the preliminary stage. Monet studied the motif, worked from it; and then responded, *in situ* or later in the studio, to the way his *sensations* had led him with that particular canvas, that particular *effet*. Monet's response was to the fundamental form, in his case the cliff, whereas in Degas's it was the model's body. That response was linked to complex patterns of artistic instinct and training, to psychological state, and the sense of desire and delight on an open cliff above the sea, in a studio with a naked woman. The artist began to go beyond what he saw before him; he exaggerated, embellished, followed sensation, veered from the seen and understood to the invented and perceived.

If this reading of Monet's recasting of the sublime in terms of his original *sensation* and instinct for form is an extrapolation from his paintings, one can support such an interpretation by comparing and contrasting his approach with other artists. The physical shock of the drop from these hundred-metre high cliffs and the unexpected visual perception of mass and plane fascinated a number of very different contemporaries. In his *Histoire d'un dessinateur* of 1879 the architect Eugène Viollet-le-Duc described leading a student to the edge of the Normandy cliffs to get exactly that combination of reactions.[94] That same year the Rouennais artist Emile Nicolle – quite independently – made two etchings which could have illustrated Viollet's text.[95] One places tiny figures on the cliff-top to emphasise awesome scale and, in a ploy Monet did not try in his 1880–3 coastal paintings, inserted three birds silhouetted against the plane of the sea, the better to emphasise

void alongside mass (fig.27). A decade later a photographic magazine offered advice to photographers wanting to work on the cliffs, remarking both on the physical impact of the gigantic shapes and the dramatic visual transition between the line of the cliffs and the plane of the sea.[96] Architect, etcher and photographer were all conscious of ways of contriving looking to generate the sublime.

Monet was crafty with his contrivances. Material analysis has shown how he altered compositions, even to the extent of adding, inventing, 'natural' forms in order to exaggerate the sublime effect. In one of the 1881 Fécamp paintings, for instance, he painted out the cliff that originally extended along the bottom edge, replacing it by sea (cat.no.37). As a result, the spectator is brought 'closer' to the vertiginous brink. And in a Pourville canvas of the following year Monet broke the flat horizon of the sea by arbitrarily adding an extra bluff to the right (cat.no.65).[97] This has the opposite effect, reducing the sense of the women's risky exposure, isolated at the edge of the void. Monet thus manipulated his canvases to engineer both spatial and perceptual effects. Figures play a limited role in this. Monet did use them as markers of scale, and sometimes in more querulous roles. In the canvas just discussed the vulnerability of the tiny *bourgeoises* on the grimly shadowed crag plays up the sublime, and vicariously prompts our own reaction to that experience of being close to the edge – silly or courageous? But on the occasions that Monet did employ figures in his cliff paintings, their role is discreet. Not for him the hyperbole of Jehan-Georges Vibert's *Coast at Etretat*, in which the artist had boasted of his own bravery in studying the fury of the sea (fig.28). Monet did brave the treacherous heights and tides, once in 1885 being washed away by a rogue wave.[98] But in his paintings he tended only to imply such dangers.

The great 1883 canvas of the Manneporte is perhaps the most remarkable example of Monet's engagement with the sublime (cat.no.74). It is a painting about great forces, churning waters, gusting winds and the mighty gravity of rock. It is also about the fugitive – spray and sunlight, flux of tide and fall of earth. Above all the painting is one in which composition counts for so much, in the way in which

Fig .26 · Edgar Degas *Study of a Nude Dancer*, c.1880–3
Cabinet des Dessins (fonds Musée d'Orsay), Musée du Louvre, Paris

the great arch masks the vast vista of the open sea, the shadows cast by its crouching form enveloping our immediate environment in unwelcome half-light. This pictorial daring is matched by the implicit physical daring of the artist, with thrashing seas all along his frontage, although even in this most sublime of canvases two tiny figures on the rock beneath the Manneporte counterpoint its awesome grandeur. Such was Monet's skill with composition that he was able to evoke a powerful sense of the sublime with canvases of relatively modest size. *Manneporte* measures less than a metre across. By contrast, painters at the Salon frequently assumed that grandeur of motif demanded canvases of impressive scale. Throughout this period Elodie La Villette, to name but one, exhibited views of the Normandy coast at the Salon typically of very large size. Her *Cliffs at Yport* at the Salon of 1878 measured 165 × 256cm (Musée des Beaux-Arts, Lille), and *Bas-Fort-Blanc Path, at Low Tide, Dieppe* (fig.29) at the Salon of 1886, 140 × 230cm.[99] Paradoxically, Monet's canvases gained grandeur by concentration.

Monet's artifices extended to his colour and brushwork. In the way he applied paint he made only a partial effort to accord with what he saw before him. For his part, Courbet had painted cliff-faces in smears from a loaded palette-knife, approximating slab for slab (cat.no.87). Monet did respond to the geological structures and physical accidents he had before him, using the strata in the chalk of the Etretat cliffs as a natural inner linearity to enliven the great flank of the western cliff (cat.no.73), or streaking his bluffs with burnt Sienna to correspond to the falls of soil that excess water brings down from above. But they also served as a springboard for caprice. The cliffs on this coast are not chalky white, not even the relatively simple modulation of tones for which Courbet or La Villette settled. When one looks at them closely they appear not only textured – by striations of flint wedged into the chalk, by rocky outcrops or clinging grasses – but also remarkably varied in colour. One finds deep ochres, burnt Sienna, ivory, olive green, russet and mustard yellows. Monet revelled in the chromatic surfaces of these vast masses, nowhere more so than in the remarkable paintings he made of the cliff-face at Varengeville at low tide.[100] This view needed to be taken quickly, as the tide advances rapidly on this stretch of coast.[101] One suspects that Monet was thus encouraged to work swiftly, improvising colour to a certain extent. In *The Church at Varengeville, Morning Effect* (cat.no.51) the cliff forms an irregular, rippling relief across the centre of the canvas. Over a surface prepared in warm grey, Monet first built up deeper tones like the colour of dried blood. On these he worked with linear and scrubbed strokes, the medley of colours – warm and cold, dark and light – going on almost *ad hoc*. Some of the most intense colours, such as the resonant blue on the jutting crag, were applied very late in the painting's genesis. It is as if both the structure of the composition and the environmental requirements conspired to encourage invention rather than description.[102]

Again quite independently, his practice came close to that of Degas, in whose pastels of the 1880s touch and the application of colour increasingly came to have a role independent of the description of form and local colour. Arbitrary colour marks, free of conventionally

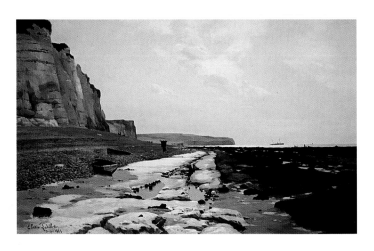

Clockwise from top left

Fig.27 · Emile Nicolle *Mesnil-Val, near Tréport*, 1879
Bibliothèque Municipale, Rouen

Fig.28 · Jehan-Georges Vibert *The Coast at Etretat*, 1867
Snite Museum of Art, University of Notre Dame, Indiana,
on extended loan from Mr and Mrs Noah L. Butkin

Fig.29 · Elodie La Villette *Bas-Fort-Blanc Path, at Low Tide, Dieppe*, 1885
Musée des Jacobins, Morlaix

descriptive duties, formed a kind of palimpsest floating disjointed from the observed form beneath. The chromatic and the tactile thus did not just record what was seen; they also acted as a kind of proxy for the act of looking. Because these coloured marks were made by gesture, almost instinctively, they were linked to the nervous response of artist to subject. In that respect both were especially modern, symptomatic of 'today's neurosis' that Montjoyeux diagnosed in Monet. However, in the main contemporary critics did not detect this audaciously experimental modernity in Monet's work, and perhaps the artist himself was only semi-conscious of how his work was developing. That said, there was an intriguing consistency among several of the responses to Monet's Fécamp paintings at the 1882 Impressionist exhibition. At least three journalists wrote of them in gastronomic terms, referring to 'cliffs like strawberry and gooseberry ice-pudding' and waves of 'whipped cream'.[103] Monet's canvases have a very sensual character, which the critics intuited, only mistaking the delight of taste for the gourmandise of looking.

SUCCESS, STATUS AND SELF-REFLECTION

By such means Monet recast his originality as an artist. But, despite the solitary nature of his campaigns on the lonely coast, Monet did not work in a vacuum. He read the press, and when he could saw exhibitions and talked to colleagues, just as they were aware of his progress. Renoir was a colleague of twenty years standing. Earlier than Monet, Renoir had benefitted from the patronage of the Charpentiers, painting family portraits and contributing drawings to *La Vie moderne*, which gave him a one-man show in June 1879. Through the Charpentiers Renoir met the wealthy Paul Bérard, who invited him to stay that summer at his country residence at Wargemont, near Dieppe. Renoir returned there the following summer. In effect, Renoir had two extended sessions painting on this stretch of the Normandy coast at this stage of his career before Monet had even started. We do not know if Renoir's example encouraged Monet to take up marines again with his visit to Petites-Dalles in September 1880, or how well Monet knew Renoir's Normandy work. For, although engaged on portraits, Renoir also painted some interesting landscapes there. Among them are several remarkable canvases of surf breaking on the beach. Courbet was a precedent here, of course, but compared to his quite heavy surfaces the paint evoking the stormy sky in Renoir's *The Wave* of 1879 is almost stained on (cat.nos.86, 89). With rich chromatics varying from blue-violet to peppermint green, Renoir powerfully evoked diagonal waves crashing and dragging on the shore. Was it a coincidence that two of the four canvases Monet painted on the coast the following year were similar views directly out to sea?[104] Renoir also painted at Varengeville, not far from Wargemont. One motif that attracted him there was the church, perched on the cliff edge. In one canvas, probably of 1880, Renoir sited the church in the upper left corner, focussing on the broken ground of the cliff-top and the undulating edge before the drop to the plane of the sea (fig.30). This viewpoint, looking westward from a slope known as Les Communes, was adopted in 1882 by Monet for four canvases (cat.nos.56, 57).[105] Was it simply an acknowledged vantage-point, did Renoir direct his friend there, or did both find it independently? If we cannot answer those questions, it is true to say that Monet used the display of his

Fig.30 · Auguste Renoir *The Church at Varengeville*, 1880
Location unknown, sold Sotheby's, 16 April 1975, lot no.63

Fécamp paintings in 1882 and of his Pourville pictures the following year substantially to enhance his reputation, and in early 1884 secretively returned to the Riviera to paint without telling Renoir, with whom he had reconnoitred the Mediterranean coast shortly before. For there was a competitive, even appropriative, edge to the ambitious Monet. Although Camille Pissarro paid a visit to Petites-Dalles in November 1883, painting a couple of cliff motifs and reporting that he would like to return for a longer campaign there, he never did. Within the Impressionist circle, Monet had by then made the Normandy cliffs his terrain.[106] For a colleague to work there would be to jeopardise his own originality.

By 1883 Monet's identity as an artist was on much firmer ground than it had been half a decade before. Although there had been some critical support at the 4th Impressionist show in 1879, complaints were still raised about what were seen as Monet's deficient draughtsmanship and incoherent colour.[107] The following year Zola had publicly taken him to task for dashing off slapdash work for quick sale.[108] But by 1883 the critical climate had significantly changed. His one-man show in February–March was treated to a full-length review article in the *Gazette des Beaux-Arts*. The writer, Alfred de Lostalot, made it clear that, while the *Gazette* took a generally conservative stance, Monet could not be dismissed; he was 'someone in art'. Lostalot based his appraisal of Monet on the artist's way of seeing: 'M. Monet's vision is exceptional'. While he admired Monet's conventional attributes – taste, drawing – Lostalot brought in recent physiological research to suggest that Monet could see ultra-violet rays, and thus was able to paint in such a way that the 'nervous fibres' of the spectator were unusually stimulated. In other words, the way to appreciate this particularly modern painting was to approach it via the modern means of physiology and psychology.[109] Modernity now also framed Monet's commercial arrangements. No longer did he need to hawk canvases to small collectors such as De Bellio and Murer, as he had in the late 1870s, content with 100 francs a canvas. Durand-Ruel was in effect his agent, leaving Monet free to work – a relatively novel deal. Durand staged Monet's one-man show in a converted apartment on the boulevard de la Madeleine, promoting the notion that this was the

kind of work the *chic* metropolitan collector should have in his own domestic environment. By 1883 Durand was taking his canvases in bulk at a minimum of 300 francs apiece. Monet's reputation was spreading. 'Monet is coming up,' wrote the American painter Mary Cassatt to her brother Alexander in October 1883; '[Georges] Petit ... has gone to Monet's pictures with a will, bought forty of them from Durand ...; so hold on to your Monets, I am only sorry I did not urge you to buy more.'[110] The fact that the fashionable dealer Petit was keen to take on his work when Durand lapsed into financial difficulties must have been reassuring for Monet. And the speculation in his work that this market promoted paid off. Charles Leroux bought several Pourville paintings from Durand-Ruel and Petit in 1883, probably for prices of about 500–600 francs apiece. When they were auctioned among the mainly contemporary pictures from Leroux's collection, just half a decade later, in February 1888, two fetched 1,000 francs, one 1,250, and a third, purchased by Cézanne's friend Victor Chocquet, an impressive 2,050.[111] Cassatt's recommendation that Monet's work of the early 1880s was an investment with a likely good return was proved emphatically correct.

Monet's much enhanced critical reputation and market value were based on his ability to develop his work in ways which fitted the flux of the modern. There was apparently no craftily preconceived strategy to this, although Monet was shrewd enough to optimise the chances that came his way. In some respects the direction his art took at this time seems contrary to current trends. If the conservative Republic of the 1870s backed retrospective, nostalgic types of landscape painting, its more radical successor in the early 1880s favoured landscapes more engaged with modern motifs and *plein-air* methods.[112] In that sense, Monet's quasi-pastoral paintings of Vétheuil and invocation of the sublime in the coastal canvases might seem perverse, out of kilter. But Monet did not follow ministerial policy; he was attuned to the deeper pulses of the modern. The broad momentum of republicanism put emphasis on the progressive and scientific; no wonder Lostalot turned to physiology to explain Monet's painting, matching modern explanation to modern expression. Monet's own fascination with the act of looking was rooted in the creative impulse, experienced in his everyday craft, and resulted in a body of work which established his originality. Between 1878 and 1883 he shifted from being a member of a controversial group of artists to being 'someone in art'. In essence, this shift in status was based on his painting, and this half-decade's work, one could argue, saw a sea-change in which the balance between subject on the one side and on the other looking and making tilted irrevocably towards the latter. This is not to say subject no longer counted, but that formal concerns predominated. Gustave Geffroy, to become perhaps the greatest of Monet's contemporary critics, seems to have sensed this in 1883, when he wrote that in Monet's paintings apples appear to give out, not reflect, light, and his cliffs suggest not solidity but liquidity.[113] Painting that in 1883 elicited that kind of suggestive response was remarkably modern.

No wonder it had such an impact on younger painters. In early 1883, probably stimulated by the one-man show, two young painters wrote to him. Charles Angrand hoped Monet had seen his recent work on show in Rouen and begged a place in a future group exhibition. Paul Signac asked if Monet would look at his tyro's work (though it

would be over a year before they met).[114] That Monet's recent painting, and particularly the cliff pictures with their challenging formal possibilities, was a stimulus to younger artists is evident from their work. We find junior figures among the Impressionist exhibitors, such as Caillebotte and Paul Gauguin, painting marines that used spatial devices or dramatic motifs that Monet had developed. In particular, the avant-garde leader of the late 1880s, Georges Seurat, elected in canvases such as *Le Bec du Hoc, Grandcamp* (fig.49) to take on Monet-like motifs, only to order them in his own system of controlled touch and colour. This was a reaction against what Seurat's colleagues, among them the converted Pissarro, dismissed as the 'romanticism' of Monet's style of Impressionism, in contrast to the order of their own 'neo-Impressionist' work.[115] Younger painters' relationships with the style and rhetoric of the previous generation – part homage, part competition – reminds us of Monet's own dialogue with his immediate predecessors. The cycle had come round again, revolving around Monet's work of 1878–1883.

During this remarkable half-decade, Monet produced the extraordinarily varied work we have discussed: now innovative, next conventional; dramatic, then tranquil; sometimes sober, sometimes sumptuous. In his early middle age, his working practice also fell into patterns. The cursory trip to Petites-Dalles in September 1880 began the cycle of extended painting campaigns around, and even just beyond, the '*hexagone*' of France which punctuated the 1880s following his move to Giverny. After exhausting Upper Normandy in the first half of the decade, there were trips to Belle-Ile off the Brittany coast (1886), the Mediterranean at Antibes (1888), and the Creuse Valley in the Massif Central (1889), as well as to the Italian frontier at Bordighera (1884). During these bursts of concentrated work Monet accumulated canvases, typically in clusters of related motifs. When he returned home to Giverny, where he settled with Alice Hoschedé and their families in April 1883, he completed the pictures before releasing them on the market. This regular cycle had been adumbrated in the previous two years, with the work at Fécamp, Pourville and Etretat.

It has been argued that this practice essentially initiated Monet's work in series, which characterised the 1890s and beyond. But we need to weigh up process and motive precisely. On his arrival at Vétheuil the artist did paint the same motif several times in different lights and weather conditions and from slightly different viewpoints. One particular view, across the expansive curve of the Seine to Lavacourt on the opposite bank, he seems to have painted twice in 1878 and no less than five times the following year (cat.no.29).[116] But this motif was taken from where he moored his boat; it was simply convenient. Consistency allowed him to acclimatise himself to the varieties of *effet* typical of his new locale, and the riverbank motif had marketable associations with Daubigny's work. We know that after Monet's first Pourville trip in early 1882 he insisted on seeing his works together in his studio before releasing them to Durand-Ruel, and may have touched up some canvases.[117] But this was readying the product for sale, a matter of professionalism, and far from the deliberate harmonisation of colour and surface across canvases intended to be shown as an ensemble that became his practice in the 1890s. At the 1882 Impressionist show Monet did exhibit marines from his Fécamp campaign that represented similar motifs, and this was recognised

approvingly by several critics.[118] He was aware that his subjects were repetitive, admitting to Durand that he could not choose canvases for show from their titles – these being much of a muchness – but needed to see the work.[119] Yet this cluster of canvases accounted for only a fifth of a very varied presentation. Indeed, other artists who worked on the Normandy coast repeated the same motif, Antoine Guillemet for one.[120] It simply made sense to re-use a satisfying and marketable subject. For Monet, repetition was also consistent with his *plein-airiste's* fascination with changing *effets*. Above all, acquaintance with a motif allowed scope for risk, elaboration and originality of expression.

With hindsight, one can see 1878–1883 as a period of transition in Monet's life, work and career. His personal life shifted from the trauma of Camille's illness and death to a stable relationship with Alice Hoschedé. It was these years which confirmed for him the stimulus of regular travel, in which his painterly practice began increasingly to coalesce around concentration and revision, when the balance tipped that little bit further from the still primary work *en plein air* towards the studio. It was the phase in which the role of the figure in his landscapes diminished but did not disappear. For at Argenteuil or even in the Paris paintings of 1877 figures are regularly active indicators of how a landscape is populated and used, whereas in our period fewer motifs feature people at all, though residual human presence – fishing nets, a remote cottage, distant boats – may be there. By the mid-1880s even that had all but gone. Again, it was a period that increasingly affirmed in Monet's work the value of concentration. More and more he seemed to find that going back to very similar motifs, usually with different *effets*, enriched his *sensations* and his painting. With hindsight we can see that this phase of intensified focus led on to the series of the 1890s. But rather than define the paintings of 1878–1883 by his later work, we should acknowledge them for what they are – powerfully drawn, strongly composed and richly coloured pictorial meditations on nature as tranquil and threatening, elemental and evanescent, on the landscape of *villégiature* and of the sublime.

There is a coda. In late February 1896 Monet wrote to the Durand-Ruel gallery to let his dealers know that he was at Pourville. 'I set myself up here several days ago, I needed to see the sea again and am enchanted to see once more so many things that I did here fifteen years ago.'[121] He worked there for a couple of months and returned early the following year for a similar stretch. In some respects things had changed. Now prosperous, Monet was able to have a sheltering cabin constructed in 1896.[122] But modernity impinged. The next year he found several motifs he had commenced had been developed, and the bare cliffs above Dieppe were being blighted by 'English games', like golf and clay-pigeon shooting, to attract the tourists.[123] His letters back from the coast are typically replete with complaints about the unpredictability of the weather, as they had been when he had first worked at Pourville. There are no significant reflections on the past in his correspondence. But it was not Monet's way to express himself in writing. His canvases, on the other hand, seem to sigh with melancholy and nostalgia. The rearing forms of the massive cliffs, the sun-soaked strand and the compact *douanier's* cottage are executed in a quite even, almost pasty touch, the tonalities soft olive-greens, muted yellows and gentle lavenders (fig.31). There is something almost

Fig.31 · Claude Monet *Gorge of the Petit-Ailly, Varengeville*, 1897
The Metropolitan Museum of Art, New York (w.1451)

plangent about these paintings. Their vistas into the distance are veiled in a hazy light, creating panoramas incompletely seen, incompletely remembered, the soothing tones jinxed by the resonance of the past.

If Monet said nothing to explain these paintings, his close friend Geffroy did. He recorded that they were painted at a time of deep sadness; Monet was recovering from serious ill health, and felt isolated as an artist.[124] Geffroy might have added anxiety about his step-daughter Suzanne, who died in early 1899 after a long illness, aged thirty. Her mother was devastated with grief. In that light, the paintings Monet made in the summer of 1901 might be seen as part of the protective process by which he tried to soothe Alice in her bereavement. That summer was too hot for Monet to work in his Giverny studio, so he rented a room at Lavacourt. The family drove out there every day; Monet painted, and Alice, Suzanne's children and other friends and family members relaxed on the riverbank. As the days passed, Monet completed fifteen canvases.[125] They are all almost square, evenly painted in soft mid-tones of yellow and green, pink and violet, and represent the same motif. It is the village of Vétheuil. Seen across the sheet of the Seine, the village clusters around the church, its tower protruding into the sky above the background ridge. As with the later paintings at Pourville, Monet seems to revel in imprecision. The motif is vague, softly embedded in the play of his brush, and repeated in the reflection. There is a deliberate symmetry to these paintings, one might almost say a soothing grasp on the present echoed by a dimmer glimpse of the past. Perhaps in this dialogue of observation and memory, enacted in the presence of Alice, with whom he had arrived in Vétheuil in 1878, Monet sought for them both some equilibrium and peace. Never did Monet go back to places he had worked before and paint so intently and so emotively on motifs he had previously treated. Painting at Pourville in 1896 and 1897, and depicting Vétheuil in 1901, Monet used landscape, one might say, as therapy, revelling in the power of paint to reveal the thaumaturgical in nature. Such was the enduring lure of the Seine and the sea.

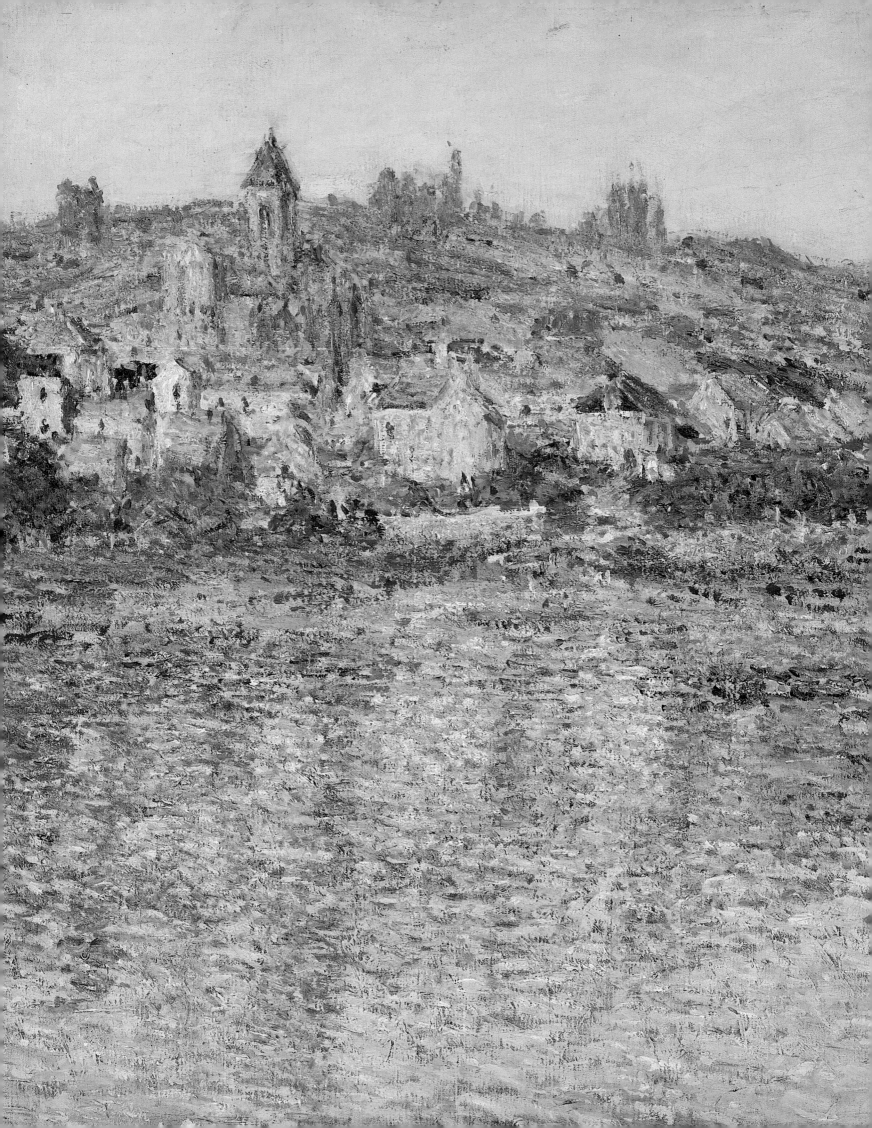

MONET AND TRADITION, OR HOW THE PAST BECAME THE FUTURE

Michael Clarke

The journey which Monet undertook in 1878 from Paris to Vétheuil, where, for reasons of economy, he settled in late August that year with his own and the Hoschedé family, led to a period of great importance in his artistic development.[1] Fresh from painting the modernity of Paris – most notably the station, railway engines and smoke of the Gare St-Lazare – over the next few years he embarked upon a detailed examination and reworking of older traditions in French landscape art, specifically those represented by the previous generation of Corot, Courbet, Daubigny and Millet. As will be demonstrated, there is ample visual evidence for this claim, despite the almost total absence of documentary references to the subject by Monet in his correspondence or in the various, often unreliable, interviews he gave later in his life. The influence of older artists on Monet during the period 1878–1883 can be likened in musical terms to a motif that struggles to break through and dominate the main theme. It never quite succeeds, but its attempts to do so create a fascinating tension between old and new which is clearly apparent just below the surface reality of Monet's work in these years.

THE SEINE

Until recently, the village of Vétheuil on the east bank of the Seine has been almost completely overlooked in the many examinations of Monet's career.[2] It remains, to this day, something of a backwater in the public perception of the Impressionist landscape. More famous sites are situated nearby, notably Giverny just a little further downstream, where Monet would settle in 1883. In 1878 the population of Vétheuil numbered 622, a total which had hardly varied over the centuries. This was less than a tenth of that of Argenteuil, which had been Monet's base from 1871 to 1878.[3] Argenteuil, however, had become a semi-industrial centre just beyond the edge of the Parisian sprawl. It offered the perspective of both town and country and during his time there Monet gave almost equal emphasis to both. Argenteuil was twenty minutes by direct rail link to the centre of Paris. Vétheuil, on the other hand, lay twelve kilometres from the nearest railway station, at Mantes, itself fifty-seven kilometres by train from the Gare St-Lazare. The historical beauty of the town of Mantes was almost completely destroyed in the Second World War on account of its importance as a crossing point of the Seine. Its eighteenth-century bridge (fig.32) had been immortalised in paint by one of Monet's greatest immediate predecessors, Camille Corot (1796–1875).[4] 'Père Corot' was one of a number of recent 'old masters' of French landscape painting who had passed away in the 1870s in the years immediately preceding Monet's move to Vétheuil.

If Argenteuil represented suburban colonisation, then Vétheuil indisputably offered an older, more timeless view of the French countryside. As Monet enthused in a letter of 1 September 1878, 'I have set up shop on the banks of the Seine in a ravishing spot'.[5] Its basic elements comprised the great sweep of the Seine as it curved round from Rolleboise and Méricourt past Vétheuil on the eastern bank with the village of Lavacourt opposite. Behind Vétheuil, to the east, rises a gentle chalk escarpment on which are scattered smallholdings and orchards. In spring and summer the verdant terrain is pleasingly sprinkled with the myriad hues of flower and blossom. In exceptional winters (before the present climate change), such as that which

< Detail from cat.no.15

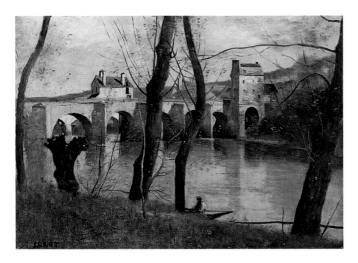

Fig.32 · Jean-Baptiste Camille Corot *The Old Bridge at Mantes, c.1868–70*
Musée du Louvre, Paris

occurred in 1879–80, there was the awesome prospect of the mighty Seine freezing over, the silence of a frozen landscape soon to be shattered by the ominous groaning and cracking of the ice as the thaw set in and the great floes gathered pace in their inevitable voyage downstream. For most of the year, however, Vétheuil provided a menu of motifs – the riverside with its twists and turns, its early morning and late evening effects; the town, dominated by its medieval church; the tapestry of floral colour set off against a green background – such as had formed the staple diet of traditional French landscapists ('herbivores' as Baudelaire called them) from the 1830s onwards. This tradition would evoke a strong response from Monet, one that was conditioned by a number of major factors that we should now consider.

THE LINGERING PAST

There persists, even today, a popular over-simplification according to which Impressionism sprang fully formed from nowhere, challenging the overweight Salon nymphs of Alexandre Cabanel (1823–1889) and others. Furthermore, it is perceived to have finally broken down the accepted hierarchy of academic art, at the pinnacle of which had stood history painting and at the base (in both senses of the word) were to be found the lowly genres such as still life and landscape. In addition to its undoubted technical innovations – the use of industrially manufactured, unmixed colours; the elimination of underdrawing and preparatory tonal underpainting – Impressionism offered a celebration of contemporary subject matter, as opposed to subjects taken from a classical or religious past. But in the decades, the 1860s and 1870s, when Monet and his fellow Impressionists first appeared and established themselves, there was one particular class of painting in French art, that of landscape, which had already recently achieved greater prominence and which some enlightened commentators considered to have assumed the mantle of the leading category by which French painting should be defined. Its most celebrated practitioners were artists such as Corot, Gustave Courbet, François Français, Henri Harpignies, Jean-François Millet and, of particular relevance for Monet during his Vétheuil years, Charles-François Daubigny.

In the 1870s there were many critical admirers of landscape who lamented the recent demise of figures such as Corot (1875) and Théodore Rousseau (1868). These artists had been regarded as the greatest contemporary practitioners of landscape painting, a genre which had gained further recognition since the 1848 Revolution and which was welcomed at the Salons as indicative of the liberalism of the new Republic. Artists such as Rousseau (whose work hitherto had been famously refused at the Salon), Corot and Daubigny were awarded medals at the Salons of the late 1840s. This approval and popularity continued under the Second Empire of Napoléon III (1852–70), when landscape was regarded in many circles as providing the most vital genre in French art. Conservative elements of officialdom remained equivocal, however, even fearing that support for such a non-religious and unhistorical category, its shortcomings often dangerously exacerbated by the inclusion of peasantry, would threaten the established political and artistic hierarchies.

Such reservations notwithstanding, Rousseau was admired for the quasi-religious symbolism of his noble, dying forests, and Corot's sylvan nymphs paid reassuring homage to the classical tradition. But the most widespread sanctioning of landscape occurred when it could be described as 'poetic'. This rather nebulous definition provided a convenient catch-all for much of the landscape painting produced during that era. Writing in 1868, the year of Rousseau's death, Marshall Vaillant, Minister of Fine Arts, claimed that:

> Modern landscape has gained a significance and an expressive value independent of the presence of man. Not only has it taught us to see better, to understand better the endlessly varied beauty of external phenomena, but also, even when it neglects the human figure as a means of expression, one can say that landscape transforms a thousand emotions that belong to the physical domain: sorrow, joy, the most opposed passions, and the most gentle as well as the most violent.[6]

This interpretation mirrored Romantic thought in which nature was seen as an elemental force, inspiring an emotional reaction in man. Indeed, Romanticism had very much sanctioned the widespread growth of interest in landscape painting from Turner to Rousseau, with particular emphasis placed on nature's sublimity, its ability to inspire awe and wonder. At the same time, Vaillant's language almost seems to anticipate that of Gauguin and the Symbolists towards the end of the nineteenth century.

A SURPRISING EXCLUSION

1878, the year of Monet's move to Vétheuil, saw the installation in Paris of the Exposition Universelle in the specially built Trocadéro Palace (fig.33) and also, linked by an enlarged Pont de Iéna, in a temporary structure on the Champ de Mars on the opposite bank of the Seine. This great exhibition was a successor to the earlier ones of 1855 and 1867. Although the range of world cultures on display was truly impressive, the selection of the fine arts section devoted to France mirrored the conservative prejudices of those at the head of the official art regime at that time. The press was almost universally critical[7] and at best lukewarm, witness the verdict of the *The English Guide*:

> There are some splendid and brilliant works, but as at the Salon, so here, we think France barely upholds her art reputation, and there are many

pictures among the number that whilst it may be said they are essentially French in character, are not of the class that show to advantage when in such an Exhibition and in such numbers.[8]

The annual exhibition of paintings at the Salon, displaced to the Champs Elysées that year, fared even worse. Despite the presence of 2,330 paintings, the same commentator in *The English Guide* opined:

The Salon of 1878 has been, almost without exception, pronounced a disappointment. It has not realised the hopes and expectations of those who have been accustomed to think French art so eminently superior to all others.[9]

The landscapes at the Salon covered the usual variety of subject matter – coastal scenes with figures, *sous-bois* or scenes of the interiors of woods and forests, forest scenes with peasants (often carrying faggots), water-meadows with trees and cows, forest interiors with rocks, marshland vistas with trees and birds and, perhaps most numerous of all, river scenes. Such was the staple diet of the mainstream landscapist at the time – markedly different from the more vigorous approach to contemporary life adopted by the Impressionists.

Perhaps the Salon suffered unfairly by comparison to the Exposition Universelle, for the latter included many paintings, arguably of greater quality, which had been shown at exhibitions over the last ten years or so, as well as some which had been lent from the Musée du Luxembourg, the national museum intended to represent the best of French contemporary art. Interestingly, the one section of the French contribution to the Exposition Universelle which generally escaped major strictures was that of landscape. According to 'A Painter', writing in the American magazine *Scribner's Monthly*:

One is here most struck by the landscapes, which are the chief glory of the French school.[10]

This would have been despite rather than because of recent official encouragement of the genre, for during the 1870s the number of landscapes acquired by the State had dramatically declined. The absence from the Exposition of some of the great recent masters of landscape, such as Narcisse Diaz and Millet, was remarked upon by many commentators. Among the more forward-thinking was Courbet's champion, Jules Castagnary, who extolled the virtues of landscape:

Landscape has been for a long time the pride of the French school, its originality is beyond dispute and its superiority evident and accepted.[11]

Fig.33. Palais de Trocadéro, Exposition Universelle, 1878

He particularly admired the masters of the '*école de 1830*', the generation of Eugène Delacroix and his contemporaries, whose unsatisfactory representation at the exhibition he decried. This could partly be explained by the fact that only works executed after the 1867 Exposition could be included (Rousseau had died in 1868!). The few whose works were admitted, such as Corot and Daubigny, were hung disadvantageously – '*Où sont les paysagistes? Ils sont en pièces.*'[12] The artists whom the exhibition favoured – Cabanel, Bouguereau, Bonnat, Laurens, Meissonier – Castagnary deplored. Worst of all, perhaps, was that this was not the Exposition Universelle that he and others of like mind had been expecting. It was, in Castaganary's opinion, not very French and not at all republican. Since the military disaster of the Franco-Prussian War in 1870–1 and the horrors of the suppression of the Paris Commune in 1871, French domestic politics had been, on the whole, repressive. The ensuing conservatism had also embraced the administration of the visual arts. Charles Blanc, Director of Fine Arts from 1870, promoted heroic art (understandable perhaps in a defeated nation) and was unsympathetic to landscape. He was succeeded in 1873 by the Marquis de Chennevières, who was appointed by the regime of President MacMahon – 'a government of moral order'. Chennevières was dismissed in 1878 on account of his perceived mismanagement of the Exposition Universelle.

The relatively widespread regret expressed at the neglect of many recently deceased masters can, however, be read as evidence of their popularity in circles outside the confines of the Exposition Universelle. A thriving commercial market for undemanding escapist landscape – the comforting imagery of ponds, meadows and willow trees – had existed since at least mid-century. As the writer and painter Frédéric Henriet observed of Corot in 1854 in a piece entitled '*Le Musée des rues*':

But it is only on the rue Laffitte that you can sample the intimate side, become familiar with his talent and that you learn to love the naïve and good Corot of Ville-d'Avray, of Bougival and of Bas-Meudon.[13]

The rue Laffitte in Paris (coincidentally the street where Monet had been born in 1840) housed a number of picture dealers, such as Bernheim-Jeune (by 1878), Beugniet, Bourges, Martin, Tempelaere and Thomas, who dealt in this sort of undemanding landscape – guaranteed to find favour with a bourgeois Parisian public well disposed to imagery that would dispel the less agreeable aspects of urban life. Goupil et Cie were just round the corner at 9 rue Chaptal and 19 boulevard Montmartre.[14] From an historical perspective, however, the most important dealer in this type of landscape was Paul Durand-Ruel, who had also become the dominant dealer in Impressionism. The taste for such landscapes was further promulgated by the publication of *Galerie Durand-Ruel*, a series of monthly fascicules in which were lavishly reproduced ten paintings from Durand-Ruel's stock. The fact that he combined dealing in these two rather different types of painting has not received enough attention from later commentators. It certainly cannot have escaped the attention of Monet and his contemporaries that their works sold less well than those of their immediate predecessors.

Durand-Ruel had moved his gallery from the rue de la Paix to the rue Laffitte just before the outbreak of the Franco-Prussian War in 1870. There, after the cessation of the War, he continued to sell the paintings of the '*école de 1830*', acquiring large numbers of works by

Rousseau, Corot, Millet, Daubigny, Diaz, Dupré and Ziem. In London in 1870 he had been personally introduced to Monet by Daubigny and shortly thereafter he began to deal in Monet's work, as well as that of Degas and Pissarro. However, the difficult post-war economic circumstances meant he was unable to support these younger artists to the degree he might have wished. His first phase of buying extensively from Monet ceased in 1876. His diminished resources also reduced his ability to take as full an advantage as he would have desired of the studio sales of Millet, Corot, Daubigny, Daumier, Barye and Diaz, which were all compressed by chance to within the relatively short period 1875–9.

Durand-Ruel's reluctance to offer full support to the nascent Impressionists has been cited as one of the main factors in their decision to set up the first of their 'independent' shows in 1874. Their second exhibition, however, was held in rooms which they rented in Durand-Ruel's house on rue Le Peletier, and he acted as 'expert' to the sale the Impressionists organised themselves in 1875. Of more significance to the present discussion is his preparedness to capitalise on the perceived neglect of the older landscape painters in the 1878 Exposition Universelle. This he achieved by staging a large retrospective exhibition of French painting 1830–70, which included no fewer than 89 works by Corot, 30 by Courbet, 18 by Daubigny, 33 by Delacroix, 13 by Huet and 23 by Rousseau. The reviewer in *Le Monde illustré* noted:

> The exhibition organised by M. Durand-Ruel in his enormous premises on the rue Laffitte and the rue Le Peletier is exceptionally interesting. A considerable number of works are reunited there by several artists, now dead, who have been the major contributors in their lifetimes to the renown and the justifiable fashion for modern French painting.[15]

Thus the critical errors of the selectors of the Exposition Universelle were redressed and Durand-Ruel, with the aid of many loans from his clients and fellow dealers, made an ambitious and calculated pitch for the custom of his major collectors. Indeed, in the late 1870s and early 1880s the prices of Corot, Courbet and the Barbizon masters rose to gratifyingly high levels[16] (as compared to the disappointing prices realised by Impressionist paintings, for example in the last Hoschedé sale of 1878).[17] Despite the apparent public indifference to the Durand-Ruel show recorded by Pissarro,[18] its impact and implied message can surely not have been lost on Monet. Durand-Ruel had, for the moment, tempered his dual interest in 'modern' French painting and the Impressionists and opted for the former.

Monet's move to Vétheuil, two months before Durand-Ruel's show, was mainly prompted, it seems, by a lack of funds and a need for cheaper living costs. Surrounded as he was there by a range of landscape motifs that had already been exploited by the more commercially viable and widely respected older school of landscape painters, it must have occurred to him to mine this potentially rich vein of subject matter in a manner which gave some degree of recognition to the recent past. Posterity, too, in the shape of Durand-Ruel's exhibition, had recently paid homage to all those masters who had died in the 1870s. Here then was Monet's chance, brought about by circumstance as much as intention, to place himself in the increasingly acknowledged French tradition.

A KINDRED SPIRIT

Of all the modern 'old masters' of landscape there was one to whom Monet must have felt particularly close as he wandered through the water-meadows at Vétheuil to place his easel on the banks of the Seine. Charles-François Daubigny (1817–1878) was Monet's most significant immediate predecessor in the depiction of river scenery.[19] His posthumous studio sale was held 6–8 May 1878, some four months before Monet moved to Vétheuil. His place in the critical hierarchy was admirably summed up by Paul Mantz, writing just a few months later:

> After the death of Théodore Rousseau, of François Millet, of Corot, of Diaz, there remained for us only one landscape painter of the great poetic family, Daubigny. He was like a younger brother next to them; he had not been listened to at first; but his tireless enthusiasm, his beautiful feeling for light, the power of his work made him a witness and survivor of the glorious school. He also, he has gone[20]

Even in the unfavourable confines of the Exposition Universelle, Daubigny had found critical favour. His appeal to collectors was admirably encapsulated in the commentary in *Scribner's Monthly* on a spring landscape included in that exhibition:

> It seems carelessly done, but how true it is, how full of thought and meaning, how necessary in every touch! At the same time it has great sentiment. One feels not only the truth, but the subtle charm of this lovely day. One seems to be there, and to breathe the dreamy, half-warm, half-moist atmosphere.[21]

The bridge that Daubigny represented between the old and the new in landscape painting is well illustrated here. His technique, while more traditional than that of the Impressionists, was viewed by many as unfinished ('carelessly done'), whereas his choice of subject matter, which embraced the seasons, orchards in blossom and riverside scenery, was perfectly in accord with the poetic current in French landscape painting ('sentiment', 'truth'). It represented, in effect, a contemporary idealisation of nature and one which replaced the outworn formula of neoclassical landscape which had held sway since the late eighteenth century and of which the death-knell was sounded by the discontinuation, in 1863, of the quadrennial Grand Prix for Historical Landscape.

In his lifetime Daubigny had found a particular champion in the painter and critic Frédéric Henriet (1826–1918). The two first met in 1851. Originally destined for the law, Henriet quickly became absorbed by the arts and occupied a series of administrative posts, many of them connected with the official Salons. In his writings on Daubigny, including two essays in *L'Artiste* in 1857, *Le Paysagiste aux champs* of 1866 (republished in 1876), and *C. Daubigny et son œuvre gravé* of 1875, he romanticised Daubigny's life as a painter of the countryside and glorified him as an artist who eschewed tradition for the pure and direct experience and transcription of nature. Monet had known and been encouraged in his formative years by Daubigny. Most importantly, the older artist had introduced him in 1870 to the dealer Durand-Ruel, whose dual importance, both as a supporter of certain of the Impressionists and as the major dealer in the works of the generation immediately preceding them, has already been stressed. Monet would not need to have read Henriet to have been convinced of Daubigny's artistic importance, but the appearance of such a relative plethora of publications would have reminded him of the consistent

public appetite for such pleasing landscapes and of their commercial appeal. 'In our era of transition and confusion', Henriet had written, landscape offered a place 'between a social order which is passing away and the formidable unknown matters of the future'.[22]

In the public's estimation Daubigny was irrevocably associated with the scenery of the three major rivers that flowed near or through Paris – the Seine, the Marne and, more particularly, the Oise. Moreover he had worked at locations such as Argenteuil, Etretat and La Roche-Guyon, which would also be depicted by Monet. He had been particularly patronised by Napoléon III, under whose regime major works by him had been acquired for the state. Dealers such as Brame and Durand-Ruel sold his works, very often riverscapes, to middle-class collectors who were reassured by such pleasing depictions of fresh and implicitly unpolluted water (Paris was still subject to the occasional ravages of typhus) as it flowed through the unspoilt French countryside.

Some of the earliest pictures which Monet painted at Vétheuil, particularly those of the *Small Arm of the Seine at Vétheuil* (fig.34), show a similar concern with river imagery, comparable to that found in Daubigny's *Banks of the Seine at Bezons* (fig.35), for example. Both artists place the horizon roughly in the middle of the canvas and both are preoccupied with a dense depiction of the trees and vegetation by the water's edge. Monet's vigorous and relatively small *esquisse* ('sketch') of *The Village of Lavacourt* (fig.36), quickly painted from a boat moored in midstream, reflects Daubigny's practice, first evolved around 1857 and immortalised in the set of etchings *Le Voyage en bateau*, published 1862,

of working from his specially constructed floating studio boat, his *botin*.[23] Daubigny, of course, had worked mainly on the nearby river Oise, whereas Monet concentrated throughout his career on the river Seine. Before moving to Vétheuil Monet had constructed his own studio boat which he depicted in a number of canvases (w.390–3) and in one painted at Vétheuil in 1881, *Vétheuil, Sunset* (fig.37).

The orchards in blossom around Vétheuil became another of Monet's favourite motifs in a group of canvases of 1879 (cat.no.11). Although more radical in composition – the trees in blossom tend to fill the foreground of the canvases – these pictures would have found their most significant predecessors in Daubigny's numerous and more conventional orchard scenes, many of them dating from the 1870s (fig.38). Pursuing the theme of floral display, and even more closely comparable to earlier pictures by Daubigny, was Monet's extensive view of *The Poppyfield* (fig.39) on the plain of Lavacourt, a subject treated in a similarly arranged composition by Daubigny in his Salon picture of 1874 (fig.40). A different kind of resonance and coincidence of motif can be detected in Monet's oil-sketches (some of the very few that survive) made on the hills of Chantemesle overlooking Vétheuil. Just a few years earlier Daubigny had executed several canvases of the ruins of the Château-Gaillard, which lies just above Les Andelys, downstream from Vétheuil. Again it is tempting to suggest that, in his choice of a broad vista from a vantage point high above the Seine, Monet (cat.no.44) was here inspired by the example of the older artist (fig.41).

In the majority of his views of Vétheuil, in which the central feature is the church seen from across the water, Monet takes an artfully

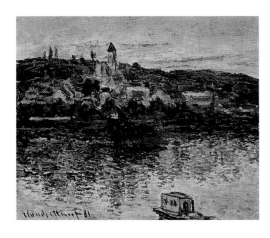
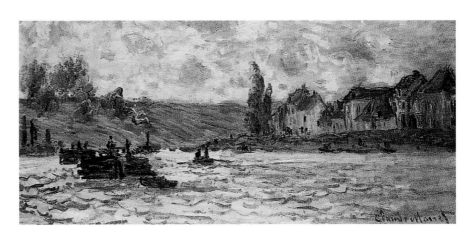

Clockwise from top left

Fig.34 · Claude Monet *Small Arm of the Seine at Vétheuil*, 1878
Private Collection (w.481A)

Fig.35 · Charles-François Daubigny *Banks of the Seine at Bezons*, 1852
Musée des Beaux-Arts, Nantes

Fig.36 · Claude Monet *The Village of Lavacourt*, 1878–9
Private Collection (w.501)

Fig.37 · Claude Monet *Vétheuil, Sunset*, 1881
Private Collection (w.668)

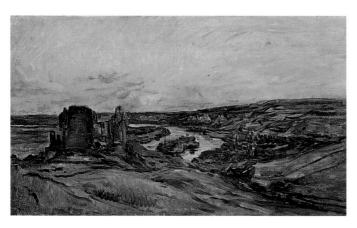
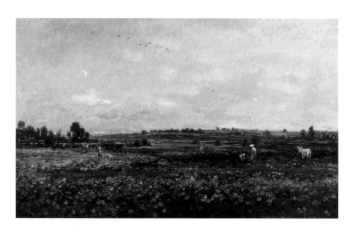

Clockwise from top left

Fig.38 · Charles-François Daubigny *Apple Trees in Blossom*
The Metropolitan Museum of Art, New York, Bequest of Collis P. Huntington, 1900

Fig.39 · Claude Monet *The Poppyfield*, 1881
Museum Boymans-van Beuningen, Rotterdam (w.677)

Fig.40 · Charles-François Daubigny *Fields in the Month of June*, 1874
Herbert F. Johnson Museum, Cornell University, Gift of Mr and Mrs Louis V. Keeler,
class of 1911

Fig.41 · Charles-François Daubigny *Château-Gaillard at Sunset*, c.1873
Museum of Fine Arts, Boston, Gift of Mrs Josiah Bradlee

matter-of-fact, 'modern' view which owes little to the conventions of the past. The far riverbank is placed roughly halfway up the picture space with sky, village and hillside resting on top of an expanse of water which is used by Monet for detailed study of the play of reflections. In a canvas of 1879 (*The Seine at Vétheuil*, Musée d'Orsay, Paris, w.532), however, one which was acquired by a local Vétheuil collector, a much more Daubigny-like atmosphere takes over. The composition is less square, more avowedly 'landscape' in format. It is framed to the left by trees, a traditional *repoussoir* device in landscape painting. The diagonal curve of the riverbank mirrors both Dutch seventeenth-century art and Daubigny's own practice in his countless riverside depictions of villages such as Herblay and La Frette. More specifically, the subdued evening light and yellow sky against which

the church tower is set evoke close comparison with similar scenes by Daubigny such as *Montigny-sur-Loing* (cat.no.83).

Sunrise and sunset were two of the traditionally favoured times of day, according to the classical landscape canon as set down by Pierre-Henri de Valenciennes in his treatise on landscape painting *Elémens de perspective ...*, first published in 1800.[24] The Impressionist painter Camille Pissarro advised study of this text to his painter son Lucien. The sometimes overlooked links between succeeding generations of French landscape painters can be illustrated by the fact that Daubigny's father, Edmond-François, had studied briefly with Valenciennes's pupil Jean-Victor Bertin. The old and the new often commingled, as is famously demonstrated in the title of Monet's 1873 canvas *Impression, Sunrise* (fig.55), from which a hostile critic coined the term 'Impressionist'. The choice of 'sunrise' echoed the neoclassical advocacy of the times of day.

One of the more surprising of Monet's Vétheuil landscapes is the semi-abstract rendition of *Sunset* (cat.no.27) of 1880. It is a pure painting of mood, of *effet* (a transitory or ephemeral phenomenon that occurs in nature), and again it is hard to resist the conclusion that his inspiration may have been Daubigny, who frequently depicted sunsets or the moon shining over lakes and ponds (cat.no.82).[25]

Across the Seine from Vétheuil lies the small village of Lavacourt. The two were linked by a modest ferry in Monet's day. He depicted Lavacourt many times, nearly always, it must be assumed, working

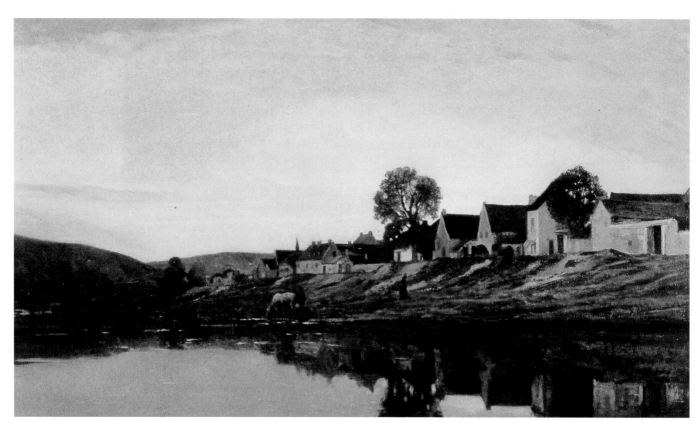

Fig. 42. Charles-François Daubigny *A View of Gloton*, 1861
Marauchi Museum, Japan

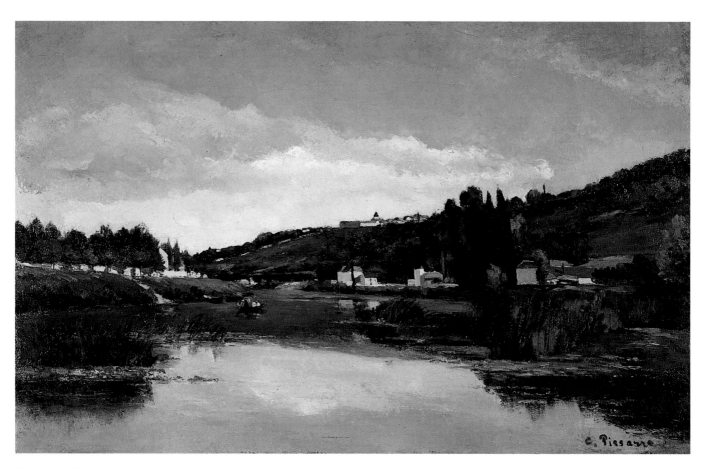

Fig. 43 · Camille Pissarro *The Marne at Chennevières*, c.1864–5
National Gallery of Scotland, Edinburgh

from his small boat. Many of his views show Lavacourt from the north-east, resulting in a series of compositions in which the buildings and their reflections provide two intersecting diagonals which cut across from the right side of the picture. It is tempting to conclude that he must have retained in his visual memory earlier prototypes such as Daubigny's great view of Gloton (fig.42), a hamlet on the Seine opposite the village of Bonnières just a few kilometres downstream from Vétheuil. Monet would have had ample opportunity to view Daubigny's masterpiece because it was exhibited at the 1861 Salon (no.793), where it excited widespread critical comment. Conservatives dismissed it, on account of its perceived lack of finish, as nothing more than a sketch (in fact it measures 82.5 × 146cm). As Gary Tinterow has correctly pointed out, Daubigny's disregard for what one might term the academic niceties of landscape were precisely the qualities in a landscape such as this which would have attracted the young Monet, Renoir and Pissarro.[26] They would have had a further chance to see this masterpiece when it was included in the 1867 Exposition Universelle (no.190). Monet's fellow Impressionist Pissarro's response to Daubigny was relatively immediate in his 1865 Salon submission *The Marne at Chennevières* (fig.43), another great 'diagonal' river scene. Monet's, by contrast, was more slow-burning. He evidently had an ability to absorb various artistic influences and then to return to them at later points in his career. His *Early Mornings on the Seine* of 1896, for example, were by his own admission partly inspired by the example of Camille Corot, in particular that artist's mature, vaporous portrayals of landscape and water as exemplified by his *Souvenir of Mortefontaine* (Musée du Louvre, Paris), acquired by the state at the 1864 Salon.[27]

Although it was certainly less fundamental than that of Daubigny, at Vétheuil the influence of Corot on Monet can also be noted, albeit intermittently. The two variants of *The Steps* (Private Collection, w.493–4) pay passing homage to the farmyard scenes Corot painted in the 1860s and 1870s. In *The Willows* (cat.no.35) of 1880 Monet took a motif frequently depicted by Corot in his later work and gave it similar emphasis in his composition, spreading a row of richly leafed willows across the foreground and giving them a diaphanous effect comparable to that achieved by Corot. The relatively uneventful scenery round Vétheuil is thus validated by its association with the art of the past. By the same token, the almost classical, carefully framed composition of *The Seine at Vétheuil* (fig.44), with its relatively restricted range of colours and tonal approach (what Corot called 'les valeurs'), puts one in mind of Corot's late, decorative landscapes of vertical format and more particularly of his views of nearby Mantes Cathedral from the opposite bank (cat.no.79). On a more general level, the views of Vétheuil seen from the opposite bank through a screen of trees and light vegetation suggest comparison with Corot's numerous views (compositionally related to the Mantes picture) of Ville-d'Avray, site of his family's small country house on the western edge of Paris, viewed from across the small lake there (see cat.no.80). What is telling with regard to Corot is that Monet chose not to portray nearby Mantes, a town very much associated with the older artist, and through which Monet had to travel on his journeys to and from Paris, as it provided the nearest railway station to Vétheuil. Whereas he undoubtedly coloured his whole approach to landscape during this period by dint of a conscious re-examination of his knowledge of the recent old masters, he did not slavishly imitate their subject matter even if it was close to hand. Only Vétheuil and its immediate environs formed the subjects of his canvases, not Mantes, Bonnières or Bennecourt. Monet's style might provoke comparison with other masters but he chose the terrain. Routine trips to Paris aside, when he did travel during the years 1878–83 it was to an entirely different type of scenery, that of the Normandy coast, beginning with a visit to Les Petites-Dalles in September 1880

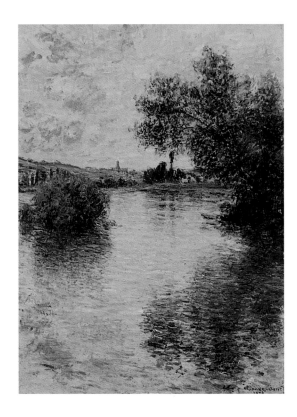

Fig.44 · Claude Monet
The Seine at Vétheuil, 1879
Musée de Beaux-Arts, Rouen (w.537)

Fig.45 · Claude Monet
La Rue Montorgueil à Paris fête de 30 Juin 1878
Musée d'Orsay, Paris (w.469)

suggested by his brother Léon. Over the next few years Monet would radically develop his compositional and observational powers in the dramatic paintings he made of the Norman coastal scenery. Immediately before this, however, he made one attempt to enter the official fold, in the form of the Salon, and was persuaded to hold a one-man retrospective show at the offices of the magazine *La Vie moderne* owned by Renoir's patron and Zola's publisher, Georges Charpentier. Taken together, these two undertakings represent something of a recapitulation in Monet's career before further advances were essayed.

Monet's submissions to the 1880 Salon, a more liberated affair since the critical disaster of 1878, encapsulate the various strands of his art at that date. Of the three large-scale pictures he intended to enter, one, probably *Sunset on the Seine, Winter* (cat.no.26), he judged to be too radical and unsuitable for Salon taste. Semi-abstract in style, it was as insubstantial in structure as his infamous *Impression, Sunrise*, exhibited at the first Impressionist show in 1874. Of the two paintings he did submit, *Les Glaçons* (fig.14), one of his more composed and less radical depictions of the ice-floes on the Seine, was rejected (it would be shown later at the 7th Impressionist exhibition in 1882), whereas *Lavacourt* (cat.no.30) was accepted. A summer scene, but painted in March 1880, it was based on studies made previously out of doors. Monet's own admission that it was '*bourgeois*' is evidence that, in this canvas at least, he was knowingly and deliberately pandering to that section of the market. Although painted in a recognisably Impressionist technique, it is broadly descriptive and carefully balanced in composition and represents a summation of Monet's efforts to date to fit himself in, when required, to the broader currents in French landscape painting.

The one-man show at the gallery of *La Vie moderne*, situated on the boulevard des Italiens, marked a further attempt by Monet to situate himself nearer to the mainstream. Charpentier's magazine supported official art as much as, if not more than, that of the avant-garde. Eighteen works were included in the exhibition. Of the Vétheuil pictures, the most important was *Floating Ice*, recently rejected at the Salon, but eventually bought by Mme Charpentier for her husband. The earliest was *Hut at Sainte-Adresse* (on deposit at the Musée d'Art et d'Histoire, Geneva, w.94) of 1867, while perhaps the most celebrated by present-day standards was *Rue Montorgueil* (fig.45), in which the Parisian street is bedecked in *tricolores* to celebrate the aforementioned Exposition Universelle of that year. In April Monet had been visited at Vétheuil by one of the magazine's regular contributors, Emile Taboureux, for an interview which appeared in the June issue. Its present-day equivalent would be a profile article of a celebrated artist appearing in one of the colour supplements of our Sunday newspapers. Its accuracy should be judged accordingly. Nevertheless, certain important facts about Monet's lifestyle and attitudes clearly emerge from the none-too-exigent text.

Monet's lifestyle was clearly modest. The house was modern and sparsely furnished. He had a number of small boats, moored at 'Port Monet'. He was a capable riverman, clearly used to navigating himself across the Seine. His recent foray to the Salon did not mean he renounced Impressionism (of which he claimed to be the founder), though he rarely saw his fellow artists. He readily paid homage to Manet and Courbet, but no other artists were mentioned. As many later writers have observed, he was eager to promote the myth of being the ultimate *plein-airiste*, gesturing grandly at the landscape and proclaiming it to be his true studio, despite the fact that a number of studies for various compositions survive from this period.

Taboureux admitted that Vétheuil was unknown to him and to most Parisians (a statement that would still hold true today). The attraction of the area to Monet became clear when journalist and interviewee were together on the river:

'Ah, it was above all on the water that I learned how to get to know Monet! Appearing all the while to be ecstatic over a dull little island we were skirting (you know, with willows, cane apples and nettles where grass snakes unfailingly pullulate), I examined my painter.'[28]

What appeared dull to Taboureux encapsulated the attraction of the area round Vétheuil for Monet. 'Dull little islands' feature prominently in many of his Vétheuil works 1878–80, indeed such a phrase could almost be used to describe the central motif in his *Lavacourt* accepted at the 1880 Salon. Willows and apple trees can also be found in relative profusion in many of his paintings of this time. Taboureux's slightly mocking comments unwittingly reveal to his readers that one of Monet's main concerns in this crucial mid-career phase was the unremarkable subject matter of rural land- and riverscape.

A far more distinguished critic than Taboureux, Théodore Duret (1838–1927), was commissioned to write the accompanying essay to the catalogue of the *La Vie moderne* exhibition. Duret had already written important articles on Impressionism, in which he correctly identified major sources in Japanese art and in artists such as Corot and Courbet. In his 1878 brochure *Les Peintres impressionnistes* he had defended the 'absolute sincerity' of the Impressionists, their truth to nature and the ridicule this drew forth from the public. He rightly proclaimed Monet to be 'the painter of water *par excellence*'. Certain aspects of Monet would change, however. In 1878 Duret had written:

Monet is hardly attracted to rural scenes. You will not find any of these in his paintings of untamed fields. You will discover no cows or untamed sheep, and even fewer peasants. The artist is drawn towards ornate depiction of nature and urban scenes. He prefers to paint flowering gardens, parks and groves.[29]

This was the Monet of the Parisian suburbs and satellite towns. At Vétheuil, on the other hand, through choice and necessity, he became very much a rural painter. Admittedly, he virtually dispensed with the traditional landscape staffage of cows, sheep and peasants so beloved of the *école de 1830* and the Salon painters, but he certainly redirected his attention to the essential verities of landscape. Duret, perhaps sensing this re-orientation, began his 1880 essay thus:

After Corot, Claude Monet is the artist who has made the most inventive and original contribution to landscape painting. Were we to classify painters according to their degree of novelty and the unexpected contained in their works, Monet's name would indubitably be included among the masters. However, because the public at large always feels a certain distinctive revulsion when it comes to any new and original work, the very personality that should have sufficed to make him popular has actually been the reason why both public and the majority of critics have so far kept him at arm's length. We maintain, however, that in the future Claude Monet will be ranked alongside Rousseau, Corot and Courbet among landscape painters ...[30]

Whereas the 1878 article had discussed Monet primarily as an Impressionist, the focus has shifted here to locate him in the French landscape tradition without, in any way, denying his originality. The visual evidence offered thus far would reinforce this claim. Monet represented, for Duret, the culmination of an evolution in landscape painting, beginning with Rousseau and developed by Corot and Courbet, whereby preparatory sketches were gradually dispensed with and the artist's impression of the landscape was set down directly on to canvas. As many commentators have subsequently demonstrated, the myth of Monet as a full-blown *plein-airiste* was one very much promoted by the artist himself. In reality, he often had recourse to preparatory studies and his canvases were frequently reworked away from the motif. The appearance of Monet's paintings, on the other hand, was certainly that they were done entirely on the spot. The relative tranquillity of the Seine, however, was about to be comple-mented by the more dramatic and bracing demands of the Channel coast.

THE SEA

Although Monet had painted the Norman coast on many occasions before, his visits from 1880 to 1883 produced a boldness of composi-tion and a reckoning with the more elemental forces of nature which had not hitherto appeared in his work. Of course, there were the occasional 'easy' references to his older contemporaries such as Eugène Boudin, his one-time mentor in the 1860s. The two upright composi-tions of *Boats Lying* at *Low Tide at Fécamp* (Fuji Art Museum,Tokyo, w.644; Private Collection, w.645) treat in a similar manner a subject made popular by Boudin since the 1860s. But such compositions seem throwbacks to an unimportant past when compared to Monet's depictions of the strikingly composed and often vertiginous views from the clifftops, the serried ranks of the breakers of the surf as it rushes towards the shore, or the dramatic coastline at Etretat. While it is not difficult to argue that Monet achieved a striking originality in these coastal scenes, there were two recently deceased masters who can both be cited as major sources of inspiration.

Jean-François Millet (1814–1875) was best known for his great heroic canvases of peasant life such as *The Gleaners* (Musée du Louvre, Paris), which strongly divided conservative and liberal critics when it was shown at the Salon of 1857 (no.1936). Landscape featured consistently in his œuvre throughout his career, but it assumed a more prominent role only in his last decade or so. During these last years he enjoyed a commercial popularity which resulted in Durand-Ruel becoming his principal dealer in the 1870s. To landscape Millet brought an originality of composition that led the critic of the *Pall Mall Gazette*, reviewing Durand-Ruel's London exhibition of 1872, to discern 'a little too much of eccentricity'[31] in a canvas entitled *Normandy Pasture* (Minneapolis Institute of Arts). In his landscapes Millet often radically dramatised and foreshortened the perspective, on occasion directing the viewer almost straight up towards the sky. His unusual approach was particularly evident in his few oils and more numerous pastels of coastal scenes of his native Cotentin peninsula in western Normandy, more particularly of the clifftops near the village of Gréville, seventeen kilometres east of Cherbourg. Striking parallels between some of these compositions and certain ones by Monet suggest a degree of inspiration from Millet's example. Two particular compositional schemata bear this out. Beginning in 1881 (coincidentally the year of publication of Sensier's monograph on Millet)[32] Monet introduced at Fécamp (fig.46) the device of a cliff-top view with the cliff dramatically cut away on either the right or the left with, beyond, an extensive vista of coastline and sea. The downward viewpoint forces the sky into the upper reaches of the composition. Such a formula had already been devised just a few years earlier by Millet in works such as his pastel of *Cliffs at Gréville* of about 1871 (fig.47), albeit on a slightly smaller scale. As Richard Thomson suggests in his essay, Monet developed in his Normandy cliff paintings an approach to the forms of nature which finds its closest parallel in the tradition of the 'sublime', the power of nature to arouse deep emotion in the onlooker. Monet would have been reminded of Millet's example on several occasions in the 1870s. They shared the same dealer in Durand-Ruel, who regularly exhibited Millet's work, most notably in his great 1878 exhibition. Furthermore,

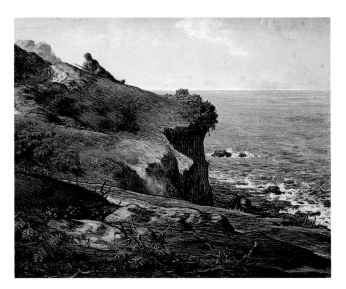

Fig.46 · Claude Monet *Sea Study seen from the Cliffs*, 1881
Private Collection (w.649)

Fig.47 · Jean-François Millet *Cliffs at Gréville*, 1871
Ohara Museum of Art, Kurashiki, Japan

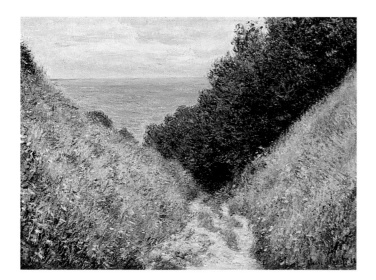

Fig.48 · Claude Monet *Road at La Cavée at Pourville*, 1882
Museum of Fine Arts, Boston, Bequest of Mrs Susan Mason Loring (w.762)

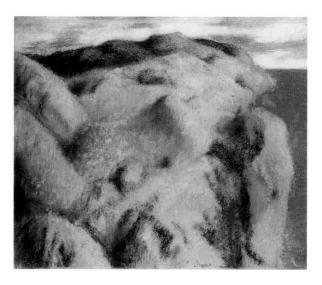

Fig.50 Edgar Degas *Steep Coast*, c.1890–2
Jan Krugier Gallery

Millet's paintings and pastels were eagerly collected during this period, as is proved by the great Emile Gavet sale of 95 pastels by Millet in 1875.

In 1882 Monet developed a fascination with the interlocking forms of the steep slopes either side of paths that wind down from the cliff-top to the shore, for example in *Road at La Cavée at Pourville* (fig.48). Again, one finds that such subjects had already been tackled by Millet in various views of the cliff-tops near Gréville. Both artists pushed themselves to the edge, literally, of where land met sea. Both largely eschewed the more common depiction of human activity on the seashore – tourists, bathers, bustling fishing ports. Instead they deliberately focussed their attention on the elemental forms of nature, the transient effects of weather, and in so doing produced composi-tions which, from a formal point of view, were daringly novel. A lineage can easily be traced for such innovation, beginning with Millet, running through Monet, to Seurat in compositions such as his

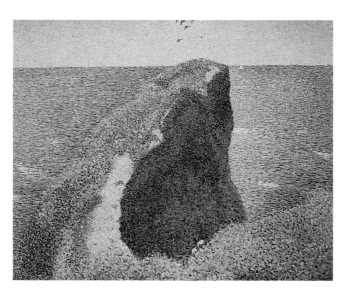

Fig.49 · Georges Seurat *Le Bec du Hoc, Grandcamp*, 1885
Tate, London

Le Bec du Hoc, Grandcamp of 1885 (fig.49) and to Degas's extraordinary metamorphic landscapes (fig.50). The real line of development was not so simple, however.

As many of Monet's contemporaries, notably Théodore Duret, observed, Impressionist painting received a major stimulus from the influx of Japanese art into Europe after the middle of the nineteenth century. The first large-scale display of Japanese art was that organised for the 1867 Exposition Universelle, and an even larger Japanese section featured at the 1878 Exposition. The sharp, cut-away angles of composition and bright, pure colouring of Japanese *ukiyo-e* prints found their echoes in many Impressionist compositions. Monet is known to have begun collecting Japanese prints in the 1860s, and his enthusiasm for them remained undimmed for the rest of his life. Indeed, in 1878, the year of his move to Vétheuil, he was cited in a major exhibition review as one of a number of painters and critics known to have collections of Japanese art.[33] Monet's collection of Japanese prints, the details of the formation of which are un-known, still decorates the walls of his house at Giverny. He would have had ample opportunity to view Japanese art in the premises of the many specialist dealers who sprang up in Paris as well as in the private collections of enthusiastic amateurs, the *japonisants*. Japanese influence in Monet's work can be discerned from the 1860s onwards. The 1878 reviewer, Ernest Chesneau, summed it up at that point as 'the summary suppression of detail for the benefit of the impression of the whole'.[34]

This whole subject was recently examined in considerable detail in the catalogue to the exhibition *Monet and Japan* shown in Australia in 2001.[35] In the period 1878–83 certain canvases stand out for their overt 'Japanese' qualities. The calligraphic quality of *Sunset on the Seine, Winter* (cat.no.26) can be compared to Japanese ink painting. The flattening of space in a number of the Vétheuil landscapes is common to many Japanese compositions, while the framing device of cut-away cliffs occurs, for example, in the landscape prints of Hiroshige. Whether Monet took direct inspiration from the latter in the early 1880s is debatable. He is more likely in this instance, as has

been already suggested, to have been immediately influenced by Millet's example, for here was a recently deceased master who had actually painted the Normandy coast. A considered judgement might be that Japan was a common source to both artists.

Whereas Millet drew his coastal imagery from that of his native western Normandy, Gustave Courbet (1819–1877), the self-proclaimed champion of Realism, was very much associated, when he ventured his bulky yet athletic frame to the seaside, with the more popular tourist area around Deauville and Trouville. Courbet had died in 1877 in exile in Switzerland. His studio sale and an exhibition of his work in the green room of the Théatre de la Gaieté had taken place in 1881. A major retrospective of his work was held in 1882 at the Ecole des Beaux-Arts in Paris. The catalogue carried an introductory essay by Castagnary, in which he noted that a number of Courbet's major works had already been accorded recognition by dint of their acquisition by important museums such as the Louvre and those of Boston, Lille, Nantes, Marseilles and Montpellier. Among the 130 paintings included in the show was the great *Cliffs of Etretat*, previously exhibited at the 1870 Salon, and several of his *Waves*. The latter motif had already been tackled by Monet in a number of canvases of 1881 (cat.no.40), in which his light, decorative palette succeeded in conveying the frothing agitation of the water's surface as it presses in towards the shore. Compositionally, especially in his frontal approach, excluding extraneous detail, Monet is quite close to Courbet's waves of the late 1860s (cat.no.86), examples of which he must surely have known. But his canvases are essentially decorative in effect, more closely related to those found in Japanese art, when compared to the elemental power Courbet achieves in his,

quite literally, darker and heavier workings of this theme.

In early 1882 Monet revisited the fishing port of Etretat, some twenty eight kilometres north-east of Le Havre, to either side of which can be found quite the most dramatic and celebrated cliff formations on the Normandy coast. Over the centuries the combined effects of wind, rain and pounding sea have fashioned three spectacular arches in the striated cliff-face. To the east of the town is the Porte-d'Amont, while to the west lies the Porte-d'Aval and beyond it, and out of sight from Etretat, the most awe-inspiring of the three, the Manneporte. Many artists in the nineteenth century, among them Horace Vernet and Eugène Isabey, had depicted the most popular view, that of the Porte-d'Aval taken from the beach at Etretat. Monet even owned a watercolour of Etretat by Delacroix, though it is not known when he acquired it (fig.51).[36] None had surpassed in power and grandeur of composition the series of views begun by Courbet in 1869 (cat.no.88). From his early years in his native Franche-Comté Courbet had shown a consistent interest in portraying the great rock formations which can be found in extraordinary natural landscapes. The highly dramatic cliffs around Etretat can be seen as a logical continuation of this particular passion.

Monet was well aware of the artistic traditions of Etretat. In January 1883 he booked into the Hôtel Blanquet on the western end of the beach there. Its sign described it as 'The Artists' Rendezvous'. The time of year Monet chose was surely significant, however. This was not the summer tourist season. Bleak and unadorned, the magisterial coastline was battered by the elements and subject to ever-changing light effects. By his choice Monet revealed himself yet again as an artist intent on coming to grips with the myriad variety of

Fig.51 · Eugène Delacroix *Cliffs of Etretat*, 1838
Musée Marmottan, Paris

nature. During his first few days there he planned two large pictures for an intended one-man show at Durand-Ruel's. One would be of boats, the other, as he admitted in a letter to Alice, of the Porte-d'Aval 'after Courbet who had done it admirably'.[37] Here then was an open acknowledgement by Monet of an earlier artist's importance and one for which there is documentary proof. As has been mentioned, Courbet's critical stock had risen rapidly after his death and many of his greatest masterpieces had been acquired for major museums. In a number of canvases Monet treated a view similar to the one which had fascinated Courbet. But he soon became bolder than his illustrious predecessor ('I will try to do it differently')[38] and ventured to more perilous spots, braving the vicissitudes of the tides, where he could discover ever more spectacular views of the coastline. The culmination of all this activity is surely the great view of *The Manneporte, Etretat* (cat.no.74). The late afternoon sun seeks out the underside of the great arch as the waves break and spume over the rocky shoreline. Whereas the foreground is cast in the shadow of the failing light, the cold sea beyond is brilliantly lit and the tiny forms of two sailing boats, keeled hard over in the strong onshore wind, punctuate the horizon. Just a short distance to their left the whole scale of things is revealed by two human figures, shown in silhouette, looking out to sea. They are indicated by nothing more than a few small dabs of paint but their presence unlocks the key to the whole meaning of the picture, to the thrill and awe felt by man when confronted by the immensity of natural forces.

The Etretat paintings undoubtedly constitute one of the most significant episodes in Monet's career. They also illustrate perfectly the importance to him of recent artistic tradition and his ability to transcend such influences and push beyond them. In the period 1878–83 Monet frequently looked back to the immediate past and developed an increasing awareness of his place in the French landscape tradition. This was partly prompted by commercial reasons and a desire to satisfy existing taste in landscape. It also acted as a launching pad for the rest of his career. 'Modern life' would no longer play a role of any significance. Light, colour, time and motif were the essential elements of landscape which would preoccupy Monet henceforth, in series such as those of poplars, haystacks, and the façade of Rouen Cathedral. On the domestic front, after an unsatisfactory two-year interlude during which the combined Monet and Hoschedé families were based nearer to Paris at Poissy, 1881–3, he was drawn back to the area around Vernon, not so far from Vétheuil, informing Durand-Ruel, 'I like the countryside round here very much'.[39] His choice fell finally on Giverny, the move aided in part by the 5000 francs he had received in April from Durand-Ruel. Monet was earning significant sums of money by this date and his cause had been taken up again by Durand-Ruel, somewhat in contradiction to the endlessly plaintive tone of Monet's numerous letters of the time.

Even smaller than Vétheuil (its population numbered 279), Giverny would be home for the remainder of Monet's long life and become the location with which his name is irrevocably associated. Understandably, its importance has tended to overshadow the advances made by Monet in the years immediately preceding this move. That crucial period enabled Monet to take stock, to measure himself against the achievements of his immediate predecessors, and then to strike ahead in a long career in which he, too, would eventually come to be revered as a modern 'old master'.

CATALOGUE

< Detail from cat.no.35

1. *The Church at Vétheuil*, 1878

Oil on canvas · 65.2 × 55.7cm
National Gallery of Scotland, Edinburgh
W.474

Painted soon after Monet settled in Vétheuil in 1878, this painting was sold in December of that year through the mediation of the homeopathic doctor and collector Dr Georges de Bellio. It was exhibited in the 4th Impressionist exhibition in 1879 (no.156). Another, landscape-format, view of the church (Private Collection, USA, w.473) was painted around the same time by Monet, but from slightly further back. These were the only close-up depictions of the church made by Monet during his three years at Vétheuil, his other paintings of it being taken mainly, but not exclusively, from the river with the church in the background.

The abbey church of Notre-Dame at Vétheuil dates from the twelfth century and its west front was remodelled in the sixteenth. As it was undoubtedly the most notable building in the whole town, it is understandable that it should form the subject of some of Monet's earliest Vétheuil paintings. They could therefore be read as symbols of Monet's identification with his new surroundings.

Monet had not tackled the motif of a church façade since his 1867 view of the Parisian church of St-Germain-l'Auxerrois (w.84). He would not return to it again (and then in much more concentrated fashion) until the great series of Rouen Cathedral of 1892–3. The Edinburgh canvas is in fact as much a study of weather and light as it is one of architecture. Of particular interest to Monet was the optical effect of dull weather and grey stone against a leaden sky. This is loosely depicted in a mixture of grey-blue and white on unprimed canvas with many of the main features delineated in purple. There is a picturesque, tumble-down, rural feel to the composition – a quality enhanced by the agricultural equipment in the right foreground. A peasant woman makes her way along the unmade road leading up to the church, while two male figures stop to converse in front of the building to the right. Monet's more compelling visual interests, however, lay in the river scenery around Vétheuil, and it was this which would hold his attention in a series of canvases painted in the autumn that year. MC

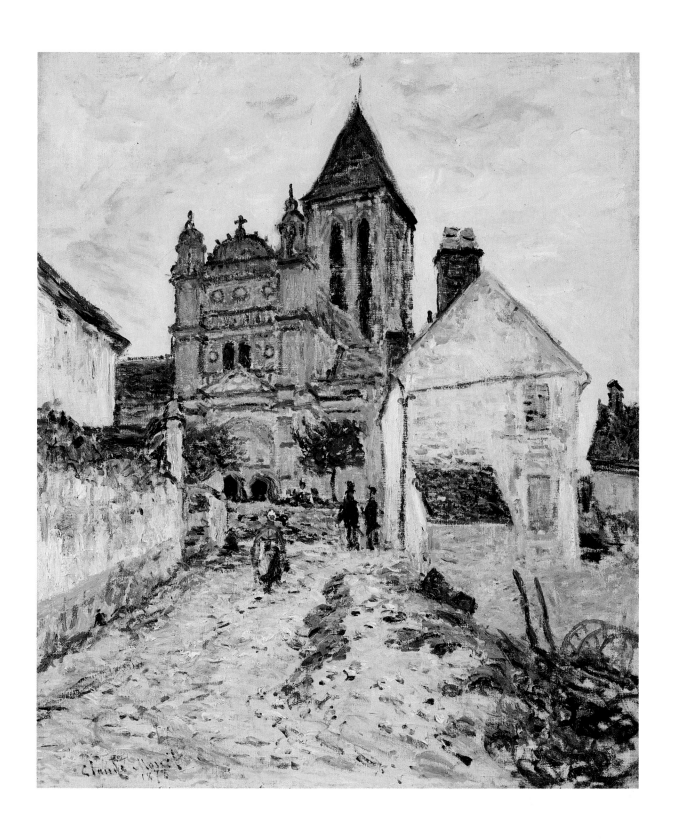

2. *Branch of the Seine near Vétheuil*, 1878

Oil on canvas · 60 × 80cm
Private Collection
W.482

On his arrival at Vétheuil in the late summer of 1878 Monet immediately began exploring the reaches of the river in the vicinity of his new home. Using his studio-boat, he ventured downstream, painting ten canvases in the waterways around the islands of Moisson and Mousseaux, slender spits of land that divide the Seine as it curves to the north-west. Half a dozen of these feature a consistently symmetrical composition.[1] Although not of exactly the same site, they all pitch the horizon of the waterline slightly less than halfway up the canvas, balancing each bank with bushes and tall poplars. The foreground is filled with the flat plane of tranquil water, its rippled surface reflecting the play of light from the different skies above.

Branch of the Seine near Vétheuil is the largest and most resolved of these six canvases. It represents a cloudy day, the cumulus banked up in the sky. Monet seems to have worked quickly, using a limited range of blue and green tones to convey the deepening tones of late summer foliage beneath a changeable sky. The river is represented as a place of calm, untroubled by any human presence. This idyllic view is achieved as much by the steady composition of masses held in equilibrium as by the description of the scene. Such a formula had been pioneered by Daubigny, who since mid-century had made a substantial reputation with peaceful, poised riverscapes (fig.52). Monet would have been well aware of this precedent, which some of his very first paintings, as well as ones made earlier in the 1870s at Argenteuil, had echoed.[2] This is not to say that he merely emulated Daubigny. Monet's handling was broader and freer, his colour more high-key. But both men were drawn to similar motifs, and – given that the older painter had died in February 1878 – it was in order that Monet, whom Daubigny had encouraged as a young artist, should pay his respects on canvas. Indeed, phrasing an established formula in his own way paid off. *Branch of the Seine near Vétheuil* was apparently sold in October 1878, very shortly after it had been painted. RT

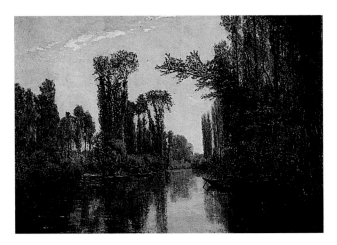

Fig.52 · Charles Daubigny *L'Ile d'Amour, c.*1852
Centraal Museum, Utrecht

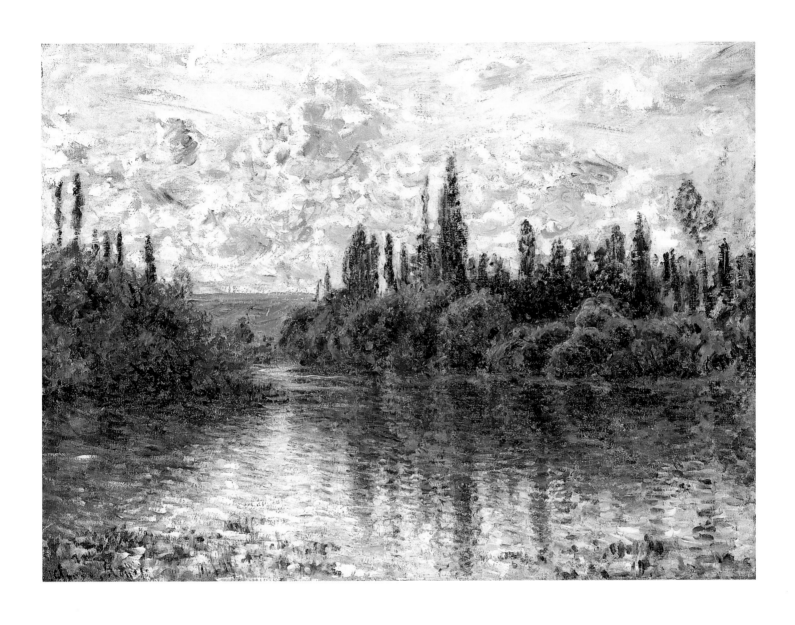

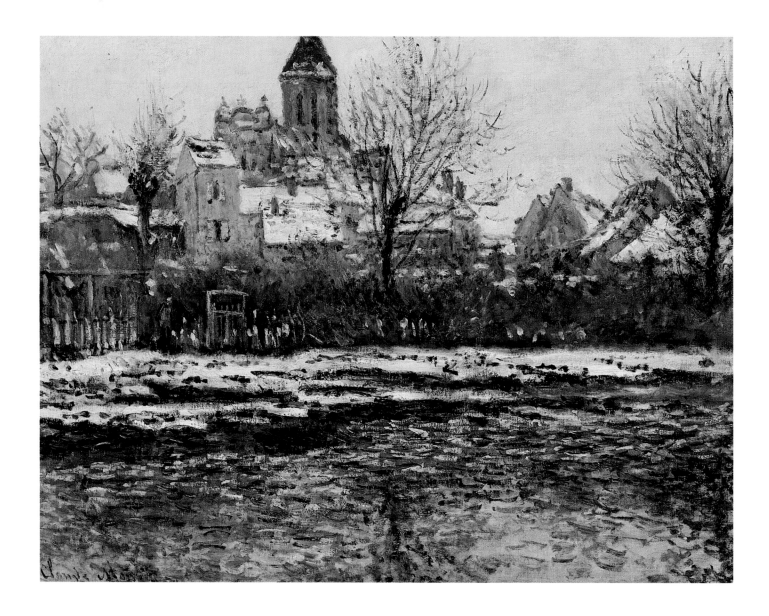

3. *The Church at Vétheuil, 1879*

Oil on canvas · 53 × 71cm
Musée d'Orsay, Paris,
Bequest of Gustave Caillebotte, 1894
W.506

4. *Vétheuil in Winter*, 1879

Oil on canvas · 69 × 90cm
The Frick Collection, New York
W.507

These two canvases were executed towards the end of the winter of 1878–9, when there was snowfall and temperatures were low, but not to the extraordinary degree of the following winter. *The Church at Vétheuil* was painted from Monet's studio-boat moored in the Seine. He organised the motif into what might be described as zones and barriers. First comes the flat water, thinly painted over the pale cream ground. Next are the ripples, more worked, and becoming pale grey and deep blue towards the bank. The bank itself is made up from long horizontal strokes of white laid over smudged browns and greys. This open space is then blocked by the fence and leafless hedge, again in blotted grey-browns. Behind this the pattern of roofs opens up space, the snow-covered slates and dove-brown walls creating both blocks and vistas, distant space denied by the thinly scrubbed cold sky. Economical as the handling of paint necessarily was in these cold conditions, Monet crafted a measured composition, with the carefully spaced trees providing an exquisite counterpoint to the off-centre focus of Notre-Dame. *The Church at Vétheuil* effectively captures the mistiness and muddiness of a winter's day. Monet made no attempt to idealise the conditions. As a naturalist artist, whatever nature put before him was worthy of rendering, though – as we have seen with the trees – his picture-making instincts insisted he ordered his colour and composition to make a harmonious ensemble. The painting was bought by Gustave Caillebotte, who lent it to the 4th Impressionist exhibition, which opened on 10 April 1879.[1]

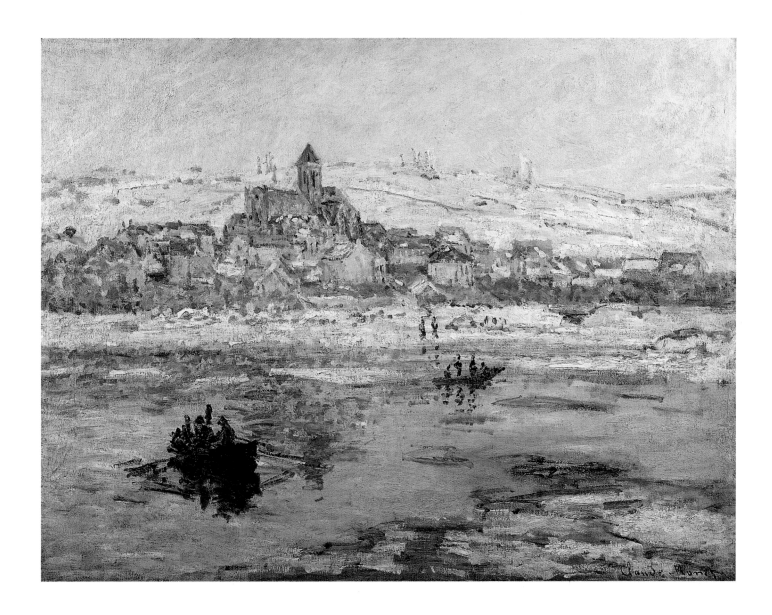

Vétheuil in Winter was not painted from the studio-boat but from the Lavacourt bank. This position gave Monet a higher viewpoint, incorporating more of the snow-covered village. The Vétheuil bank is set halfway up the canvas, but, while the canvas is equally divided on the horizontal axis between river and landscape, in the vertical sense it is weighted more to the left, where the dominant bulk of the church rises off-centre. Monet adeptly balanced this by the wedge of snow and ice that intrudes from the foreground right and by the line of dark marks that run on an implicit diagonal from lower left to centre right – the ferry-boat, the other craft in mid-stream, and the little bridge where the tributary joins the Seine. Monet applied the paint thickly and rapidly in the freezing conditions, leaving almost an eddy of dabs in the foreground. In the central band Monet allowed the grey primed canvas to remain bare, while he scumbled the sky in dense blue and grey. Although the predominant tones are such wintry colours the surface is animated by unexpected touches of aubergine and mint green.

As in other early paintings of Vétheuil (cat.nos.12 and 13), Monet discreetly made the figures play appropriate parts. In *Vétheuil in Winter* some ten figures can be made out. Monet intended the ferry-boat from the outset, as the paint surface reveals. In the bow a blue-jerseyed man is at the oars, and one of Monet's final touches was to add a circle of black, with a dash of the grey-violet he had used for the surface of the river, to give him a hat and face, turned to us as he feathers his oars for arrival at the Lavacourt bank. RT

5. The Road into Vétheuil, Winter, 1879

Oil on canvas · 60 × 81cm
Museum of Fine Arts, Boston,
Gift of Julia C. Prendergast in memory of her
brother, James Maurice Prendergast
W.509

6. Entrance to Vétheuil, Winter, 1879

Oil on canvas · 52.5 × 71.5cm
Konstmuseum, Göteborg
W.510

7. Lavacourt, Sun and Snow, 1879

Oil on canvas · 59.5 × 81cm
The National Gallery, London
W.511

On his arrival at Vétheuil Monet at first painted the medieval church (cat.no.1) and then, in the late summer and autumn, concentrated on the countryside immediately surrounding the village. As winter approached, however, he withdrew nearer the community, painting the view from the road to La Roche-Guyon looking back into Vétheuil in a series of three canvases (w.508–10) which are dimly illuminated by the failing seasonal light. The winter of 1878–9 proved severe and all three pictures show Vétheuil under snow. In the distance rises the Chênay hill at the edge of the Arthies plateau, while the house that Monet rented from the widow Elliott is the last in the row visible on the left. It is overlooked by the towers of the widow's own residence, 'Les Tourelles'. To the right, beyond the views shown here, lay the Seine. Monet had portrayed winter scenes fairly consistently throughout his career to date, at Honfleur, Bougival and, most notably, at Argenteuil in the winter of 1874–5. The melancholy air of these Vétheuil views may well reflect his troubled state of mind, beset as he was by financial worries and deep concern for the failing health of his wife Camille.

The other motif on which he concentrated during this winter was the little village of Lavacourt, which lay opposite Vétheuil on the far bank of the Seine. In the glowing and deceptively simple canvas exhibited here the time of day must be relatively early morning, as the sun is rising in the east and beginning to light up the sky over the houses on the right. The richness of colour that Monet is able to observe on the snow anticipates similar effects he would achieve in the early 1890s in his winter depictions of haystacks. MC

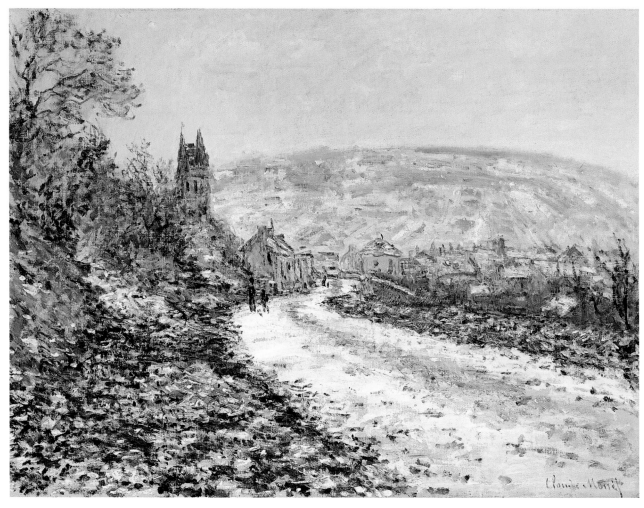

5

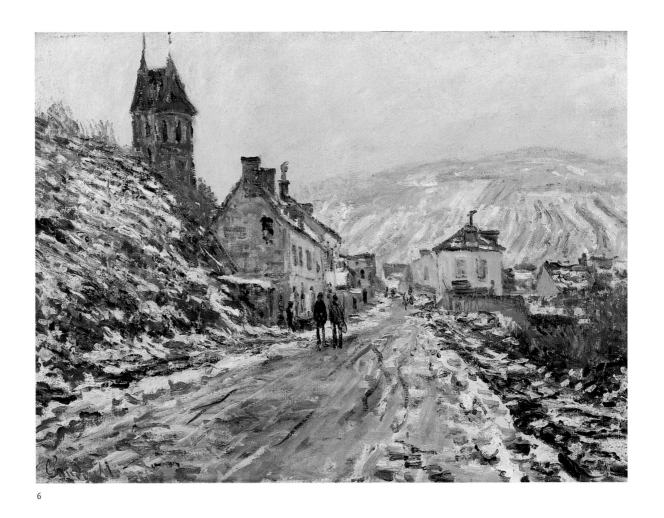

6

7

8. Banks of the Seine at Lavacourt, 1878

Oil on canvas · 65 × 80cm
Galerie Neue Meister, Staatliche
Kunstsammlungen, Dresden
W.495

9. The Riverbank at Lavacourt, Snow, 1879

Oil on canvas · 55 × 74cm
Private Collection
W.513

10. The Seine at Lavacourt, 1879

Oil on canvas · 54 × 65cm
Portland Art Museum, Oregon,
Bequest of C. F. Adams
W.517

Banks of the Seine at Lavacourt is one of a group (w.495–9) of views Monet painted looking downstream from the bank of the Lavacourt side of the river. The riverside view was a compositional type he had perfected earlier in his career in his depictions of the riverbanks at Bougival and Argenteuil. His fellow Impressionists Pissarro and Sisley had also essayed many similar compositions. Despite the fact that the Seine was a busy river with a great variety of commercial and leisure craft passing through, this is one of the few Vétheuil pictures in which any rivercraft are depicted. In the majority of his portrayals of the Seine at this time Monet was at pains to preserve the fiction of a rural idyll, untouched by the intrusions of modern life.

River scenery had been popularised by the generation of artists and printmakers immediately preceding Monet, in particular by Charles Daubigny. Indeed, Daubigny had moored his studio-boat at Vétheuil during one of his painting campaigns in the area. Whereas for the Romantic artists of the early nineteenth century water was an elemental, dramatic force, for the painters of mid-century and later it was a symbol of regeneration and relaxation. Monet's paintings of the Seine around this time paid more than passing homage to this tradition, and deliberately so, for such reassuring imagery was more likely to find buyers in the bourgeois market of the time.

Monet continued the group of canvases he had painted on the Lavacourt bank in late 1878 with another group, made in early 1879. This cluster (w.511–17) of seven canvases charts the changing weather conditions. It began with paintings of winter snow, such as *Lavacourt, Sun and Snow* (cat.no.7), and continued with views looking upstream along the river swollen with floodwater. *The Riverbank at Lavacourt, Snow* represents the locale while the snow was thawing along the muddy waterline. Such conditions are not usually appealing, but this painting demonstrates the democratic willingness of the *plein-air* painter to treat nature in all her moods. Monet made the most of the conditions. The patches of snow on the path and shore created a friable pattern of contrasting tones, the sullied whites of the snow offset by the warm browns beneath. The background landscape of the poplars along the distant Vétheuil riverbank made a similar but more subdued contrast of blues and blue-greys. These two medleys of colour were set within the quite austerely structured spatial composition that Monet found within the motif. The perspective of the path, together with the tumbling diagonal of the buildings on the left and the wedge of water to the right, forms a firm armature within which are held the more irregular elements – leafless trees, strolling citizens, and patches of melting snow. Under a cold sky and from apparently unpromising material, Monet could conjure both a remarkably accurate rendition of the climatic conditions and a tightly composed canvas.

The Seine at Lavacourt was painted slightly later. The snow had melted, and the Seine was high with meltwater. Monet must have executed this painting from his studio-boat, moored a few metres from the Lavacourt bank. He was facing roughly south-wards, though from a different vantage-point than that of the London picture. The composition is relatively simple. The stark trees make an irregular vertical column just off-centre. To the right is the staccato orthogonal of buildings which typify many of Monet's Lavacourt motifs, while to the left is the far ridge behind St-Martin-la-Garenne. Monet painted rapidly in conditions no doubt damp and cold. The brushstrokes that block in the clouds, for instance, seem to have been applied with brio and approxima-tion. Monet's medley of blues, greys and greens admirably evoke moisture and chill, for his motif once more was an unprepossessing one – a quiet riverside hamlet, a river at high-water, and (for Monet) a rare glimpse of a passing tug-boat. MC / RT

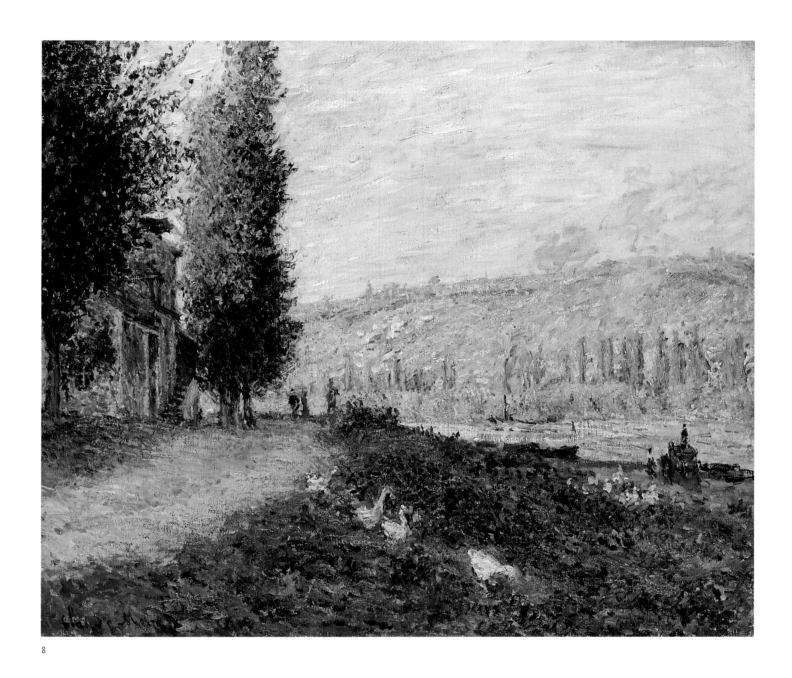

8

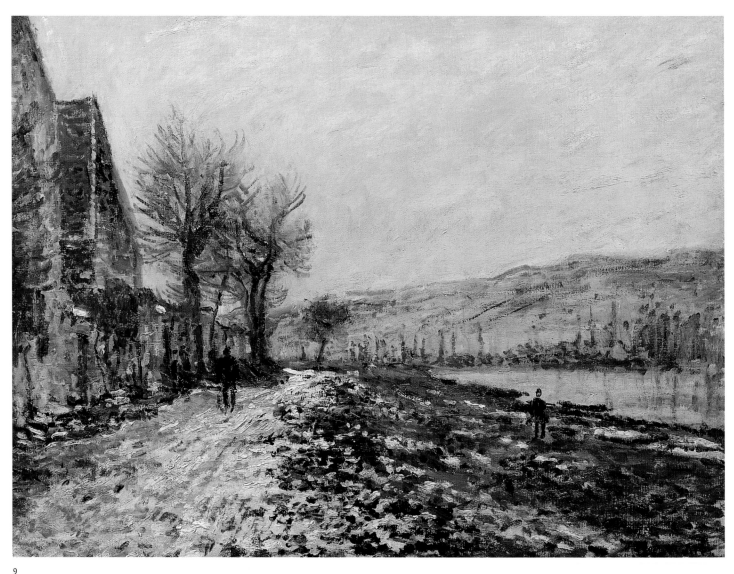

9

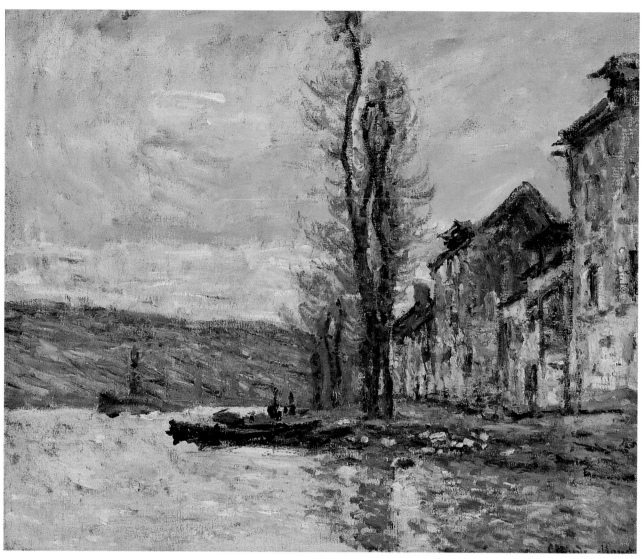

10

11. *Plum Trees in Blossom, Vétheuil*, 1879

Oil on canvas · 64.5 × 81cm
Szépművészeti Múzeum, Budapest
w.520

During the spring of 1879 Monet painted seven canvases of the fruit trees in blossom (w.519–24). The group is quite varied in approach, and gives a sense of Monet's ability to find different solutions for painting the same simple material. Two canvases, for example, concentrate on a single blossoming tree, centrally placed, its branches reaching out almost to fill the picture space (w.523–4). These are reminiscent of the 'portraits' of oak trees that Théodore Rousseau had painted in mid-century and which Monet would have certainly known. Another canvas represents a path between the trees in a fenced-off orchard, at the end of which stands the proprietor (w.521a). Several of the long branches are propped up with forked poles, in expectation of the heavy crop of fruit that the blossom foretells. This painting amounts to an account of an aspect of the agricultural economy of the Vétheuil community, and as such is unusual in Monet's output.

Three other paintings take a more audacious painterly stance. They all take a similar view, looking across a brief open foreground directly into the dense orchard itself, with the village's roofs and the Chênay ridge to the south of Vétheuil rising behind (w.519–21). Such a motif fills the entire central space with a bank of blossom, entirely breaking with the lucid unfolding of pictorial space which was standard practice in landscape painting. *Plum Trees in Blossom, Vétheuil* seems to have been painted very rapidly. It has little layering of different paint marks. In the sky, for instance, the blues and whites are juxtaposed in an uncomplicated manner. Monet developed a motif very close to this to a more intense level of finish in a painting on a canvas of the next size up, a *toile de 30* rather than a *toile de 25* (w.521). These paintings give a vibrant sense of a spring day, the blossoming fruit trees making their presence emphatically – if temporarily – felt. They articulate the landscape painter's thrill at seeing burgeoning nature push human presence to the margins. RT

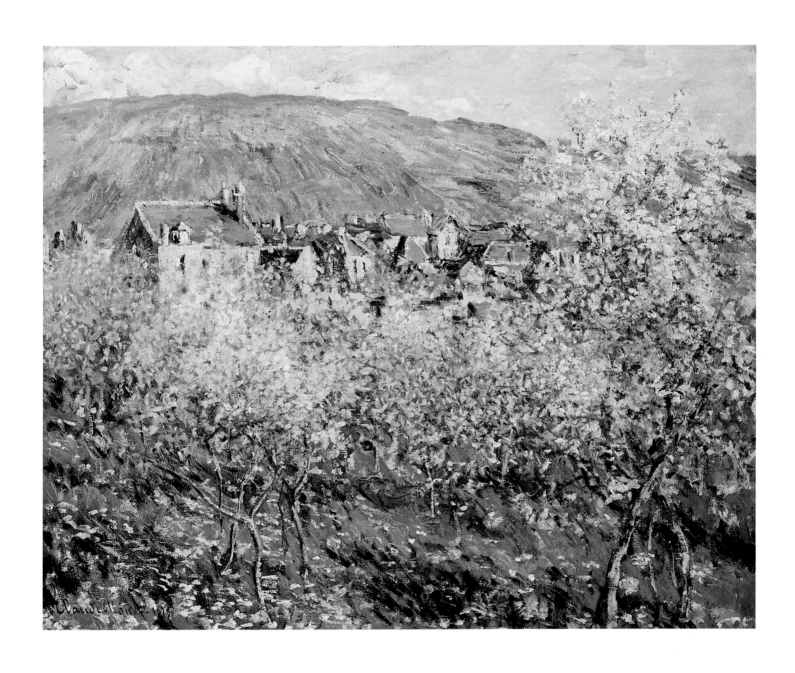

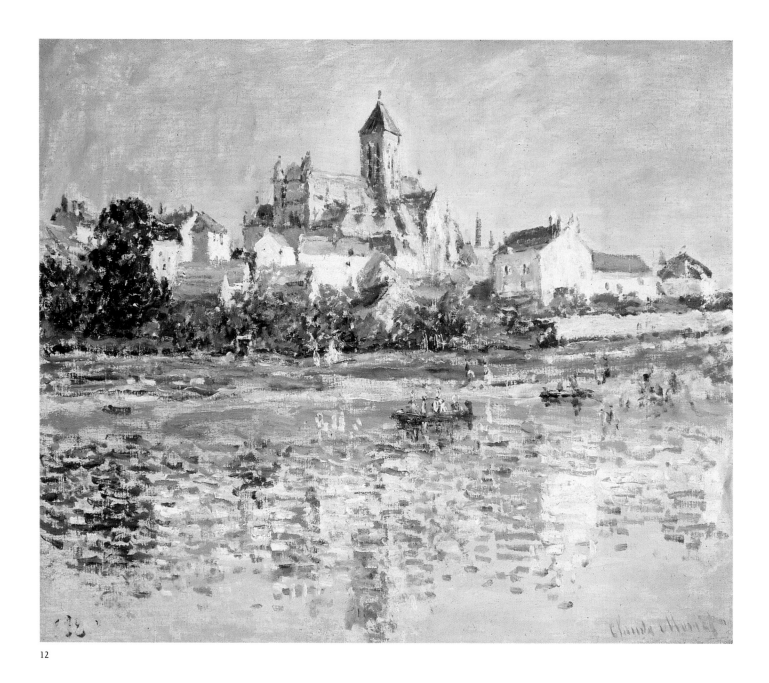

12

12. *The Church at Vétheuil,* 1879

Oil on canvas · 51 × 61cm
Southampton City Art Gallery
W.531

13. *Vétheuil,* 1879

Oil on canvas · 65 × 92cm
Triton Foundation, The Netherlands
W.527

Painted during Monet's first full summer at Vétheuil, these two canvases represent ways in which Monet integrated the village motif into his vision of landscape painting. Both take on motifs that had precedents in earlier nineteenth-century French landscape. Daubigny, for one, had treated both the view of a village nestled into hills along the banks of a river and seen across the water (cat.no.81). But Monet's solutions were his own, personalised both by a more approximate touch adapted to catch the vagaries of natural light and also by his more high-key palette.

The view of Vétheuil from the south was taken from the riverbank just off the road to Les Noues, less than two kilometres away. A less elongated variant of the same motif may have served as a preliminary investigation of the motif (fig.78). In the more widely embracing version Monet used a large and open touch, producing an expansive effect that tallies well with the harmonious treatment of colour. The buildings and the ridge behind, and to a certain extent the clouds, are handled in a pale warm pink tone, balanced by an equally concordant pale blue-grey which features in the clouds, roofs and walls. In the foreground a medley of greens deepen closer to the surface, so the

shadows cast by the early morning sun sit on the top of previous paint layers. The amplitude of this relatively economical system of painting serves in pictorial terms to couch the village in the fabric of the painted landscape just as the buildings themselves lodge comfortably in the physical environment.

Like the view of the whole village from upstream, the more focused motif of Vétheuil seen across the water and centring on the church emphasises the organic unity between natural environment and man-made structures. This fusion is, one might say, symbolised by the reflections of the village in the water. In both cases Monet made much of this, the mirroring of the same tones in more shaped or disparate touches serving as his pictorial acknowledgement of the reassuring notion of the village as existing in harmony with surrounding nature. The view across the river was perhaps painted later in the summer of 1879, as the leaves appear to be turning. It was made from the studio-boat moored in mid-stream, the better to catch the reflections which echo the blanched brown tones of the buildings, if not their angled forms, on the surface of the Seine. Both canvases discreetly give a sense of Vétheuil as an active community. In the view from across the water quite a number of figures are telegraphically but legibly marked in boats and on the bank, while in the view from upstream cows graze under the trees by the water's edge. RT

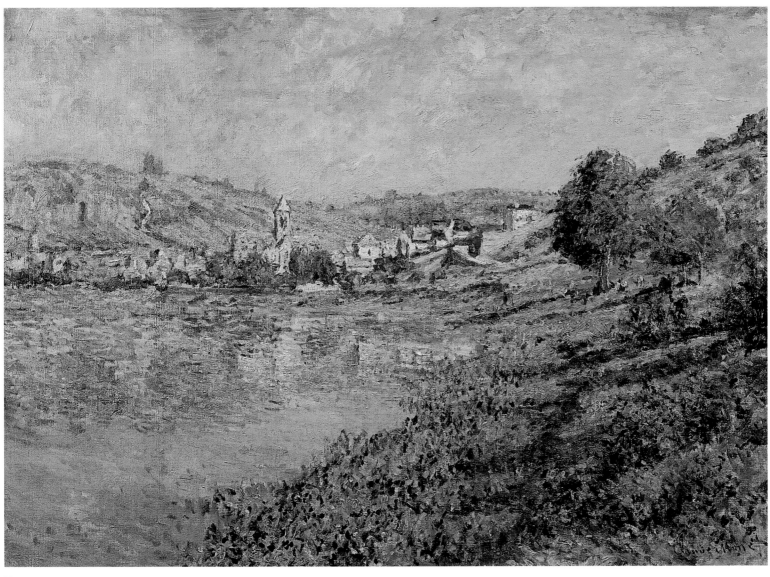

13

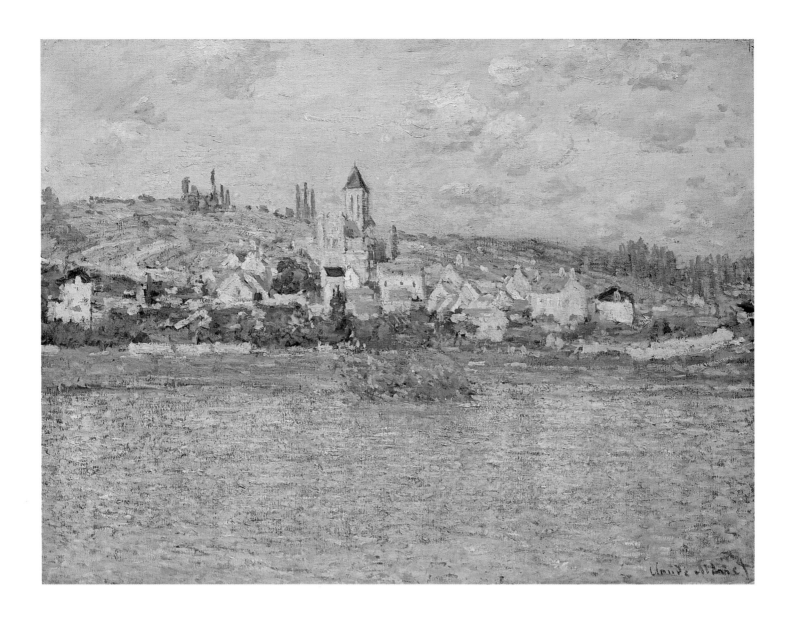

14. Vétheuil, 1879

Oil on canvas · 60 × 81cm
National Gallery of Victoria, Melbourne,
Australia, Felton Bequest, 1937
w.533

15. Vétheuil in Summer, 1879

Oil on canvas · 68 × 90cm
Art Gallery of Ontario, Toronto
w.534

Monet painted these two views of Vétheuil in the summer of 1879 looking across from the Lavacourt side. He has often been praised as the painter of water *par excellence* and his subtle way with reflections is in evidence here. Indeed, handling of the water occupies the whole of the lower half of the composition on which the semi-abstract shapes of the town shimmer in iridescent colours, which, to Impressionism's critics, would give further weight to the accusation that such a technique amounted to nothing more than forms and colours seen through the distorting effects of a prism. There is an essential truth to Monet's observations, however. Our perceptions of Monet's light and colour instigate a sensory recognition of the essence of a particular scene and its accompanying effects. The feeling of atmosphere is such that we can almost feel the heat of the summer sun as it plays upon the buildings of Vétheuil and creates a molten mixture of red, orange and pink.

With the Melbourne picture, a similar study of reflection, Monet pitched the horizontal of the riverbank at a lower level than in the Toronto painting, allowing a greater expanse of sky. However, despite this, the overall effect of the Melbourne canvas is steadier and more solid. The water does not give off such multiple, fragmented reflections, and the buildings of the village have a robust architectural quality under a breezy summer sky. Both canvases show Monet representing a unified and organic image of the typical French riverside village, which he elaborated with his personal,

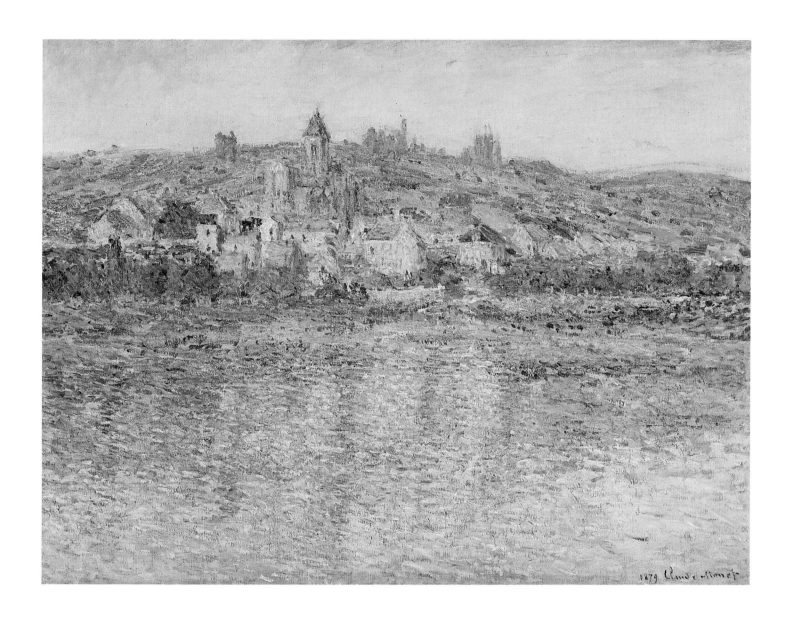

experimental handling. Such paintings did sell, albeit around 1880 only for low prices. The Melbourne canvas seems to have been purchased by the dealer Dubourg in October 1880 and then sold on to Durand-Ruel on 9 January 1882. The Toronto picture was among the canvases that Monet sold in groups to Dr de Bellio in 1879 and 1880. However, Monet's financial fortunes were gradually improving. Having sold a still life (w.545) to the important dealer Georges Petit in late December 1879 for 500 francs, Monet had been given the sound market advice no longer to release work to old supporters at advantageous rates below what he could command on the open market, as he had been forced to do in recent years. On 8 January 1880 Monet wrote to De Bellio informing him that he could no longer sell him works so cheaply. 'The other day I could not refuse to sell you that *View of Vétheuil* [the Toronto painting] for 150 francs and I don't regret it, even though I've suffered myself to see the best and most important of my canvases sell at such a low price.'[1] MC / RT

16. *Poppy Field near Vétheuil,* 1879

Oil on canvas · 70 × 90cm
Foundation E.G. Bührle, Zurich
w.536

Despite the trauma of his wife Camille's long and painful final illness, culminating in her death probably from uterine cancer in September 1879, Monet continued to paint extensively out of doors in the spring and summer of that year. This radiant view is taken from the bank at Lavacourt looking across the Seine to Vétheuil with the woods on the Ile de Moisson to the left. In its subject matter – a field of poppies – it is reminiscent of the famous *Poppies at Argenteuil* (fig.53) of 1873, painted at a time of prosperity and personal happiness for the Monet family. The ambiguity of the Vétheuil canvas becomes apparent, however, when it is realised the adult female figure is in all probability Alice Hoschedé who is depicted with both the Monet and the Hoschedé children. In visual terms, at least, she has now replaced the dying Camille. The following year a scurrilous article in *Le Gaulois* would appear, in which a mock lament for Monet's withdrawal from the Impressionist exhibitions in favour of the official Salon would be coupled with a sly reference to the artist 'who divides his time between his art and his family: a charming wife and two pretty babies of seven and eight years old'. Alice would not become his wife until 1892 but the clear – and probably unjust – imputation is that Monet and Alice were already living connubially. MC

Fig.53 · Claude Monet *Poppies at Argenteuil*, 1873
Musée d'Orsay, Paris (w.274)

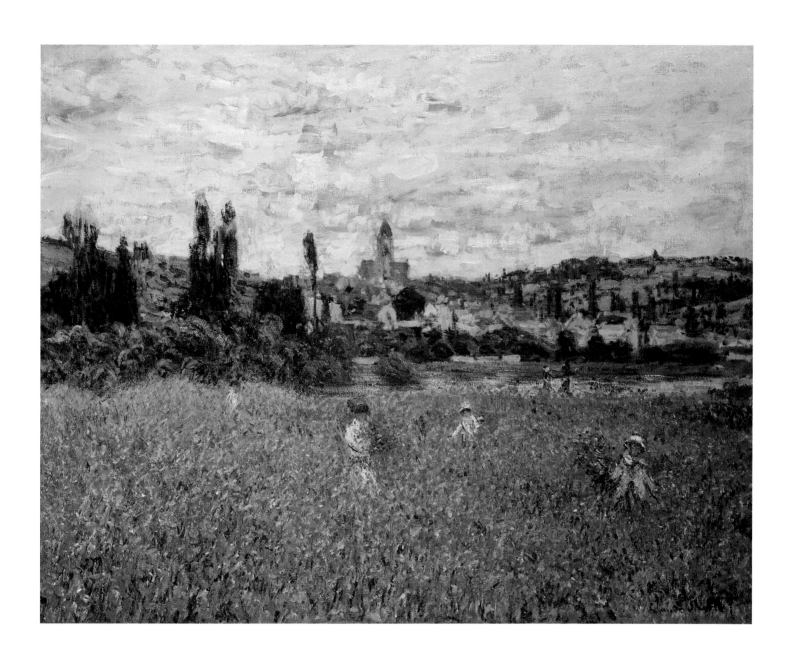

17. *Camille Monet on her Deathbed*, 1879

Oil on canvas · 90 × 68cm
Musée d'Orsay, Paris
Gift of Mme Katia Granoff, 1963
w.543

Fig.54 · Claude Monet *Camille Monet Embroidering*, 1875
Barnes Foundation, Merion, Philadelphia (w.366)

Camille-Léonie Monet (née Doncieux) was born in Lyons on 16 January 1847 and died at Vétheuil at 11 a.m. on 5 September 1879, aged thirty-two. The precise cause of her death is not known, but it would seem to have been due to gynaecological problems, perhaps uterine cancer. She had never fully regained her health after the birth of her second son, Michel, in March 1878. Her death certificate was signed by the mayor of Vétheuil, Louis-François Pinet, by a mason, Denis-Aimé-Marie Paillet, and a clockmaker, Louis-Joseph Havare, listed as friends of the deceased. On 31 August Camille and Claude had been married by the village *curé*, M. Amaury – a religious ceremony *in extremis* in addition to their civil marriage of 1870. The *curé* buried Camille in a ceremony at the Vétheuil cemetery on 7 September.[1]

Monet's deathbed portrait of his wife was thus painted within this two-day period between her death and interment. Such memorial images were common in the nineteenth century, though few – and often the most moving – were made by those closest to the deceased.[2] Although Camille's death had been expected, Monet must have been deeply moved. He chose a canvas large enough to paint her life-size, head and shoulders propped up on the pillows, jaw bound, and hands clasping a wooden cross on her chest. Necessarily, Monet worked quickly. His palette was simple. Deep grey-violet was used to map in the shadows around the body and, with the addition of some russet, the corpse itself. The head was thinly worked in the same violet, slightly lightened and tinted with pink. The result is not a typical deathbed portrait, in that the face is neither idealised nor closely described, but rather veiled by the play of brushwork.

Understandably, Monet kept the painting in his possession for the rest of his life. It first came to public attention in his friend Georges Clemenceau's book on the artist published two years after Monet's death.[3] In Clemenceau's account, Monet confessed to having become so accustomed to considering nuances of colour that as he painted his dead wife his painterly instincts 'mechanically', and by implication heartlessly, took over from his emotions. This statement is too often taken at face value. Perhaps, with the passage of time, Monet had become too hard on himself. Concentration on pictorial matters might have provided a welcome distraction from his grief. On the other hand, this painting did not involve the complex play of colour and reflection that he, or Clemenceau, later claimed. Rather, one might usefully compare *Camille Monet on her Deathbed* with an earlier portrait, made in 1875 (fig.54). This elaborate portrait of Camille embroidering in a comfortable interior fits contemporary notions of the woman's role – domestic, fecund, tranquil. Above all, it is a harmonious painting, with Camille enclosed by the protective symmetry of arching curtains and surrounding foliage. By contrast, the deathbed portrait is almost angrily brushed, cold in tone, with the figure pushed askew into the upper corner. Its instability bespeaks not painterly precision but emotional turmoil scarcely controlled. Indeed, without wishing to offer an over-sentimental interpretation, one wonders whether its tremulous and blurred imprecision suggests that Monet, with intense honesty of experience, painted it through a veil of tears. RT

 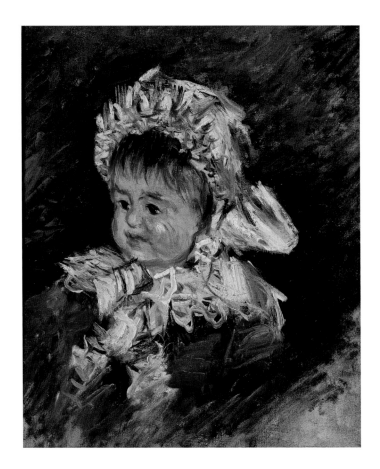

18. Jean Monet, 1880

Oil on canvas · 46 × 37cm
Musée Marmottan, Paris
w.632

19. Michel Monet as a Baby, 1878 or 1879

Oil on canvas · 46 × 37cm
Musée Marmottan, Paris
w.504

These two portraits of Monet's sons were painted each side of their mother's death. The painting of Michel, born in March 1878, seems to show him towards the end of his first year, with a full head of hair and an alert gaze. Monet painted a similar portrait of the slightly older Jean-Pierre Hoschedé, which he offered to the boy's mother as a New Year present, signing it '31 December 1878' (w.503). It is perhaps reasonable to suggest that the portrait of Michel was made for the ailing Camille at about the same time. Despite Monet's necessarily rather rapid execution, the portrait is entirely conventional, with the rubicund face seen in half-profile under a freshly starched bonnet. The dark-blue tonal background sets the baby's face in relief, drawing attention to the record of his infant features. There is no excessive sentimentality here, though painting the portrait of the child from whose birth his mother was never to recover must have been a moving experience for the artist.

The portrait of Jean is a different matter. Dated August 1880, it was made when Jean – born in July 1867 – was thirteen. Monet painted his eldest son almost full-face, but with his head slightly tilted, in what may have been a characteristic position. Jean's dark blonde hair and his blue schoolboy's jacket make his head stand out against the paler background. Monet detailed the adolescent features with some care, delineating the curved lips, long nose and somewhat wistful brown eyes. The boy's rather distant mien reminds us that his mother had died just a year before. Monet's decision to paint Jean at this time, having often painted him in the past in the company of Camille, may have been a way of bringing father and teenager together at a difficult time for them both. RT

20. *Still Life with Pheasants and Plovers*, 1879

Oil on canvas · 68 × 90cm
The Minneapolis Institute of Arts,
Gift of Anne Pierce Rogers in memory of
John DeCoster Rogers
W.550

The hard winter of 1879–80 made painting out of doors difficult for Monet, and he turned, for a brief period, to the making of still lifes, a genre he had last essayed in 1872. This composition belongs to a series of three similar game-pieces, the other two of which are both in private collections (w.548, 550). Apart from the weather, another reason for Monet's return to still lifes was their relative ease of sale (all three pheasant paintings were sold to prominent Parisian dealers by 1880), as opposed to the difficulties he was experiencing in this respect with many of his landscapes. He also produced a trio of paintings of fruit around this time. His identification with this particular piece is reflected in its inclusion in his first solo exhibition at the gallery of *La Vie moderne* in 1880 and in the 7th Impressionist exhibition in 1882. Like that of many of his fellow Impressionists, Monet's approach to still life is relatively traditional and a lineage can be traced back to the great eighteenth-century painters Jean-Baptiste Oudry and Jean-Siméon Chardin. More immediately, such game-pieces had also been painted by the young Monet's friend and mentor Eugène Boudin. MC

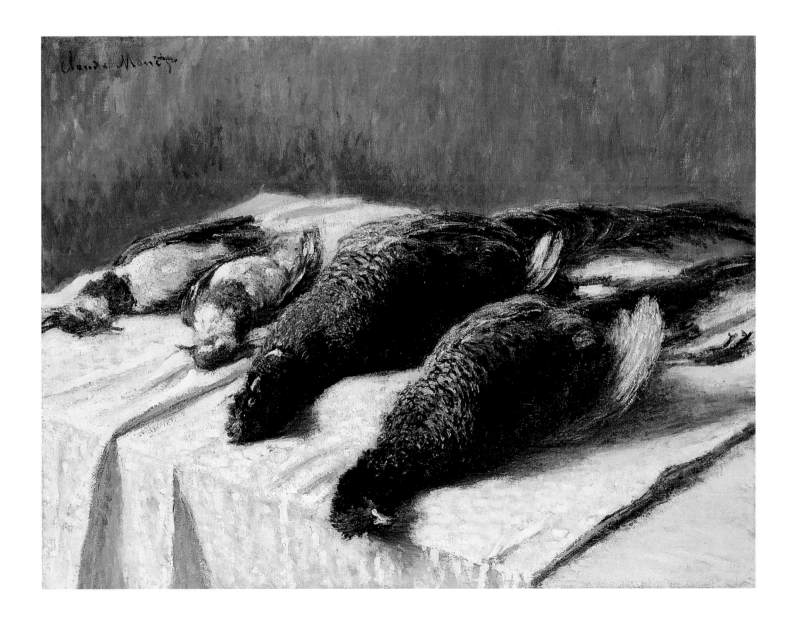

21. *Still Life with Honeydew Melon*, 1879

Oil on canvas · 90 × 68cm
Private Collection
W.544

22. *Chrysanthemums*, c.1880–1

Oil on canvas · 100 × 81cm
The Metropolitan Museum of Art,
New York , H.O. Havemeyer Collection,
Bequest of Mrs H.O. Havemeyer, 1929
W.634

The still-life paintings Monet made in the 1878–1883 period served various purposes, providing a break from landscape work and offering an alternative activity in poor weather. But above all they were commercially expedient, at a time when the artist and his family were in pressing need of funds. *Still Life with Honeydew Melon* was purchased by the dealer Theulier in December 1879, along with another representing pheasants, woodcocks and partridges.[1] The two paintings were a pair, on canvases of the same size and representing contrasting autumnal subjects of fruit and game. No wonder Theulier bought them together for 800 francs: they would have made appropriate matching pictures to decorate a dining room, and were probably intended as such by the artist. Monet made two other paintings of this basket of fruit on the same damask table cloth, and these, too, sold quickly, one to Georges Petit for 500 francs and the other, it seems, to a certain Cahuzac.[2]

The *Chrysanthemums*, although dated 1882 by Monet, probably in error, when he sold the canvas to Durand-Ruel that year, would seem to belong to a substantial group of still-life pictures made over the winter of 1880–1. Seven of these are flower pieces and two fruit motifs.[3] Again these sold well. The fruit subjects were both sold to Delius in October 1880, while during 1881–2 Durand-Ruel bought three of the flower paintings, another going to Cahuzac in November 1880 and one more to Caillebotte in 1882. The marketability of Monet's still-life paintings is apparent not just from their reliable turnover. Monet made a point of exhibiting them alongside his landscapes whenever he had a substantial show of his work. Still-life pictures were shown at both his one-man shows at *La Vie moderne* in 1880 and with Durand-Ruel in 1883. At the 7th Impressionist exhibition in 1882 he had six on show, out of thirty-five exhibits in total.[4] In terms of his total output across the genres, this proportion, almost twenty per cent of the show, tipped the balance of his work between still life and landscape quite notably in favour of the former, and was no doubt a business decision. A further point might be made. In 1882 Monet exhibited three types of still life, with different functions as furniture. Flower pieces like *Chrysanthemums* were ideal for sitting rooms or bedrooms. A game subject was appropriate for a dining room. And two elongated motifs of gladioli in vases were frankly decorative in design, suitable as insets into wood panelling. In that, they prefigured the work that Monet was to paint as door panels for Paul Durand-Ruel's dining room, a commission for thirty-six still-life canvases which he received in May 1882 and completed in 1885.[5] In sum, Monet was well served in painting still life.

He did so with dispatch. *Still Life with Honeydew Melon* was rapidly and thickly brushed. The background is a simple transition from pale green-grey to deep blue-grey. Monet slashed on the tablecloth, swiping on greys to give the effect of the fabric's weave. He gave most attention to the fruits themselves, giving each kind a different texture, but one determined by the play of his brush rather than any concern for verisimilitude. *Chrysanthemums* was also swiftly executed. It is a harmony of silvery green and resonant russet-pink, stabilised by the dark green of the central mass of leaves. The handling of the background has a loose, almost petal-like quality which echoes the rhythms of the blooms, while the well-polished surface of the table reflects the background, again serving to stress the dominant harmony. Monet painted such canvases with a flourish, confident in his ability to animate any still-life motif with the vivacity of his brushwork, unity of his light, and coherence of his chromatics, and without excessive commitment to surface exactitude. RT

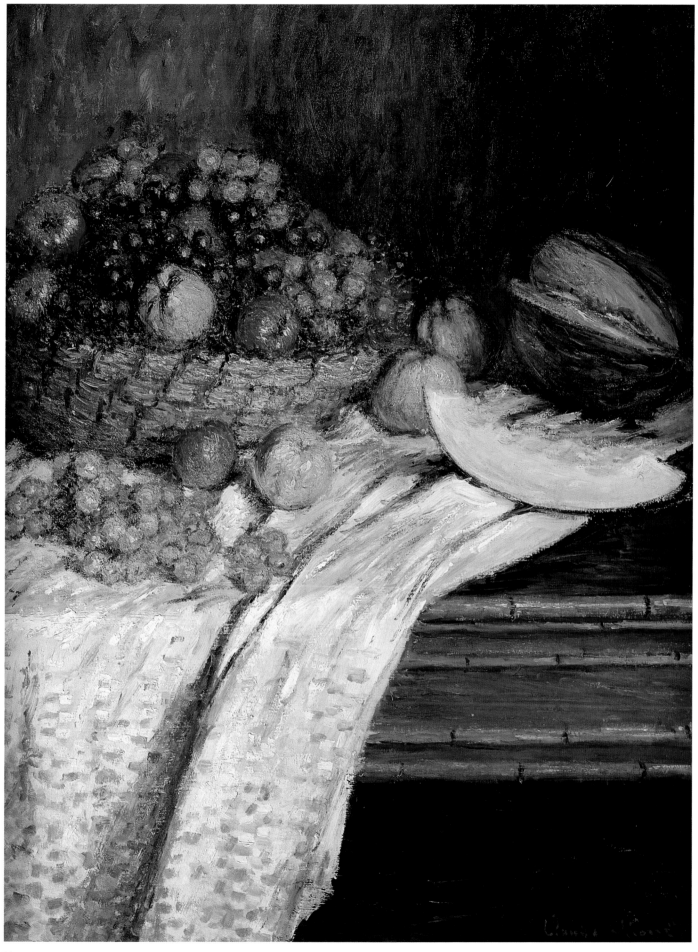

21

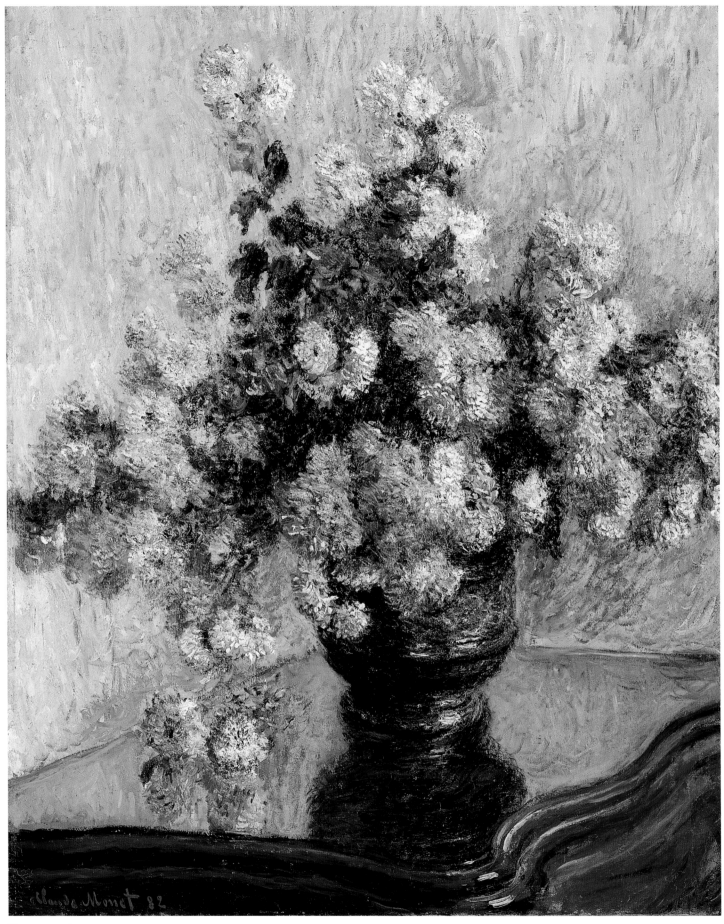

22

23. *The Break up of the Ice, Grey Weather*, 1880

Oil on canvas · 68 × 90cm
Calouste Gulbenkian Museum, Lisbon
w.560

24. *The Break up of the Ice, 1880*

Oil on canvas · 72.5 × 99.5cm
Musée des Beaux-Arts, Lille
w.561

25. *The Break up of the Ice, 1880*

Oil on canvas · 60 × 99cm
University of Michigan Museum of Art, Ann Arbor, Michigan, Acquired through the generosity of Russell B. Stearns and his wife Andrée B. Stearns, Dedham, Massachusetts
w.565

The winter of 1879–80 was notoriously severe, submitting much of Europe to the equivalent of a Siberian climate. By late November temperatures had dropped to –7°c in Paris and –9°c in Le Havre. Much worse was to follow and, incredibly, –26.5°c was recorded in Paris on 10 December. As it had during the severe winters of 1830–1 and 1870–1, the Seine froze over. Roads were paralysed, trains were unable to bring essential goods to Paris. In the capital there were severe worries about public health and the safety of the bridges over the Seine, many of which were severely damaged when the thaw arrived in January. Out in the country at Vétheuil Alice Hoschedé vividly described the break up of the ice, which began on the morning of 5 January: 'On Monday, at five in the morning, I was woken by a terrifying noise, like thunder; a few minutes later I heard Madeleine [the cook] knocking on M. Monet's window, telling him to get up. I immediately did the same, while the booming sound was mixed with cries coming from Lavacourt. I quickly ran to the window, and, dark as it was, I could see blocks of white falling; this time it was the real break up of the ice floes.' For Monet, such a spectacle provided an unmissable visual opportunity, as he admitted in a letter of 8 January to the collector Dr de Bellio: 'Here we have had a terrible *débâcle* [break up] and of course I have tried to make something of it'. The resulting canvases he produced were some of the most startling and profound in his career to date. The muddy and dirty qualities of a thaw are well represented in the Lisbon painting, while that from Ann Arbor perfectly captures the blue-grey bleakness of such scenery. As later commentators have remarked, the patches of ice on the Seine uncannily anticipate the floating lily-pads in the garden at Giverny. The unpeopled, elemental grandeur of these scenes was at odds with more conventional representations of this force of nature. Artists such as Luigi Loir, Ludovic Napoléon Lepic and Edmond Yon successfully submitted their anecdotal depictions of the great freeze to the 1880 Salon. Monet, breaking with some of his fellow Impressionists, and following the example of Renoir, also submitted two paintings to the Salon that year. That of *Lavacourt* (cat.no.30) was accepted, whereas his great *Les Glaçons* (fig.14) was rejected, but was subsequently acquired by Mme Charpentier and shown at the 7th Impressionist exhibition in 1882 (no.58).

Monet's paintings of the melting ice-floes on the Seine, made in the early months of 1880, may represent the same subject, but they are rather different kinds of picture. In fact, they typify different aspects of his practice, and reveal much about how he went about his work. A canvas now in the Louvre (fig.13) was made *en plein air*. The evidence for this is its rapid execution, the paint quickly ordered into layers defining broad areas of tone and more textured surface-strokes to identify the varied physical matter Monet was depicting, be it bare branches or blocks of ice. In addition, the palette is limited to a range of grey tones, chilled with blue and heightened with white, with some browns used to pick out the stark vegetation. This was the kind of painting Monet made on site, in cold conditions, quickly.

The two canvases now in Lille and Lisbon seem to have resulted from a different procedure. They represent essentially the same motif, albeit with some variations – the view from Monet's mooring-point across the river to Lavacourt on the far bank. They are on canvases very close in size. How do we explain this *cousinage*? Obviously it was a convenient vantage-point to work from, and it provided a satisfying motif, with a distant view upriver to the left, Lavacourt in the far middle ground, and one of the islands nearer on the right, with a substantial expanse of water in the foreground. This space acted as a kind of theatre, a stage on which the natural drama played itself out. Massive blocks of ice, the weight of which has broken big trunks on the island, float across the picture area, while a tall slender tree stands sentinel against a leaden sky. There are more floes in the Lisbon painting, whereas the Lille version shows the river now navigable again. In that sense, the two canvases form an informally sequential

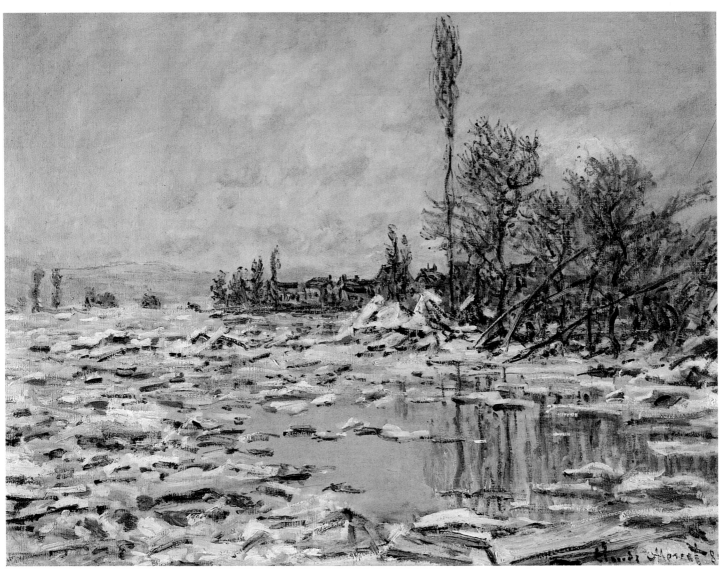

23

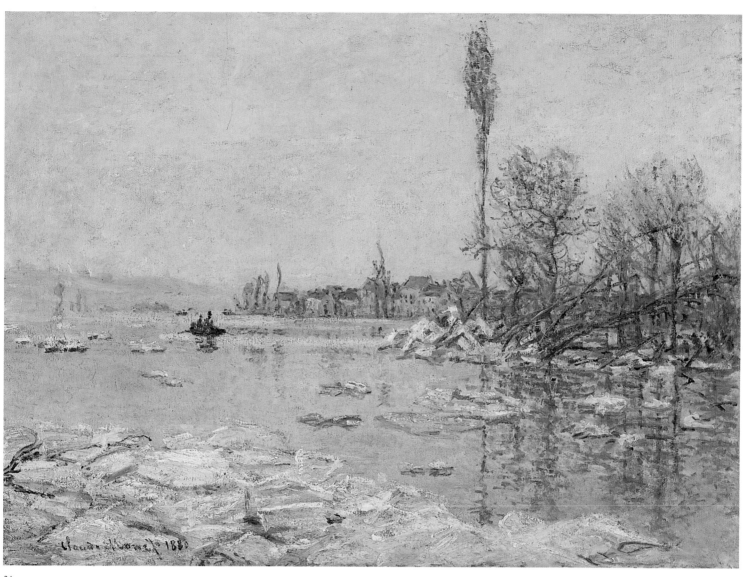

24

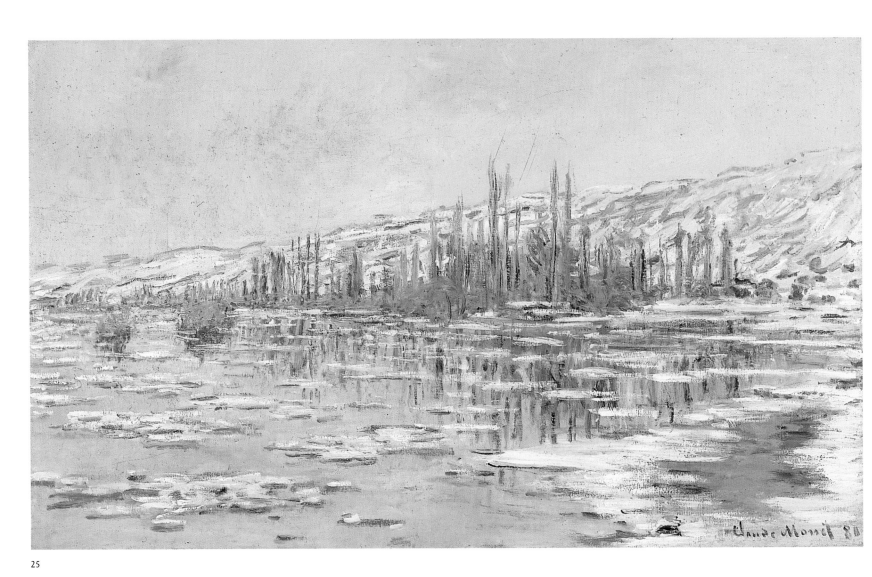

25

pair. Although both are resolved pictures, signed and dated, Monet seems not to have been in a hurry either to exhibit or to sell them. Neither seems to have left the studio until the 1890s, and the first to be exhibited was the Lisbon painting, shown at the 1900 Exposition Universelle. Both paintings are very balanced in composition, the canvases bisected by the horizon and balanced by the verticals of the standing trees and their reflections. The painted surfaces are a combination of rapidly laid in tones, for example in the skies, through which primed canvas is visible, and more elaborated forms, for instance the ice floes, which are quite carefully modelled. Perhaps these canvases were substantially painted *en plein air*, and then retouched in the studio.

Three other canvases establish yet another set of relationships. The painting now in the Musée d'Orsay (fig.8) was probably painted out of doors. It served as a *modello* for the larger canvas of the same motif – 150cm wide rather than 1 metre – that Monet submitted unsuccessfully to the Salon of 1880 and was later bought by Mme. Charpentier (fig.14). A third painting, with only a very slightly altered motif, was signed and dated 1881 (w.569). This may have been a replica variant, made for sale, or a canvas unfinished while the motif of the melting ice-floes was there to be painted, and brought up to marketable level the following year. MC / RT

26. *Sunset on the Seine, Winter*, 1880

Oil on canvas · 100 × 152cm
Musée du Petit Palais, Paris
W.576

27. *Sunset*, 1880

Oil on canvas · 50 × 61.5cm
Private Collection, courtesy Galerie Cazeau-
Béraudière, Paris
W.577

Fig.55 · Claude Monet *Impression, Sunrise*, 1873
Musée Marmottan, Paris (w.263)

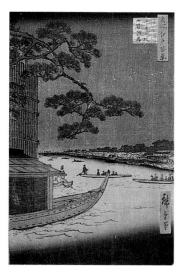

Fig.56 · Utagawa Hiroshige *The Pine of Good
Fortune on the Banks of the Asakusa River*, 1857
Musée Claude Monet, Giverny

On 8 March 1880 Monet wrote to Théodore Duret explaining, 'I'm working hard on three big canvases of which only two are for the Salon, because one of the three is too much to my own taste and it would be refused, and so I've got to do something better behaved, more bourgeois'.[1] All three were on canvases measuring a metre by a metre and a half, befitting work of exhibition status. The two more 'prudent' canvases were the summer scene *Lavacourt* (cat.no.30) and a scene of the recent break up of the Seine ice (fig.14). Both were submitted to the Salon in the spring of 1880, but the jury only accepted the former. Monet was surely right about the painting he preferred. *Sunset on the Seine, Winter* is a dramatic painting, emphatic in its starkly reduced forms and sense of sombre chill, and yet animated by graphic brushwork and adventurous depiction of reflected light. This audacious picture, it is often pointed out, was reminiscent – perhaps consciously so – of *Impression, Sunrise* (fig.55), which had so infuriated critics at the first Impressionist exhibition in 1874.[2]

Monet made it clear to Duret that all three canvases were in train in early March 1880. Yet only *Sunset on the Seine, Winter*, with its high water and leafless trees, represents that time of year. The *Les Glaçons (Break up of the Ice)* depicts the spectacular conditions of several weeks before, while *Lavacourt* is a scene of mid-summer sunshine. Although supporters like Duret, writing extended pieces on Monet, as well as art critics passing his work under review in their newspaper columns, took it for granted that Monet's work was the apogee of *plein-air* truth to nature, these three large canvases were compositions crafted in the small studio space in the attic of his Vétheuil house. So much for Monet's claim to the journalist Taboureux in the interview that he gave that June to *La Vie moderne* that the outdoors was his studio! In all three cases, however, Monet went back to smaller canvases that he had made out of doors, in the case of *Lavacourt* many months before.[3] Such paintings were not necessarily planned as studies for a larger exhibition painting. Three smaller canvases come into the orbit of *Sunset on the Seine, Winter*. Two (w.574–5) represent very much the same motif, looking across the river from Monet's landing-stage towards Lavacourt. From these Monet derived the composition for the larger painting. The third, a subtle evocation of damp wintry twilight, shows a different view, looking between two overgrown islands in the Seine towards the sun setting in the mist, with the bare branches of a tree reaching across the field of view. This apparently casual but contrived device is reminiscent of the Japanese prints Monet so admired (fig.56). Interestingly enough, Daubigny had also painted a number of canvases of sunsets and even moonrises framed by screens of trees, which Monet may well have known (cat.no.82). The gestation of *Sunset on the Seine, Winter* was typical of Monet at this period – a combination of observation on site of a striking motif, reminiscence of a mentor's work, a bow to the Japanese craft of the silhouette, and above all Monet's own bravura sense of balanced design, reflected light, and graphic economy of brushwork.

Those highly personal qualities made the painting impossible for the Salon, but Monet did exhibit *Sunset on the Seine, Winter* at the 1882 Impressionist exhibition. There it aroused admiration from several critics, among them the young Japoniste printmaker Henri Rivière and the Parnassian poet Armand Silvestre. Nevertheless, the bold treatment of the setting sun attracted a number of facetious comparisons with oranges. The critic of *Le Soleil*, conscious perhaps of the honour of his masthead, wondered how a tomato could have reflections in violet.[4] This kind of reaction suggests that Monet was prudent to select carefully where he exhibited such ambitious and adventurous work. That said, the large canvas, sold to Durand-Ruel in December 1881 for 1,000 francs, was purchased from the dealer after the Impressionist show by the businessman Ernest Clapisson (1837–1894). Even work 'to my own taste' was beginning to sell for good prices as Monet's reputation rose. RT

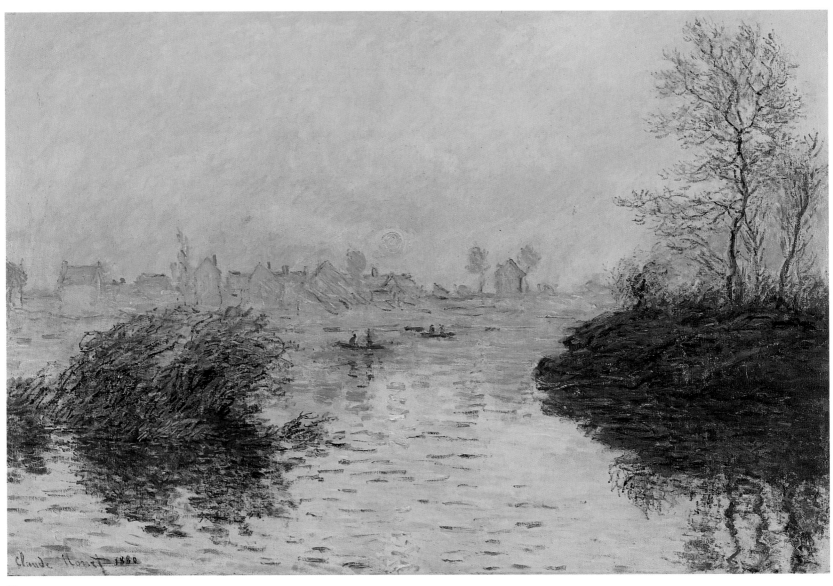

26

27

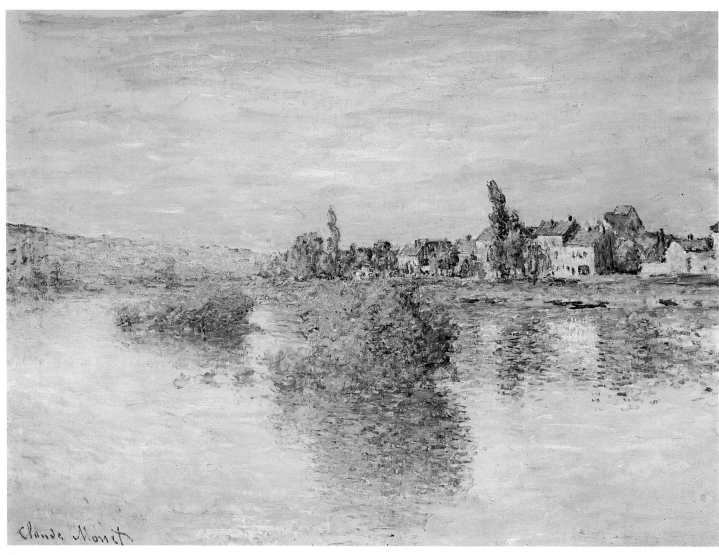

28

28. *The Banks of the Seine at Lavacourt*, 1879

Oil on canvas · 60 × 81cm
The Frick Art and Historical Center, Pittsburgh,
Pennsylvania
w.538

29. *The Seine at Lavacourt*, 1879

Oil on canvas · 60 × 81cm
Fogg Art Museum, Harvard University Art
Museums, anonymous gift
w.540

30. *Lavacourt*, 1880

Oil on canvas · 100 × 150cm
Dallas Museum of Art, Munger Fund
w.578

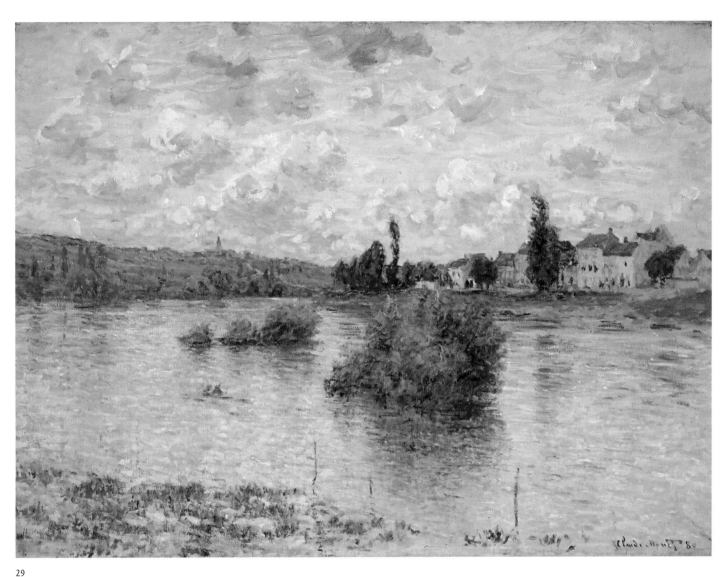

29

On arrival at Vétheuil in 1878 Monet had painted two canvases, and during his first full year there a further five, of the view south-westwards from the bank at the end of his garden across the river to the small village of Lavacourt (w.475–6, 538–41). Typically, he varied his position slightly and tackled different *effets*. The Fogg Art Museum's painting is one of the larger and more finished of the later group, representing the Seine in full spate, inundating the foreground bank, under a cloud-filled sky. The high water of the river suggests a date in spring 1879. The choice of the same motif was perhaps primarily practical. His wife Camille was suffering from a terminal disease at home, and from the place where he painted these canvases Monet could easily be summoned. In addition, the view was an appealing one, with the foreground plane of water allowing a play of reflections and the low horizon an amplitude of sky, while along the horizon clustered the more solid forms of Lavacourt and on the left-hand ridge the accent of the church tower at St-Martin-la-Garenne. Indeed, this kind of composition had been made popular over the last couple of decades by Daubigny, and played well on the market. It may have been for that reason that Monet seems to have exhibited three canvases of this motif at the 1879 Impressionist exhibition. Two of these had been painted in 1878 (w.475–6), the third just recently (cat.no.28).[1] These pictures were quite well received at the exhibition. The critic of *Le Soleil* praised their

accuracy and sincerity, while 'Montjoyeux' in *Le Gaulois* – who was apparently an acquaintance – admired their luminosity.[2]

Such a positive response may have encouraged Monet to return to this reliable motif when he decided to prepare a submission to the Salon of 1880. On 8 March 1880 he wrote to Théodore Duret that he was preparing three large canvases. Two of these were to be submitted to the Salon – *Lavacourt* and a *Les Glaçons* (fig.14) – while a third, a stark wintry sunset (cat.no.26), was 'too much to my taste to send and would be refused.' By contrast, a canvas like *Lavacourt* was 'better behaved, more bourgeois'.[3] Monet may have meant various things by this. One issue was convention. Thanks to Daubigny and others this type of subject – the waterways and villages of *la France profonde* – was established and appreciated. Another was finish. As Monet knew, neither the Salon jury nor the press would easily tolerate what was considered sketchy and approximate work. He needed therefore to submit canvases that came as close as he could, without entirely relinquishing his artistic principles, to the accepted norms. This raised the third matter of execution. To paint a canvas sufficiently large to make an impact at the crowded Salon – all three of the paintings Monet mentioned to Duret measure a metre by a metre and a half – it would be more convenient to work in the modest studio he had in his Vétheuil house. There he could work the painting up to an appropriate level of finish without being subject to the vagaries of *plein-air* work in the unreliable spring weather, for the Salon opened in May. To bring this off, what could be more convenient than a reprise of a motif that he had previously painted seven times?

Lavacourt, with its bright sky with high cloud reflected in the flowing river, its tranquil motif brushed by a passing breeze, and its quite reassuringly muted brushstrokes, was a reasonable success for Monet at the Salon, though *Les Glaçons* was refused. It was praised both by his friend the naturalist novelist Emile Zola and the conservative Marquis de Chennevières, until recently a power in the Ministry of Fine Arts.[4] However, although Durand-Ruel bought the painting from Monet in February 1881, it found no immediate buyer, despite its polished presentation, until purchased by A.W. Kingman, a New York collector, in 1886. Monet himself seems to have had mixed feelings about a painting on which he had lavished a good deal of work. In August and September 1880 he was happy to have it exhibited in Le Havre at the Société des Amis des Arts du Havre, but was peeved when it made no impression.[5] Less than two years later he was determined that it should not be shown again at the 1882 Impressionist exhibition.[6] By that time his work had taken on a new character – the concept of a campaign, in this first instance the Fécamp work – and had a stronger market presence with the regular support of Durand-Ruel. The time for polished public gestures such as *Lavacourt* had passed. RT

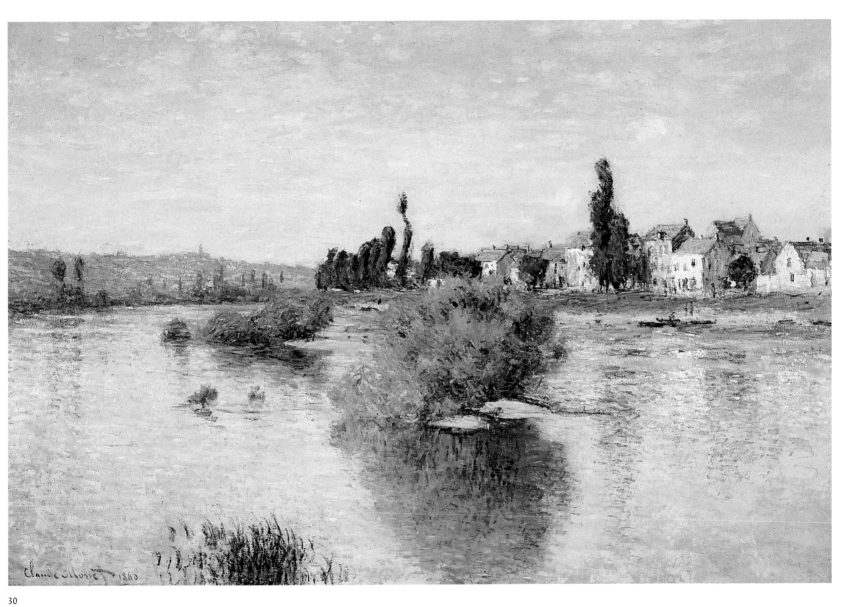

30

31. *Apple Trees in Blossom by the Water*, 1880

Oil on canvas · 73 × 60cm
Private Collection
w.585

32. *Springtime*, 1880

Oil on canvas · 60 × 81cm
Musée des Beaux-Arts, Lyon
w.586

Painted in the spring of 1880, these two contrasting canvases show the diversity of Monet's practice. *Apple Trees* is a daringly experimental painting. Monet looked directly into the mass of vegetation, his field of vision filled with branches, foliage and blossoms. Such is the density of the surface activity that the painting has no conventional focus or compositional base. Instead, the crescent form of the tree's trunk, brushed in scumbled browns and greys, curves through the busy surface scree of marks, and vertical touches in the lower quarter chart the sloping bank from which the tree grows. This is a canvas about touch, texture and colour, upon which the close-up motif insists and to the painterly imperatives of which it is then subordinated. As such, this unusual canvas is an extremely audacious step beyond the orchard paintings Monet had painted at Vétheuil the previous spring, in which the centre of the canvases is nothing more than a blur of blossom (w.519–21: cat.no.11). Monet clearly valued the picture, exhibiting it in his one-man show at *La Vie moderne* in 1880. It was later owned by another artist, Paul Signac. The title is somewhat confusing, as no water appears in the painting. However, this may be explained by the sloping bank from which the tree curves upwards. Perhaps this tree grew on the riverbank, and the canvas was painted from the studio-boat.

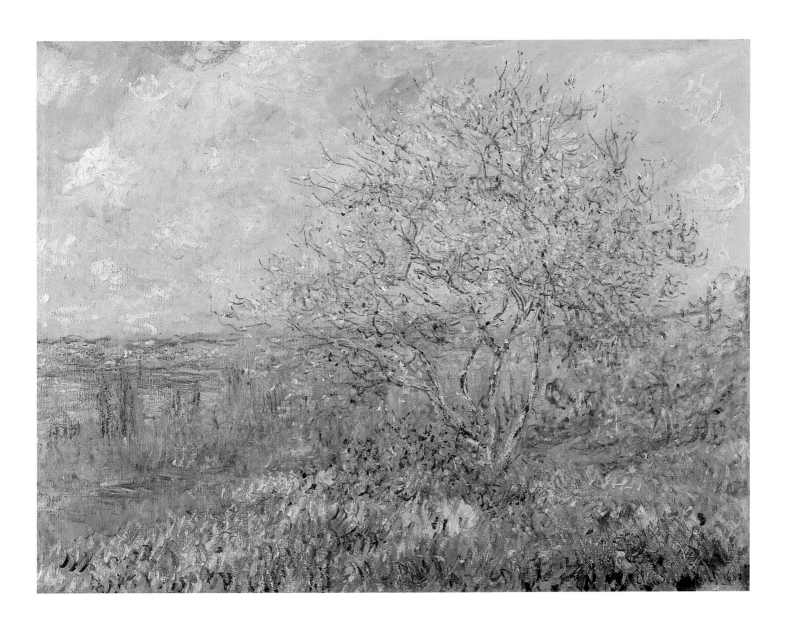

Springtime is a painting of an entirely different order. Painted from the ridge of Chantmesle, above the Seine downstream from Vétheuil, it looks across the elongated Ile de Haute-Isle north-westwards towards La Roche-Guyon. But this village, with its historic château of the ducs de la Rochefoucauld, is rendered as little more than a number of off-white marks in the distance. Monet concerned himself with a rapid *impression* of the sharp colours of spring vegetation tossed by brisk breezes on the heights. The canvas was prepared in mushroom pink, which is allowed to appear through the paint surface across the central strip of hillside. In the foreground a curled stroke is used to apply touches of love-in-the-mist blue, peppermint and sharply acidic greens, and pale cream-pink. The sky's similar pink combines with a bright pale blue to create an almost lavender effect. Against this, the tree's dark blue and aubergine branches form loose arabesques highlit in buttery yellow. Monet misdated the painting sometime after its execution; he was no longer working near Vétheuil in 1882. RT

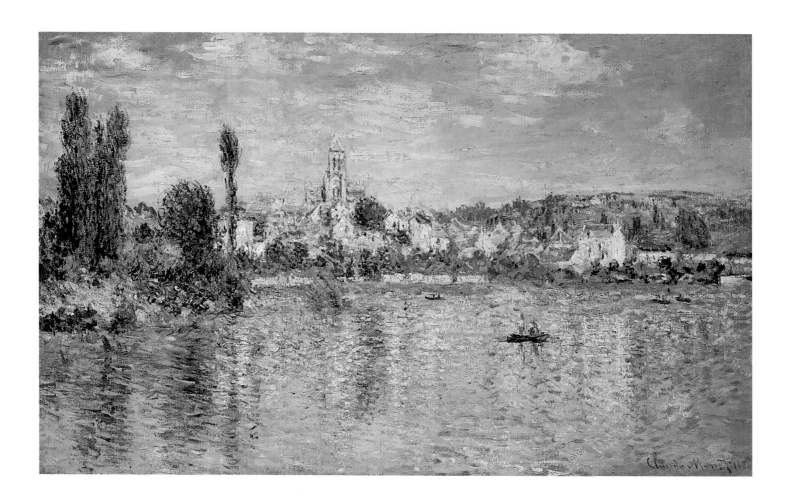

33. *Vétheuil in Summer*, 1880

Oil on canvas · 60 × 100cm
The Metropolitan Museum of Art, New York,
Bequest of William Church Osborn, 1951
w.605

34. *Vétheuil*, 1880

Oil on canvas · 60 × 100cm
Nationalgalerie, Staatliche Museen zu Berlin
w.609

During the summer of 1880 Monet continued to paint the view of Vétheuil from the Lavacourt bank that had interested him the previous year (w.531–4, 536; cat.nos.12, 14–16). In 1880 he painted a number of variants of the view across or along the Seine, using the tower of the church of Notre-Dame as a focal point. Two of these were painted downstream from the village (w.601–2). Made from the studio-boat, they frame the village between great clumps of foliage growing on the banks. Another group of five canvases were viewed from the higher vantage-point of the riverside outside Lavacourt (w.605–9).

The New York and Berlin canvases, *Vétheuil in Summer* and *Vétheuil*, belong to this group, and they admirably demonstrate how for Monet, although he might elect to paint fundamentally the same site, each painting was a new experience. There were a number of variable factors – motif, atmospheric effect, canvas size and brushwork among them. These two paintings, with another (w.608), were all made on canvases measuring 60 × 100cm, essentially a canvas designed for marine subjects, size 40.[1] In selecting this particularly wide format, Monet stressed the flow of the great river though the centre of his picture space, allowing the eye to traverse the painting as it would an actual view, picking out the constituent elements – tree-covered islands, rowing boats and the features of the village, the clustered houses and block-like larger properties surmounted by the large church. Monet took slightly different positions to paint each canvas. The New York painting places the spectator right at the water's edge, while the Berlin picture presents an expanse of meadow before we arrive at the river, and – painted from further to the left – screens the village more with the tree-covered island. In comparison to the elaborate and highly coloured reflections with which he had experimented in 1879 (cat.no.15), the 1880 paintings are more loyal to local colour.

Richly verdant greens and resonant mid-blues predominate, the lush tones of summer in the Ile-de-France. But the two canvases were executed in noticeably different manners. The New York painting is painted in dabs and touches which are consistent with the areas they define – mosaic-like reflections or wispy branches, for instance. The surface has a steady, carefully built quality. On the other hand, the Berlin painting is more graphic, the river brushed in with quite long, flowing strokes, and the clouds depicted in curves and flicks which echo the play of Monet's wrist. It would seem that Monet's primary reason for adapting his handling in this way was to respond to light and weather. Executed on a windier day, the Berlin painting required the animation of his handling to register atmospheric movement. By contrast, the New York picture was made on a warmer and more tranquil day, so a composition with steadier horizontal accents and a more regular touch corresponded better to the stillness that surrounded the artist. RT

35. *The Willows*, 1880

Oil on canvas · 66 × 81.5cm
The Corcoran Gallery of Art, Washington DC
Edward C. and Mary Walker Collection
W.611

The view is of Lavacourt seen from one of the Iles de Moisson; a similar composition is now in a private collection (w.612) and both were included by Monet in the 7th Impressionist exhibition in 1882 (nos.611–12). Also to be grouped with these two canvases is one of vertical format in Washington (fig.57) with a comparable view through the willows but with the addition of a seated woman, doubtless Alice Hoschedé, seated in the foreground and seemingly reading. There are traditional resonances in all three pictures. Willows had featured strongly in many landscape paintings produced by the so-called *école de 1830*, especially in the work of Camille Corot (fig.58). Romantic poetry had also celebrated the willow, notably Alfred de Musset's *Le Saule*, published in fragments from 1830 onwards, lines from which may have inspired Corot's painting of 1864, *The Shepherd's Star* (Musée des Augustins, Toulouse). Monet's three paintings pay visual homage to Corot, not only in their portrayal of the willow tree, but also in their use of a compositional device – the screen of trees through which can be seen an expanse of water and buildings beyond – which very much puts one in mind of Corot's numerous late views of Mantes and Ville-d'Avray (cat.nos.79, 80). Ville-d'Avray, just to the west of Paris, was the site of the Corot family home, a small country house acquired by the artist's father in 1817. Views of the area round Ville-d'Avray featured prominently in Corot's work throughout his career (fig.59). In 1866 Monet had rented a house with Camille Doncieux (his then mistress and future wife) for the first half of the year at Sèvres, near Ville-d'Avray, and would doubtless have been familiar with the locale. A further echo of Corot's influence is evident in the vertical Washington painting (fig.57), which in tonality, subject and composition is strongly reminiscent of the work of Berthe Morisot, who in the 1860s had styled herself *'élève de Corot'*. MC

Clockwise from top left

Fig.57 · Claude Monet *Woman Seated under the Willows*, 1880
National Gallery of Art, Washington DC, Chester Dale Collection (w.613)

Fig.58 · Camille Corot *A Man Scything by a Willow Grove, Artois*, 1860s
National Gallery of Scotland, Edinburgh

Fig.59 · Camille Corot *Ville-d'Avray*, 1870
The Metropolitan Museum of Art, New York, Bequest of Catharine Lorillard Wolfe

36. *Vétheuil*, 1880

Oil on canvas · 78 × 64cm
Los Angeles County Museum of Art,
Gift of Howard Ahmanson Jr
w.603

The unusual picture now in Los Angeles views Vétheuil almost directly from the north. Monet painted it from the ridge of Les Tilleuls as it slopes steeply towards the loop of the Seine. In the middle ground Vétheuil occupies the valley debouching into the river, while in the background rises the hillside of Chénay. The buildings of the village are not picked out in detail, and this view, more distant and thus generalised than was Monet's habit, combined with his quite gestural brushwork, contrives to render Vétheuil an almost organic element in the surrounding nature. The high horizon – shared with a squarer treatment of the same motif executed at the same time (w.604) – as well as the blurred and sometimes approximate brushwork, made this a somewhat experimental canvas, which Monet kept in his studio throughout his life. RT

37. *The Cliffs at Fécamp*, 1881

Oil on canvas · 63.5 × 80cm
Aberdeen Art Gallery and Museums Collections
w.656

38. *Rough Sea, Fécamp*, 1881

Oil on canvas · 67 × 80cm
Musée Malraux, Le Havre
w.652

These two paintings, made on Monet's short but seminal campaign at Fécamp in March and April 1881, both register *effets* of different weather conditions. The Aberdeen painting represents a clear but windy day, with quite good distant visibility, and clutches of cloud being blown across a blue spring sky. The strength of the wind can be gauged from the animation of Monet's brushwork in the greens and browns that describe the foreground herbage. The bright light on the chalk cliffs and the deep blues of the steady sea reflecting the sky suggest a time in the middle of the day. By contrast, the Le Havre canvas depicts a much rougher sea, the surging lines of breakers probably stirred up by a wind from the north-west. The sky is overcast, the pearly clouds illuminated by a dimming yellow light from the headland towards Yport. The time must be the end of the day, towards sunset. These variations demonstrate the variety of effects Monet could find within a very limited area, if the conditions appealed to his painterly instincts. Those at Fécamp evidently did, for he wrote to Durand-Ruel a fortnight after arrival that 'I have come here for a short visit to the seashore and I have found it so good that I have a strong desire to stay here a little longer.'[1]

Despite their evident differences, the viewpoints of the two pictures were very close to each other. One was painted on the heights, and the other at the foot, of the cliffs at Grainval, to the west of Fécamp. Thus within easy walking distance Monet could find a variety of motifs and, with the changing weather of the Channel coast, a range of *effets* that could satisfy him for an extended period. While at Fécamp he painted four canvases from the cliffs of Grainval looking east, like the Aberdeen painting (w.653–6), and another four looking west towards Yport (w.647–50). He painted that same westward view twice from the beach, in the Le Havre canvas and one other (w.651). Monet's Fécamp canvases concentrate on motif and *effet*; the presence of the port itself is ignored, and other human elements such as fishing boats and salient buildings are either neglected altogether or made to play a very minor role in the fabric of the picture. This is in contrast to the work of previous landscape painters who had worked in this region. Antoine Chintreuil's paintings of the environs of Fécamp also show interest in the sensations of vast or cramped space that the cliffs offered. But in paintings such as *The Sea at Sunset, Fécamp* (fig.60) or *Landscape, Fécamp* (c.1862; London, National Gallery) he insisted on the inclusion of a lonely shepherd boy and of cramped cottages, respectively, to augment his interpretation of the natural environment. For Monet, on the other hand, the sense of human experience of these sites was conveyed not by such intermediaries but by the animation of his personal touch. RT

Fig.60. Antoine Chintreuil *The Sea at Sunset, Fécamp, c.1866*
Musée de Brou, Bourg-en-Bresse

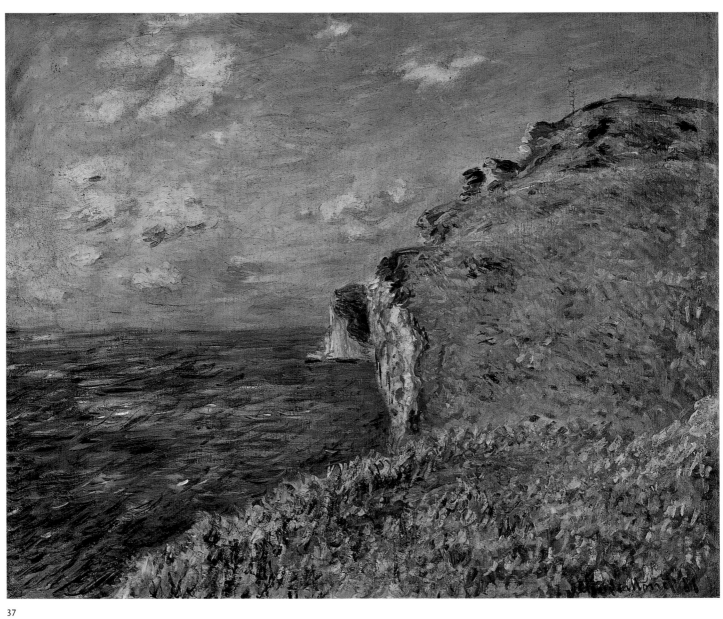

37

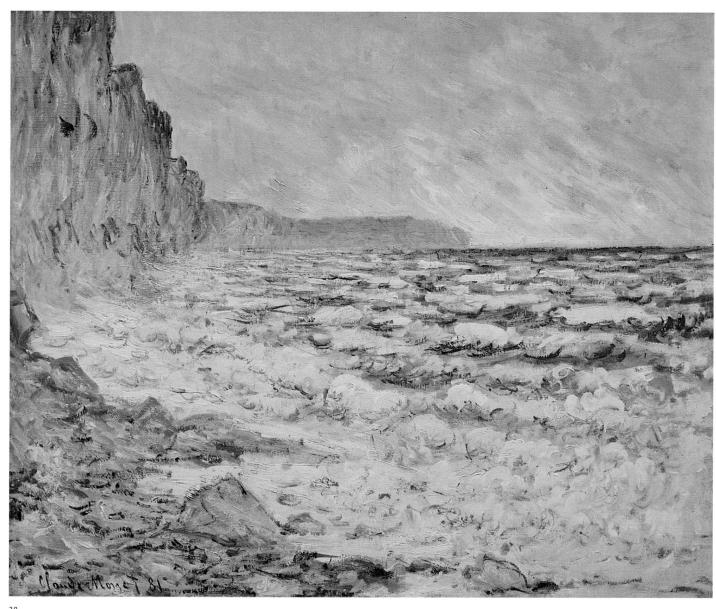

38

39. *View from the Grainval Cliffs*, 1881

Oil on canvas · 61 × 81cm
Galerie Rosengart, Lucerne
w.655

This canvas is one of four Monet painted in Fécamp from the cliffs of Grainval to the west of the port (w.653–6). The view is eastwards and the aspect wild. While three of these paintings, including the one now in Aberdeen (cat.no.37), give a sense of the savage and exposed character of this cliff-top by the presence of a great shoulder of rock to the right, the position of the Lucerne painting is further out along the cliff as it abuts the Channel. One gets a sense not just of a half-hidden void immediately to one's front but also of an invisible void not far to one's left. Monet adeptly evoked strong wind, too, with clouds scudding across the sky and in the sharp spring sunshine casting their shadows on the sea. Breezes whip the bushes and grass around the spot where Monet pitched his easel.

Monet's view was over the bay of Fécamp. But the busy port he hid behind the line of cliffs to the right. There are no sails to be seen in the roads, although they do appear in another painting in the group (w.653). In the Lucerne canvas the only evidence of human habitation is the distant presence on the far cliff of Notre-Dame-de-Salut, an historic fisherman's chapel. Even this monument takes on an almost organic character in Monet's characterisation of the shifting moods of wild coastal nature. The Fécamp paintings set the tone that he continued in his two more extended campaigns at Pourville the following year, in which Monet did his utmost to play down the presence of harbour or resort in order to confront unblemished effects of light and atmosphere on this dramatic coastline. The Lucerne canvas typifies his success in doing this, though his favoured site – with Fécamp dismissed behind the Grainval cliffs – reminds us of how his focus on the elemental could be precariously balanced by his repudiation of the civilised. RT

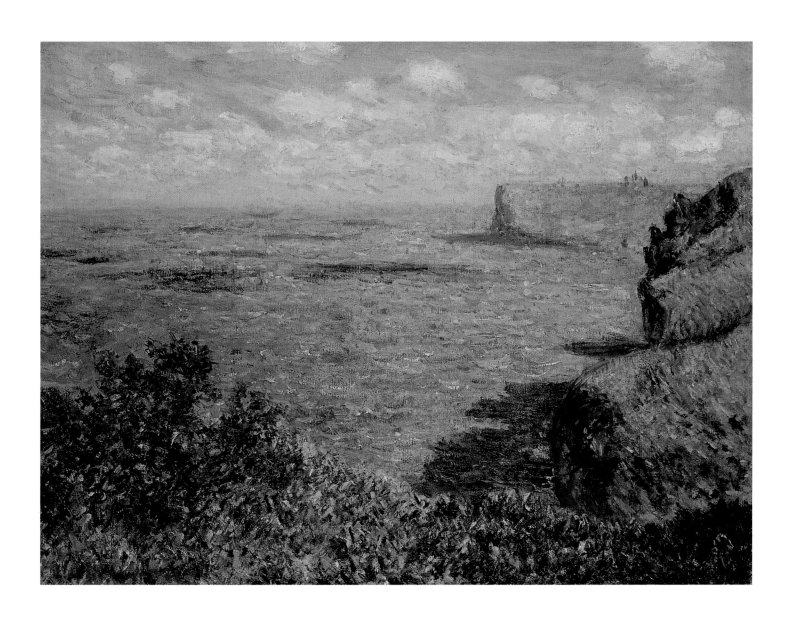

40. *Rough Sea*, 1881

Oil on canvas · 60 × 81cm
Fine Arts Museums of San Francisco,
Gift of Prentis Cobb Hale
w.661

During Monet's productive stay at Fécamp in March and April 1881 he painted three canvases looking directly out to sea (w.661–3). Unlike the five paintings of the same kind he made the following year at Pourville (w.766, 771–4; cat.no.54), which all represent the Channel in calm weather, the three Fécamp marines show breakers crashing onto the beach from a heavy sea. The 1881 paintings were made right at the water's edge, with scarcely any shingle or sand represented at the bottom of the paintings. It is a view we have all seen, the whole of one's field of vision filled with nothing but sea and sky, and it evokes in us feelings of loneliness and insignificance in the face of nature's immensity. In that sense, these paintings – despite not being very large – discreetly play their part in Monet's meditation on the sublime. They present an image of the painter as one fearless in his confrontation of the noise and violence of the thrashing waves, pitting his skills as a painter against such a great force. This is particularly so in the San Francisco canvas, in which Monet pitched the horizon quite high, surrendering two-thirds of the picture to the roll and spray of the incoming breakers.

The power of the sea had fascinated the Romantic generations of French artists, from Delacroix and Huet to Gudin and Isabey. But in quite recent years the theme had been stripped of the histrionic paraphernalia of wreckage and drownings to focus more closely on the waves themselves. Such concentration had been a particular feature of Courbet's work. At the Salon of 1870 he had exhibited a large canvas of a great wave breaking on a beach on which a couple of fishing boats are drawn up (fig.61). Monet's confrontations with the sea involved rephrasing a motif that had challenged his predecessors and contemporaries in his own personal painterly language. RT

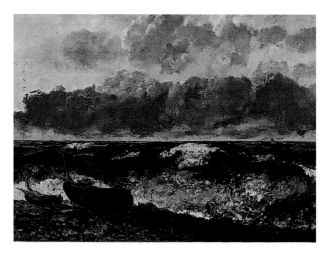

Fig.61 · Gustave Courbet *The Wave*, 1870
Musée d'Orsay, Paris

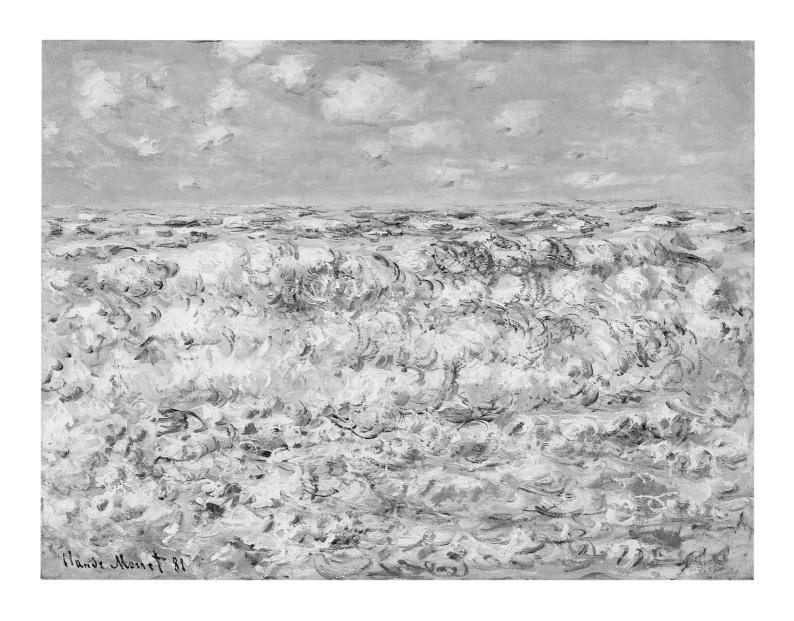

41. *The Sea at Fécamp*, 1881

Oil on canvas · 65.5 × 82cm
Staatsgalerie, Stuttgart
w.660

The paintings Monet made of the cliffs at Fécamp early in 1881 divide more or less equally into those taken from on the cliff-tops and those executed at beach level. However, when he chose work from the Fécamp campaign as part of his contribution to the 7th Impressionist exhibition in 1882, he included six of the former, with their dramatic plunging views, and only one of the latter.[1] This is surprising, given the impact of several of the canvases executed at sea level.

The Sea at Fécamp is one of two that take the same motif.[2] It is on a slightly larger canvas – a size 25 portrait format rather than a 20 – and includes more of the overhanging rock face to the right than the other. Monet seems to have taken pleasure in this apparently treacherous vantage-point, perched on a shelf of rock, the cliff just in front pressing over him, and the breakers smashing on to the rocks to his left. All the features that would make such a place dangerously unwelcoming Monet included – wind whipping up the white horses, a heavy rain-filled sky, rocks covered in slippery seaweed. Implicitly he advertised, and asks the spectator vicariously to share, his daring at venturing to such a spot. This painting is one of the most overt in this period of Monet's career in its casting of the painter, and by implication the spectator, too, as a protagonist, not merely an onlooker, in the ceaseless throes of natural forces. It may have been for this reason that, perhaps advised by Durand-Ruel, he opted not to show such a dramatic painting publicly. *The Sea at Fécamp* may have seemed too ostentatious in its manly willingness to confront the raging elements, whereas thrilling views from the high cliffs, of the kind that most tourists to the Normandy coast would have experienced, were more likely to find a market.

Similar motifs and effects had sometimes been painted by Courbet. But canvases such as *The Waterspout*, executed at Etretat in 1870 (fig.62), have a very different visual identity to Monet's *The Sea at Fécamp*. Made with a palette knife, which creates broad effects, Courbet was able to make his paint surface suggest the solid matter of the rocks very effectively, but the technique served less well for the vaporousness and fluidity of sky and water. The overall impact is somewhat generalised, as if made back in the studio, from memory. Monet's small touches were better able to convey not only the character of forms and effects, but also their actuality. Horizontal striations on the rear rock give a sense of geological exactitude, for instance, just as wispier strokes approximate admirably to the filmy spume thrown up by the crashing waves. In such a canvas, Monet had finely tuned his painterly means to the forbidding motif he had chosen to pit them against. RT

Fig. 62. Gustave Courbet
The Waterspout, Etretat, 1870
Musée des Beaux-Arts, Dijon

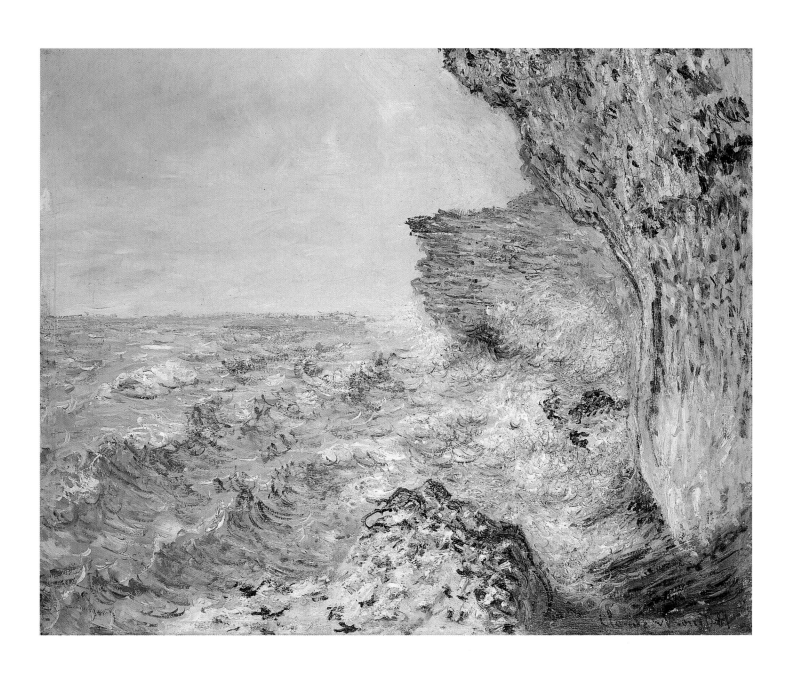

42. *The Cliffs near Vétheuil,* 1881

Oil on canvas · 14.4 × 22.1cm
Musée des Beaux-Arts, Rouen
w.669

43. *The Village of Vétheuil,* 1881

Oil on canvas · 14.4 × 22.6cm
Musée des Beaux-Arts, Rouen
w.670

44. *The Seine seen from the Heights of Chantmesle,* 1881

Oil on canvas · 14.4 × 22.3cm
Musée des Beaux-Arts, Rouen
w.671

These three small oil-sketches remain something of an enigma. Painting landscapes *en plein air* on small surfaces had been a common practice since the eighteenth century. Little panels or canvases were easily transportable and could be carried in numbers. They were useful for quickly charting terrain and its possible motifs, for getting the eye in, and for rapidly recording shifting weather effects such as fogs and sunsets. The practice remained widespread in the nineteenth century and among artists of different generations and styles, from Corot to Seurat. However, it is not clear how frequently Monet made such small landscape sketches. His inclination to paint medium-sized canvases *sur le motif*, established since the beginning of his career in the 1860s, tended to obviate the need for them.

Nevertheless, Monet did employ various alternative methods for preliminary notations of landscape. He made rapid delineations of possible sites and compositions in pencil in sketchbooks; he occasionally used pastel to note motifs and changing weather effects; and he made some oil sketches, of which the three made at Vétheuil in 1881 are a particularly intriguing clutch. We know little of Monet's practice in any of these different media, and his use of them all seems to have been unsystematic and sporadic. With these three oil sketches we can only speculate about their purpose or purposes. No others survive from this period, though it is not impossible that more were made and, as insignificant work intended neither for sale nor exhibition, were discarded. These studies seem to have been painted after Monet's trip to Fécamp in early 1881, when he had exploited the pictorial possibilities of high vantage-points. It may be that the two oil sketches made from the chalk crags between Vétheuil and Chantmesle were made as Monet explored the possibility of painting similar motifs along the Seine. It would have been convenient to essay painting from such inaccessible sites on smaller supports, before attempting it with full-size canvases. In the event, he did not pursue these motifs. Another dimension also presents itself. All three little paintings belonged to Blanche Hoschedé (1865–1947). Blanche herself became a painter, tutored by Monet, who depicted her at work *en plein air* in 1887 (w.1131). It is possible that these little studies, and particularly the rather conventionally framed view of Vétheuil viewed from the studio-boat, were made as a means of giving the teenage Blanche her first lessons in painting. RT

106

42

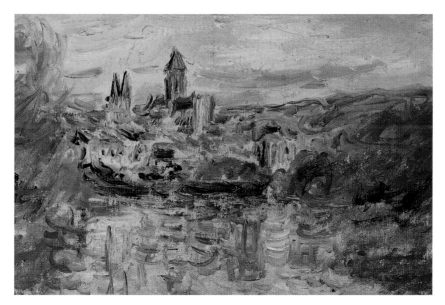

43

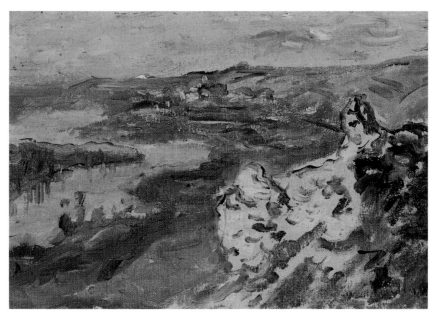

44

45. *Path in the Wheat*, 1881

Oil on canvas · 65.5 × 81.5cm
The Cleveland Museum of Art,
Gift of Mrs Henry White Cannon
w.676

This extraordinary painting was made on the presqu'île de Moisson, the flat peninsula of land that fills the great curve of the Seine that swings past Vétheuil between Rolleboise and Bonnières. When Monet crossed the river from his home to the Lavacourt bank, he usually turned to face Vétheuil or placed his canvas to look either up or down river. In this instance, he walked beyond the hamlet of Lavacourt, stretched along the bend of the river, and tackled the flat arable land on the alluvial plain. Painted in high summer, after his return in mid-April 1881 from the successful trip to Fécamp, *Path in the Wheat* is one of the handful of entirely successful paintings that Monet painted at that time, as he began to tire of Vétheuil. The very fact that he was walking further away from the river to find such a site is indicative of his search for new visual stimuli in the locality.

Path in the Wheat immediately and immaculately gives a sense of extraordinary actuality. Monet showed it at the 1882 Impressionist exhibition, and the only critic who remarked upon it called it '*bien vrai*', 'very true' or 'very accurate'.[1] The poplars in the middle ground, like the silvery crop of alfalfa rendered in flicked strokes at the artist's feet, seem to oscillate gently in the warm summer breeze, while high in the sky the cirrus spins its skeins across the panoply of blue. This is *plein-air* painting *par excellence*. And yet it is also a notable example of Monet's craft as a composer of pictures. The painting has several 'horizons' – the band of red-orange strokes at the base of the corn, the strip where the gold of the distant cornfield ends, and the hazy blue hills in the very distance – perfectly pitched at spatially nuanced moments. The path, equally, is set agreeably off-centre, its gentle arc playing against the horizontals and verticals to which it leads the eye. Above the regular equilibrium of these planes and accents, the more gestural treatment of the sky offers the eye a textural alternative, but one equally evocative of space, this time void not distance. Monet's instinct for construction necessarily involved colour. In *Path in the Wheat* the middle ground is established with the warm band of the ripe field of grain, which is surrounded by cooler tones of green and blue. But he was shrewd enough to insert accents of other colours to animate this simple chromatic armature. In the foreground, for instance, flecks of vermilion represent poppies blooming in the crop. These bright marks act as complementaries to the green amongst which they are scattered, just as the larger zone of orange-gold in the centre plays off against the complementary blue of the summer sky. *Path in the Wheat* bears witness to Monet the master craftsman. RT

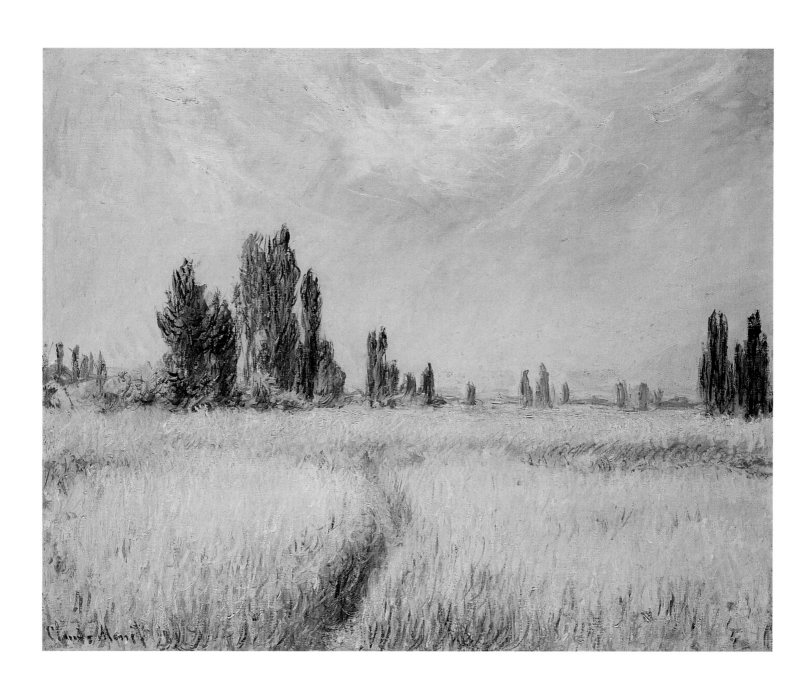

46. *The Artist's Garden at Vétheuil*, 1881

Oil on canvas · 150 × 120cm
National Gallery of Art, Washington DC,
Ailsa Mellon Bruce Collection
W.685

The largest painting that Monet executed at Vétheuil, this sun-drenched canvas might well be seen as a pictorial resolution of the personal difficulties Monet had experienced there. The canvas is signed and dated 1880, but in the hand of the elderly Monet, and was in fact painted in the high summer of 1881, the year in which three smaller versions of the same motif were dated.[1] The painting is set in Monet's garden, which stretched down from the path from which he painted behind him to the river. At the top of the steps the road to La Roche-Guyon separated the garden from the Monet-Hoschedé house, the roof of which can be seen at the top of the canvas.

The sequence of the three smaller paintings is not certain. It is possible that the smallest (W.682) came first, as it is the simplest, with no figures. The two others are on canvases of the same size, *toile de 40*, one introducing two blue-and-white vases filled with gladioli (W.683) and the other both vases and two children on the stair (W.684). The Washington painting is not only significantly larger; it was also painted on a canvas not corresponding to the stock commercial formats, suggesting that Monet stretched it himself to arrive at particular proportions. Both its size and his care over the canvas suggest that he might have considered the big picture for exhibition, though in fact it was never shown publicly in his lifetime. This returns us to the notion that, despite its scale, the painting was a private work, in some way a farewell to Vétheuil, which he left in December 1881. The smaller variants, on the other hand, seem all to have been sold to Durand-Ruel within a year of their execution, the smallest being purchased by Alexander Cassatt, brother of the American painter Mary Cassatt. The paintings' decorative qualities, prefiguring Monet's views of his flower garden at Giverny, obviously appealed to the market. One of the two equally sized canvases was shown at the 1882 Impressionist exhibition.[2]

Monet prepared the large canvas with a brown-grey ground, and laid on the deeper tones – dark blue, petrol blue and aubergine – first. From this base he built up the colours of the extraordinary profusion of flowers and foliage, using rich pink, blanched green and mid grey-blue on the vegetation and the house and peach pink on the path, these almost pastel tones being offset by grey-blue shadows, touched with dull pond-green and crimson. Monet animated the extensive surface, and differentiated the multiplicity of shapes and textures, with a very varied touch. He used brushes of different size. The edges were painted in fat, comma-like dabs, while around the stair rails he employed more horizontal, widely placed, touches. By contrast, the gladioli that help fix the foreground planes were executed in long, quite heavily textured strokes.

The Artist's Garden presents the viewer with an entirely bourgeois experience. It may have been painted in a rural village – determinedly excluded here – but this is no peasant yard. Its prodigality of plants nurtured for colour and delight, its oriental vases, and the symmetry of its design lend an aura of prosperity and propriety. One of the teenaged Hoschedé girls plays an appropriately motherly role, keeping an eye on the two little boys. Michel Monet stands on the steps and Jean-Pierre Hoschedé at their foot. The two families are thus integrated in this *hortus conclusus*, the psychological harmony of this new arrangement echoed by the formal symmetry and chromatic richness that surrounds the children. Once again, one might say, Monet found himself able to return to an encapsulating and harmonious form for representing his family, such as he had used in his 1875 portrait of Camille embroidering (fig.54), after the disruptive asymmetry of *Camille on her Deathbed* (cat.no.17). With *The Artist's Garden at Vétheuil* Monet used his professional means of expression – the painting of nature – to articulate a private psychological state of contentment and resolution. RT

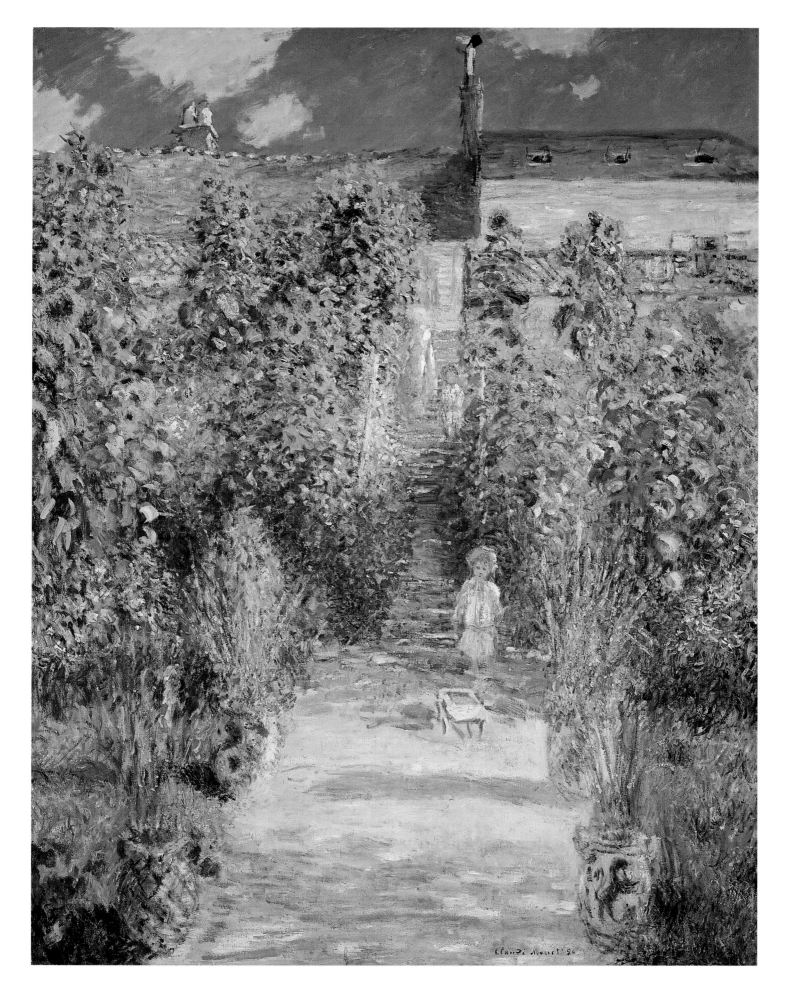

47. *The Cottage at Trouville, Low Tide*, 1881

Oil on canvas · 60 × 73.6cm
Carmen Thyssen-Bornemisza Collection on
loan to the Museo Thyssen-Bornemisza, Madrid
w.686

48. *The Sea Coast at Trouville*, 1881

Oil on canvas · 60 × 81cm
Museum of Fine Arts, Boston
The John Pickering Lyman Collection,
Gift of Miss Theodora Lyman
w.687

49. *Cliff at Sainte-Adresse, Grey Weather*

Oil on canvas · 60 × 73.5cm
Ordrupgaard, Copenhagen
w.689

In late summer 1881 Monet made another, brief trip to the Normandy coast. The motives for this were probably twofold. In all likelihood he wanted to follow up the successful campaign at Fécamp earlier in the year, and he was already tiring of the motifs available at Vétheuil, from which he would move in December. We know very little about the trip. On 13 September he wrote dispiritedly to Durand-Ruel: 'I'm back at Vétheuil. The persistent bad weather having hindered any kind of work, I have had to come back, and to return with an empty bag.'[1] This was not entirely frank, as four paintings seem to have resulted from this excursion. Monet travelled to the vicinity of Le Havre, at the mouth of the Seine, the area where he had spent his boyhood and much of his apprenticeship as a painter in the 1860s. He painted one canvas at Sainte-Adresse (w.689), in fact a motif he had already painted in 1873, and three on the hills above the fashionable tourist resort of Trouville (w.686–8) on the other side of the Seine estuary.

Despite Monet's own disparagement of this brief trip, the four paintings serve as a litmus test of what Monet sought out when on a painting campaign at this time. The motifs are resolutely asocial. *The Cottage at Trouville* represents an isolated former customs watch-house, with fishing boats far across the bay, while *Cliff at Sainte-Adresse* depicts a tourist beach in inclement conditions, a holiday villa lonely on the heights and a couple of figures down by the breakers. The other two canvases represent the undulating pastures atop the coastline, staffed only by wind-shaped trees and the occasional cow. Typically, they show Monet's fascination with weather effects. In *The Cottage at Trouville* the low tide has all but bared the sand, and the artist was fascinated by the play of light on the surface of the shallow water, warm pinks and yellows modulating against the blues and greens. The stone structure itself acts as a solid mass, weighing down the foreground to counterpoint the vast plane of colour relations that stretches out beyond. *The Sea Coast at Trouville* also deals with space, but paradoxically by masking it off. The canvas is dominated by rich mid-green tones, flecked with blues, even violet in the foreground, as well as yellows and pinks, to give a sense of the play of sunlight. The sea is more heavily textured than the sky, but the transition from one to the other is gentle in the haze. On the horizon Monet placed a white mark to indicate a distant sail, a late addition intended to evoke vast space. The central tree both establishes the foreground and, while obscuring the central horizon, nevertheless draws attention to the far fusion of sea and sky. Interestingly, Daubigny

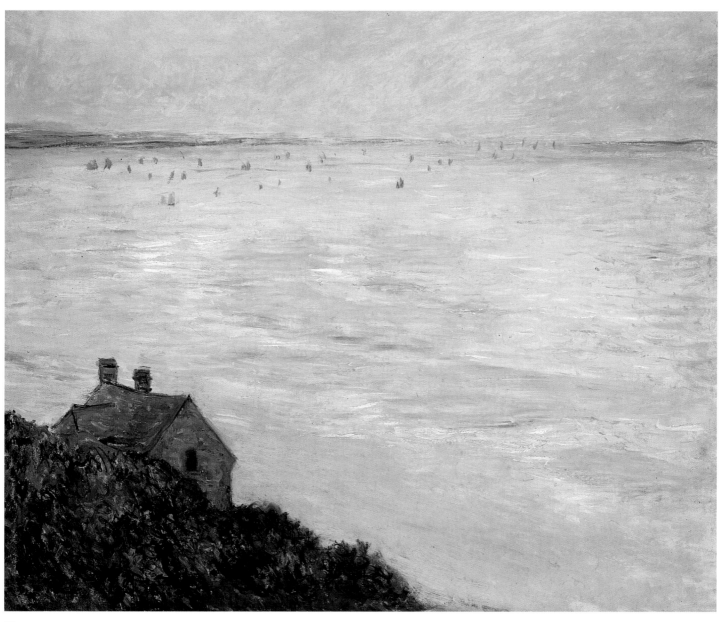

47

48

Fig. 63. Charles-François Daubigny *The Coast at Villerville (Calvados)*, 1859
Musée des Beaux-Arts, Marseilles

49

had exhibited a canvas of windswept trees on cliffs not far from Trouville, the *Coast at Villerville (Calvados)* (fig. 63), at the Salon of 1859. The eighteen year-old Monet had seen that exhibition. But his approach shows the difference between the generations. Daubigny's larger canvas was deep in tone and rich in texture and detail, while Monet's was more high key in colour and economical in form. However, both in their own way evoke the elemental loneliness of these exposed places. Monet included *The Sea Coast at Trouville* among the works he showed at the 1882 Impressionist exhibition.[2]

Cliff at Sainte-Adresse most closely tallies with Monet's letter to Durand. The painting remained a sketch, with much bare canvas remaining visible beneath the grey, brown and white tones Monet dashed down. One gets a vivid sense of the artist struggling with palette and easel as a strong west wind gusted in from the Channel. Nevertheless, he felt satisfied enough with the vitality of the work to sign it, perhaps at a later date. The canvas was sold in 1899 to the publisher and collector Paul Gallimard. RT

50. *The Port of Dieppe, Evening,* 1882

Oil on canvas · 69 × 73cm
The Dixon Gallery and Gardens, Memphis,
Gift of Montgomery H.W. Ritchie
w.706

Early in 1882, with the family now settled at Poissy, Monet decided to travel to Dieppe for a painting campaign. He had never worked there before. On 6 February he arrived in the town, and reported enthusiastically to Alice Hoschedé, 'There are some lovely things to do. The sea is superb, but the disposition of the cliffs is less beautiful than at Fécamp. Here, I'll definitely do more boats.'[1] He wrote to Durand-Ruel the same day, saying that he expected to return with a good deal of canvases.[2] But Monet's enthusiasm did not last. He spent the next day exploring the potential motifs both on the beaches and on the cliffs each side of the port, and despite the sunny weather was only confirmed in his initial view that Dieppe was not as stimulating a site as Fécamp.[3] Having paid a week in advance for his hotel room, Monet was committed to stay at Dieppe until 14 February, when he moved to the small beach resort of Pourville, some five kilometres to the west. Three paintings attest to the week's activity: this view of the port across the harbour, a panorama over the town taken from the cliff to the west, with the château in the foreground (w.707), and a view from the cliff edge along the beach (w.708). Together, these three canvases typify the way he might initially explore a locale, because they exemplify different categories of landscape painting – in these cases the scene of everyday modern life, the picturesque tourist view, and the solitary sublime that he had so savoured at Fécamp.

Monet's dissatisfaction with Dieppe tells us something about him as both a man and an artist. His letters to Alice indicate that he was worried about his son Jean, then settling into a new school in Poissy, and about the future of his relationship with Alice. There were financial considerations, too. Dieppe, a commercial and tourist centre, was costly, and Monet needed cheaper lodgings for an extended campaign. In addition, his hotel was in the centre of a town of 20,000 people. It was an enormous relief for him to be able to report on arrival at Pourville that his new lodgings were right on the shingle.[4] Reading between the lines of these letters we see how Monet's character as a painter had shifted over the last five years. Gone was the artist who had painted the Gare St-Lazare and the Parc Monceau in 1877; now he preferred unpeopled coasts and exposure to the elements.

Nevertheless, he did not waste his week at Dieppe. The view of the port, with the sun setting behind the church of St Jacques, is a reprise of the port scenes he had painted in the later 1860s and early 1870s, in particular those he had made at Le Havre in 1873 and 1874 (w.263–4; w.295–7). The painting, although not of small scale, is in effect an *impression*, a picture rapidly executed in order to catch fleeting conditions – here the sunset – and not carried to a high level of finish. This status would correspond to the painting's history: it never left Monet's studio. Standing on the quay on the eastern, Pollet, side of the harbour, Monet blocked out the main forms of the buildings in varied tones of mid and deep blue. Around this cool armature he played the yellows, oranges and violets of the light of the setting sun, in strokes more horizontal in the sky and rippling on the waters of the *avant-port*. The need for haste brought out Monet's remarkable flexibility of wrist, which enabled him to draw fluidly with paint. For all the personal qualities of Monet's painting, the motif was not a new one. Many artists had painted Dieppe, and Daubigny, for one, had depicted this very motif only a few years before (fig.64). It is possible that another reason why Monet moved from Dieppe to the less-known Pourville was that he wanted motifs that he could categorically make his own. RT

Fig.64. Charles-François Daubigny *Dieppe,* 1877
The Frick Collection, New York

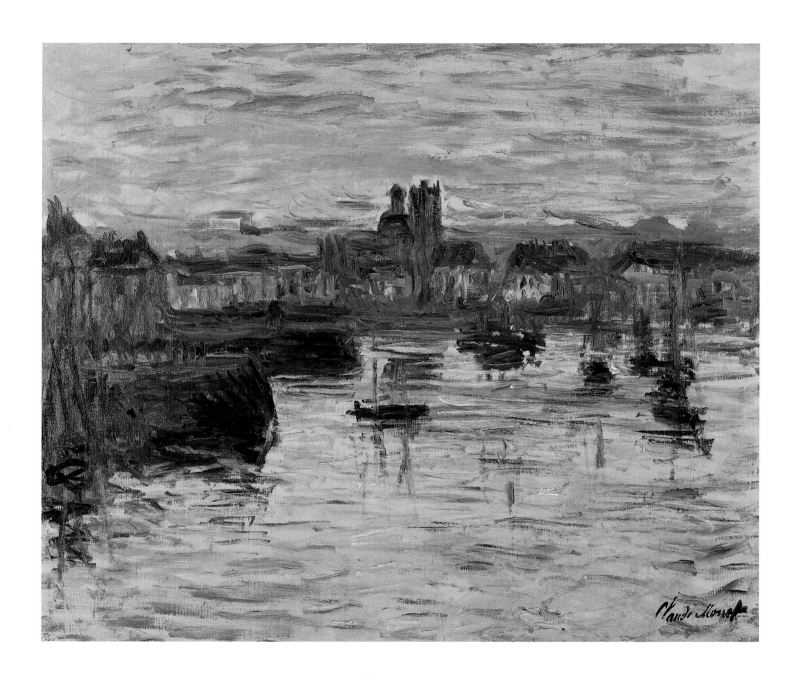

51. *The Church at Varengeville, Morning Effect*, 1882

Oil on canvas · 60 × 73cm
Private Collection, courtesy of Richard L. Feigen
and Company
W.795

52. *Low Tide at Varengeville*, 1882

Oil on canvas · 60 × 81cm
Carmen Thyssen-Bornemisza Collection on
loan to the Thyssen-Bornemisza Collection,
Madrid
W.722

Fig.65. Jean-François Millet *In the Auvergne*,
c.1866–9
The Art Institute of Chicago, Potter Palmer Collection

Monet was alone in Pourville from mid-February to mid-April, and again with Alice Hoschedé and their children from mid-June to early October, a total of five and a half months. Some one hundred canvases survive from these two sojourns, suggesting a prodigious output of about four paintings per week. The letters Monet wrote to Alice during his first stay attest to his hard work. He described how he would work on eight different paintings in the course of a day, exertion of an hour or so on each making each daily session a period of intense creativity. Sometimes he was so exhausted that, on returning to his lodgings with the Pauls (see cat.nos.62 and 63) he would eat his dinner and go straight to bed.[1] For the variety of canvases he now needed, swapping from one to another as conditions changed, he needed help, and employed a local man to carry them. One day his work plans were stymied because his porter was dead drunk.[2] On his second trip he probably used the more reliable children for this task. The number of canvases in train at once testifies not only to Monet's hard work, but also to the variety of effects and motifs he sought, and above all to the nuances that he now brought to his work as a *plein-air* painter.

These two paintings were – it seems – made at a very similar place on the beach between Pourville and Varengeville, and in similar conditions, at low tide. However, whereas the painting of the Varengeville church was painted during the summer of 1882, the view along the beach was executed during his stay earlier in the year, as it was purchased from Monet by Durand-Ruel in April that year. The motifs could hardly be more contrasting.

Low Tide at Varengeville was painted to the west of Pourville, which is lodged in the break in the cliffs that Monet painted in the middle distance. By choosing a low tide motif Monet added another option to his inventory of possibilities at beach level. While he frequently used this low vantage-point to offset the relatively flat plane of the sea against the flanking mass of the cliff, here the sea is little more than a strip to the far left. Instead, the still pool formed by the retreating tide gave the artist a natural mirror in which to echo the forms of the cliffs. Monet's painting is a remarkable evocation of the light, colours, textures and one might almost say smell of a Channel beach at low tide. Beneath a soggy overcast sky through which the sunlight tries to break, Monet conjured the rich pink-gold of the moist sand, the dense greens of the seaweed-covered rocks, and the deep red-browns of the rich soil that smears the cliff edges, having been carried down by the rains. The superbly realised atmospheric effects of this canvas were recognised by Alfred de Lostalot, reviewing Monet's one-man show in the *Gazette des Beaux-Arts* in April 1883.[3] He wrote admiringly of '*The Low Tide*, with the imposing cliffs of Varengeville, covered with algae and reflected in tranquil pools, filtered by the sand of the beach: a marvellous impression, a painting of a rare charm and accuracy'.

Monet had painted the church at Varengeville four times earlier in the year, always from the top of the cliffs (cat.nos.56, 57). On his second sojourn at Pourville he represented it again, but this time his three canvases were painted from the beach (w.794–6). At high tide, the church cannot be seen from the shore, so Monet had to wait until the tide was way out over the shallow beach before he could get the view of the building peeping precariously over the cliff edge that we see in *The Church at Varengeville, Morning Effect*. Monet might simply have found this startling vantage-point haphazardly while on a scouting trip or while working at beach level. However, this kind of angle of view, in which the artist/spectator looks quite abruptly upwards so that objects are partially obscured behind the steeply pitched horizon and the sky forms rather less of a feature than one would expect in a more conventional landscape, had been essayed recently by Jean-François Millet. During the late 1860s Millet had found that working in the mountainous region of the Auvergne, in the Massif Central, had led him to such solutions (fig.65). Millet's work, including his Auvergne compositions, was well

51

52

represented in the exhibition of *Maîtres modernes* that Durand-Ruel had staged in 1878. It is possible that here, or elsewhere, Monet had seen Millet's adventurously tilted landscapes, and that the sight of the Varengeville church from the beach in 1882 encouraged him to try something similar. That said, *The Church at Varengeville, Morning Effect* shows Monet at his most confident and personal. Three quarters of the composition are filled by the massive cliff-face. It is painted not as a block but as a matted surface of strokes and colours, ranging from deep blue in the shadows to streaks of pink and yellow on the surface, as the light falls on the soil and chalk. There is a spontaneity about the play of brush and medium which suggests not simply the need to work rapidly while the tide was out but also Monet's excitement at tackling such a stirringly vertiginous site. Landscape painting, conventionally an art concerned with the suggestion of extensive space, here has its conventions all but denied. Foreground space is abruptly limited by a great wall, the sublime dominating space. But just as Monet implied void in his paintings looking down from cliffs, in the angle between cliff and sea, so here he suggests vast space behind the great bluff and beneath the scudding clouds. RT

53. *Low Tide, Pourville,* 1882

Oil on canvas · 60 × 81cm
The Cleveland Museum of Art,
Gift of Mrs Henry White Cannon
W.716

54. *The Sea at Pourville,* 1882

Oil on canvas · 54 × 73cm
Philadelphia Museum of Art,
Bequest of Mrs Frank Graham Thomson
W.772

55. *Shadows on the Sea, Pourville,* 1882

Oil on canvas · 57 × 80cm
Ny Carlsberg Glyptotek, Copenhagen
W.792

Low Tide, Pourville was painted on Monet's visit to the fishing village-cum-resort in the early months of 1882, and *Shadows on the Sea* during his second sojourn over the summer months. Both were painted on the same size of canvas – apparently a *toile de 25* – and take approximately the same view from the west of Pourville, which can just be glimpsed to the right. In neither canvas was Monet much interested in the place, the buildings of which serve merely to give a sense of scale and distance. Rather, he more or less bisected each canvas with the horizon line, devoting the upper half to an expanse of sky and the lower to the plane of water. The cliffs rising to the east of Pourville served as a mass at the right-hand centre.

That said, there are distinct differences between the canvases, as one would expect. Given that these cliffs face almost due north, the Cleveland canvas was apparently painted towards the end of the day, with strong late afternoon light coming from behind the painter, his easel set in the sand flats. The Copenhagen picture, on the other hand, takes a moment nearer midday, with a cliff to Monet's right casting a shadow across the shallow water. Again, the Cleveland painting was made early in the year and has the crisp, clear light of, say, March, while the Copenhagen work has a more moist light that veils the distance, more fitting to a summer's day. As John House has pointed out, the surface of *Low Tide, Pourville* reveals a number of changes Monet made in the course of the painting's execution, adjustments he improvised in response to changing

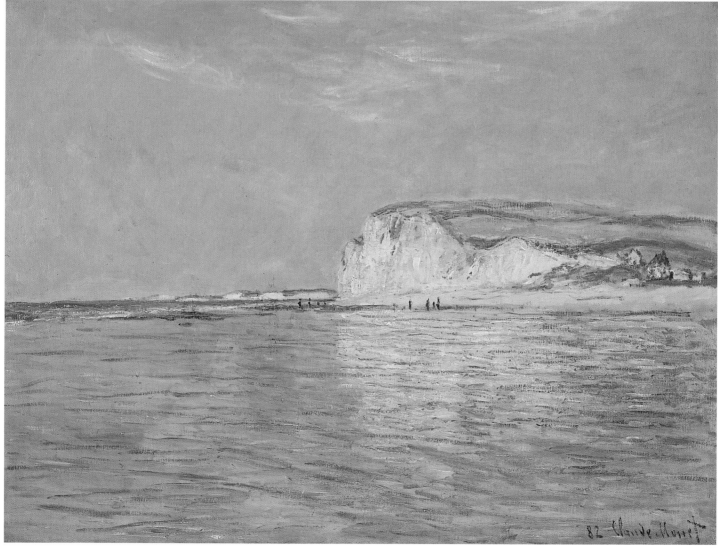

53

54

effets and his own instincts for pictorial balance. The foreground was originally sand, but Monet painted over it a thin wash of water, presumably because the tide came in as he worked. Again, there were once clouds over the cliff, which he painted out in all probability because the weather improved. But when he added blue sky at the right to make the cliff slope more, and painted out what may have been poles for fishing nets to the left of the cliff, he was responding to his own aesthetic sense.[1] With *Shadows on the Sea* a similar process may have taken place. The vantage-point seems to place Monet in the water. He may have painted from an exposed rock, of course, though it is possible that he brushed in the foreground while the water was still sufficiently shallow for him to work *in situ*, and added the comma-like strokes which define the nearby wavelets back in his hotel room or studio.

 The Sea at Pourville was also painted on the campaign of summer 1882, one of five

55

paintings he made then looking directly out to sea (w.766, 771–4). The pinks and
yellows that animate the sky suggest a time towards sunset, though it is possible, too,
that the painting might represent a dawn effect. The painting is about expanse, trying
to evoke ten or more miles' unbroken distance on the flat surface of a canvas. But it is
crucially also about illumination, light that falls not on a three-dimensional object like a
cliff, building or figure, which it then helps to shape, but on the undefined dimensions
of sea and sky. Monet did not necessarily plan his paintings to read from edge to edge as
a linked panorama, now looking westwards along the coast, then looking northwards
out to sea, finally looking eastwards along the coast. But, as he worked at beach level, his
eye must have been successively attracted to the different pictorial challenges that
views in various cardinal points provoked, and in the ensemble of his work striven to
meet them. RT

56. The Church at Varengeville and the Gorge des Moutiers, 1882

Oil on canvas · 60 × 81cm
Columbus Museum of Art, Ohio,
Gift of Mr and Mrs Arthur J. Kobacker
W.728

57. The Church at Varengeville, Contre-Jour, 1882

Oil on canvas · 65 × 81cm
The Barber Institute of Fine Arts, The University of Birmingham
W.727

On his first trip to Pourville in early 1882 Monet painted four views of the church at nearby Varengeville. While Pourville is a small coastal resort down on the beach, Varengeville, then a small farming community, is up on the cliffs a couple of kilometres to the west. Varengeville's most prominent building is the medieval church, perched perilously close to the edge of the cliffs and a point of reference to sailors out on the Channel waves. The motif obviously attracted Monet, who painted four versions of this motif (W.725–8).

Typically, the paintings represent different weather effects and times of day, although the fall of light in all four canvases suggests that Monet painted them after midday. The Columbus painting, for instance, seems to represent full afternoon sun. The sky is clear, though a sea mist blurs the horizon. The gorse is in flower, heralding spring, and a brisk breeze blows across the undulating pastures. By contrast, the Barber canvas represents a later hour. The sun is setting behind the church, which is silhouetted in *contre-jour*. This has the effect of simplifying the scene, because in the failing yet glowing light the landscape loses its defining features, only the pines, their foliage fanning across the golden sky, retaining any detail. Monet adapted his brushwork and colour accordingly. In the Columbus picture the strokes are quite tight and encrusted, particularly in the definition of the gorse, while the colour Monet applied corresponds very directly to the local colour of the natural features of stone and sky, grass and water. His handling in the Barber painting, which may have had some retouches in the studio, differs somewhat. Although the foreground vegetation retains a descriptive texture, the strokes on the slope up towards the church are long gestural marks that appear almost to lie on the surface. Here Monet seems to have used the physical actuality of the paint-loaded brushstroke to stand in for the intangible play of fading sunlight over the grass.

The result of these variations in, first, the chosen *effets*, light and weather effects, and, second, the means Monet chose to paint them was two rather different looking paintings. Despite being of the same motif from almost the same viewpoint, the Columbus painting is very exact in its description of site, moment and weather, a thoroughly naturalist landscape. The Barber painting, on the other hand, may respond to a natural occurrence – the flooding light of sunset – but its reductive simplifications and apparently exaggerated colour seem to be reaching towards a new kind of suggestive, rather than descriptive, painting. Nowhere is that more evident than in the free-floating brushstrokes that do not seek to describe surfaces but to approximate to the

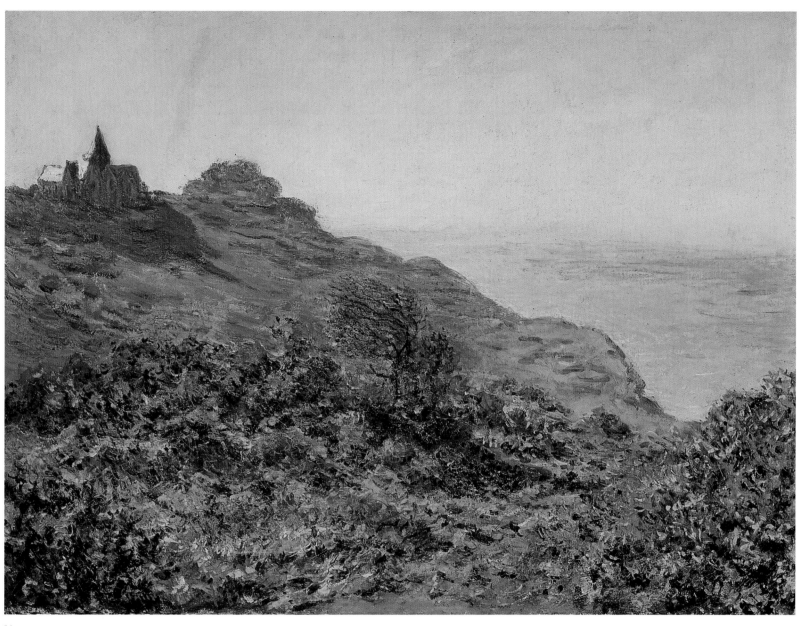

56

intangible. These were initiatives of which in 1882 Monet was probably only instinctively aware as he painted and which as yet he made no attempt to articulate verbally. Further developed, they would bear fruit by the end of the decade, as he began work on the *Grainstacks*, his first great series.

The site Monet chose for his views of the church at Varengeville was from a hill known locally as Les Communes. From there he looked across the concealed gorge of Les Moutiers, one of the great clefts in the cliffs cut by streams that run from the farmland above to the beaches below. To the other side the bank slopes up to the church. Similar kinds of motif – with well-anchored foreground, suggested central void, and solid background focus – can be found in landscapes of the previous generation, such as Corot's *Canteleu, near Rouen*, painted in 1872 (fig.66). But whereas Corot screened off the central valley in his painting with a row of trees, adding a figure to give a sense of scale and human purpose, Monet's inclination was to make the suggestion of void crucial to his composition, to emphasise the wild and windswept openness of such a place, and the precariousness of a place of worship set against sea and sky. Whereas Corot's landscape dealt in the soothing poetry of the pastoral, Monet's tilted towards the epic of the elemental.

It was neither the more naturalistic Columbus nor the more evocative Barber painting that Monet chose to represent this group of four paintings at his one-man show in 1883. Instead he chose another (W.726; location unknown), which seems to function at a mid-point between these two extremes in his work at this period. This painting was reproduced as a *gillotage* drawing in the *Gazette des Beaux-Arts* review of the exhibition (fig.67), which surely indicates that Monet found the composition of the *Church at Varengeville* group of particular importance in his recent work. RT

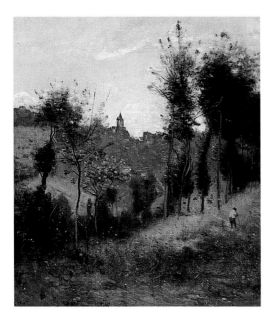

Fig.66. Camille Corot *Canteleu, near Rouen*, 1872
Musée du Petit Palais, Paris

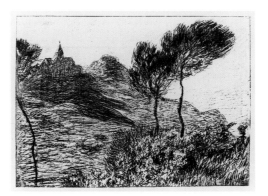

Fig.67. Claude Monet *The Church at Varengeville at Sunset*, 1882
Reproduced in the *Gazette des Beaux-Arts*, April 1883, p.347

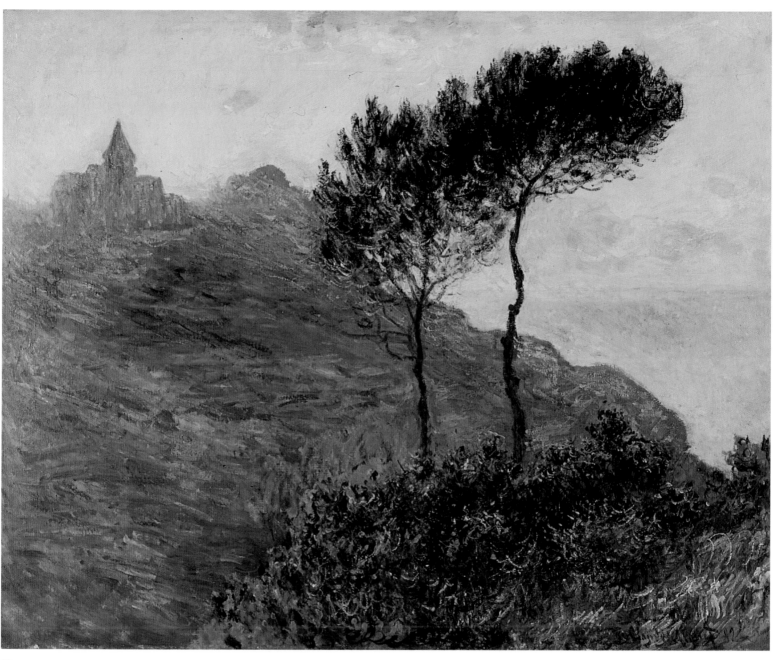

57

58. *The Douanier's Post*, 1882

Oil on canvas · 62 × 76cm
Fogg Art Museum, Harvard University Art
Museums, Bequest of Annie Swan Coburn
W.739

59. *Rising Tide at Pourville*, 1882

Oil on canvas · 65 × 81cm
Brooklyn Museum of Art, New York,
Gift of Mrs Horace Havemeyer
W.740

60. *The Douanier's Post*, 1882

Oil on canvas · 60 × 81cm
Philadelphia Museum of Art,
William L. Elkins Collection
W.743

61. *Path in the Cliffs at Varengeville*, 1882

Oil on canvas · 60 × 73cm
The New Art Gallery, Walsall,
The Garman Ryan Collection
W.804

Monet painted the small stone cottage on the cliffs to the west of Pourville some seventeen times during his two campaigns there in 1882 (w.730–43, 803–5). The building was one of a chain built along the French coast by Napoleon during the first decade of the nineteenth century to protect his Continental System, designed to cripple British trade with Europe. Sited on a cliff-top perch allowing customs officers (*douaniers*) to survey the coastal approaches westward of Dieppe, the cottage no longer exists, erosion of the cliffs having caused it to fall into the sea. The building that Monet so frequently represented – returning to it in the later 1890s (fig.31) – is often said to be at Le Petit-Ailly, though it may have been at the end of the Gorge des Moutiers between Pourville and Varengeville, and thus more within his known range.

Monet painted the motif in several compositional clusters, each canvas varying the type slightly. Thus the Fogg and Brooklyn canvases are two of three (the other is w.741) which view the cottage from above and place it to the right, while another group views it from slightly further away and places it to the left (w.735–8). Yet again, the Philadelphia painting is one of two (also w.742) which look down steeply on the structure from a higher bluff. Within these sub-groups Monet treated different *effets*. Thus the Fogg picture shows quite a cloudless sky with foaming breakers much stirred by the wind, while the Brooklyn painting represents a cloudier sky and a more regularly rolling sea dragging up the sand beneath to give the water a yellowish tone. In the Philadelphia painting, the pale pinkish marks overlaying the greens at the top of the cliff suggest the wind scuffing the long grass. Painting such variations, each of which required a modest but significant adjustment of the position of his easel as the weather effect changed, meant that Monet would have several canvases in train at once. He explained this multiple *plein-air* procedure in a letter to Alice in April 1882, perhaps while at work on these very paintings: 'Yesterday I worked on eight studies, supposing I worked there on each one for a bit less than an hour, you'll see that I don't waste my time'.[1]

These paintings have been interpreted variously. A common account is that the

Fig.68. Jules Breton *The Cliff*, exhibited Salon 1874
Forbes Magazine Collection, New York

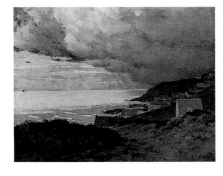

Fig.69. Jean-Charles Cazin, *The Storm, Equihen, Pas-de-Calais*, 1876 Musée d'Orsay, Paris

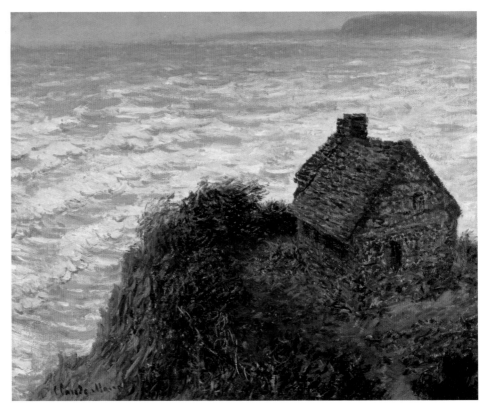

58

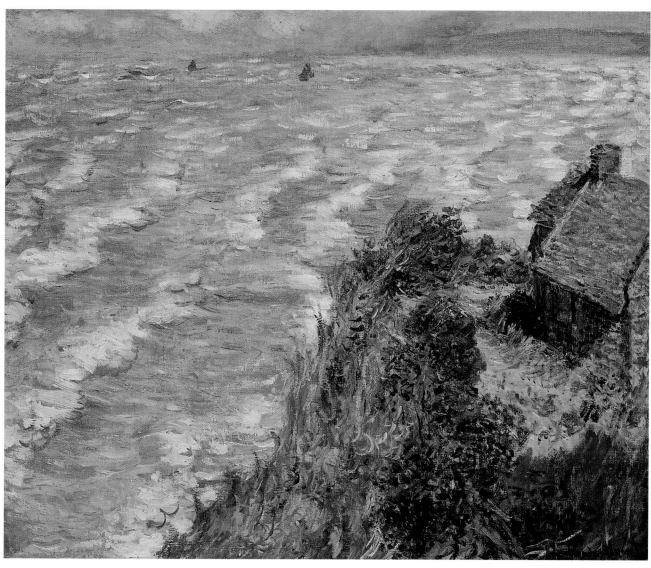

59

cottage is in some way an inanimate stand-in for the artist himself. As Andrew Forge has put it, 'the cabin is a presence on the edge of the cliff, looking out to sea as Monet is looking out to sea, the triangle of its peaked roof appropriating the perspective of his viewing.'[2] The building also serves a formal purpose. Its regular angles and shapes contrast with the more haphazard and rhythmic forms of the cliffs which surround it, and its block-like presence gives pictorial weight in a composition which is also concerned with evoking the void and plane over the surface of the sea. It might also be argued that Monet's use of a man-made structure to survey the sea, rather than an actual figure as was common in contemporary painting (fig.68), was a denial of commonplace sentimentality in favour of a more suggestive kind of landscape.[3] Another painter of Monet's generation, Jean-Charles Cazin, was currently making a considerable reputation with landscapes of his native Pas-de-Calais, typically painted in sombre brown and grey tones and with human presence hinted at by buildings and boats (fig.69). Indeed, at the Salon of 1881 Cazin had exhibited a marine of a *Rescue Post* (location unknown) which had attracted critical acclaim. Monet's canvases of the *douanier*'s post might at some level have been in response to such paintings. The Walsall *Path in the Cliffs at Varengeville*, painted on the second Pourville campaign and perhaps left unfinished, is painted in moody crepuscular tones that might be seen as an essay in rivalling Cazin's landscape vocabulary. RT

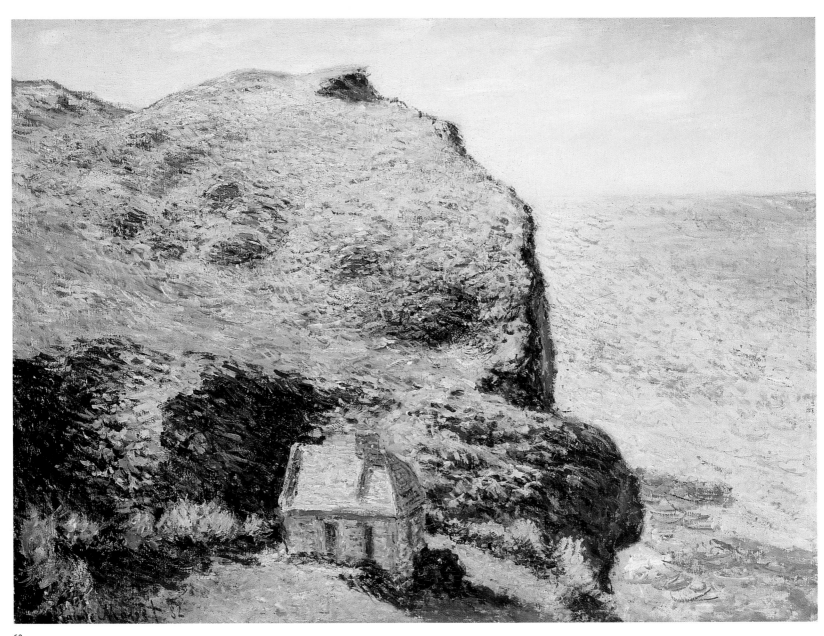

60

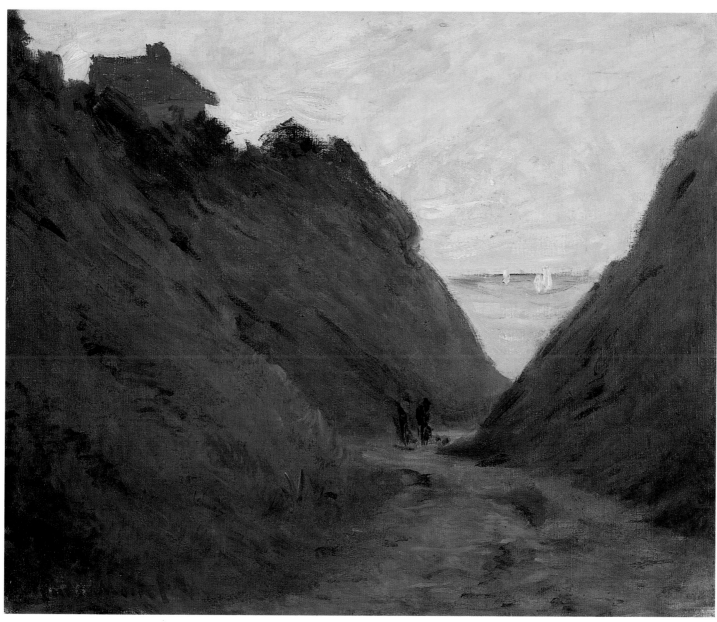

61

62. *Le Père Paul*, 1882

Oil on canvas · 64 × 51cm
Österreichische Galerie, Belvedere, Vienna
W.744

63. *La Mère Paul*, 1882

Oil on canvas · 65 × 54cm
Fogg Art Museum, Harvard University Art
Museums, Gift of The Wertheim Fund, Inc.
W.745

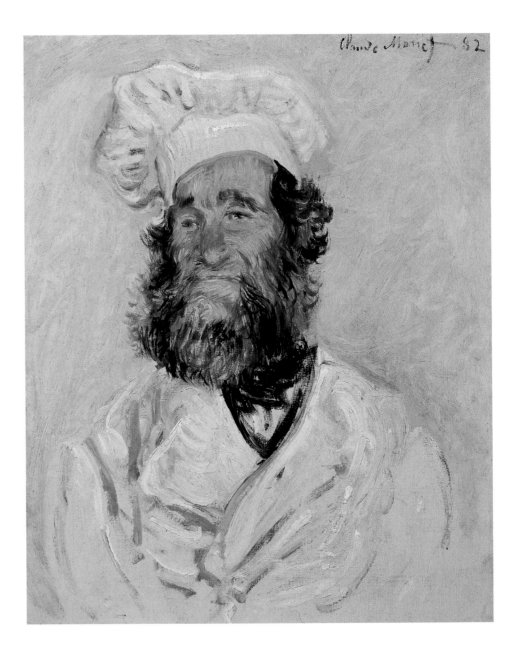

Taking against Dieppe, despite his initial enthusiasm, Monet moved in February 1882 to nearly Pourville, to the west (see cat.no.50). On 15 February he reported to Alice that he had found an admirable place to stay: 'One could not be closer to the sea than I am, right on the shingle, and the waves break at the base of the house'.[1] This was the hotel-restaurant run by Paul Graff (1823–1893) and his wife Eugénie (née Lavergne, 1819–1891). Both were natives of Alsace, and may have settled in Normandy in the wake of the Franco-Prussian War of 1870–1, after which Alsace and much of Lorraine were ceded to victorious Germany. Such resettlement was not always successful, and émigré families from Mulhouse re-housed at Le Havre, along the coast from Pourville, suffered abuse from the local Norman population. There is, perhaps, a somewhat resigned and sad expression both to the ruddy face of the master pastry-cook and the wrinkled features and rheumy eyes of his older wife.

Both paintings were executed quite rapidly, in all likelihood on occasions when bad weather prevented Monet from painting out of doors. Evidently intended as pendants, both share a similar palette, notably the swiftly sketched duck-egg blue background, and casual finish around the edges. Indeed, one might expect *Mère Paul* to be set in an

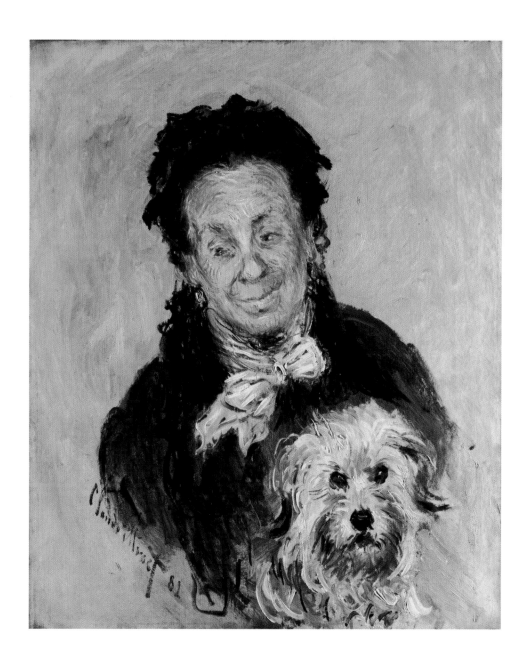

Fig.70 · Claude Monet *Galettes*, 1882
Private Collection (w.746)

oval frame. The two portraits demonstrate Monet's sharp eye for an individual's salient features, a skill honed in the caricatures he made as a teenager. He picked out Père Paul's grimly tight lips, thick, hooked nose and kind eyes, as well as his wife's wistful, rueful gaze, playfully counter-pointed by the alert visage of her griffon terrier Follette.[2]

Monet prized the former picture sufficiently to include it in his 1883 one-man show, though he did consider Alice's *caveat* that it might be considered a diversion from his landscapes and marines.[3] Gustave Geffroy recalled that the Graffs hung the two portraits in the linen room of their hotel – thus out of public gaze – each side of Monet's still life of *galettes* made by Père Paul (fig.70), so creating an informal private triptych.[4] RT

64. *Fishermen at Poissy*, 1882

Oil on canvas · 60 × 81cm
Österreichische Galerie, Belvedere, Vienna
W.748

In May 1881 Monet began to look for a new place to live, needing a better school for the adolescent Jean than Vétheuil could provide. Thinking of 'a pretty place on the banks of the Seine', and perhaps Poissy, he wrote asking for advice to Emile Zola, who lived at nearby Médan.[1] In mid December that year the Monet and Hoschedé entourage rented the Villa St-Louis in Poissy. But from the painter's point of view the move to the small town on the Seine some twenty-five kilometres west of Paris was a disappointment. As soon as 6 February the following year Monet was writing to Durand-Ruel from Dieppe, whither he had escaped to work, complaining that 'Poissy has hardly inspired me'.[2] Although the family was domiciled in Poissy for sixteen months before Monet finally settled at Giverny in April 1883, he painted only four paintings of local motifs. One was of trees in the town square, another a *sous-bois* in the nearby Fôret de St-Germain-en-Laye, and two were of men angling in the river (W.747, 750, 748–9). Although Monet found Poissy and its environs dull, other artists enjoyed the locale. The highly successful battle and costume painter Ernest Meissonier had a country villa at Poissy, and on several occasions he painted the nearby riverbanks (fig.71).

Monet viewed the anglers from a vantage in his house sharply above them. Such a tilted and apparently haphazard view denies the conventional notion of pictorial construction with perspective vanishing towards a horizon, but it does approximate to the way we might actually look. This kind of actuality, responding to our daily habits of viewing rather than aesthetic dogma, was frequently explored by contemporary naturalist artists such as the exhibitors at the Impressionist exhibitions. Monet's *Fishermen at Poissy* might be compared, for example, to some of Degas's ballet pictures in which we look down on the dancers on stage from a theatre box (fig.72). In this painting Monet also used the naturalist device of 'cutting off' a figure – here the angler standing on the bank – in order to give a sense of life beyond the confines of the canvas. Nevertheless, the composition is carefully controlled, with the moored boats forming parallels to the towpath, this structure of forms ordering the play of greens and browns that suggest the rippling surface of the Seine.

Monet exhibited this painting at his 1883 one-man show, the same year as it was sold to the opera singer Jean-Baptiste Faure. There it would have struck an unusual note among his other landscapes. In April 1883 the periodical *L'Art moderne* published a *gillotage* drawing (Fogg Art Museum) of the other angler motif, which includes two boats and fishermen. These compositions seem to have impressed the young Georges Seurat, who in 1883 painted a very similar scene, which he exhibited at the eight Impressionist exhibition in 1886 (fig.73). RT

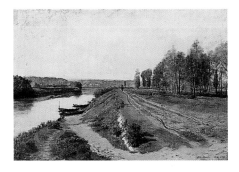

Fig.71 · Ernest Meissonier *The Seine at Poissy*, 1884
Philadelphia Museum of Art

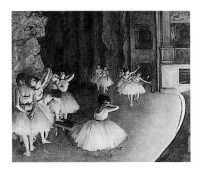

Fig.72 · Edgar Degas, *Rehearsal of a Ballet on Stage*, 1874 Musée d'Orsay, Paris

Fig.73 · Georges Seurat *Anglers*, 1883
Musée d'Art Moderne, Troyes

65. *Promenade on the Cliff at Pourville, 1882*

Oil on canvas · 65 × 81cm
The Art Institute of Chicago, Mr and Mrs Lewis
Larned Coburn Memorial Collection
w.758

66. *On the Cliff at Pourville, 1882*

Oil on canvas · 65 × 81cm
Nationalmuseum, Stockholm
w.755

Both these paintings date from Monet's second visit to visit to Pourville, during the summer of 1882. They belong to a cluster of five paintings which represent the cliff-tops to the east of Pourville, between the resort and the port of Dieppe (w.754–8). These canvases all look out to sea, in a generally north-easterly direction, rather than along the coastline, and all pitch the uneven line of the cliff edge against the flat plane of the sea. Two, the Stockholm painting and another in the Museum of Modern Art, New York (w.756), represent a view down a steep slope on the cliffs to a great cleft in the chalk face, a site known as the Val St-Nicolas, now much altered by erosion. The mass of the cliff seems to gape open, and the sea to pour into it, an effect exaggerated by Monet's vertiginous viewpoint which shoved the horizon out of the top of the picture. Both these dramatic compositions, staged like a competition between surging land forms and gently swelling sea, include fishing boats out to sea, man's tiny presence in this sublime setting.

Two other canvases, that in Chicago and another of the same motif (w.757), look out to sea at an angle of about forty-five degrees. This offers a view of the bluffs in something of a step formation, rising from lower left to bottom right. It was a motif that Monet altered to suit his fancy, for the right-hand shoulder in the Chicago canvas was not originally in the painting, but was added.[1] The Chicago painting additionally represents two figures, probably posed by two of Alice Hoschedé's daughters, in the wind near the

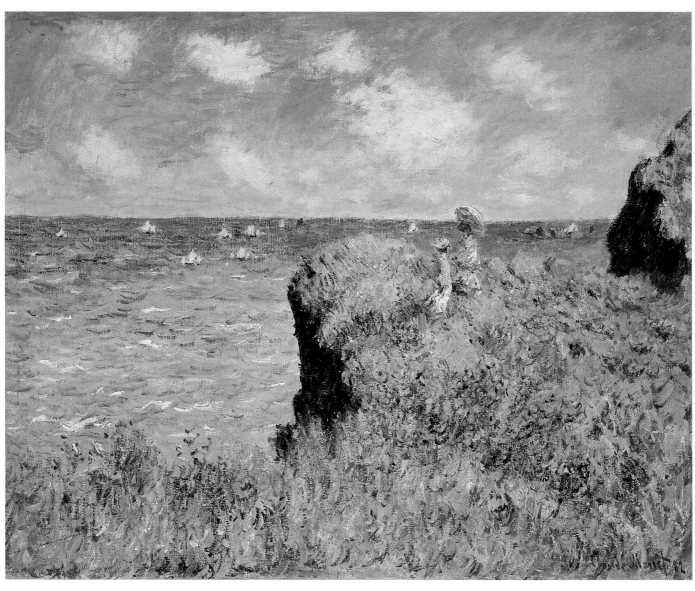

65

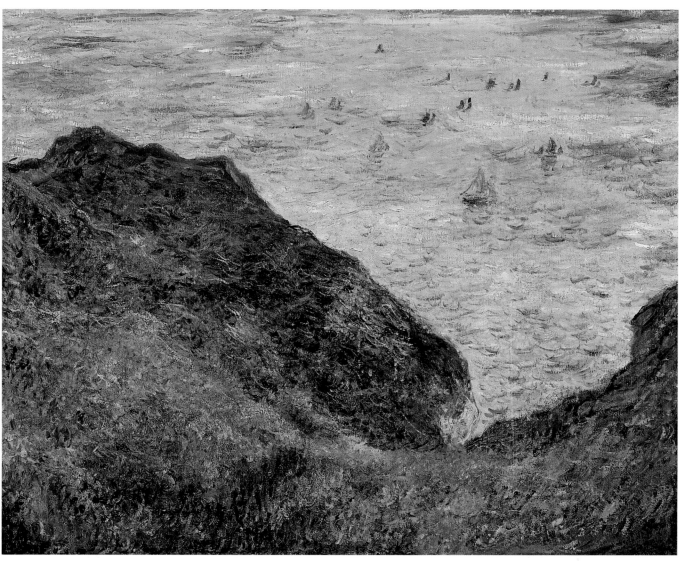

66

edge of the cliff. A fifth canvas, in a more horizontal format, about a metre across, is almost a fusion of these two pairs (w.754). It looks straight out to sea across a valley on the cliff-top to the boats out in the Channel, watched by two women. However, this painting is more tranquil than the two pairs, with the plunge of the edge pushed well back and the surface of the sea smooth and still.

Durand-Ruel bought all five canvases, the panoramic vista in January 1883 and the other four in the same year or the year before. Monet elected to show one each of the pairs at his one-man show in 1883. *Promenade on the Cliff at Pourville* was no.20, and either the Stockholm or the New York canvas no.23. This choice of two paintings was a carefully selected contrast. The *Promenade*, with its bourgeois women in their windblown dresses, would have reminded the visitor to the exhibition that the Normandy coast was a tourist destination, celebrated for its bracing climate and dramatic coastline. While Monet was fascinated by the effects of scudding clouds, choppy sea and wind-tossed grasses, all shimmering under the summer light, his combination of tourists and fishing boats juxtaposed the temporary visitors at leisure with the local toilers of the sea, an implicit recognition of the contemporary character of places such as Pourville and Dieppe.[2] By contrast, a motif such as *On the Cliff at Pourville* set up a different dialogue. Here the fishing fleet confronts its traditional enemies, the shifting moods of the sea and the potential threat of the rocky shore. Monet was adept at selecting the paintings he displayed to the Parisian public, the better to show the full range of his work. RT

137

67. *The Cliff at Dieppe*, 1882

Oil on canvas · 65 × 81cm
Kunsthaus, Zurich
w.759

This unusual painting was made during Monet's second visit to Pourville in 1882. It was executed on a visit to Dieppe, and represents a view of the great cliff that flanks the west of the port. Monet would have painted it near the château, which stands on raised ground in the lee of the cliff. The painting was lightly and spontaneously realised. Sea and sky were quite thinly brushed in, the artist reserving most of his attention for the massive form of the chalk cliff. This vertiginous mass he painted in a medley of greens, offset against the white of the chalk. Monet made the most of the local colour offered, bringing out the blue-grey of the shadow on the cliff-face and contrasting it with the complementary terracotta of the soil that spills down the edge, just as the new roofs of the precariously positioned buildings oscillate chromatically against the sky.

But this painting is exceptional not just in its unusually emphatic conjunction of mass and void and in its Dieppe site. It is a painting of the tourist season. Women with parasols promenade on the cliff-top, and the beach below is populated with bathers. Monet only very rarely painted the villas and cottages constructed for the holiday visitors that coastal towns like Dieppe, ports diversifying into resorts, increasingly attracted.[1] However, such places did attract his Impressionist colleagues. In 1882 Renoir, staying with his patron Paul Bérard at his château de Wargemont near Dieppe, made a point of painting the house that the celebrated actress Blanche Pierson had taken at Pourville for the holiday season.[2] Gustave Caillebotte, too, painted a considerable number of canvases on the Normandy coast during the early 1880s. His *Regatta, Villerville*, made in 1884, represents newly constructed holiday homes, superbly sited for an excellent view over the Channel and fenced off from the road, while out at sea is shown not the local fishing fleet but a race for prosperous yachtsmen like Caillebotte himself (fig.74). Caillebotte's painting emphasises the modernity – of construction, pastime and consumption – which dominates the natural beauty of the site. Monet's *Cliff at Dieppe* spurns such a reading. Monet did indeed represent tourists and their new accommodation. But while their villas top the cliff, they do not command. Indeed, they seem clumsy in form and fragile in substance, against the titanic block on which they stand. There is something cussed and ironic in Monet's approach, in what one might call a landscape painting of resistance.

This painting was shown at the Society of Scottish Artists, exhibiting in the Royal Scottish Academy building in Edinburgh, in 1902.[3] RT

Fig.74 · Gustave Caillebotte
Regatta, Villerville, 1884
The Toledo Museum of Art, Ohio

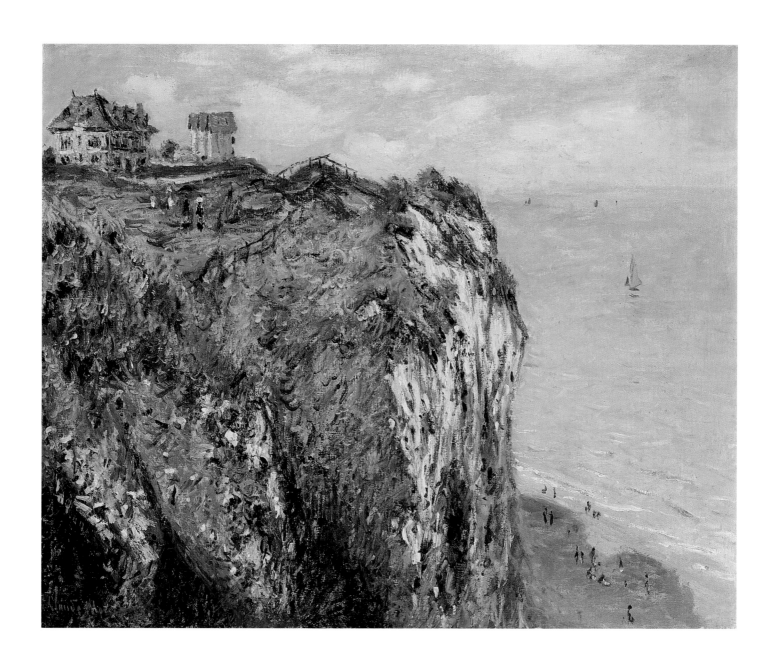

68. *Fishing Nets at Pourville,* 1882

Oil on canvas · 60 × 81cm
Gemeentemuseum, The Hague
w.768

69. *The Rocks at Low Tide, Pourville,* 1882

Oil on canvas · 63 × 77cm
Memorial Art Gallery of the University
of Rochester, New York,
Gift of Emily Sibley Watson
w.767

These two canvases were painted during Monet's second sojourn at Pourville, when he went there over the summer with Alice and the children from their two families. The weather in Normandy was poor during the summer of 1882, and regular sunshine did not arrive until mid September.[1] Thus, while these two paintings show overcast or cloud-blown days, they nevertheless were painted during the holiday season. Both represent the view from more-or-less the same position to the east of Pourville's beach, looking westwards towards the lighthouse on the pointe d'Ailly. In *The Rocks at Low Tide* the pines and church of Varengeville can be made out on the distant cliff.

Two further canvases (w.769 and 770) show almost the same view, though none of the four paintings appears to have been executed from exactly the same spot. A rapid drawing in one of Monet's sketchbooks (Musée Marmottan, 5131, fol.17r.) corresponds to the motif of *Fishing Nets*. It may be that Monet, having thus registered a satisfactory motif on a scouting trip, returned to it regularly, eventually reaching a tally of four paintings. In all four he adopted a vantage-point near the water's edge, with seaweed-covered rocks in the foreground. His position almost at sea level meant that the horizon is high, about two thirds of the way up the canvas, and in all four canvases the line of the horizon is broken halfway by the distant cliffs. The paintings differ in their *effets* – the Rochester canvas representing a skim of overcast, the Hague picture wind-blown clouds – and in the height of the tides.

All four might be described as 'working' landscapes, too. *The Rocks at Low Tide*

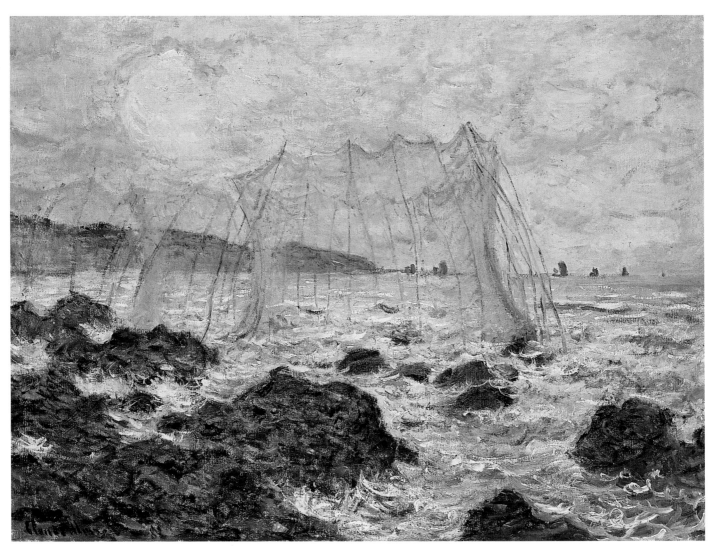

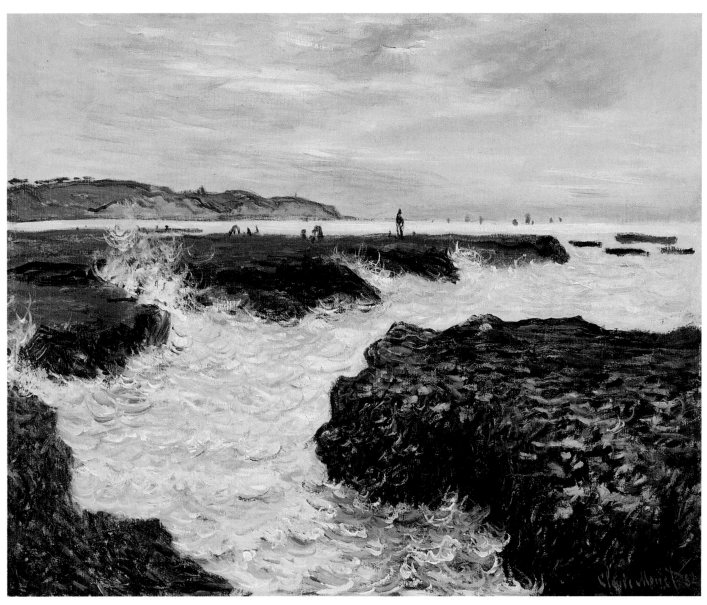

69

apparently shows local fisherfolk catching shellfish in the exposed tidal pools, with the fishing fleet out to sea. In the Hague painting the higher tide has covered the flat rocks, but inshore nets are spread, through which can be glimpsed boats out in the choppy Channel. The other two paintings both show quite a high tide, the fourth with the nets taken down and only their poles exposed above the sea. These four canvases were not necessarily painted in one unified phase of work. But the location evidently pleased Monet, and the four paintings can be seen as an informal sequence of images, working variations on vantage-point, *effet*, time of day and tide and – with that – different forms of harvesting sea and shore by the local populations. In that sense, Monet's very different kind of work acted in some sort of fraternity with the fisherfolk.

Fishing Nets at Pourville, with its adventurous veiling of the landscape with the outstretched fishing nets, reminds us of Monet's interest in Japanese woodblock prints, which he collected. Such apparently haphazard, but in fact deliberately contrived, devices were common in the work of artists such as Utamaro, Hiroshige and Kuniyoshi (fig.75). Monet's arrival at such a composition suggests that he had studied the ways in which such artists implied a sense of spontaneous looking, and applied it to his own naturalist vision. RT

Fig.75 · Utagawa Kuniyoshi *View of Mount Fuji*, c.1852–3
Victoria and Albert Museum, London

70. *Cliffs near Pourville*, 1882

Oil on canvas · 60 × 81cm
Rijksmuseum Twenthe, Enschede
w.788

This grand motif of the cliffs seen from the beach, painted on the second trip to Pourville, makes the outdoor character of Monet's work marvellously clear. The motif was chosen for the splendid surety of the massive cliff-face, which fills the left and centre of the picture space, compressing the sky into the upper right-hand corner and all but effacing the view out to sea. Monet defined this mass by the same means as he depicted the play of light upon it, by vivid coloured brushmarks. Monet eschewed the obvious colouring – white cliff, sandy shore, green grass. The cliff face, for instance, has deep coral-red and blue streaks in the shadows, pinks and yellows on the surface, with the great bluff reflecting the turquoise surface of the sea against a meaty red, laid on in impasted, irregular strokes. But this is not artistic caprice. The deep terracotta red with which Monet striated the cliff is entirely typical of these rock formations, earth pressed into the strata of the chalk. His exactitude, which worked in parallel to his sleight of hand and conception of the pictorial whole, is also evident in the grass. This is represented by strokes in yellow-green, apt for parched summer vegetation, but mingled with straw yellow and pinks. The dashed brushwork on the grass gives a sense of a strong breeze sweeping across the undulating heights, an effect matched by the blurred forms of the clouds gusting across the summer sky. If this painting represents Monet at his best both as a composer of sublime motifs and as a *plein-air* painter of great sensitivity, it perhaps also shows him at his most practical. Earlier in the year he had complained to Alice that, compared to the environs of Fécamp, the Pourville area offered no shelter against the problems posed by the weather.[1] The choice of the site for a painting such as the Enschede canvas, therefore, may have been made not just because it presented a motif of grandeur. Painting on the beach, in the lee of the cliff, was a practical expedient on windy days, when keeping an easel stable on the cliff-top would have been impossible. Over forty of the Pourville paintings were made at beach level. RT

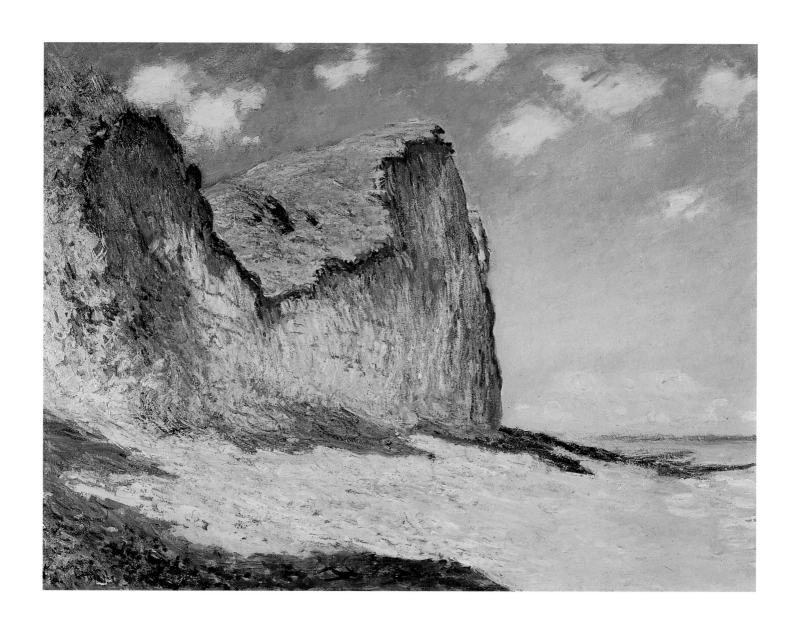

71. *Sunset, Etretat, 1883*

Oil on canvas · 55 × 81cm
North Carolina Museum of Art, Raleigh,
Purchased with funds from the State of
North Carolina
w.817

72. *Sunset, Etretat, 1883*

Oil on canvas · 60 × 73cm
Musée des Beaux-Arts, Nancy
w.818

73. *Rough Sea, Etretat, 1883*

Oil on canvas · 81 × 100cm
Musée des Beaux-Arts, Lyon
w.821

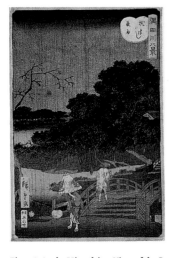

Fig.76. Ando Hiroshige *View of the Provinces, c.1850*
National Gallery of Scotland, Edinburgh

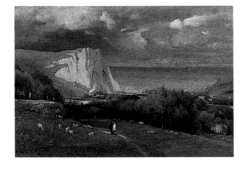

Fig.77. George Inness *Etretat, 1875*
Wadsworth Atheneum, Hartford, Connecticut

Of the twenty canvases Monet painted on his short stay in Etretat in early 1883, eight represent the dramatic Porte-d'Aval to the west of the fishing village (w.816–22). Four of these represent the great rock portal silhouetted against the setting sun. By thus eliminating the local colour of rock, chalk and grass, and rendering the flank of the cliff in a deep monochrome, Monet served to exaggerate its strange profile – a jagged rhythm of dark forms rearing and tumbling towards the sea. This creates an effect similar to those found in the *ukiyo-e* woodcuts of Japanese artists such as Hiroshige, whose prints Monet knew and collected (fig.76). The Raleigh and Nancy variants of this motif differ in that while the former shows the sun just before it slips below the horizon, its dying light glistening across the empty sea, the latter shows a sky illuminated by strips of warm pink from the hidden sun and the fishing boats putting out to sea. The Raleigh painting thus evokes a sense of elemental emptiness, while the Nancy picture uses the craft to give a sense of the cliff's gigantic scale. The time of day Monet chose for these canvases allowed him a relatively economical play of form and colour, the cool blues and greens of cliff and sea contrasting with the warm pinks and oranges projected by the setting sun. Although both these canvases had been purchased by Durand-Ruel by the end of 1883, both seem to have remained in his stock until they were sold to American collectors in 1899 and 1892 respectively. Despite the apparent marketability of this celebrated site, it may have been the elemental economy of these paintings that initially deterred purchasers.

Rough Sea, Etretat, the largest painting that Monet essayed on the 1883 campaign, was also a view of the Porte-d'Aval, painted during stormy weather and executed from his window at the Hôtel Blanquet. This angle hid the solitary Aiguille, a needle of rock spit from the land, behind the bulk of the cliff. However, as in the sunset pictures, the sinister Trou-à-l'homme, a tunnel passing right through the cliff to the beach and great rock arch of the Manneporte beyond, can be made out as a dark mouth at the base of the cliff. In the foreground Monet represented the *caloges* used for storage and a beached boat beside which stand a couple of fishermen, unable to put to sea in the face of such breakers. In that sense, *Rough Sea, Etretat* is a matter-of-fact image of men's work – whether painters' or fishermen's – affected by adverse weather conditions. It presents an account of Etretat quite different to that of the American George Inness's relatively recent painting of 1875 (fig.77). While Inness also showed the Porte-d'Aval, his sharper angle made it less dramatic than Monet's. Not only is Inness's brushwork and tonal structure more subdued, but his concern to inventory the landscape – from the farm animals grazing inland to the cottages, villas and hotels of Etretat itself – illustrates how Monet's matching of personal touch and the site's elemental identity created effects more sublime than naturalistic.

Painted on a portrait-format *toile de 40, Rough Sea, Etretat* has a dove-grey ground. While Monet painted the sky with a broad brush in steely blue, he allowed the ground to come through the area of the sea, giving the effect of thrashing waves with arching marks in blues and greys. While the general tone of the sea is a grey mid-green, colours such as primrose yellow, prawn pink and sludge green appear along the shoreline, with a denser white used for the foam and flying spray. In contrast to the almost monochrome silhouette of the sunset paintings, here the cliff is marked with aubergine, pink, pale steel and yellow-ochre. Yet for all this interplay of colour, orchestrated to obey the overall marine tone of grey-green, the drama of the painting is in the play of textures – delineated boat, striated sky, craggy cliff and heaving water. Purchased from Monet by Durand-Ruel in December 1883, *Rough Sea, Etretat* was bought from the dealer by the museum in Lyons in 1902, then an adventurous purchase for a provincial museum. RT

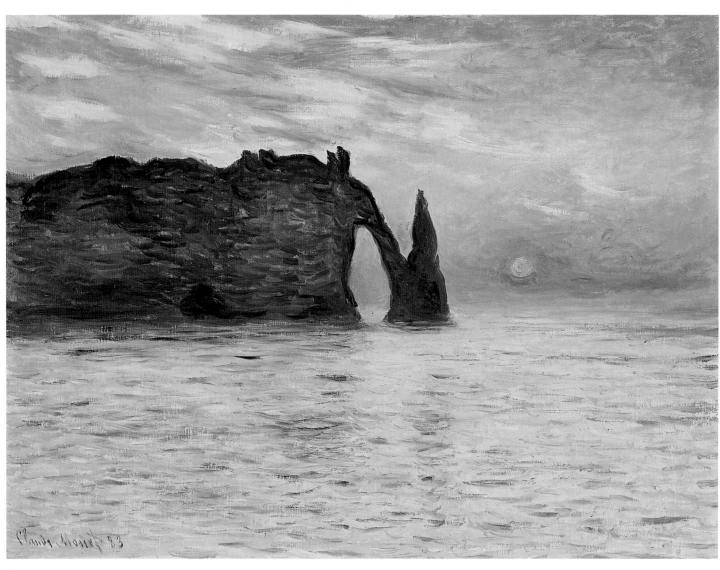

71

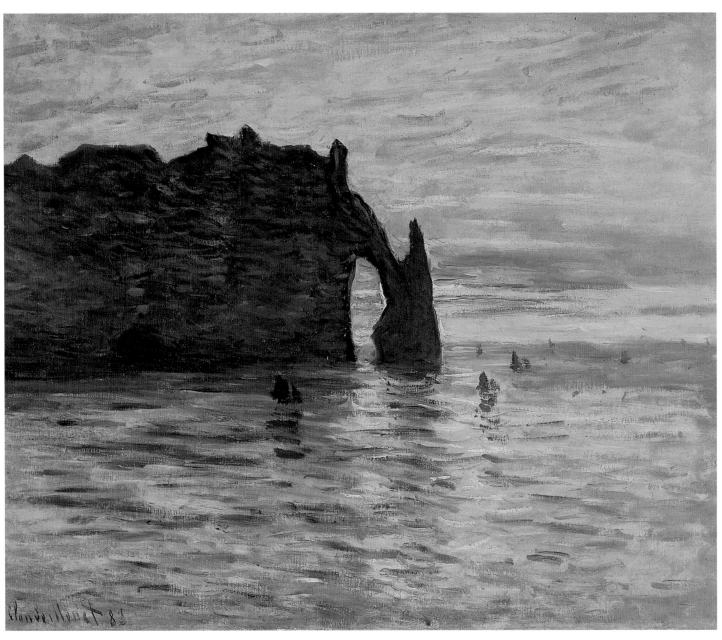

72

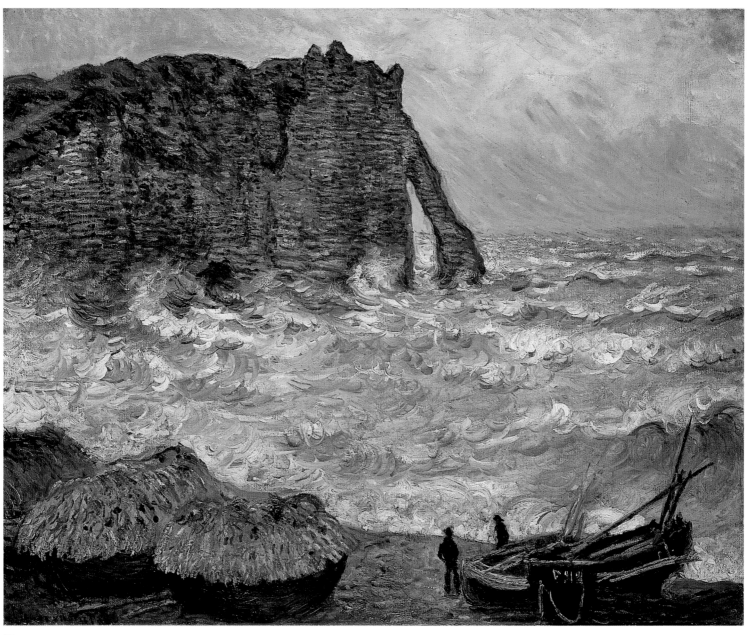

73

74. The Manneporte, Etretat, 1883

Oil on canvas · 65 × 81cm
The Metropolitan Museum of Art, New York,
Bequest of William Church Osborn, 1951
w.832

Quite the most dramatic of Monet's paintings made at Etretat in early 1883 is this view of the vast Manneporte. With this composition he put behind him the more conventional scenes painted from the fishing village itself, representing the cliffs to east and west or boats on the shingle beach. Instead he concentrated on the massive natural structure of a great portal punched by the sea through the jutting shoulder of rock. To reach this extraordinary geological phenomenon Monet would have had to shuffle his way though the long, damp tunnel called the Trou-à-l'homme, which passes through the cliff behind the Porte-d'Aval and is the only means of access from Etretat to the next bay to the west other than by boat. In that bay stand L'Aiguille, the 'needle'-shaped pyramid of rock that stands just out to sea and which Monet represented in one canvas made on this campaign (w.831), and, to the west, the Manneporte.

Monet represented the Manneporte in two canvases in 1883. The larger, measuring 73 × 92cm (w.833), does not seem to have entirely satisfied him as he did not exhibit it and it remained in his studio all his life. The painting now in the Metropolitan, however, he exhibited both at the 4th *Exposition internationale de peinture* in May 1885, organised by the prestigious Paris dealer Georges Petit, and – it seems – in 1886 at *Les XX*, the enterprising Belgian cultural forum based in Brussels. It was a painting, in other words, that he selected to represent him as he showed his work in the context of leading modern artists from Europe and America.

The Manneporte is a truly striking composition. Its great sculptural form gives it the impact of the sublime. In the cramped confines of the cliff-rimmed bay, working in carefully timed sessions to avoid being stranded by the tide in a treacherous spot, Monet chose to bring the great portal into close focus, so that its huge arch fills the centre of the canvas, with views far out to sea on either side. Working from a mid-grey priming, Monet brushed the canvas quite densely overall. He established the foreground rocks in dark aubergine and green tones, with the towering rock-face painted in a medley of blue-greys and ochres, with deep pink in the shadows and flashes of citron where the evening sun shines through. Monet responded to the Manneporte as a sculptural mass in two ways. The low light of the end of the day plays across the water from the west, illuminating the inner arch and setting it in relief against the shadowed flank of the enormous form. In addition, by graphic touches, by drawing, in fact, Monet brought out the irregular edges and bulges of the Manneporte, in awareness of its textured surfaces. If he successfully evoked the sculptural sublime of the Manneporte, this was not to the detriment of naturalism and the actuality of looking. His sense of local colour was acute, nowhere more than in the sea's pearly green just below the horizon. He respected natural features, such as the flat strata set in the geological layering of the rock and chalk, or the streaks of deep brown soil spilling down from above. And he caught the moment, with silvery spray breaking on the rocks, paradoxically painted in quite matted strands.

One is tempted to think that Monet arrived at this motif quite of his own accord, even by chance, deciding that this titanic freak of nature seen close to would make an exceptional composition which would sharply differentiate his 'take' on Etretat from the more conventional views adopted by Courbet (cat.no.88) and so many others. However, unusual views through such rock formations, whether observed or invented, can be found in a wide variety of earlier painters, particularly those who in the eighteenth and early nineteenth centuries explored the coasts of southern Italy.[1] Monet may or may not have known such works, but there is one picture that he certainly knew and which might have come back to him as he explored the environs of Etretat for new challenges. In 1862 the elderly Delacroix had painted an imaginary marine of shipwreck, viewed from under a massive rock formation or cave with a great foot reaching down into the sea (cat.no.78). From the 1860s to the 1890s this painting was in the

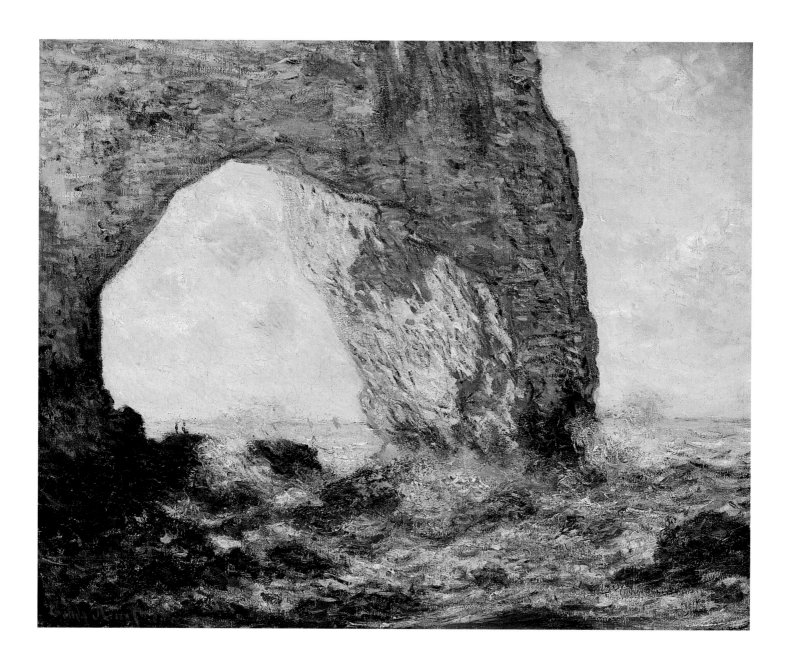

collection of Victor Chocquet (1821–1891).[2] In 1876 Monet had painted four views of the
Tuileries Gardens in central Paris (w.401–4), working from Chocquet's apartment on
the rue de Rivoli. There he would have been able to see Delacroix's marine. Monet much
admired Delacroix, and himself came to own one of his watercolours of Etretat (fig.51).
A reminiscence of the painting in Chocquet's collection may have sparked Monet's
competitive instincts, determining him to pitch his own, more modern, way of seeing
against the great cliff formations.

Etretat continued to fascinate Monet, and he returned to the close-up view of the
Manneporte on several occasions on later visits – twice in both 1885 (w.1035–6) and
1886 (w.1052–3). But of all these, the Metropolitan's dramatically poised and highly
resolved canvas of the sublime and the immediate is the mightiest. RT

75. *The Cliffs at Pourville in the Morning*, 1897

Oil on canvas · 65 × 100cm
The Montreal Museum of Fine Arts,
John W. Tempest Bequest
W.1442

During the early months of 1897 Monet revisited Pourville, to which he had already returned at the same time the previous year. His 1897 campaign produced thirty-three canvases (w.1440–3, 1443a, 1444–64, 1464a–71). He concentrated on four motifs, all of which he had tackled on his two sojourns in Pourville in 1882. These were views across the cliff tops eastwards towards Dieppe, prefigured in w.806; the *douanier*'s cottage, variations on cat.nos.58 and 59; the great shoulder of cliff first appearing in the Philadelphia canvas (cat.no.60); and a substantial group of the cliffs to the west of Pourville, looking along the curving beach.

This last group consists of six paintings (w.1440–4), of which *The Cliffs at Pourville in the Morning* is one of the most serene. The motif was one with which Monet was thoroughly familiar. He had painted it in no less than sixteen canvases, three made on his first visit (w.709–11) and thirteen on his second (w.776-776a, 777–778a, 779–86). Whereas in 1882 Monet had sometimes changed his vantage-point a little – perhaps painting from beach level, or from higher up – in 1897 he kept his position more consistent. His motif was the pleasing arabesque of the beach in the foreground, which he viewed from a raised point, offset by the sweep of the cliffs on the other side of the bay. It offered an open plane in the foreground and an irregular mass to the rear, both poised on the same ellipse and embraced by zones of sea and sky.

When Monet had painted the motif in 1896, his paintings (w.1421–6) had tended to be rougher in texture and more extreme in their effects of storm and sunset. In 1897, however, canvases such as *The Cliffs at Pourville in the Morning* inclined to be more emollient in weather effect and harmonious in surface. With this painting Monet chose a moment when the morning sun was coming over his left shoulder, drenching the surfaces of the cliff-tops, beach and sea in a rich golden light. The cliff-faces remain in shadowed relief, but even this is warmed by pinks and violets. The surrounding *enveloppe* moistly shimmers. Such paintings seem to exist in a strange equilibrium, a hinterland between the *plein-air* naturalism that Monet had so triumphantly pursued in 1882 and a more evocative, almost dreamlike quality more consistent with the cultural climate of Symbolism in the 1890s. For such paintings prompt a variety of responses – a sense of solitude, a pantheistic tranquillity in the warm clasp of nature, and, perhaps particularly in Monet's case, a sense of nostalgia for the verities of familiar natural elements and forces in a changing modern world. RT

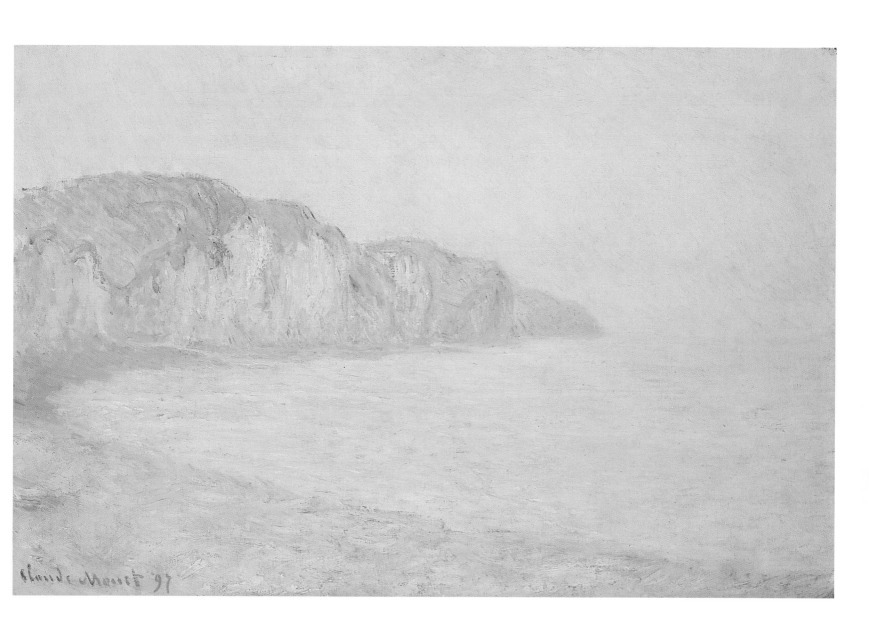

76. *Vétheuil in Pink Light (Effet rose)*, 1901

Oil on canvas · 90 × 93cm
The Art Institute of Chicago, Mr and Mrs Lewis
Larned Coburn Memorial Collection
w.1643

77. *Vétheuil, Sunset*, 1901

Oil on canvas · 89 × 92cm
The Art Institute of Chicago, Mr and Mrs
Martin A. Ryerson Collection
w.1645

In July 1901 Monet wrote to Durand-Ruel complaining that it was too hot to paint in his Giverny studio, where he was presumably hoping to undertake studio work on canvases both of his garden and of the Thames in London; he worried that he was losing time.[1] Monet found his way around the problem by reverting, in his early sixties, to the practice of his youth – working out of doors. That October he was able to report to Durand, 'I have undertaken a series of *Views of Vétheuil* that I thought I would be able to finish quickly and which have taken me all summer'. He expected to complete them within the next week.[2] Monet was referring to a substantial series of fifteen canvases that he had completed over the summer months (w.1635–49). Taking advantage of his new car, he had been regularly driven over by his chauffeur from Giverny to Lavacourt, twelve kilometres away. In that hamlet strung along the left bank of the Seine he had temporarily rented a small building (now destroyed) next to a riverside inn, 'Au Rendez-vous des Canotiers'. Working from the balcony, he did not paint the Lavacourt bank but rather the view directly across the river to Vétheuil. Accompanied by his wife Alice, her daughter Germaine and his old friend Alfred Sisley's daughter Jeanne, these painting trips were family excursions, made the more sociable by the revival of old contacts from the Vétheuil days of 1878–81. Monet's temporary accommodation was rented from Mme Clothilde de Chambry, who he had probably known then, and he

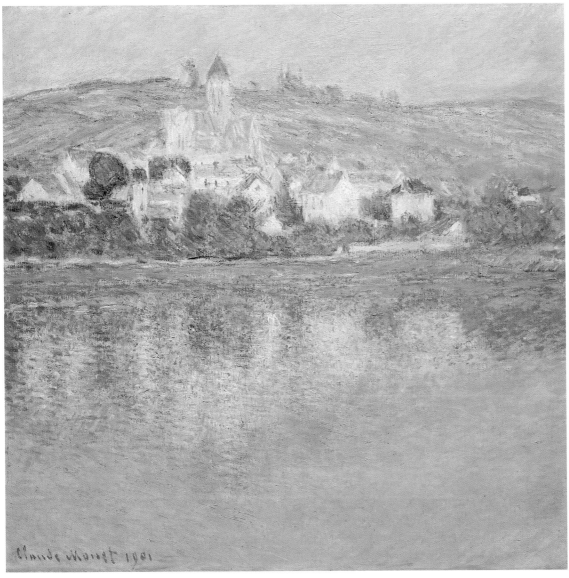

76

was sometimes visited at work by the local painter Abel Lauvray.[3] Monet had painted Lauvray's brother André in 1880 (w.620), and Lauvray himself had recently exhibited two views of the Seine at Vétheuil at the Paris Exposition Universelle of 1900.[4]

With its unconventionally square canvases, the 1901 series has a decorative quality, the village itself pressed into the canvases' upper third, with the larger lower section given over to the expanse of river and reflection. While the paintings do set up a play of space and distance, they are also integrated on the surface by the consistency of Monet's handling and his harmonisation of colour. In the canvas of the *effet rose* (pink effect) Monet seems to have painted a midday or afternoon scene. The roofs make quite strong contrasts of salmon pink and deep violet-blue, while the ridge behind sets a sharp mint-green against pink-ochres. The riverbank, with its foliage in olive green and pale aubergine, creates a central band, below which the reflection echoes all these colours in a co-ordinated horizontal touch. The sunset canvas, with the evening light flooding in from behind the painter, saturates the village in warm tones of violet, pink and orange. The sky, cross-hatched in dull egg-shell blue and pale yellow, becomes violet-mauve above the hills as darkness settles. Monet painted the buildings in flecked, diagonal strokes and the reflections in horizontal touches, differentiating decoratively the two zones of his canvas. RT

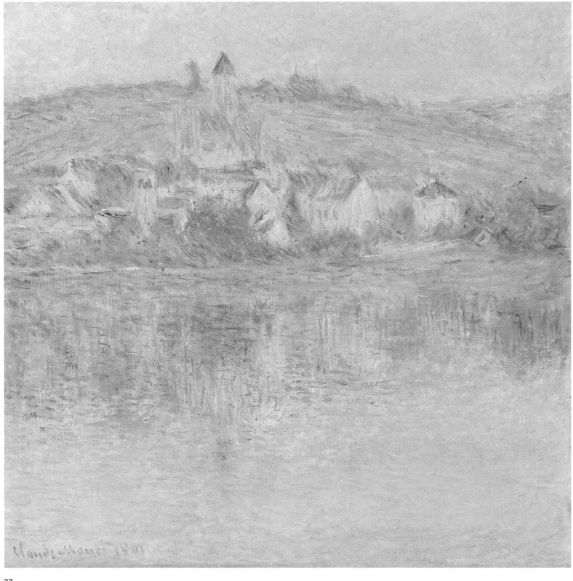

77

78. Eugène Delacroix
(1798–1863)
Shipwreck on the Coast, 1862

Oil on canvas · 38.8 × 46.7cm
Private Collection, courtesy of Richard L. Feigen
and Company

Delacroix's dramatic late marine, with its rhythmic swell glimpsed through the entrance to a sea cave, is a product of the artist's rich imagination and powerful visual memory rather than of observation. On his trip to Morocco in 1832 Delacroix had visited the Grottoes of Hercules, near Tangier, and in the years around 1850 he had visited Etretat and the Normandy coast. Such experiences of startling coastal rock formations no doubt fuelled his imagination when he painted this vivid studio piece of shipwrecked mariners.[1]

Monet greatly admired Delacroix, despite the fact that he was an artist two generations older and primarily a history painter, although landscape forms an aspect of his oeuvre. The young Monet had visited the Salon of 1859, at which Delacroix had shown paintings such as *Ovid among the Scythians* (London, National Gallery), essentially a landscape composition. Monet wrote to his mentor Eugène Boudin saying how much he relished the verve and movement of Delacroix's work.[2] At some later point in his career Monet even acquired two watercolours by Delacroix, one of cliffs near Dieppe and the other of the Porte-d'Aval at Etretat (fig.51).[3]

Shipwreck on the Coast was purchased shortly after Delacroix's death in 1863 by Victor Chocquet, in whose collection it remained until he died in 1891, when the picture passed to his widow. Chocquet was a minor civil servant at the Ministry of Finance, but he and his wife also had a modest private income. He was a collector of paintings who had purchased from the sale of Delacroix's studio in 1864 and who bought the work of younger artists who, he felt, continued something of Delacroix's characteristics in contemporary French art, in particular Renoir and Paul Cézanne.[4] Thus in the 1870s Chocquet had become a supporter of the Impressionists. Not only did he buy paintings from Monet, but he also allowed Monet to work from his apartment in the rue de Rivoli during the summer of 1876, when the artist produced four views of the Tuileries gardens.[5] Monet would therefore have had ample opportunity to study Chocquet's collection, including Delacroix's *Shipwreck on the Coast*. Six and a half years later, working at Etretat in early 1883, Monet came up with the arresting composition of the vast Manneporte seen from close to (cat.no.74). The striking design of this composition, one might surmise, may have been triggered by a recollection of the Delacroix he had seen at Chocquet's. In that case, Delacroix's *Shipwreck on the Coast* – made from memory filtered through the imagination – would have served, again through recollection, to help Monet conceive the awesome composition of *The Manneporte*, itself a painting apparently painted *en plein air* but perhaps given final touches in the studio. However immediate and frank Monet's great painting may seem to the viewer, its genesis was owed in part to a complex process of pictorial genealogy; this suggests how complex the creation of 'naturalistic' Impressionist landscape might be. RT

79. Camille Corot
(1796–1875) *Mantes*, 1860s

Oil on panel · 52.1 × 32.6cm
Musée des Beaux-Arts de la Ville de Reims

80. Camille Corot
Road by the River, 1860s

Oil on canvas · 50.17 × 81.28cm
The Montreal Museum of Fine Arts, Gift in
Memory of Senator and Mrs Lorne C. Webster
by their Family

Corot has often been portrayed as providing the essential link between the French neoclassical tradition in landscape and the new developments of Impressionism. While it is certainly true that his freshly executed studies painted directly from nature in preparation for his studio 'machines' anticipate the brighter colouring and truth to nature that are so evident in early and mature Impressionist pictures, he was a more individual artist than he is often given credit for. His late *Souvenirs* and figure studies indicate an artistic personality more in tune with certain aspects of French Romantic poetry and music (Corot was something of a melomaniac) than with the avowed contemporaneity of Impressionism. By the time of his death in 1875 Corot was regarded as one of the elder statesmen of French landscape painting and a memorial exhibition of his work was held that same year at the Ecole des Beaux-Arts in Paris. His work was widely collected and passed through many of the most influential dealers of the day. In the 1860s, the date of the picture from Rheims, Corot was frequently in the picturesque town of Mantes, where he stayed with the Robert family. Mantes lies just a few kilometres upstream from Vétheuil, and in Monet's day was connected directly by rail to Paris. The view shown is from the Ile de Limay looking across to the collegiate church of Notre-Dame with, to the left, the tower of St-Maclou. The foliage on the foreground willows indicates the season to be spring. The overall composition, with the town buildings and church tower in the distance observed from across the water, would find echoes in a number of Monet's views of Vétheuil, although his approach differed from the consciously picturesque effect Corot sought to achieve.

In the canvas from Montreal Corot employs one of his favourite devices of a foreground screen of trees, through which the middle and far distances are glimpsed. Here it is employed in an idealised and non-specific view of Ville-d'Avray, the site of the Corot family home just to the west of Paris. Such a formula was also favoured on occasion by Monet, particularly in the group of pictures he painted in 1880 of Lavacourt seen from one of the Iles de Moisson in the middle of the Seine (cat.no.35). Corot did not exercise such a profound influence on Monet as Daubigny during the Vétheuil years, but he did represent one of the major figures in the French landscape tradition into which Monet undoubtedly wished to integrate himself during this crucial period in his career. MC

79

80

81. Charles-François Daubigny (1817–1878)
View on a River, Sunset, 1864

Oil on canvas · 35.9 × 55.2cm
Syndics of the Fitzwilliam Museum, Cambridge

82. Charles-François Daubigny *Moonrise at Barbizon*, c.1865–70

Oil on canvas · 93 × 151cm
Museum voor Schone Kunsten, Ghent

83. Charles-François Daubigny *Montigny-sur-Loing at Sunset*, c.1870

Oil on panel · 24 × 49.9cm
National Gallery of Scotland, Edinburgh

Charles-François Daubigny was approximately half a generation younger than the so-called *école de 1830* and is often credited, with considerable justification, as having provided a crucial artistic link between them and the young Impressionists, a number of whom he knew personally and assisted. The riverscape scenery he depicted in his paintings from about 1857 to about 1870 was undoubtedly highly influential upon Monet during his Vétheuil years, as can be demonstrated by comparison between his *View on a River, Sunset* and Monet's *Lavacourt* compositions (cat.nos.28–30). There is the same use of receding diagonals and the balancing of water, riverbank and sky. Similarly, his panoramic *View of Herblay* (National Gallery of Scotland) on the Seine with the church tower set high above the village typifies the type of riverside view which would be echoed by Monet in his views of Vétheuil seen from some distance across the water.

Daubigny's sources for such compositions could be found in seventeenth-century art, notably the river scenes of Dutch painters such as Salomon van Ruysdael. He was well acquainted with the Old Masters, having received numerous commissions to copy their works in printed format. Indeed, although he is now primarily considered as a painter, Daubigny's vast graphic output has suffered comparative neglect by comparison. He himself referred to the security that constant employment in the print medium provided him with as his 'insurance policy'. His range of subject matter was enormous and embraced illustrations for advertisements, romantic novels, religious publications and journalistic accounts for newspapers and magazines. Nevertheless, it was as a painter that he sought official recognition. Despite two failed attempts to win the Grand Prix for Historical Landscape he had succeeded in exhibiting at the Salon as early as 1838. In 1857 he launched his *botin*, a floating studio constructed on the hull of a 28-foot barge, from which he depicted the banks, spire-topped villages and inlets that lay along the rivers Marne, Oise and Seine. Monet used a similar studio-boat at Vétheuil. Both artists produced in their river scenes images that would appeal to the growing urban middle classes and with which they could decorate their suburban villas. Such pictures were relatively undemanding, required no knowledge of esoteric subject matter on the part of the viewer, and suggested a pleasant day out in the country away from the cares of the city.

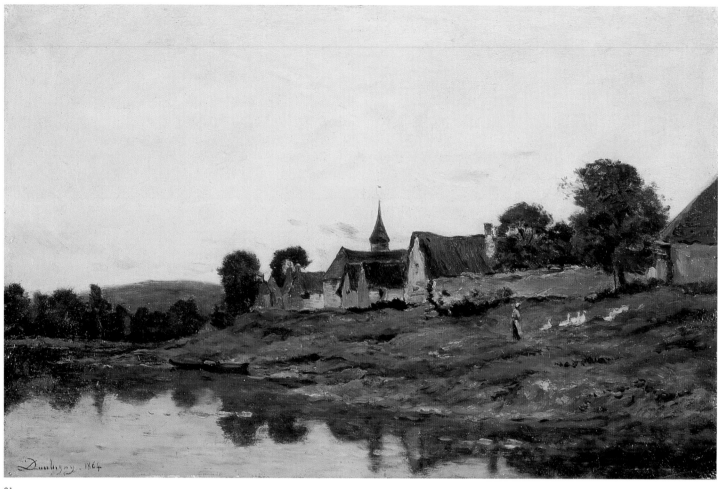

81

83

82

The combination of city and country was mirrored in Daubigny's lifestyle, for he divided his time between his Parisian residence and his country home at Auvers north of Paris. Monet, on the other hand, was in permanent residence at Vétheuil, observing the harsh winters as well as the verdant summers. His exploration of nature's moods inevitably went considerably further than those of his benevolent predecessor. Daubigny had, however, perfected the mood of evening rural idyll in paintings such as his view of *Montigny-sur-Loing at Sunset*. Monet paid suitable homage to Daubigny's achievements in his own canvases such as *The Seine at Vétheuil* (w.532). The poetic nature of many of Daubigny's canvases was remarked on by numerous commentators and was particularly evident in a work such as the now considerably darkened *Moonrise at Barbizon*, in which the reflections on the water invoke a mood of contemplation and reverie. A comparable frontal depiction of the setting sun is to be found in Monet's *Sunset on the Seine, Winter* (cat.no.26), a painting that was at one time destined for the 1880 Salon. MC

84. Jean-François Millet (1814–1875) *Cliffs at Gréville, 1870–1*

Oil on canvas · 94.3 × 117.5cm
Albright-Knox Art Gallery, Buffalo, New York,
Elisabeth H. Gates Fund, 1919

This dramatic coastal view in western Normandy was taken from the rocky outcrop above Landemer called 'Mauvais pas' or 'Maupas'. Hidden beyond the horizon to the left and only one and a half kilometres away lie the pastures and little hamlet of Gruchy, where Millet was born. He was brought up there in the family house with his parents, grandmother, great aunt and great uncle and seven siblings. The family lived off the land, and it is perhaps hardly surprising that Millet would later become a painter of peasant subject matter, celebrated for such masterpieces as *The Angelus* (1855–7) and *The Gleaners* (1857; both Musée d'Orsay, Paris). Landscape always featured prominently in his work, but he devoted much greater attention to it in the last decade of his life. This canvas dates from 1870–1, when Millet took his family to Cherbourg to escape the Franco-Prussian War. He had therefore returned to the landscape of his youth. The high horizon and plunging perspective were devices he had already explored a few years previously in the very different landscape of the Auvergne. He had also become interested in and an avid collector of Japanese prints, which offered a similar fascination with sharp profiles and forms cut off at the composition's edge. By the late 1870s Millet's work was extremely well known and commanded high prices on the art market. A knowledge of these pioneering compositions must have informed Monet's own vertiginous cliff-top paintings of 1881–2. MC

85. Gustave Courbet
(1819–1877) *Low Tide at Trouville*, 1865

Oil on canvas · 57 × 72cm
National Museums Liverpool (The Walker)

86. Gustave Courbet
The Wave, 1869

Oil on canvas · 46 × 55cm
National Gallery of Scotland, Edinburgh

87. Gustave Courbet
*A Bay with Cliffs c.*1869

Oil on canvas · 38 × 46cm
Wadsworth Atheneum, Hartford, Connecticut,
The Ella Gallup Sumner and Mary Catlin Sumner
Collection Fund

88. Gustave Courbet
The Sea Arch at Etretat, 1869

Oil on canvas · 76.2 × 123.1cm
The Barber Institute of Fine Arts, The University
of Birmingham

Courbet was indisputably the most controversial of Monet's immediate predecessors. His outsize personality and his willingness to challenge the artistic and political hierarchies of his day marked him down for heroic status in the history of Western art. He was a native of the Franche-Comté, and his first essays in landscape reflected the strong stimulus provided by the distinctive, rock-strewn scenery of that region. His first experience of the sea probably dated from a visit to Le Havre in 1841, but his earliest seascapes were of the Mediterranean and were painted in 1854 while on a visit to his patron Alfred Bruyas in Montpellier. A crucial meeting took place in 1859 at Le Havre with Monet's mentor Eugène Boudin, whom Courbet dubbed 'the king of skies'. Something of Boudin's influence is visible in the Liverpool canvas of 1865, in which the vast expanse of sky, subtly differentiated in atmospheric tone and colour, evokes in particular the pastels of the earlier master.

The Liverpool canvas was one of many marines painted by Courbet on a visit to the fashionable coastal resort of Trouville that year. Patronised by the duc de Morny and the Empress Eugénie amongst others, Trouville was shrewdly recognised by Courbet as a potentially profitable subject among Second Empire collectors. Besides, Courbet was physically exhilarated by the light and water there. In a letter to Bruyas of January 1866 he related that he had bathed at Trouville eighty times the previous summer and referred to 'twenty-five autumn skies – each one more extraordinary and free than the last'. The 'elegant, sea-bathing public' eagerly bought his seascapes, or '*paysages de mer*' as he called them. His production of them was industrial in its scale and rapidity: he estimated two hours per painting. He returned to the Normandy coast in 1866, to the nearby resort of Deauville, where he produced a large number of seascapes, which he

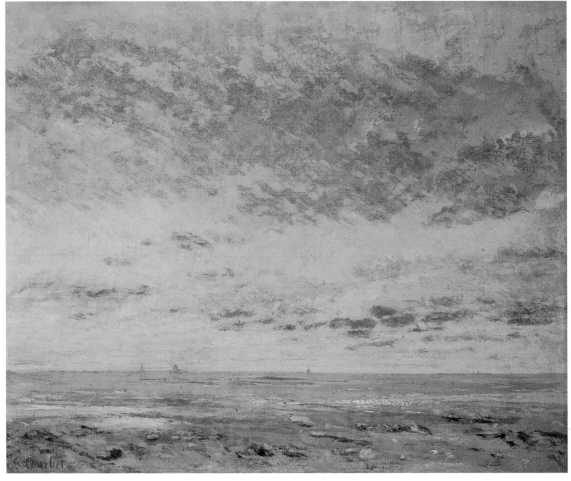

85

included in his 1867 solo exhibition at the place de l'Alma, held to coincide with the Exposition Universelle. The largest single category in the show was that of seascapes. It is highly probable that Monet would have been impressed by such concentrated production and have duly recognised the commercial appeal of marine painting.

Echoes of Courbet's compositional formulae, daringly emptied of almost all human content, are found in many of Monet's marines of the early 1880s. In addition to the calm tranquillity of views such as *The Sea at Pourville* (cat.no.54), comparable in type to the Liverpool picture, there are numerous wave pictures by Monet which find a dual origin in Japanese prints and in Courbet's various depictions of this subject, particularly in his canvases of 1869–70, stimulated by observation of the stormy seas at Etretat, in which a breaking wave is the central motif. The Edinburgh picture is perhaps one of the most balanced and 'formal' of this group. There is a corporeal and visceral quality to many of Courbet's other wave paintings, however, that distinguishes them from the more decorative qualities Monet brings to his many depictions of this motif. The closest and most deliberate coincidence between the two artists occurs with Monet's 'homage' of 1883 to Courbet's great cliff paintings (cat.nos.87–8) at Etretat of 1869 (the two artists had met there that year). Courbet entered two of these at the 1870 Salon and both feature beached fishing boats. The Birmingham picture, a variation on this theme, is painted from a viewpoint further to the eastern end of the shore. The rugged cliff shapes echo the outbreaks of bare limestone which feature so prominently in Courbet's landscapes of his native Franche-Comté. In early 1883 Monet painted a whole series of views of this same motif, one of which (cat.no.73) is particularly close to Courbet's Salon submissions of 1870. MC

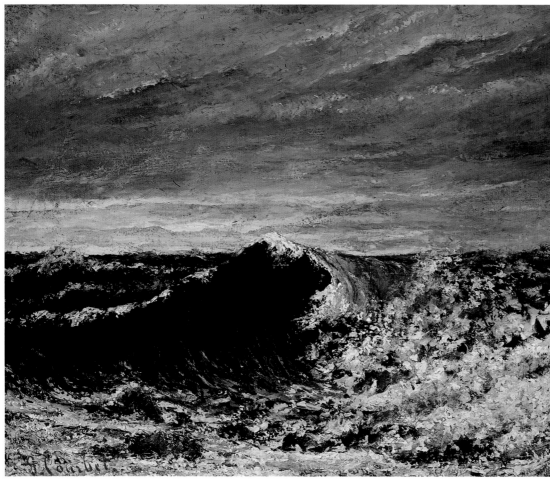

86

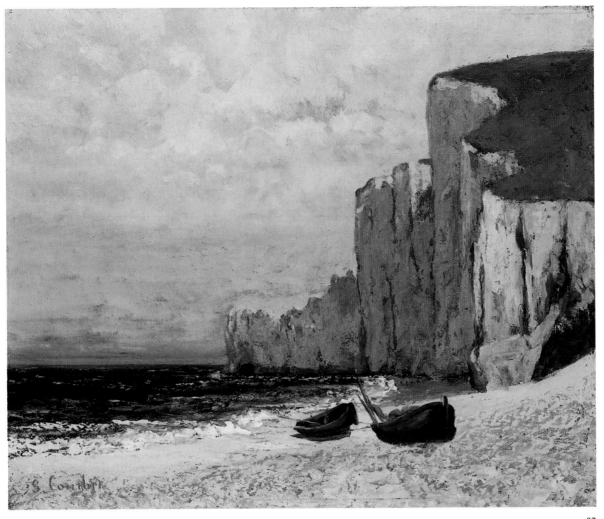

87

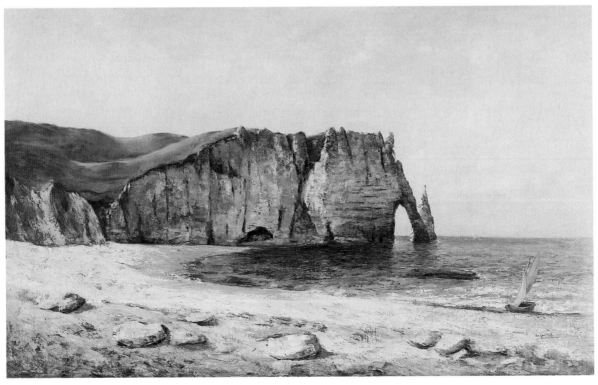

88

164

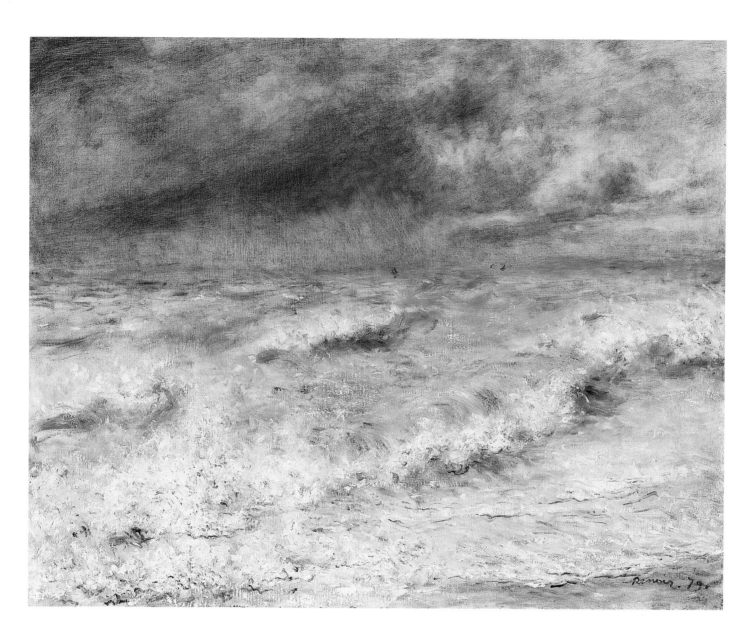

89. Pierre-Auguste Renoir
(1841–1919) *The Wave*, 1879

Oil on canvas · 64.8 × 99.2cm
The Art Institute of Chicago,
Potter Palmer Collection

In this highly decorative canvas Renoir anticipates some of the issues tackled by his good friend Monet in that artist's own wave pictures of 1880 (for example, cat.no.40). That Renoir's approach should have been more decorative is understandable, given that he was born in Limoges, home to the production of both enamelware and hard-paste porcelain. Indeed, Renoir had first trained as a painter on porcelain. He came to know Monet in 1862 when they were fellow pupils in the Parisian studio of the Swiss history painter Charles Gleyre. Renoir was never so wedded to the Impressionist exhibitions as some of the other members of the group, and in 1879 he was persuaded by his patrons the Charpentiers to return to the Salon, where he enjoyed great success that year. It was also in that summer that he stayed in the house at Wargemont on the Normandy coast of another of his patrons, Paul Antoine Berard, a diplomat and company director whom he had met at the Charpentiers' salon. This seascape dates from that period. In its concentration solely on sea and sky, with no reference to the shoreline, it must have been inspired in part by Courbet's Normandy marines of the late 1860s. Renoir's vision of nature was essentially gentle, however, whereas there was a toughness to Courbet's depiction of the Channel that suggested darker, more elemental forces at work. Monet's approach to this subject matter fell somewhere between the two: neither as 'feminine' as Renoir, nor as marmoreal as Courbet. MC

90. Adolphe Frédéric Lejeune
Morning at Vétheuil, 1889

Oil on canvas · 103 × 176cm
Town Hall, Vétheuil

Little is known about Adolphe Frédéric Lejeune. He was apparently a pupil of the portrait and history painter Léon Bonnat. It seems that he was loyal to the landscape in the Vétheuil area. This large canvas, dated 1889, was exhibited at the Paris Salon the following year, under the title *Le Matin, à Veteuil* [sic] *(Seine-et-Oise)*.[1] Lejeune continued to paint sites in the locality of Vétheuil. At the Exposition Universelle of 1900 he featured with *The Landing-Stage at Chantmesle, Middle Reach of the Seine*. Around the turn of the century a number of landscape painters were active in the environs of Vétheuil, and the Exposition Universelle included a painting each of Moisson and Lavacourt by Camille Dufour, Léon Joubert's *A Spot on the Seine at Lavacourt*, and two canvases of Vétheuil by Abel Lauvray, whose brother André, then a boy, Monet had painted in 1880 (w.620).[2]

Lejeune's *Morning at Vétheuil* is typical of the landscape paintings which crowded the Salons of the late nineteenth century. Confident in scale, it seeks to render a particular site in detail. In that sense it acts both as a precise 'report' on a locale – for those who know the place – and as a general evocation of the tranquil fertility of *la France profonde* for those who do not. He was more specific in the accessories of landscape than Monet, placing a boat in the foreground and indicating in the rear right the smoke coming from a cottage and perhaps the chimney of one of the little workshops around the village. Lejeune painted with a flat touch quite at odds with the more gestural and varied handling of Monet. He also adhered reliably to somewhat obvious local colours, such as mid and deep greens and warm browns. No doubt coincidentally, the paintings that Monet made not far from Lejeune's vantage to the south of Vétheuil (fig.78) are among the ones in which he was at his most conventionally naturalistic in colour. *Vétheuil* (cat.no.13), for example, uses a relatively uncomplicated palette, but it is lifted from the simply descriptive by the vigour of Monet's touch and the confidence of his abbreviations of detail. RT

Fig.78 · Claude Monet *Landscape, Vétheuil*, 1879
Musée d'Orsay, Paris (w.526)

CLAUDE MONET: A CHRONOLOGY 1878–1883

Anne L. Cowe

NOTE

The prefix WL. refers to letters catalogued in Daniel Wildenstein, *Claude Monet. Biographie et catalogue raisonné*, 5 vols., Lausanne and Paris 1974–91

Fig.79 · Claude Monet in 1877, aged thirty-seven
Bibliothèque nationale de France

1878

17 MARCH · Birth of Monet's second son Michel. The pregnancy takes a huge toll on Camille's health, which was already poor, and her condition begins to deteriorate.

MAY · Opening of the Exposition Universelle in Paris.

15 JULY (UNTIL 1 OCTOBER) · *Exposition retrospective de tableaux et dessins de maîtres modernes* is held at the Durand-Ruel galleries, featuring 380 works, by Corot, Millet, Rousseau, Delacroix, Courbet, Ricard, Diaz, Daubigny, Tassaert, Huet, Troyon, Chintreuil, Fromentin, Barye, Decamps.

SEPTEMBER · Monet leaves Paris with his family for a short stay in Vétheuil, a village about sixty-five kilometres north west of Paris on the banks of the River Seine. With the recently bankrupt Ernest Hoschedé, his wife Alice and their six children they rent a small house. The financial situation of both families is critical.

The first paintings Monet does of the area are *The Church at Vétheuil* (w.473 and 474). He also paints views of the river (w.475–87).

23 SEPTEMBER · Monet sends a letter to the homeopathic doctor, and friend, Georges de Bellio, describing Camille's condition: *Without strength, she wanted to use brandy, drinking a large glass, which left her completely intoxicated, and ill for two days with deliria* (WL.139).

OCTOBER · The families decide to continue living in Vétheuil and rent more permanent accommodation on the edge of the village. In front, on the opposite side of the road, the house has a garden which reaches down to the river with a jetty for the artist's studio boat. Around the same time Monet moves his Paris studio to a ground-floor apartment at 20, rue Vintimille, paid for by the artist Gustave Caillebotte.

Monet extends his subject matter to the local orchards. He also makes several views of Lavacourt, a hamlet situated on the opposite bank to Vétheuil, viewed from in front of the houses, and looking down the banks of the river (w.488–91, 495–9). He manages to sell some of his river landscapes this month to buyers such as De Bellio, Luquet and Hecht (w.477, 481–4).

DECEMBER · Monet makes a trip to Paris in an attempt to sell some paintings and raise money. Dr Gachet from Auvers-sur-Oise, who will later look after Van Gogh, buys a still life of chrysanthemums (w.492).

9 DECEMBER · In a letter to Georges Charpentier, a Parisian publisher and collector, Monet asks for a financial advance of five or six louis. The artist has been in Paris for ten days and says that he cannot return to the country, where his wife is very ill, without any money (WL.142).

MID-DECEMBER (& MID-JANUARY) · During periods of snowfall Monet paints several snow scenes of Lavacourt and Vétheuil, viewing the latter from the road next to their house, as well as from the river (w.505–14).

30 DECEMBER · Monet writes to De Bellio again, *I'm starting not to be a debutant anymore and it is sad to get to my age in such a situation, still obliged to ask, to solicit business. I am reliving doubly my misfortune at this time of year, and '79 is going to start like this*

year has ended, very sadly, for my family above all, to whom I cannot offer the most modest present (WL.148). Probably out of sympathy for the artist, De Bellio buys *Vétheuil in Winter* (W.507).

31 DECEMBER · Monet paints small portraits of his own son Michel and of 'Bébé Jean', the youngest Hoschedé child, which he inscribes as a gift to the boy's mother, Alice (W.503 and 504).

1879

27 JANUARY · Monet goes to Paris for twenty-four hours and sells four snowscapes, two of which are bought by Caillebotte and Vayson (W.506 and 514). The painting of *Vétheuil in the Fog* (W.518), also painted around this time, is later offered to the famous baritone Jean-Baptiste Faure for fifty francs. The singer finds it to be 'too white' and Monet then refuses to relinquish the painting at any price.

10 MARCH · Completely demoralised, Monet writes to De Bellio saying he has lost hope, and that he has decided not to take part in the 4th Impressionist exhibition, as he has painted nothing worth showing (WL.155).

25 MARCH · Reluctantly, Monet agrees to participate in the exhibition. In a letter to the collector Murer he describes how he is busy being watch-nurse for his wife and the baby, and says that he should have refused to take part, having nothing to show (WL.156).

10 APRIL (UNTIL 11 MAY) · 4th Impressionist exhibition opens at 28, avenue de l'Opéra, in five specially decorated rooms, possibly with electric lighting. The exhibition includes about 250 works by sixteen artists; missing from the original group are Cézanne, Morisot, Renoir and Sisley. Monet's works are hung in the last room with Pissarro's. The paintings by Monet are listed in the catalogue and span the artist's whole career (W.68, 95, 139, 154, 184, 263, 350, 362, 364, 456, 457, 468–70, 474, 490, 496, 506, 5 28). Most acclaimed are his paintings of flags in *La Rue Montorgueil, fête de 30 juin 1878* and *La Rue Saint-Denis, fête de 30 juin 1878* in Paris. Monet does not go to Paris to see the exhibition, staying in Vétheuil to paint and look after his wife and child (WL.158).

During spring Monet paints several pictures of fruit trees in blossom; however, they do not appear in the exhibition (W.519–24).

14 MAY · Despite the moderate success of the exhibition Monet is disheartened by his family's predicament. He sees no hope for the future, and offers to move out of the Vétheuil house where he and his sick wife are nothing but a hindrance to the Hoschedés (WL.158). Monet also writes to Manet, thanking him for not demanding repayment of the money he owes. He explains how all his money is being spent on medication and doctor's visits for his wife and child. In addition, the vile weather prevents any serious attempts at working (WL.159).

SPRING – SUMMER · Despite letters by the artist stating the contrary, Monet produces several paintings of the Vétheuil area over this period. These include two paintings of the children in the meadows on the islands next to the village (W.535 and 536), and repeated views of both Vétheuil and Lavacourt, seen across the water (W.531–4, 538–41). The last group of paintings were probably done in late summer, from Monet's jetty.

17 AUGUST · Monet writes to De Bellio saying he fears he will have to give up all hope of better days. Camille is suffering more and more and getting very weak. She no longer has the strength to stand up or walk and, although hungry, is unable hold down food. The artist is unable to work as he has run out of paints and has no money. He tells De Bellio to take any canvases he wants from the studio in the rue Vintimille (WL.161); De Bellio, however, considers the paintings he sees to be 'very far from completion'.

5 SEPTEMBER · Death of Camille, aged thirty-two, at 10.30 in the morning. Writing to inform De Bellio, Monet expresses his dismay at being left alone with the children. As well as asking him to announce the death and funeral arrangements, he also asks the doctor to retrieve his wife's medallion from the pawnbrokers so that it can be put around her neck when she is buried (WL.163). After her death Monet paints *Camille Monet on her Deathbed* (W.543).

27 SEPTEMBER · The artist is beginning to get back to work. His friend Théodore Duret has sent him a 100 franc note and in return Monet promises him a painting when he next visits Paris (WL.165).

OCTOBER · The Monet and Hoschedé families are two quarters behind with their rent. Monet sends a message to De Bellio, begging him not to abandon him. De Bellio takes five of Monet's paintings, and Camille Lefèvre, Jean-Baptiste Faure and Ernest May also buy paintings (among these W.534, 537, 539, 541).

16 NOVEMBER · Monet writes to Hoschedé suggesting he returns to Vétheuil to dispel rumours regarding an improper relationship between the artist and Alice Hoschedé.

The weather is getting bitterly cold and snow has already begun to fall. Painting mostly indoors, Monet produces several still-life paintings of fruit, flowers and game birds (W.544–7).

20 NOVEMBER · Marthe, the eldest Hoschedé child, aged fifteen, writes to her father describing Monet's work:
… yesterday, as the sun came and bothered him in a painting of fruit that he was doing, he did a little blue porcelain pot with nasturtiums in it and he succeeded perfectly straight away and the little painting is charming (W.547; WL.37).

DECEMBER · During the first half of the month there is a large amount of snowfall. Temperatures fall to a record – 25°c and the waters of the Seine freeze over completely. Monet begins to paint the effects of the extreme weather, focusing particularly on the frozen river (W.552–8).

28–30 DECEMBER · Monet negotiates some sales in Paris, including some new 'snow effects' (WL.185), pictures of fruit and one of game birds (W.544, 545 and 551).

1880

5 JANUARY · Moderate until now, the thaw begins in earnest. The thunderous noise of the break up of the ice is enough to wake the artist's household. Monet goes out to paint the effects of the phenomenon on the river (W.560–71).

10 JANUARY · Jacques-Emile Blanche buys two paintings from Monet: *Frost at Vétheuil* (W.554) and *Cottage* (W.524a). Towards the end of the thaw Monet paints a group of sunset paintings, looking across the river towards Lavacourt (W.574–7).

24 JANUARY · An announcement is published in

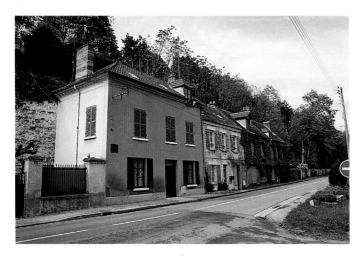

Fig 80 · Monet's house at Vétheuil, April 2003

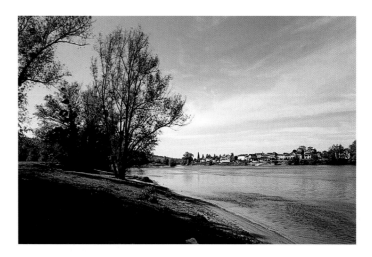

Fig 81 · View of Lavacourt, May 2001

Le Gaulois newspaper reporting the 'grievous loss' of Claude Monet. The funeral, it says, will take place at the opening of the Salon. Readers are requested not to attend. The article goes on to refer to Monet's 'charming wife', meaning Alice Hoschedé. The author is never identified.

2 FEBRUARY · Astonished and upset, Monet writes to Pissarro about the article asking who the author is and why such things had been published (WL.172).

14 FEBRUARY · The servants working for the Hoschedés and Monets leave, and file a lawsuit for unpaid wages.

8 MARCH · Monet writes to Duret informing him of his intention to submit two paintings to the Salon. He has been working on three large canvases recently; however, he says one is too much to his own personal tastes and will be refused (w.576). Instead he has done another, 'more safe and more bourgeois'. He hopes that acceptance will have a positive effect on business (WL.173). Five days after the deadline, Monet submits *Glaçons*, and *Lavacourt* (w.568 and 578). In his other paintings Monet has been experimenting with different views along the road towards La Roche-Guyon, which runs past his house (w.582–9). Over the course of the following spring and summer he will paint Vétheuil from a variety of distant viewpoints, often from the islands (w.590–614).

1–30 APRIL · 5th Impressionist exhibition: Monet, Cézanne, Morisot, Renoir and Sisley do not take part.

9 APRIL · *Glaçons* is rejected, *Lavacourt* is accepted for the Salon. Monet tells Murer that he is asking 1500 francs each for both (WL.175).

19 APRIL · In Paris, Monet sells paintings to buyers such as De Bellio, Luquet, and Alexandre Dubourg (*e.g.* w.473?, 505?, 508, 579, 580). Charpentier, probably influenced by Renoir, has offered to put on a one-man exhibition of Monet's paintings in the offices of his magazine *La Vie moderne* (WL.178).

LATE APRIL · The journalist Emile Taboureux goes to Vétheuil to interview Monet for an article which will appear in *La Vie moderne* at the time of the artist's exhibition.

19 MAY · Monet writes to Duret who, along with Hoschedé, is helping to organise the exhibition at *La Vie moderne*. The artist is meant to be in Paris but has no money to get there. Claiming that he has done nothing new that is worthwhile, and wondering whether he has ever done anything famous, he declares he is in a state of complete discouragement. He says that, if it was not for the commitment made by Duret and Hoschedé, he would give up on the exhibition (WL.179).

4 JUNE · Two days before the opening of his exhibition, Monet is still in Vétheuil trying to finish paintings.

6 JUNE (FOR ONE MONTH) · Exhibition at *La Vie moderne*, 7 boulevard des Italiens. Duret writes the introduction to the exhibition catalogue, describing Monet as painting nature directly on to the canvas. There are eighteen works in total, including the ice floe painting which was rejected from the Salon (those identified include w.94, 129, 469, 520, 546, 551, 553, 555, 568, 582, 585, 590, 595).

12 JUNE · Taboureux's interview with Monet is published. When questioned about his allegiance to the Impressionist exhibitions, he replies, 'I still am and always will be an Impressionist.'

22 JUNE · Mme Charpentier writes to Monet, wanting to buy the rejected Salon painting of *Glaçons* as a present for her husband. Despite interest from Ratisbonne and Ephrussi in the same painting, Mme Charpentier gets what she wants (WL.46).

30 JUNE · Monet writes to Ephrussi asking for the 400 francs for the other picture he wanted from the exhibition, so that the he can pay off a difficult creditor (w.592 or 593). Despite the success of the exhibition, Monet is still being pursued by creditors.

5 JULY · Monet writes to Duret saying that he would have sold many more canvases at the exhibition had they all belonged to him. Several new collectors have shown interest in buying paintings. The artist claims that he is in a good working mode and is painting a lot (WL.191).

25 JULY · In a letter to Hoschedé, who is still in Paris, Monet says that he has been asked to send two or three canvases to an exhibition in Le Havre

(WL.196). Three of Monet's paintings, including the one which appeared at the Salon, will be exhibited (w.522, 578, 580).

4 AUGUST · Again asking for money, Monet writes to Duret complaining that he is at a complete dead end. All the collectors have left Paris, and the weather is not suitable for working. He hopes that the end of the summer will be more beautiful (WL.197).

AUGUST · Monet is commissioned to do three portraits of local bourgeois (w.617, 618 and 620).

AROUND 10 SEPTEMBER · Having spent a few days in Rouen with his brother Léon, Monet then accompanies him to his holiday house at Les Petites-Dalles on the Normandy coast. Here the artist paints views of the cliffs and the sea (w.621–4).

3 OCTOBER · Thanking him for the money he has sent, Monet writes to Duret saying that it is impossible for him to leave Vétheuil without abandoning a series of studies he is working on. Apparently his work exhibited at Le Havre caused great agitation and mad laughter (WL.200).

Over the winter Monet paints several still lifes, particularly of flowers (w.624–31, 634 and 635) as well as two portraits of his sons (w.632 and 633).

1881

JANUARY · Narcisse Coqueret, a local businessman, who had bought a portrait in August 1880, commissions two more from Monet this month (w.636 and 637). For most of January Monet is prevented from working by an injured finger (WL.208).

15 FEBRUARY · Flooding at Vétheuil reaches its height. Monet paints several views of the occurrence (w.638–42).

17 FEBRUARY · Having secured the financial backing of the Union Générale bank, Durand-Ruel has been re-establishing his business with the Impressionists over the course of the winter. He now buys fifteen paintings from Monet for the sum of 4500 francs. These comprise a wide variety of the artists' recent paintings, including the Salon painting *Lavacourt*, as well as some works from Les Petites-Dalles, and those of the floods (w.485, 495, 569, 578, 589, 591, 601, 616,

Fig 82 · Etretat, May 2003

Fig 83 · The cliffs at Varengeville, Varengeville, April 2002

169

621, 624, 625, 639, 642, and possibly two of 511, 605, 607 or 609. Some were sold before completion). Durand-Ruel becomes Monet's main source of income, his works now being sold almost exclusively through the dealer's gallery in Paris.

8 MARCH · Monet writes to Durand-Ruel, announcing that he is leaving the next day to spend three weeks in Fécamp, on the Normandy coast, with the intention of painting some marines (WL.211). Over the course of his stay the artist paints a large number of cliff views, as well as some which show only the sky and the waves (w.644–65b).

2 APRIL (UNTIL 1 MAY) · 6th Impressionist exhibition takes place at 35, boulevard des Capucines, Paris. Caillebotte, Cézanne, Monet, Renoir and Sisley do not take part.

18 APRIL · Monet writes to Durand-Ruel to inform him that he is considering going to Paris at the end of the week. He says that he does not want to stay for long, however, as there are 'too many pretty things to do in the country' (WL.214). As well as painting some of his more practised views of the river, islands and village, Monet also experiments with new locations and perspectives (w.666–75).

29 APRIL · Monet is in Paris showing his new paintings of the coast to Durand-Ruel. The dealer buys four that day (including w.643, 657, 666) but returns to buy eighteen more at the beginning of May for 300 francs each (w.639, 642, 645–53, 655, 656, 659–65).

2 MAY · De Bellio sends Monet 300 francs in payment for a still life of flowers, which he says is 'charming,' and 'perfume for the eyes' (w.548; WL.48).

24 MAY · In a letter to Zola, Monet explains that he will soon have to leave Vétheuil and wants to move somewhere pretty on the Seine, with a good college for his son Jean (WL.218). He is considering Poissy.

JUNE · Income from paintings is higher than it has been for almost ten years. The price of the average canvas is now set at 300 francs.

JULY · & AUGUST · Over the summer, Monet paints the meadows and fields, as he did the year before, and also develops views of his own garden (w.676–85).

EARLY SEPTEMBER · Monet spends time at Trouville and Sainte-Adresse, again painting the coast (w.686–9).

1 OCTOBER · The lease of the house rented by the Monet and Hoschedé families in Vétheuil expires. But they stay on, and Monet paints various views of the area, mostly aspects of the river (w.692–705). Hoschedé is in substantial debt to Monet with regard to his family's living expenses.

31 OCTOBER · Monet makes a very short trip to Paris, delivering eleven paintings to Durand-Ruel (w.516, 586, 613, 628, 677–9, 694, 698, 699, 704; WL.225).

17 DECEMBER · Monet, his two sons, Alice Hoschedé and her six children have moved into the Villa Saint-Louis, 10, cours de 14 juillet, on the edge of the Seine in Poissy. Situated twenty kilometres to the west of Paris, the town is not only larger than Vétheuil but much nearer the city. Monet writes to Durand-Ruel saying he has at last settled in and the previous day was able to take up his brushes again (WL.227). (Paintings sold to Durand-Ruel this month include w.598, 602, 654, 679–81.)

1882

19 JANUARY · Crash of the Union Générale bank, which had given Durand-Ruel substantial financial backing throughout the previous year.

5 FEBRUARY · Leaving Alice Hoschedé unwell, and alone with the children, Monet leaves Poissy to go to Dieppe, staying at the Hôtel Victoria. During this and subsequent trips he and Alice Hoschedé exchange letters almost every day.

9 & 10 FEBRUARY · Monet writes to Pissarro, Caillebotte and Durand-Ruel to inform them of his decision not to exhibit in that year's Impressionist exhibition. Although naming no-one in particular, he makes clear that he does not approve of some of the other exhibitors. In any case, he argues, he has only just arrived at the coast and has not painted anything for months (WL.235). Durand-Ruel buys two paintings of the artist's garden at Vétheuil (w.683 and 684).

15 FEBRUARY · Monet moves to the nearby fishing village of Pourville, lodging with M. Paul and Mme. Eugénie Graff, whose portraits he will

paint (w.744 and 745). Monet thinks the countryside to be very beautiful here and says to Alice that he wishes he had moved sooner (WL.242). But he is apprehensive of the future (WL.243). Not only finances but the domestic predicament of the Monet and the Hoschedé families are causing anxiety. Ernest Hoschedé is living in Paris and Alice and Monet have moved to a new house together, which is highly unconventional. Alice, left alone to cope with a succession of ill children while Monet is away, is also very unhappy in Poissy (WL.240).

23 & 24 FEBRUARY · Less than a week before the opening, Monet writes to Durand-Ruel agreeing to exhibit in the 7th Impressionist exhibition. Referring to the paintings to be shown, the artist is emphatic that the Salon painting *Lavacourt* should be left out (WL.249, 250).

1 MARCH (UNTIL 2 APRIL) 7th Impressionist exhibition at 251, rue Saint-Honoré in the Salle Valentino. There are approximately 210 new works by nine artists: Caillebotte, Gauguin, Guillaumin, Monet, Morisot, Pissarro, Renoir, Sisley, and Vignon. Most of the figurative painters, notably Degas and Raffaëlli, do not participate. Monet shows thirty-five paintings, most of which have been painted at Vétheuil (including w.473, 508, 535, 550, 568, 576, 601, 611 or 612, 628, 629, 635, 642, 643, 645, 648, 649, 650, 651, 653, 655, 656, 665, 676, 678, 679, 681, 683 or 684, 687, 694, 695).

25 MARCH · Monet writes to Durand-Ruel asking him to send money to Mme Hoschedé as the youngest Hoschedé child is very ill. He informs the dealer that he plans to return from the coast at Easter. Although he has already finished some canvases, he prefers to wait and show him the whole series of studies together (WL.260).

4 APRIL · Louis Gonse, a writer for the *Gazette des Beaux-Arts*, contacts Monet wanting to buy a painting. Durand-Ruel is reportedly now pricing some of Monet's paintings at 2000 to 2500 francs each. Finding this too expensive, Gonse wants to buy cheaper, directly from the artist. Monet refuses. With regard to his work, Monet is becoming dissatisfied. A letter to Alice, however, describes the rapid changes of nature, saying that the countryside is becoming increasingly beautiful (WL.263bis, 265).

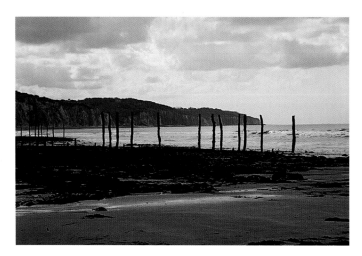

Fig 84 · The stakes for holding fishing nets at Pourville, April 2002

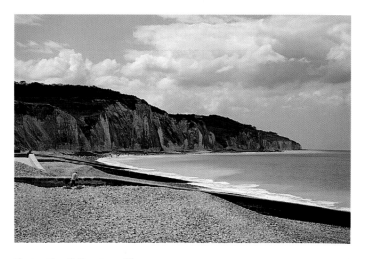

Fig 85 · The cliffs at Pourville, May 2002

14 APRIL · Monet returns to Poissy with a large number of completed canvases. To begin with he had painted several cliff scenes, similar to those he had done at Fécamp; he had then progressed to paint Varengeville, depicting views from on top of the cliffs. This latter set of works comprised those of the Varengeville church, and the old customs house (w.706-43).

22 APRIL · Monet takes a batch of sixteen paintings to Durand-Ruel, followed by seven more a few days later (w.709, 711, 712, 716, 721, 722, 724-7, 730, 731, 733, 734, 736, 742, 743, 755 or 756, 786, 788, 792, 806, 808).

MAY · Courbet retrospective exhibition at the Ecole des Beaux-Arts. The paintings exhibited include some of the cliffs at Etretat.

24 MAY · The artist complains to Durand-Ruel that he has been unable to work, apart from a 'few bad flower efforts that he had to rub out afterwards' (WL.273).

26 MAY · In response, Durand-Ruel urges Monet to get back to work as he did in Pourville. He suggests the artist paint flowers, and tells him not to waste this precious time of year. He even proposes that Monet consider leaving Poissy before the end of his lease, as the house there appears to be making them all ill and unhappy (WL.85). The few remaining pictures from Poissy show little of its landscape. One shows a square filled with lime trees (w.747), another is a *sous-bois* in the nearby forest of Saint-Germain (w.750), and two others look down on to a group of fishermen (w.748 and 749).

17 JUNE · In the interests of his work and the families' health, Monet returns to Pourville for the summer with Alice and all the children, renting a house called the Villa Juliette (WL.275). Paintings sold to Durand-Ruel this month include w.687, 732, 735, 738, 787, 791.

JULY · Over the course of his stay, Monet paints a large number of canvases, exploring all around the clifftops, paths and beaches (w.751-808). The weather is not good this summer, however, and Monet has to take advantage of sunny spells as they appear (WL.280).

MID-JULY · Durand-Ruel spends a short time with the artist at Pourville. At some point during the summer four of Monet's works are shown at an Impressionist exhibition organised by Durand-Ruel at 13 King St, London (w.290, 722, 731, 734).

EARLY AUGUST · Durand-Ruel visits Monet at Pourville, and brings Renoir with him. They rent a house arranged by the artist and are later followed by Victor Chocquet, whom Monet sees often (WL.279, 287).

SEPTEMBER · During the autumn two of Monet's paintings are exhibited in Berlin (w.377, 464) and two in Tours (w.722, 735).

16 SEPTEMBER · Monet is becoming impatient with the bad weather, which is preventing him from working. Again considering moving, the artist makes inquiries through Pissarro regarding the college in Pontoise (WL.287).

11 OCTOBER · After visiting his brother in Rouen, Monet returns to Poissy (WL.290, 291 and 293). Monet's sales to Durand-Ruel of twenty-six paintings done over the summer total 11,100 francs (w.708, 714, 719, 741, 751, 758, 760-3, 765, 766, 769-72, 778-81, 794, 79-9, 803, 805). He attempts to paint outdoor subjects at Poissy, but these never amount to anything.

EARLY NOVEMBER · Monet takes a short holiday on the banks of the Seine, probably in search of somewhere new to live.

21 NOVEMBER · Still in Poissy, Monet has been painting flowers (w.809-12).

7 DECEMBER · The Seine is in flood and Poissy is badly affected.

1883

1 JANUARY · Monet is angry that Hoschedé will not come to see his children on New Year's day, solely because of the artist's presence. In a curt letter, Monet points out that they have moved to Poissy with Hoschedé's assent (WL.306).

25 JANUARY · Having left to go to the Normandy coast again, Monet writes to Alice from Le Havre. The situation between the artist and Hoschedé is becoming more strained. Knowing they will soon have to find new accommodation, Monet is impatient for a decision regarding the two families' future (WL.307).

31 JANUARY · Monet moves on to the Hôtel Blanquet at Etretat. Although he had hoped to paint the boats at Le Havre, the weather made it impossible to work. He writes to Alice, however, saying he will 'do some very good things' at Etretat, and that he has 'motifs at the door of his hotel, and a superb one from his window' (WL.310).

1 FEBRUARY · Monet is pleased with his work. The weather, although cold, is good and he is considering embarking on two large canvases. As well as a picture of boats, he plans to paint the cliff at Etretat. He tells Alice,
... it may · be terribly audacious of me to do this after Courbet, who did it admirably, but I will try to do it differently (WL.312).

3 FEBRUARY · In raptures about the beauty of the sea, the artist is also frustrated at being unable to capture it in his work. He speaks of going to a place where he had not ventured before, and having to come straight back to fetch his canvases (w.832-3; WL.314).

4 FEBRUARY · Monet is visited by his brother Léon. Suffering from vertigo, the latter has great difficulty following the artist along the cliff paths. Monet jokes to Alice that he was forced to give him his hand, 'as if to a lady' (WL.315).

7 FEBRUARY · The weather at Etretat changes to rain and grey clouds. In a letter to Alice, Monet says that he would have preferred the grey weather if he had not already started his studies in the sun. He explains that it would be more suitable for doing different informative studies, with a view to painting something larger on his return (WL.318).

10 & 11 FEBRUARY · Although the weather is worsening, Monet is able to paint from a room in his hotel where, he says, there is a 'superb view of the cliffs and the boats' (w.825-9; WL.321). To his annoyance, his efforts are hindered by the fishermen, who continually move their boats to protect them from the high seas (WL.323). The artist is also busy writing to collectors to generate support and secure loans for his next exhibition (WL.329).

17 FEBRUARY · Monet is at his wits' end. Having battled with the changing climate and the movement of the boats as well as a head cold, he is completely dissatisfied with his work, and blames the 'blasted exhibition' for not allowing him enough time. The artist is also greatly troubled by the imminent meeting of Alice and Ernest Hoschedé, who are to decide the families' futures (WL.326-31).

21 FEBRUARY · Monet returns to Poissy. After all his anxiety, the living arrangements of the Monets and the Hoschedés do not change.

28 FEBRUARY (UNTIL 25 MARCH) · *Exposition des oeuvres de Claude Monet* at Durand-Ruel's galleries, 9 boulevard de la Madeleine. It is Monet's second one-man show (including w.39, 172, 177, 184, 217, 255, 263, 289, 290, 292, 324, 356, 373, 401, 402, 442, 489, 539, 548, 625, 628, 630, 631, 634, 694, 695, 711, 724, 726, 730, 733, 734, 736?, 743, 744, 746, 748, 751, 755 or 756?, 758, 760 or 762?, 761, 765, 769, 770, 771, 776, 778, 792, 794?, 796, 797, 806, 808?, 814, 951, 952.) None of his paintings from Etretat appear to have been included.

5 MARCH · In a letter to Durand-Ruel, Monet complains about the lighting in the exhibition room and asks for it to be changed (WL.336). He sees the exhibition as a catastrophe. Not used to the silence and indifference of the newspapers, he regards it as a sign of failure. Although he does not value the opinion of the press, he recognises its importance (WL.337, 338).

8 MARCH · Monet expresses his interest in the 'Japanese exhibition' in a letter to Durand-Ruel (WL.339). Opening the next day at the Georges Petit galleries, the exhibition will feature a large retrospective of Japanese art.

20 APRIL (UNTIL 7 JULY) · Dowdeswell & Dowdeswell, London, show four of Monet's paintings in an exhibition for *La Société des impressionnistes* (w.290, 751, 758, 762).

29 APRIL · Eight days later than planned, Monet leaves Poissy for a new house in the small village of Giverny with some of the children. Alice, however, is unable to follow because of a shortage of funds and Monet, again, has to apply to Durand-Ruel for help (WL.348).

30 APRIL · Death of Edouard Manet. The next day Monet leaves to go to Paris for the funeral, where he is to be a pallbearer (WL.349).

JULY · Monet sells some of his paintings from Pourville and Etretat to Durand-Ruel (w.740, 768, 816, 826, 829, 832).

1 SEPTEMBER (UNTIL 1 DECEMBER) · *American Exhibition of Foreign Products, Art and Manufactures*, Boston, shows three of Monet's paintings (w.284, 722, 735). Durand-Ruel is beginning to develop an American market in Impressionist paintings.

NOVEMBER – DECEMBER · Durand-Ruel buys most of the remaining paintings of the Normandy coast (including w.718, 723, 752, 758, 782, 793, 817, 818, 821, 823, 830, 832).

BIBLIOGRAPHY

Books and articles

ACKERMAN
E. Ackerman, 'Alternative to Rural Exodus: the development of the commune of Bonnières-sur-Seine in the nineteenth century', *French Historical Studies*, X, no.1, Spring 1977, pp.126–48

ANGRAND
Charles Angrand, *Correspondances, 1883–1926*, ed. François Lespinasse, Rouen 1988

ANONYMOUS
Anon., 'Les Rues de Paris', *Le Monde illustré*, XLV, 13 December 1879, p.378; 'Le Froid à Paris', *ibid.*, 20 December 1879, p.394; 'La Buvette groënlandosie au quai de l'Hôtel de Ville', *ibid.*, 27 December 1879, p.411; 'Le Débâcle de la Seine', *ibid.*, XLVI, 10 January 1880, p.22

Anon., 'Revue des ventes. Collection Ch. Leroux', *Le Journal des arts*, X, no.12, 28 February 1888, p.3

BAIGNERES
Arthur Baignères, 'Le Salon de 1879, II,' *Gazette des Beaux-Arts*, pér. 2, XX, July 1879, pp.35–57

BARBEY D'AUREVILLY
Jules Barbey d'Aurevilly, *L'Amour de l'art*, ed. Jean-François Delaunay, Paris 1993

BARRON
Louis Barron, *Les Environs de Paris*, Paris 1886

Louis Barron, *La Seine*, Paris [n.d.]

BERSON
Ruth Berson (ed.), *The New Painting: Impressionism, 1874–1886*, 2 vols., San Francisco 1996

BREJON DE LAVERGNEE / SCOTTEZ-DE WAMBRECHIES
Arnauld Brejon de Lavergnée and Annie Scottez-De Wambrechies, *Musée des Beaux-Arts de Lille. Catalogue sommaire illustré des peintures. II – Ecole française*, Paris 2001

BUISSON
J. Buisson, 'Le Salon de 1881. I', *Gazette des Beaux-Arts*, pér. 2, XXIII, June 1881, pp.473–513; II, XXIV, July 1881, pp.29–81

BUNEL AND TOUGARD
Abbé J. Bunel and Abbé A. Tougard, *Géographie du Département de la Seine-Inférieure. Arrondissement du Havre*, Rouen 1877

BURTON
Jacques Louis Burton, *Commune de Vétheuil*, Ms., 1900, Archives les Amis de Vétheuil

CALLEN
Anthea Callen, *The Art of Impressionism: Painting Technique and the Making of Modernity*, New Haven and London 2000

CHAMPIER
Victor Champier, *L'Année artistique. Année 1878*, Paris 1879

CHENNEVIERES
Philippe de Chennevières, 'Le Salon de 1880. III', *Gazette des Beaux-Arts*, pér.2, vol.XXII, July 1880, pp.41–70

CLEMENCEAU
Georges Clemenceau, *Claude Monet. Les Nymphéas*, Paris 1928

DISTEL
Anne Distel, *Les Collectionneurs des Impressionnistes: amateurs et marchands*, Paris 1989

DUMAS
F.-G. Dumas (ed.), *1882. Annuaire illustrée des Beaux-arts*, Paris 1882

GEFFROY
Gustave Geffroy, *Claude Monet, sa vie, son oeuvre*, Paris 1924 (Paris 1980, ed. Claudine Judrin)

GIDEL
Paul Gidel, 'La Normandie maritime', *Photojournal*, I, Paris 1891, pp.65–70

HANDBOOK FOR TRAVELLERS
A Handbook for Travellers in France, Part I, London 1879

HEMMINGS
F. W. J. Hemmings, *Emile Zola* (2nd edn), Oxford 1966

HERBERT
Robert L. Herbert, *Impressionism. Art, Leisure and Parisian Society*, New Haven and London 1988

HERBERT
Robert L. Herbert, *Monet on the Normandy Coast. Tourism and Painting, 1867–1886*. New Haven and London 1994

HOSCHEDE
Jean-Pierre Hoschedé, *Claude Monet, ce mal connu*, 2 vols., Paris 1960

HOUSE
John House, *Monet: Nature into Art*, New Haven and London 1986

ISAACSON
Joel Isaacson, *Claude Monet: Observation and Reflection*, Oxford 1978

JOEL
David Joel, *Monet at Vétheuil*, Woodbridge 2002

JOHNSON
Lee Johnson, *The Paintings of Eugène Delacroix. A Critical Catalogue 1832–1863*, vols.III and IV, Oxford 1986

KENDALL
Richard Kendall, *Monet by Himself*, London 1989

KLEIN
Jacques-Sylvain Klein, *La Normandie, berceau de l'impressionnisme, 1820–1900*, Rennes 1999

LESPINASSE
François Lespinasse, *Emile Nicolle, 1830–1894*, Rouen 1998

LEVINE
Steven Z. Levine, *Monet, Narcissus and Self-Reflection. The Modernist Myth of the Self*, Chicago and London 1994

DE LOSTALOT
Alfred de Lostalot, 'Exposition des oeuvres de Claude Monet', *Gazette des Beaux-Arts*, pér. 2, XXVII, April 1883, pp.342–8

MAINARDI
Patricia Mainardi, *The End of the Salon. Art and the State in the Early Third Republic*, Cambridge 1993

MATHEWS
Nancy Mowll Mathews (ed.), *Cassatt and her Circle. Selected Letters*, New York 1984

DE MAUPASSANT
Guy de Maupassant, *Pierre et Jean*, Paris 1888

Guy de Maupassant, *Chroniques I*, ed. Hubert Juin, Paris 1980

MITCHELL
Peter Mitchell, *Jean Baptiste Antoine Guillemet, 1841–1918*, London 1981

MOREAU-NELATON
E. Moreau-Nélaton, *Histoire de Corot et ses oeuvres*, Paris 1905

PISSARRO
Camille Pissarro, *Correspondance de Camille Pissarro*, ed. Janine Bailly-Herzberg, vol.I, Paris 1980, vol.II, Paris 1986

PROTH
Mario Proth, *Voyage au Pays des Peintres. Salon Universel de 1878*, Paris 1879

RAPETTI
Rodolphe Rapetti, 'Débâcles', *Monet. I luoghi della pittura*, Casa dei Carraresi, Treviso 2001, pp.67–80

RENARD
Jules Renard, *L'Ecornifleur*, Paris 1892 (English edn, London 1957)

REWALD
John Rewald, *Studies in Post-Impressionism*, New York 1986

REWALD AND WEITZENHOFFER
John Rewald and Frances Weitzenhoffer, *Aspects of Monet. A Symposium*, New York 1984

ROBIDA
Michel Robida, *Le Salon Charpentier et les impressionnistes*, Paris 1958

ROGER-BALLU
Roger-Ballu, *La Peinture au Salon de 1880*, Paris 1880

SHONE
Richard Shone, *The Janice H. Levin Collection of French Art*, New Haven and London 2002

SPATE
Virginia Spate, *Claude Monet. The Colour of Time*, London 1992

STEVENS
MaryAnne Stevens, 'Dalla disperazione all'esaltazione. Il viaggio artistico di Monet da Vétheuil a Giverny', *L'impressionismo e l'età di Van Gogh*, Casa dei Carraresi, Treviso 2002, pp.153–66

STUCKEY
Charles Stuckey (ed.), *Monet. A Retrospective*, New York 1985

THOMAS
Greg M. Thomas, *Art and Ecology in Nineteenth-Century France. The Landscapes of Théodore Rousseau*, Princeton 2000

THOMSON

Richard Thomson, 'Les Quat' Pattes': the image of the dog in late nineteenth-century French art, *Art History*, vol.5, no.3, September 1982, pp.321–37.

Richard Thomson, *Degas. The Nudes*, London 1988

TUCKER

Paul Tucker, *Monet at Argenteuil*, New Haven and London 1982

Paul Tucker, *Claude Monet. Life and Art*, New Haven and London 1995

W.+NO. / WL.+NO.

Daniel Wildenstein, *Claude Monet. Biographie et catalogue raisonné*, 5 vols., Lausanne and Paris 1974–91

ZOLA

Emile Zola, *La Joie de vivre*, Paris 1884 (English edn, London 1955)

Emile Zola, *Le Bon combat: de Courbet aux Impressionnistes*, ed. Jean-Paul Bouillon, Paris 1974

Exhibition catalogues

ANN ARBOR

Joel Isaacson, Jean-Paul Bouillon *et al.*, *The Crisis of Impressionism, 1878–1882*, Ann Arbor, University of Michigan, November 1979–January 1980

ANN ARBOR / DALLAS / MINNEAPOLIS

Charles Stuckey, Carole McNamara and Annette Dixon, *Monet at Vethéuil, The Turning Point*, Ann Arbor, University of Michigan, Dallas Museum of Art, Minneapolis Institute of Arts 1998

EDINBURGH

Douglas Cooper and John Richardson, *Claude Monet*, Royal Scottish Academy, August–September 1957

Richard Thomson and Michael Clarke, *Monet to Matisse: Landscape Painting In France 1874–1914*, National Gallery of Scotland, Edinburgh, August–October 1994

CHICAGO

Charles Stuckey, *Claude Monet, 1840–1926*, Art Institute of Chicago, July–November 1995

FECAMP

Marie-Hélène Desjardins-Ménégalli and Yvan Leclerc, *Maupassant 1850–1893*, Musées Municipaux Fécamp, May–July 1993

LONDON

David Bomford, Jo Kirby, John Leighton and Ashok Roy, *Art in the Making. Impressionism*, 1990–1, National Gallery, London

LONDON / AMSTERDAM / WILLIAMSTOWN

Richard R. Brettell, *Impressionism. Painting Quickly in France, 1860–1890*, National Gallery, London, Van Gogh Museum, Amsterdam and The Francine and Sterling Clark Institute, Williamstown 2000–1

LONDON / BOSTON

Ann Dumas, John House *et al.*, *Landscapes of France. Impressionism and its Rivals.* Hayward Gallery, London and Museum of Fine Arts, Boston 1995–6

PARIS

Exposition des Beaux-Arts. Salon de 1890. Catalogue illustré. Peinture et sculpture, Paris 1890

Emmanuelle Héran, Joëlle Bolloch *et al.*, *Le Dernier Portrait*, Musée d'Orsay, Paris 2002

TREVISO

Marco Goldin, Rodolphe Rapetti *et al.*, *Monet. I luoghi della pittura*, Casa dei Carraresi, Treviso, September 2001–February 2002

WASHINGTON

Eliza E. Rathbone, George T. M. Shackelford *et al.*, *Impressionist Still Life*, Philips Collection, Washington and Museum of Fine Arts, Boston 2001–2

Photographic Credits

NOTES

Looking to Paint: Monet 1878–83
pages 15–35

1 Champier 1879, p.118.

2 Buisson 1881, pp.75, 78.

3 Baignères 1879, p.48.

4 Mainardi 1993, pp.61–2; p.169, n.17; John House, 'Framing the landscape', in London/Boston 1995–6, p.28.

5 '... républicain et français': Henry Havard, 'L'Exposition des artistes indépendants', *Le Siècle*, 27 April 1879 (Berson 1996, I, p.223).

6 Philippe Burty, 'Les paysages de Claude Monet', *La République française*, 27 March 1883 (Stuckey 1985, p.101).

7 In 1879, no.140, *Marine* (1865; w.73, Metropolitan Museum, New York), no.157, *Jardin à Sainte-Adresse* (1867; w.95, Metropolitan Museum, New York); 1883, no.2, *Pointe de la Hève* (1864; w.39, National Gallery, London).

8 Tucker 1982, chap.6; Tucker 1995, pp.98–100.

9 W.416–33.

10 Hélène Adhémar, 'Ernest Hoschedé', in Rewald 1984, pp.52–71. I am grateful to Claire Joyes and Jean-Marie Toulgouat for additional information.

11 Charles Stuckey, 'Love, Money and Monet's *Débâcle* Paintings of 1880', in Ann Arbor/Dallas/Minneapolis 1998, pp.45–53.

12 Burton 1900, pp.9–19.

13 Burton 1900, pp.77–9; Barron [n.d.], p.212.

14 Burton 1900, p.10; Carole McNamara, 'Monet's Vétheuil Paintings: site, subject, and *Débâcles*', in Ann Arbor/Dallas/Minneapolis 1998, pp.67, 75.

15 WL.140

16 Ackerman 1977, pp.126–9.

17 Burton 1900, p.6.

18 '... aux bords de la Seine à Vétheuil, dans un endroit ravissant d'où je pourrais rapporter pas mal de bonnes choses': WL.136 (1 September 1878).

19 Spate 1992, p.133.

20 For example, w.495, 500–1, 517.

21 For example, w.552, 591.

22 For example, w.594.

23 W.493–4.

24 Hoschedé 1960, I, p.75.

25 W.542.

26 WL.200 (3 October 1880).

27 'Hélas, voilà mon beau soleil parti, de la pluie toute la matinée, je suis désolé, car avec une séance ou deux je finissais plusieurs études': WL.318 (7 February 1883).

28 'Voilà mon atelier. A moi!': Emile Taboureux,

'Claude Monet', *La Vie moderne*, 12 June 1880 (Stuckey 1985, p.90).

29 For Silvy see Mark Haworth-Booth, *Camille Silvy. 'River Scene, France'*, Malibu 1992.

30 Thomas 2000, p.37.

31 W.488–91.

32 The second is w.604.

33 W.647–50, w.653–6.

34 The canvas is w.667.

35 Barron 1886, p.556; Barron [n.d.], pp.212–13.

36 For example, w.673–5, 678–9, 692–3, 696–705.

37 Isaacson 1978, p.216; House 1986, p.45.

38 See London 1990–1, p.185.

39 W.566, 569.

40 McNamara in Ann Arbor/Dallas/Minneapolis 1998, pp.78–9.

41 'Ce n'est plus Paris, c'est Saint-Petersbourg'; Anonymous, 13, 20 and 27 December 1879.

42 McNamara in Ann Arbor/Dallas/Minneapolis 1998, pp.80–2; Anonymous, 10 January 1880, p.22.

43 Rodolphe Rapetti, 'Débâcles', in Treviso 2001–2, pp.71–2.

44 Tucker 1995, p.102.

45 WL.158 (to Ernest Hoschedé, 14 May 1879); WL.203 (to Théodore Duret, 9 December 1880).

46 The canvases included w.522?, 578, 580?, WL.196 (to Ernest Hoschedé, 25 July 1880); WL.200 (to Théodore Duret, 3 October 1880).

47 Landscapes w.532, 583?; portraits w.618, 636–7.

48 W.617, 620.

49 Burton 1900, p.75.

50 WL.312 (to Alice Hoschedé, 10 February 1883).

51 House 1986, p.147.

52 House 1986, p.40.

53 WL.173 (to Théodore Duret, 8 March 1880).

54 Emile Zola, 'Le Naturalisme au Salon', *Le Voltaire*, 18–22 June 1880, in Zola 1974, pp.217–8; Chennevières 1880, p.44.

55 Roger-Ballu 1880, pp.42–3.

56 Letter of 7 June 1880, in Mitchell 1981, p.26.

57 Robida 1958, p.81.

58 See WL.179 (to Théodore Duret, 19 May 1880.).

59 Geffroy 1942 (1980 edn, pp.159–61); Spate 1992, p.141; Annette Dixon, 'The Marketing of Monet; the exhibition at *La Vie moderne*', in Ann Arbor/Dallas/Minneapolis 1998, pp.97–108.

60 WL.186 (to Mme Charpentier, 27 June 1880).

61 Hemmings 1966, pp.87, 124–6.

62 WL.219 (to Charles Ephrussi, 5 June 1881).

63 House 1986, p.11; Spate 1992, pp.144, 148.

64 'Ses lignes sont plus arrêtées, ses masses sont plus lourdes, plus étroit est son horizon. Même aux approches de l'orage, la mer normande et plus lente, plus épaisse': Proth 1879, pp.56–7.

65 Guy de Maupassant, 'La Vie d'un paysagiste', *Gil Blas*, 28 September 1886, in Maupassant 1980, p.287.

66 'Les chemins de fer ont étendu le rayon de la banlieue, et au lieu d'aller, comme autrefois, travailler à Viroflay ou à Chaville, on va faire des études à Sainte-Adresse, à Villerville et au delà. Un nouveau genre s'est crée qu'on pourrait appeler la marine à figures': Baignères 1879, p.42.

67 Bunel/Tougard 1877, pp.137, 139, 140, 146.

68 W.644–6.

69 W.621–4; 663?, 664–5, 665 a and b

70 W.II, pp.2, 4.

71 *Handbook*, 1879, p.42.

72 W.706–7.

73 W.816–33.

74 Bunel/Tougard 1877, p.115.

75 W.821–30.

76 WL.310 (to Alice Hoschedé, 31 January 1883).

77 Herbert 1994, p.1.

78 Herbert 1994, p.39.

79 Guy de Maupassant, 'Etretat', *Le Gaulois*, 20 August 1880, in Maupassant 1980, pp.45–51; Herbert 1994, pp.66, 68.

80 Zola 1884 (1955 edn, p.166).

81 Fécamp 1993, p.41; Maupassant 1888, p.16

82 Renard 1892 (1957 edn), pp.53, 64.

83 '... ma passion pour la mer, ... Je sens que chaque jour je la comprends mieux, la gueuse': WL.730 (to Alice Hoschedé, 30 October 1886); Herbert 1994, p.42.

84 Probably w.653.

85 Berson 1996, I, pp.204–7.

86 For example, Henri Rivière, 'Aux Indépendants', *Le Chat noir*, 8 April 1882, p.4, and J.P., 'Beaux-arts. L'Exposition des artistes indépendants', *Le Petit Parisien*, 4 March 1882, in Berson 1996, I, pp.407, 409.

87 'Personne mieux que Millet n'a exprimé l'infini de la nature et la mélancolie de l'homme quand on le jette dans cet infini, sentiment inconnu aux brutalistes de ce temps!' in 'J-F. Millet', *Le Constitutionnnel*, 19 April 1876, in Barbey d'Aurevilly 1993, p.246. I am grateful to Bradley Fratello for drawing this text to my attention.

88 'Quant aux falaises elles sont ici comme nulle part. Je suis descendu aujourd'hui dans un endroit où je n'avais jamais osé m'aventurer autrefois et j'au vu des choses admirables': WL.314 (to Alice Hoschedé, 3 February 1883).

89 WL.315 (to Alice Hoschedé, 4 February 1883).

90 WL.254 (to Paul Durand-Ruel, 14 March 1882).

91 '... les gonflements et les longs soupirs de la mer, et les ruisellements du flot qui se retire, et les colorations glauques des eaux profondes': Ernest Chesneau, 'Groupes sympathiques: Les Peintres impressionnistes', Paris-Journal, 7 March 1882, in Berson 1996, I, p.385.

92 'Capable de puissants enthousiasmes et sujet à d'invincibles dégoûts. Proie flottante entre les exaltations de triomphe et les anéantissements de défaite ... La nevrose du temps a passé là': Montjoyeux, 'Chroniques parisiennes: Les Indépendants', Le Gaulois, 18 April 1879 (Berson 1996, I, p.233.)

93 Thomson 1988, pp.119–25.

94 See Charles Stuckey, 'Monet's art and the act of vision', in Rewald/Weitzenhoffer 1984, p.116.

95 Lespinasse 1998, pp.148–9.

96 Gidel 1891, pp.66–7.

97 House 1986, p.185.

98 House 1986, p.141.

99 Bréjon de Lavergnée/Scottez-De Wambrechies 2001, p.128; London/Boston 1995–6, no.50.

100 W.794–6.

101 Michael Clarke drew this to my attention on site.

102 House 1986, pp.86–7.

103 'Des falaises en bombe glacée, framboise et groseille'; 'la crème fouettée': Fichtre, 'L'Actualité: L'Exposition des peintres indépendants', Le Réveil, 2 March 1882; Jean de Nivelle, 'Les Peintres indépendants', Le Soleil, 4 March 1882; also A. Hustin, 'L'Exposition des impressionnistes', Moniteur des arts, 10 March 1882; La Fare, 'Exposition des impressionnistes', Le Gaulois, 2 March 1882 (Berson 1996, I, pp.387, 406, 395, 300).

104 W.623–4.

105 W.725–8.

106 Letter 193 (to Lucien Pissarro, 27 November 1883) and letter 195 (to the same, 1 December 1883), in Pissarro 1980, I, pp.255, 257.

107 For critical reviews see Bertall, 'Exposition des Indépendants: Ex-Impressionnistes, demain intentionnistes', L'Artiste, 1 June 1879, pp.396–8; Victor Fournel, 'Les Œuvres et les hommes: Courrier de théâtre, de la littérature et des arts', Le Correspondent, 25 May 1879 (Berson 1996, I, pp.210, 221).

108 Emile Zola, 'Le Naturalisme au Salon', Le Voltaire, 18–22 June 1880, in Zola 1974, p.218.

109 'Quelqu'un en art La vision de M. Monet est exceptionnelle': Lostalot 1883, pp.342, 344, 346, 348.

110 Mathews 1984, p.173 (14 October 1883).

111 W.731, 736, 738?, 741; Anon. 1888, p.3, nos.55–8.

112 John House, 'Introduction', in London/ Boston 1995–6, pp.8, 10.

113 Gustave Geffroy, 'Claude Monet', La Justice, 15 March 1883 (Stuckey 1985, p.97).

114 Angrand 1988, p.19 (letter of February 1883); Geffroy 1924 (1980 edn, p.175; undated).

115 For instance letter 348 (to Lucien Pissarro, 30 July 1886), in Pissarro 1986, p.64.

116 W.474–5 (1878); W.538–41 (1879).

117 House 1986, p.150.

118 E.g. Jacques de Biez, 'Les Petits Salons. Les Indépendants', Paris, 8 March 1882; Armand Sallanches, 'L'Exposition des artistes indépendants', Le Journal des arts, 3 March 1882, in Berson 1996, I, pp.380, 412.

119 WL.249 (to Paul Durand-Ruel, 23 February 1882).

120 See, for instance, Mitchell 1998, p.28; Klein 1999, p.81.

121 'Je suis installé ici depuis quelques jours, j'avais besoin de revoir la mer et suis enchanté de revoir tant de choses que j'ai faites il y a quinze années': WL.1324 (to Durand-Ruel, 25 February 1896).

122 WL.1331 (to Alice Monet, 8 March 1896).

123 'Jeux anglais': WL.1367 (to Alice Monet, 6 February 1897).

124 Geffroy 1924 (1980 edn, p.350).

125 W.1635–49.

Monet and Tradition, or How the Past became the Future
pages 37–50

1 I am particularly grateful to Richard Thomson for many useful suggestions made during the preparation of this essay. Anne Cowe generously provided essential documentary material from various libraries and archives in Paris. Frances Fowle applied her customary rigour to various drafts of the text.

2 See Ann Arbor 1998 and Joel 2002.

3 Tucker 1982.

4 R. Walter, Corot à Mantes, Paris 1997.

5 WL.136

6 Reprinted in the catalogue of the 1869 Salon and quoted by J. House, 'Authority versus independence: the position of French landscape in the 1870s', in Framing France: The representation of landscape in France, 1870–1914, Manchester, 1998, p.17.

7 The critical reverberations continued for some time, witness Théodore Véron's fulminations in his lectures at the Sorbonne, published in La Revue du Lyonnais, VIII, 1879. After listing (p.37) the French artists worthy of note he concluded, 'For, let us say it, we do not know how, unlike the English, the Austrians, the Belgians and the Spanish, to show off our riches'.

8 The English Guide to the Paris Exhibition 1878, Mason & Co, London, 6th edn, p.44.

9 Ibid., p.132.

10 Scribner's Monthly, December 1878, p.276.

11 Le Siècle, 30 May 1878.

12 Ibid.

13 Moreau-Nélaton, pp.148–9.

14 Information kindly provided by Frances Fowle.

15 Le Monde illustré, 12 October 1878.

16 Distel 1989, p.26.

17 W.I, pp.136–7.

18 Distel 1989, p.25.

19 B.L. Grad, An Analysis of the development of Daubigny's naturalism culminating in the riverscape period (1857–1870), Ph.D. University of Virginia 1977, New York 1977.

20 Feuilleton du Temps, 25 July 1878.

21 Scribner's Monthly, December 1878, p.276.

22 F. Henriet, Le Paysagiste aux champs, Paris 1876, p.235.

23 Daubigny, in turn, had derived the idea of the botin from the artist Jules Breton.

24 P.H. de Valenciennes, Elémens de perspective pratique à l'usage des artistes Paris, 1800 (2nd edn 1820).

25 For example, R. Hellebranth, Charles-François Daubigny 1817–1878, Morges 1976, nos.947–8.

26 Origins of Impressionism, exhibition catalogue, Metropolitan Museum of Art, New York, 1994–5, p.366.

27 There had also, more immediately, been a major retrospective of Corot's work at the Palais Galliéra, Paris, to mark the centenary of his birth.

28 Stuckey 1985, p.91.

29 Ibid., p.67.

30 Ibid., p.70.

31 Anon., 'The Society of French Artists', Pall Mall Gazette, no.8, 28 November 1872, p.11.

32 A. Sensier and P. Mantz, La vie et l'œuvre de Jean-François Millet, Paris 1881.

33 E. Chesneau, 'Le Japon à Paris', Gazette des Beaux-Arts, 1878, pp.385–97, a review of the Japanese section of the Exposition Universelle that year. Other artists cited in this respect included Manet, Tissot, Fantin-Latour, Degas and Carolus Duran. Among the critics on the list were the Goncourt brothers, Champfleury, Burty and Zola.

34 Ibid., p.396.

35 Monet and Japan, exhibition catalogue, Canberra and Perth, 2001.

36 Falaises d'Etretat, Le Pied, 1838, Musée Marmottan, Paris.

37 WL.312 (to Alice Hoschedé, 1 February 1883).

38 Ibid.

39 WL.346 to Durand-Ruel, 15 April 1883.

Notes to the Catalogue
pages 52–166

2
1 W.481–5, 481a.
2 For example, WL.199.

3 & 4
1 Berson 1996, II, IV–144.

14 & 15
1 'Je ne pouvais vous refuser l'autre jour de vous vendre cette Vue de Vétheuil pour 150 francs et je ne le regrette pas, quoique j'aie souffert en moi-même de voir la meilleure et la plus importante de mes toiles vendre à si bas prix': WL.170 (8 January 1880).

17
1 Documentation kindly provided by the mairie de Vétheuil, via M. Thierry Gardi.
2 For a recent alternative interpretation of this painting to the one given above, see Paris 2002, p.62.
3 Clemenceau 1928, pp.19–20.

21 & 22
1 W.551.
2 W.544–5; House 1986, p.40.
3 W.625–9, 634–5 (flowers), W.630–1 (fruit).
4 Berson 1996, II, VII–57, VII–69, VII–78, VII–80, VII–81, VII–82: W.629, 635, 628, 694, 695, and either W.549 or W.550.
5 W.919–58.

26 & 27
1 'Je travaille à force à trois grandes toiles dont deux seulement pour le Salon, car l'une des trois est trop de mon goût à moi pour l'envoyer et elle serait refusé, et j'ai dû en place faire une chose plus sage, plus bourgeoise': WL.242 (8 March 1880).
2 For instance Spate 1992, p.143.
3 House 1986, pp.153,155.
4 Henri Rivière, 'Aux indépendants', *Le Chat noir*, 8 April 1882, p.4; Armand Silvestre, 'Le Monde des arts: Expositions particulières: Septième exposition des artistes indépendants', *La Vie moderne*, 11 March 1882, p.150; Jean de Nivelle, 'Les Peintres indépendants', *Le Soleil*, 4 March 1882: in Berson 1996, I, pp. 409, 413, 406.

28, 29 & 30
1 Berson 1996, II, nos.IV–149, IV–161, IV–150.
2 E.C., 'Deux Expositions', *Le Soleil*, 11 April 1879; Montjoyeux, 'Chroniques parisiennes. Les Indépendants', *Le Gaulois*, 18 April 1879, in Berson 1996, I, pp.214, 233.
3 'Trop de mon goût à moi pour l'envoyer et elle serait refusé ... plus sage, plus bourgeoise': WL.173 (8 March 1880).
4 E. Zola, 'Le Naturalisme au Salon', *Le Voltaire*, 18–22 June 1880, in Zola 1974, p.217; Chennevières 1880, p.44.

5
5 WL.196 (to Ernest Hoschedé, 25 July 1880); WL.200 (to Théodore Duret, 3 October 1880).
6 WL.249 (to Paul Durand-Ruel, 23 February 1882).

33 & 34
1 Callen 2000, p.15.

37 & 38
1 'Je suis venu faire un petit séjour aux bords de la mer et je m'en trouve si bien que j'ai grand désir de rester un peu plus longtemps': WL.212 (to Paul Durand-Ruel, 23 March 1881).

41
1 Berson 1996, I, VII–61, VII–66, VII–67, VII–76, VII–77, VII–87: W.655, 650, 648, 649, 653, and unidentified; VII–83, W.651, is from beach level.
2 The other is W.659.

45
1 Paul de Charry, 'Beaux-Arts', *Le Pays*, 14 March 1882 (Berson 1996, I, p.384).

46
1 Isaacson 1978, p.212; House 1986, p.155.
2 Berson 1996, II, VII–70.

47, 48 & 49
1 'Me voici de retour à Vétheuil. La persistance du mauvais temps m'ayant empêché toute espèce de travail, force m'a été de revenir, et de revenir bredouille': WL.222 (13 September 1881).
2 Berson 1996, II, VII–84.

50
1 'Il y a des jolies choses à faire. La mer est superbe, mais les falaises par leur disposition sont moins belles qu'à Fécamp. Ici, je ferai certainement plus de bateaux': WL.233 (6 February 1882).
2 WL.234 (6 February 1882).
3 WL.235 (to Alice Hoschedé, 7 February 1882).
4 WL.241 (14 February); ibid., WL.236, (8 February, 1882); ibid., WL.235 (7 February 1882); ibid, WL.242 (15 February 1882).

51 & 52
1 WL.266 (7 April 1882); ibid., WL.264 (6 April 1882).
2 WL.270 (to Alice Hoschedé, 11 April 1882).
3 'La Marée basse, avec ses imposantes falaises de Varengeville, chargées de mousses et se mirant dans un eau tranquille, filtrée par les sables de la plage: une merveille d'impression, une peinture d'un charme et d'une justesse rares': Lostalot 1883, p.346.

53, 54 & 55
1 House 1986, p.190.

56, 57, 58 & 59
1 'Hier j'ai travaillé à huit études, en supposant que j'y travaille à chaque une petite heure, vous voyez que je ne perds pas mon temps': WL.266 (to Alice Hoschedé, 7 April 1882).

2
2 A. Forge, 'Voilà mon atelier. A moi!', in Rewald/Weitzenhoffer 1984, p.104.
3 See also Antoine Chintreuil, *The Sea at Sunset, Fécamp*, c.1866, Bourg-en-Bresse, Musée de Brou (fig.60).

62 & 63
1 'On ne peut être plus près de la mer que je ne suis, sur le gâlet même, et les vagues battent le pied de la maison': WL.242 (15 February 1882).
2 Thomson 1982, p.327. W.745a is a study of Follette.
3 WL.328 (15 February 1883).
4 Geffroy 1924 (1980 edn, p.350).

64
1 'Un joli endroit au bords de la Seine': WL.218 (to Emile Zola, 24 May 1881).
2 'Poissy ne m'a guère inspiré': WL.234 (to Paul Durand-Ruel, 6 February 1883).

65 & 66
1 House 1986, p.185.
2 Herbert 1988, pp.299–300.

67
1 W.764 is another example.
2 Auguste Renoir, *Blanche Pierson's Cottage, Pourville*, 1882, New York, the Philip and Janice Levin Foundation; Shone 2002, no.13.
3 I am grateful to Nicola Ireland for this information.

68 & 69
1 W. II, p.8.

70
1 WL.243 (17 February 1882).

74
1 Herbert 1994, p.120.
2 Johnson 1986, III, no.490.

76 & 77
1 WL.1639 (to Paul Durand-Ruel, 19 July 1901).
2 'J'ai entrepris une série de *Vues de Vétheuil*, que je pensais pouvoir faire rapidement et qui m'a pris tout l'été': WL.1644 (to Paul Durand-Ruel, 19 October 1901).
3 Hoschedé 1960, I, pp.126–7; W. IV., pp.30–1.
4 Burton 1900, p.41.

78
1 Johnson 1986, III, no.490.
2 Letter of 3 June 1859, cited in Geffroy 1924 (1980 edn, p.28).
3 Musée Marmottan, Paris, inv.5052, 5053.
4 Johnson 1986, III, no.490. For Chocquet see Rewald 1985, pp.121–87.
5 W.401–4.

90
1 Paris 1890, no.1453.
2 Burton 1900, p.41.